STEVE JOY uncreated light

For my parents Joan and Leonard

STEVE JOY

uncreated light
paintings 1980–2007

JOSLYN
Art Museum

Prestel
Munich · Berlin · London · New York

contents

foreword

While I have long admired the masterful individuality of Steve Joy's paintings, it was on the occasion of his small exhibition of Pope paintings in the Old Market in Omaha two years ago that I saw the importance of mounting a career survey of his work for Joslyn Art Museum. It became clear to me after our informal meeting, graciously arranged by collector and mutual friend Dr. Thomas Huerter, that Steve possessed a profound capacity to express a hierarchy of intangible human and otherworldly feelings through his art in the form of what is referred to in this book as "spiritual abstractions," or non-objective paintings.

Joslyn Art Museum is pleased and honored to recognize the achievements of Steve Joy in this first comprehensive survey of his artistic career. The exhibition covers almost three decades of activity, includes over fifty paintings and additional drawings, and borrows from public and private collections in this country and abroad.

Inspired by such pioneering abstractionists as Wassily Kandinsky, Kazimir Malevich, Mark Rothko, Barnett Newman, and Brice Marden, Steve has explored the making of non-objective icons or devotional images utilizing broad surfaces of color and gold hinged by rich tonalities that recall the figurative icons and religious paintings of an earlier time. His paintings act upon us as pictorial bridges to the underlying sources of his subject matter—that of Christian iconography and its antecedents, the ancient geometric and figurative forms that populated the art of Mesopotamia, Egypt, and Greece.

The titles of his work suggest such familiar subjects as the Trinity, Madonna and Child, and the *Virgin of Vladimir*, yet their formal presentation is rooted deeply in Steve's intuitive configuration of abstract geometric surfaces, tonal hierarchies, and matrices of vertical and horizontal compartments. So haunting are his works that we are summoned to them much the way one is drawn to the warmth and glow

of an evening campfire. They are, however, more than physical experiences. They possess an intellectual richness and completeness reflective of a life's journey of discovery in pursuit of the self.

To encourage spirituality in all of us; to draw down on our infrequently exercised powers of self discovery and aesthetic joy; and to contemplate the enigmatic, cryptic, and profound symbolism that we find in art have been the consequences of Steve Joy's creative journey thus far. With this exhibition he shares that journey with us.

J. Brooks Joyner
Director, Joslyn Art Museum

introduction

There is no shortage of British artists who have left the comforts of home to travel the world. While one might expect a Briton to seek a Rome Prize or travel to the beauties of Provence, a good number have sought out the exotic and the unfamiliar. The Enlightenment in the late eighteenth and early nineteenth centuries saw artists looking first to exotic landscapes, as did David Roberts and Edward Lear, then unfamiliar cultures when, for instance, the Pre-Raphaelite Brotherhood sought to bring the landscape of the Holy Land to pictures of moral lessons personified by Biblical narratives. In 1772 William Hodges was the expedition artist for Captain Cook's second voyage to the South Seas. He sent back objects that were not only documentary in nature but also extraordinary works of art. Hodges, an artist, used the sea to travel, to see new things. Steve Joy, in the Royal Air Force, used the sea and travel to become an artist.

The stereotype of a soldier might not be one of a man searching for universal truths in diverse cultures, but to Steve Joy a shore leave was an occasion to sample the cultures and visit the art museums of his various ports of call. Upon demobilization, the need to continue that search, without a logical outlet, led to art school. While living with an acknowledged *Wanderlust*, the artist's work is not about travel or exotic sights. Joy's paintings join with earlier seekers of the human condition, with other artists, writers, philosophers, theologians, and even film directors as they make their own journey, their own spiritual travels through art.

Joy's technique echoes his search. The materials of his art have a mysterious depth. Non-traditional supports, sometimes heavy and occasionally three-dimensional, lie under saturated colors, the riches of gold and silver leaf and wax. Traditionally wax has been used to hide the truth, for instance in concealing repairs. The term *sin cere*, or "without wax" was used to connote truth in condition. For Joy, wax does

not so much conceal as it symbolizes the mysteries inherent in a spiritual and metaphysical journey.

While Steve Joy has followed his compatriot artists in a number of ways, his work certainly falls outside stereotypes of British art and artists, not least his difference from the Young British Artists movement of today. He came to maturity chronologically between the neo-Romanticism of British artists that generally populated the British art establishment of Joy's early career—the sort of traditional painters that became Royal Academicians in the late 1970s and early 1980s—and that of the "Sensation"-era artists who came to prominence a decade later in the early '90s. Joy's work differs from each and perhaps has its closest kindred spirit in the work of another expatriate artist, the American who worked in Britain, R. B. Kitaj, who likewise used painting as a means to describe his own life journey.

Joy's attention to the history of art allies him with a venerable brotherhood of British artists ranging from Rubens and van Dyck (two foreigners claimed by Britain) to Joshua Reynolds and Thomas Lawrence. These artists knew the history of their craft and sought to make their own art better by attention to earlier masters. But perhaps Joy has the closest affinity to J. M. W. Turner, the greatest of British artists. Turner's creative and inventive technique, his Romantic and proto-Impressionistic vision of landscape and nature, his knowledge of history, and his constant challenges to himself to out-do the work of his venerable heroes—Claude Lorrain, Nicolas Poussin, Rubens, Canaletto, Titian—and even his contemporaries such as David Wilkie, all find an echo in the work of Steve Joy, whose paintings, like Turner's, occasionally trumpet the challenge in a title. Moreover, like Turner, Joy's art is as often an *homage* to these artists (or film directors, or authors, or spiritual leaders) as his paintings commemorate the influence of his ongoing journey.

Steve Joy works in the quiet but fertile environment of Omaha, a small city that supports a serious community of creative artists (with a vigorous transient element manifested in the Bemis Center's residency program). It provides the perfect base and foil for the artist's intellectual and physical travels. It is clear that Steve Joy's journeys, like Cavafy's journey to Ithaca, begin with a prayer that the road is long.

John Wilson
Senior Curator of Collections, Joslyn Art Museum

biography

1952

Steve Joy is born on 7 October in the city of Plymouth, England, to Dorothy Joan and Leonard Joy.

1954

The family moves to a small village near the sea in Cornwall, called St. Anthony and moves shortly thereafter to nearby St. John.

Steve with his father, 1953 and his mother, 1952

1968

Joins the Royal Air Force and travels extensively through the Far East, Middle East, and Mediterranean, including two years on a small tropical coral island at the southernmost atoll of the Maldives in the Indian Ocean. Discovers *The Masterpiece*, a book by Emile Zola about Cezanne, which instills the notion of eventually becoming an artist and painter.

1971

Joins the bicycle racing team for the Royal Air Force, and represents the service throughout Europe, as well as at the Commonwealth games in New Zealand, entertaining the idea of becoming a professional. (There was, incidentally, quite a tradition of painter/cyclists in France and Belgium at the time of the Impressionists).

1973

A chance visit to the Stedelijk Museum in Amsterdam exposes Joy to the paintings and philosophy of Barnett Newman, and it is here that the idea of becoming an abstract painter takes shape. Begins to study comparative religions at the Royal Air Force, Chaplains College, Andover, England. Thinks of becoming an ordained minister at this point.

1975–79

Begins art education at Cardiff College of Art in Wales, moving to Exeter to complete a B.A. (Hons) program in fine arts. Begins by studying sculpture.

1978

First important solo exhibition at the Riverside Studios in London. Summer: bicycles from Holland to Norway with two fellow painters from Exeter College.

1980

Begins a Master's program at Chelsea School of Art in London, graduating in 1981 with an M.F.A. in painting. Meets, and is profoundly influenced by, the painters Ian Stephenson and Bob Law. It is particularly Bob Law's vision of painting which motivates Joy in the directions his work will take.

1981

After graduating takes some time to bicycle through Spain alone and discovers the poetry of Pablo Neruda, Antonio Machado, and, especially, the work of the Peruvian poet Cesar Vallejo, which will guide Joy through his life.

In autumn: Takes a painting fellowship at Chelterham College, England. This provides the first real studio in a converted museum in the town of Stroud, in the Cotswolds. Works on a series of monolith, monochrome paintings, based on the *Duino Elegies* by Rainer Maria Rilke. These would be exhibited at the Serpentine Gallery, London, and would be Joy's first museum exhibition.

1982

Moves to Kyoto, Japan, to study calligraphy and Japanese culture at Kyoto University of Arts. Reads and is very influenced by the writings of Yukio Mishima.

1983

Moves to Norway, at first to a small cottage at Tysnes, a Viking burial ground. Later moves to Oslo, marries Elenor Martinsen and rents a studio in the center of Oslo. Becomes a professor at the Kunstakademi in Trondheim.

1986

Packs all belongings in an old car and drives to Italy. Finds a wonderful studio in Umbria. At first the studio is in a medieval castle not far from Assisi, Castello di Polgeto, and then later moves nearby to a studio attached to an eleventh-century church.

Begins an extensive study of pre-Renaissance and Renaissance painting. Represents Norway at the Stockholm International Art Fair.

Royal Air Force College for Chaplains, Andover, England, 1973

Outside the Stroud Studio, Cotswolds, England, 1982

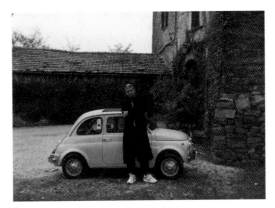
Steve Joy in Polgeto, Italy, 1986

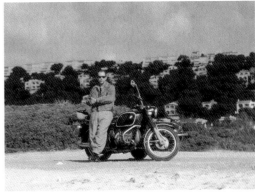
With a BMW motorcycle and sidecar, Minorca, Spain, 1989

looking at his work

WILLIAM ZIMMER "Steve Joy strikes a balance between the sublime and the quotidian as well as between color and form. Central to Joy's concept of painting is that no mark can be meaningless."

G. FAYANCE "All his painting is a celebration. Joy speaks a delicate and sensitive language open to all cultures which goes beyond ethnocentrism. From his many travels, he finds the difference and his vision becomes universal."

"The most salient feature of the painting of Steve Joy is that it strikes a balance between being cryptic—meaning private and therefore close to his own bone—and being very clear, open and friendly. It is a difficult equation demanding genuine cleverness, but exemplifying what we need most at this time."

1987

Spends winters in the medieval Belgian city of Bruges. Joins the 'tleerhuys Galerij and works in a studio in a sixteenth-century coaching house close to the Groeninge Museum. This, and the proximity of Antwerp and Ghent, afford access to the great masters of Flemish painting. Divides time between Bruges (winters) and Umbria, Italy (summers) for the coming years.

STEVE JOY
BRUGES, DECEMBER, 1988

There is an unbroken line to the present from the past in my work. A simple acknowledgment of seminal works and periods in the history of our culture. But I travel—there are other cultures! And then art is a part of life, not separate. There is much to absorb—and belief to be retained. At the same time there are mountains, the sea. The beauty and history in the earth around my studio in Umbria. I make these paintings in a state of surrender. They are made with control. Confused and knowing. There is no illusion within these panels; they exist physically to carry the poetry.

1989

Moves to the Balearic Island of Minorca, taking a studio in the capitol (Mahon) at first, and then later in a disused convent in the middle of the island.

1990

Moves to New York City and begins to work in a studio on Bond Street. Joins the Ruth Siegel Gallery on West 57th Street. Spends the summers in a new studio in Barcelona, close to the port in the Gothic quarter.

MIQUEL JANE HUGUET

"Allegories: geometrical forms, fiberglass … architecture of hotels; golden and silver shapes … lost glamour; waxed green color … copper roofs of the towers. The ornamented window opens into an imaginary harem. The stars are the key to the Arabian Nights, the key to art as a vehicle for abstract thought complexities."
"In his last paintings about oriental hotels, Steve Joy remembers the lost grandeur of the emblematic palaces. His multi-shaped way of painting makes us travel through the history of art.

Traveling around … through the multi-cultural aspect he leads to a universal vision; through his abstract way of painting he carries his universal thought."

1992

Becomes professor of painting at the Ecole des Beaux-Arts de Caen in France and moves to a studio in the village of Thury-Harcourt (Suisse-Normande). Has first museum show in France in the City Museum of Caen.

1994

Takes a new studio in Barcelona, close to the university and joins the Ferran Cano Gallery in Palma de Mallorca and Barcelona. Friendship with Sean Scully deepens—Scully lives across the hallway in Barcelona.

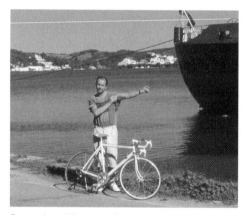
Steve Joy, Minorca, Spain, 1992

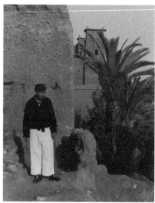
Ait-Benhaddou, Atlas Mountains, Morocco, 2002

1995

Accepts a professorship at the Western Academy of Arts, Bergen, Norway. Commutes between Norway and Spain. First museum shows in Norway—in Haugesund and later Bergen.

1998

Becomes curator at the Bemis Center for Contemporary Art in Omaha, Nebraska, moving more permanently to the United States later that year.

STEVE JOY, 2001

The initial impetus for painting came to me through exposure to the works of Barnett Newman and Mark Rothko. To this day, I remain committed to the idea of spiritual abstraction and to the development of painting and its history from the fifteenth century to today. Influences from the past would include Duccio, Giotto, Velasquez, and Matisse.

biography

The works in this exhibition are influenced by the ancient cities along the so-called Silk Route—beginning in China and ending in Constantinople (now called Istanbul); the ancient temples and sacred places of the Cyladic Islands of Greece and an obscure and remote pirate cemetery on the island of Saint Mairie, off the coast of Madagascar.

1999

After leaving the Bemis, begins to work in New York again. Spends summers back in Umbria, Italy.

2002

Begins to travel extensively in Mexico (Yucatan), India, and Morocco. In Morocco travels over the Atlas Mountains to Erfoud at the edge of the Sahara. Joins Galleri Elenor, Oslo, Norway. Revisits the Indian Ocean islands of the Maldives and earlier places of inspiration and abode. Journeys to the southern Addu Atoll, site of the Royal Air Force base in 1971.

Continues to work in New York. Also spends time working in the Old Market district of Omaha. Begins to show with Anderson O'Brien Fine Arts of Omaha.

2002-08

Continues (from 2003) to be based in Omaha, but spends most summers back in his hometown in England at the family home on the edge of Dartmoor, Devon.

I have lived all over the world, including many years in the Far East, and my current works include the somewhat romantic idea that exotic and mysterious places can be contained within painting—giving us all the taste of the unknown without having to make the journey ourselves.

In recent years I have made paintings that I hope contain the spirit of places as diverse as a pirate cemetery in Madagascar, the grand nineteenth-century hotels and palaces of India and the Far East, a Mayan temple in Southern Yucatan, or the remote deserts of North Africa, to name just a few. The most recent paintings in this exhibition are an attempt to deal with certain codes of ethics, aesthetics, and spirituality that run throughout the history of humanity. This includes the warrior code of the Samurai, the devotion and loyalty of people such as Saint Francis of Assisi, the great tradition of Russian Orthodox icon painting, and finally homage to the sublime, ethereal portraits of Leonardo da Vinci.

island and ikons: the ANEGADA NIGHT PAINTINGS

I've been drawn to islands all my life and grew up in Devon and Cornwall in southwestern England, amongst early memories of the sea and stories of smugglers and pirates, and later, the mists and fog of the Moorland and Celts and the mythology of the ancient world. I've lived on islands: the Maldives, Indian Ocean, Greek and Spanish islands, and keep returning to them whenever I'm restless. In a recent exhibition that I named *Architecture of Silence*, I was thinking of sacred places, abbeys and cathedrals perhaps, of darkened, candlelit rooms and the perfume of incense and spices from the East. Most of all, I was thinking of silence—the kind of silence I connect to icons, especially the great icons of the Byzantine period. In these paintings you see angels transfixed in ecstatic, petrified silence. I've often thought, "Is it possible to produce this kind of frozen silence in a painting, the kind that comes in the form of petrified longing?" Trying to connect these thoughts of Byzantine culture, my yearning for the islands and the ancient mysteries of prehistoric Britain is possible only through the traces and threads of my life that leave behind the idealized geometry of these paintings.

2005

Summer and autumn: rents a studio in Norway—a cottage by the Fjord between Oslo and Bergen, alongside the Hole Art Centre at Naess.

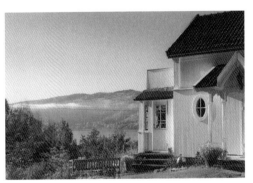
Studio in Norway, summer 2005

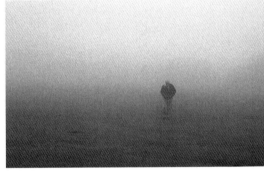
Dartmoor (in the fog), 2006

2006

Rents a cottage on the edge of Dartmoor, England. Begins the series entitled *The Temple of Athene*.

2008

Joy moves to a new studio at 1101 Jackson Street in Omaha; the design and concept of the studio are planned by local architect Paul Nelson.

2007–2005

omaha
mexico

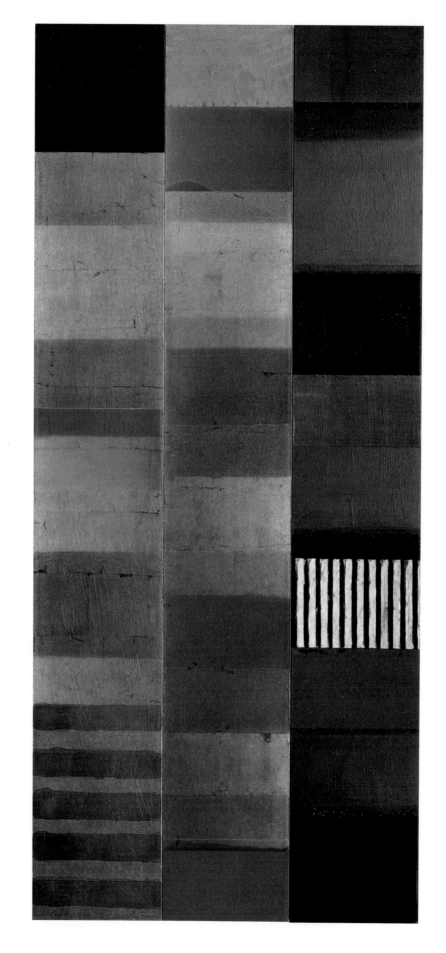

18

Two Saints (I): The Thessalonic, 2007 mixed media on wood
203 × 91 cm, 80 × 36", private collection, Omaha, USA

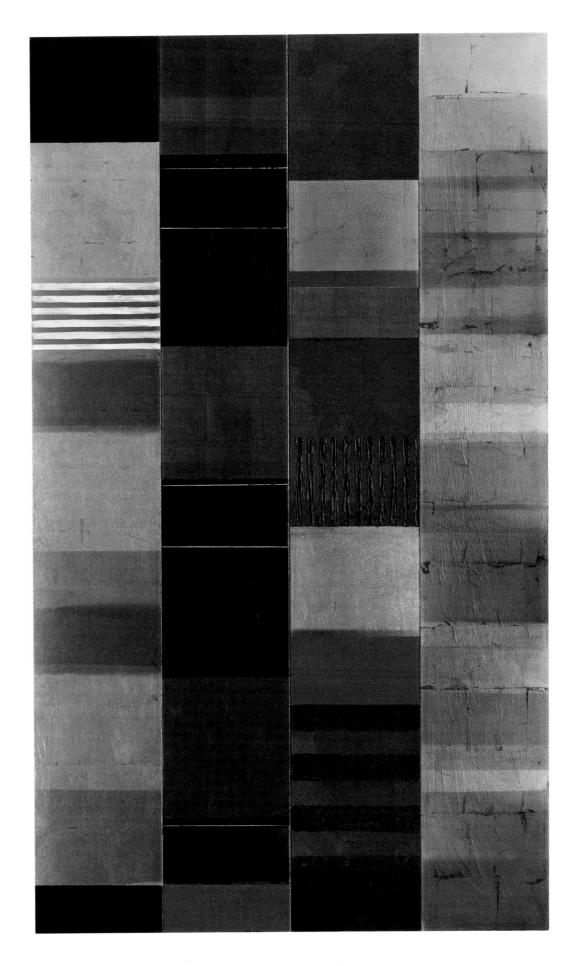

Two Saints (II): The Thessalonic, 2007 mixed media on wood
203×122 cm, 80×48", collection of the artist

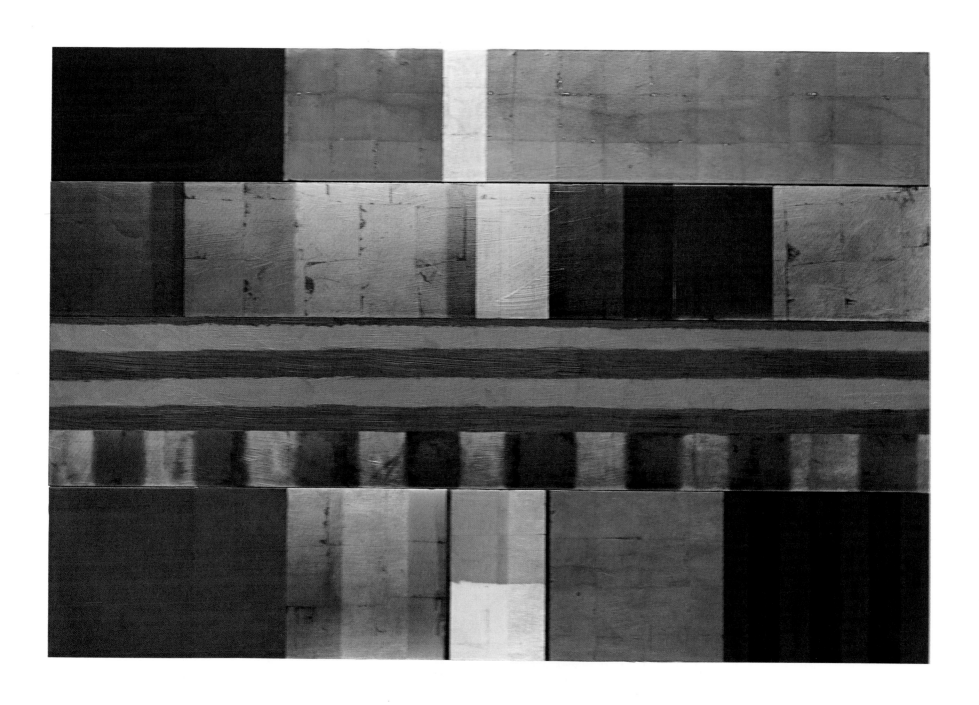

Icon (after Giotto) II, 2007 mixed media on wood
154×201 cm, 60 ¹/₂×79", private collection, Omaha, USA

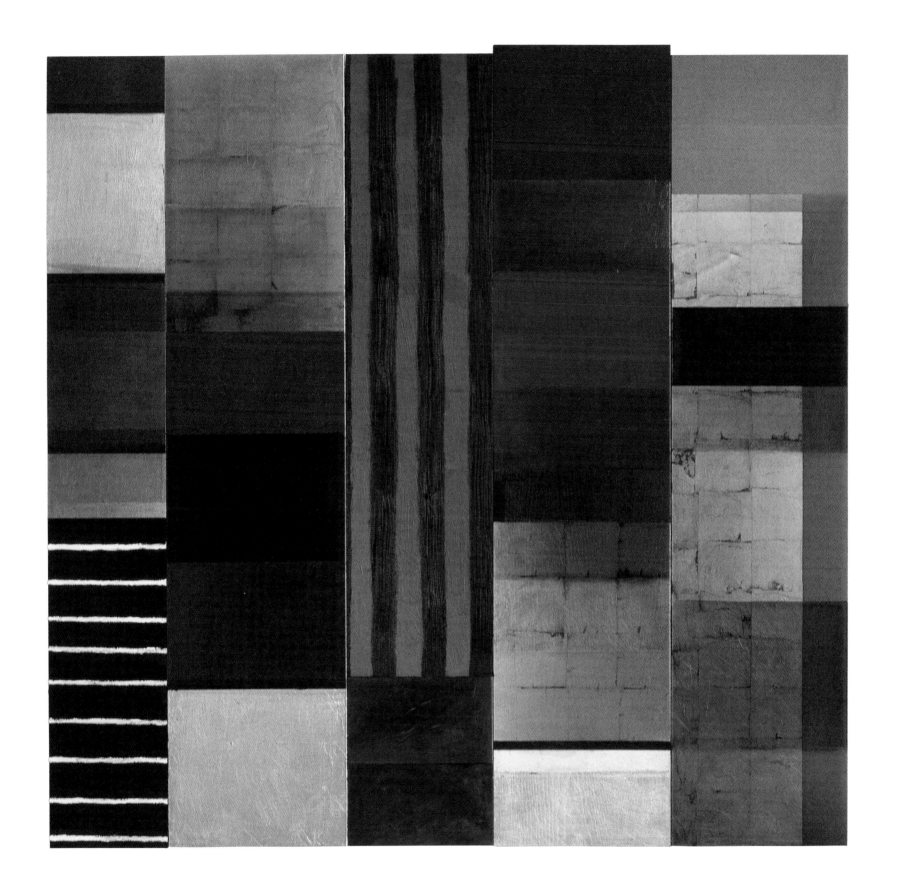

Icon (after Giotto) III, 2007 mixed media on wood
169×130 cm, 66 1/2×51", private collection, Omaha, USA

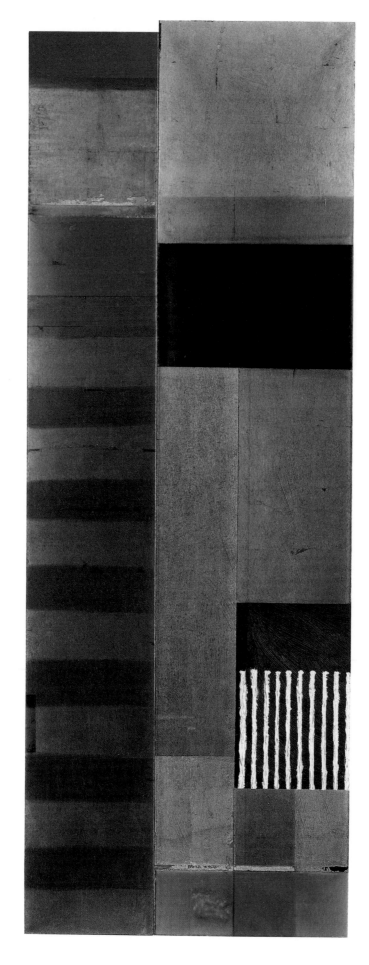

Sanctuary (Oasis), 2007 mixed media on wood
203×76 cm, 80×30", private collection, Omaha, USA

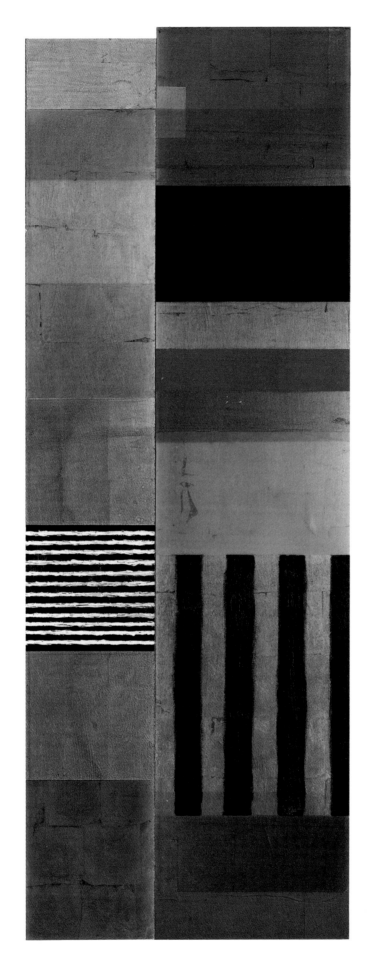

Sanctuary (Desert Red), 2007 mixed media on wood
203×76 cm, 80×30", private collection, Omaha, USA

23

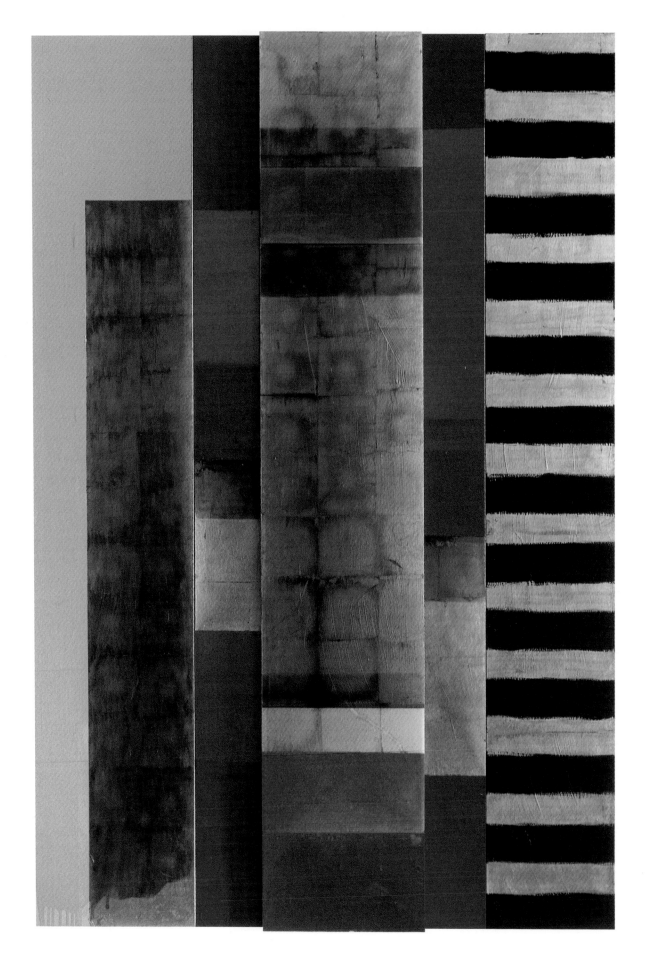

Two Saints (III): Balaam, 2007 mixed media on wood
· 203×155 cm, 80×61", collection of the artist

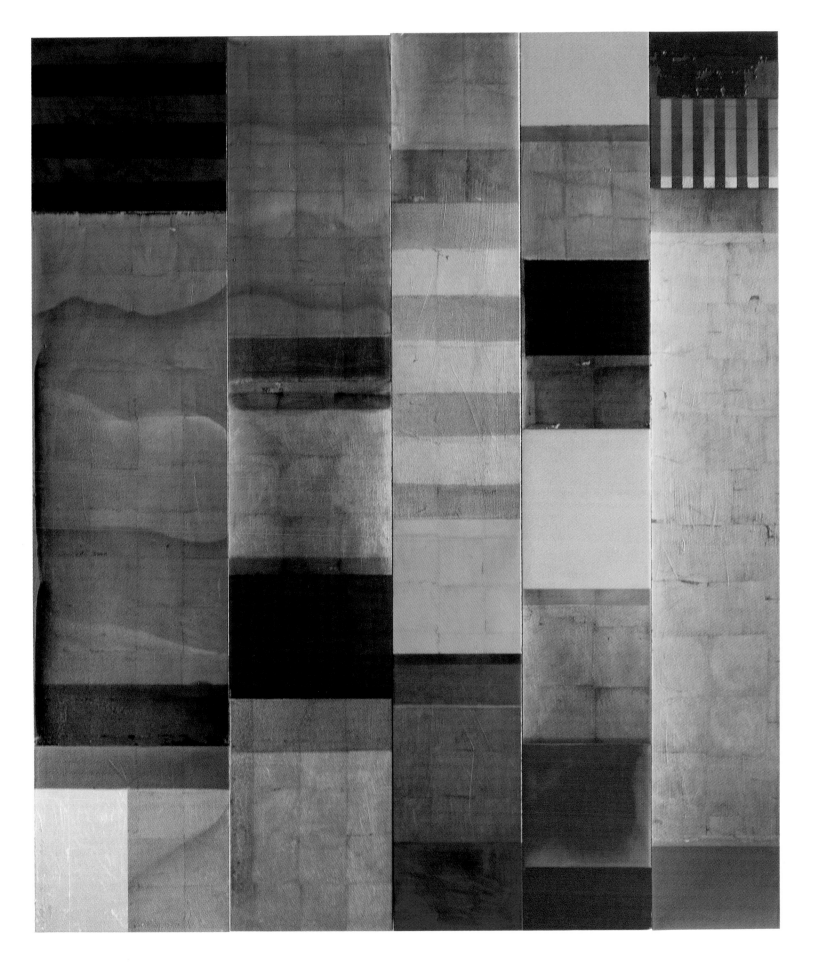

Elysian Fields, 2007 mixed media on wood
203 × 168 cm, 80 × 66", private collection, Omaha, USA

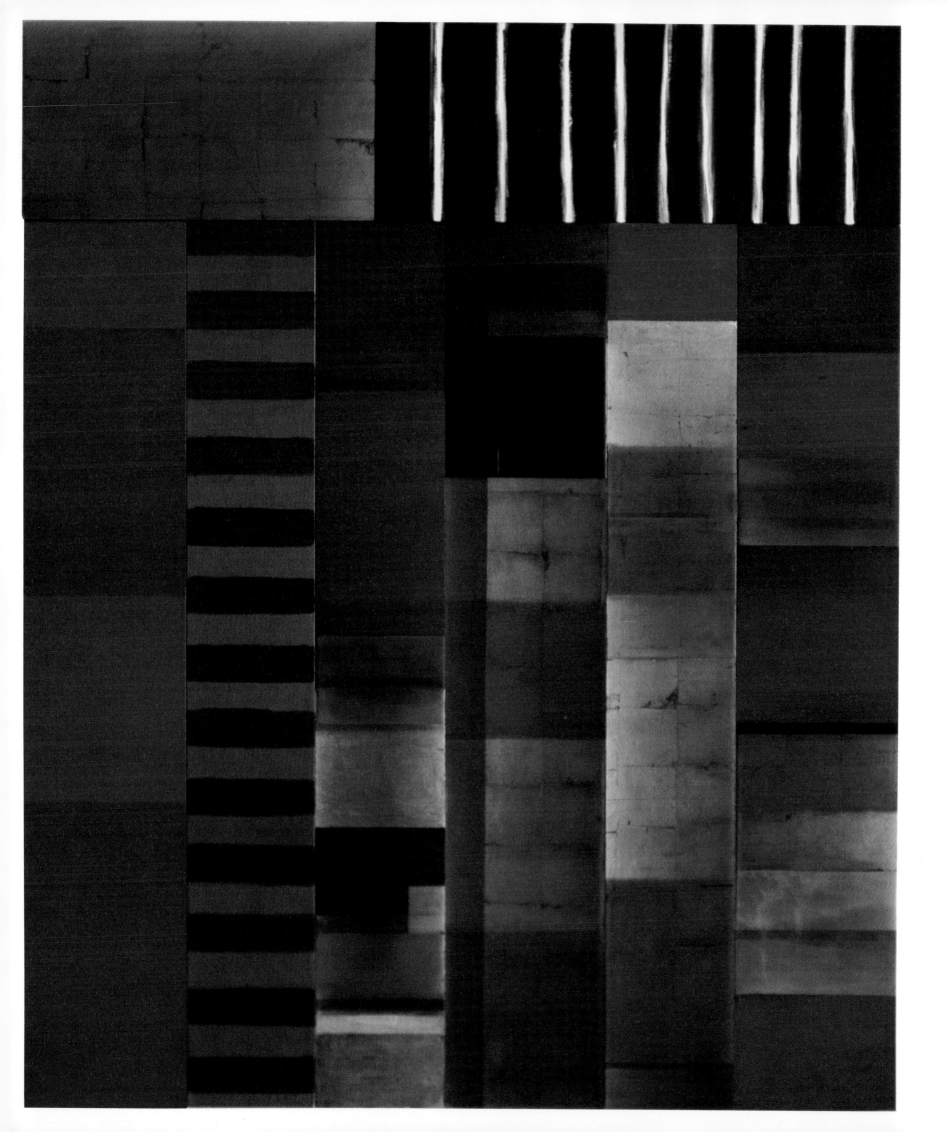

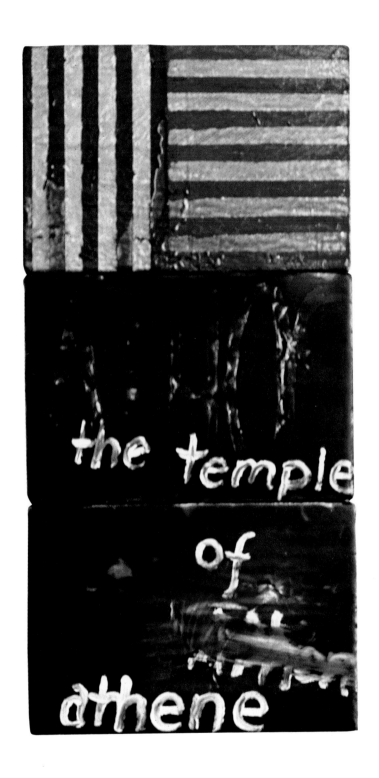

Silk Veil (Red Horizon), 2007 mixed media on wood
241 × 203 cm, 95 × 80", private collection, Omaha, USA

The Temple of Athene, 2007 mixed media on wood
51 × 24 cm, 20 × 9 ¹/2", collection of the artist

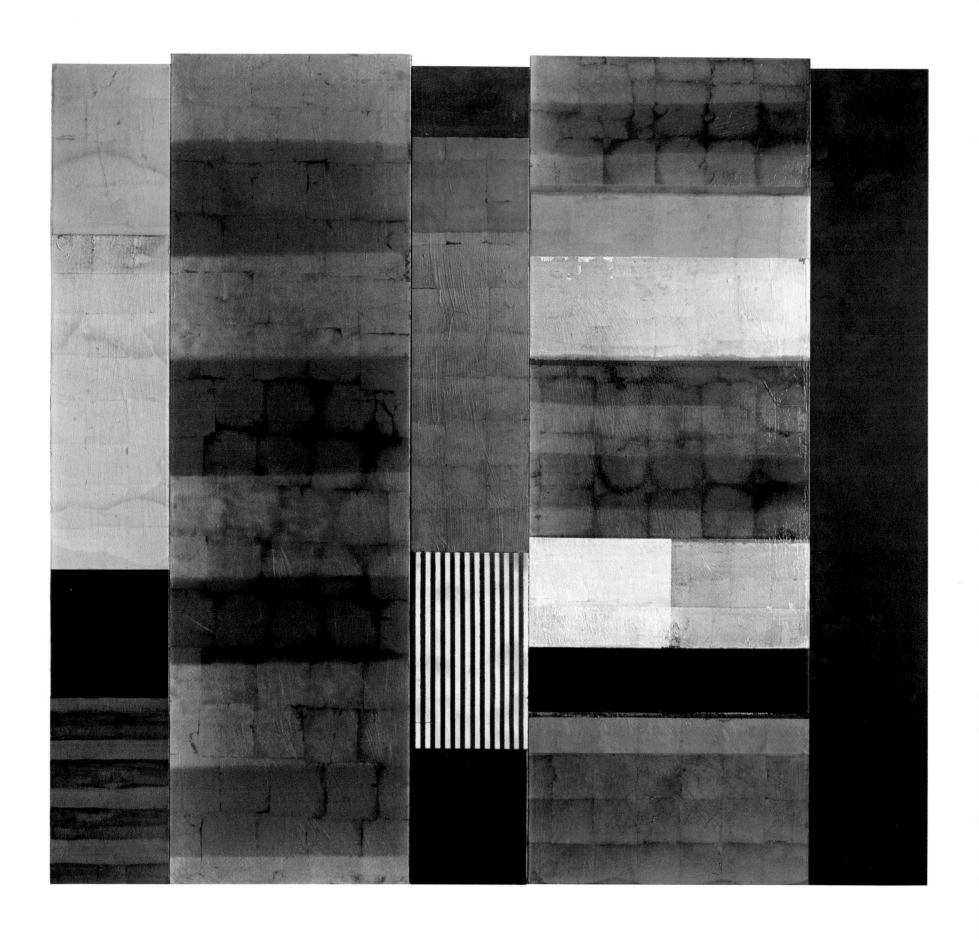

Athos, 2006 mixed media on wood
203×213 cm, 80×84", collection of Zaiss & Co., Omaha, USA

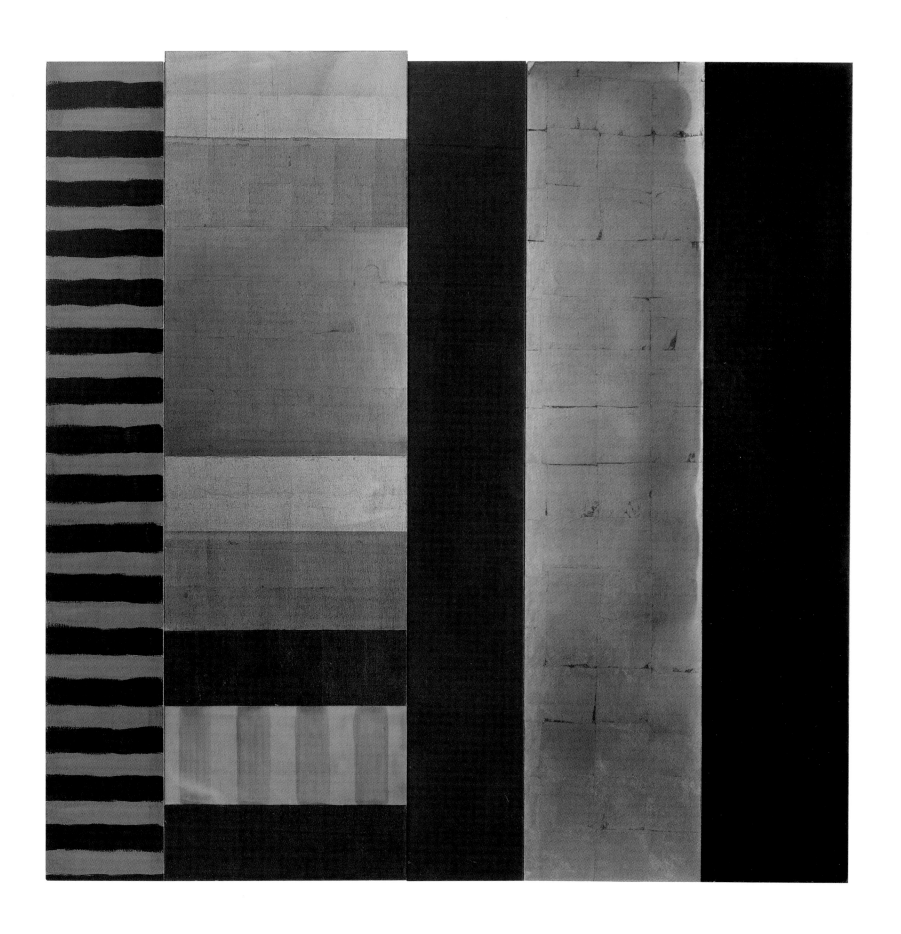

Ozymandias (Easter Island), 2006 mixed media on wood
203×204 cm, 80×80 ½", collection of David and Kate Clark, Omaha, USA

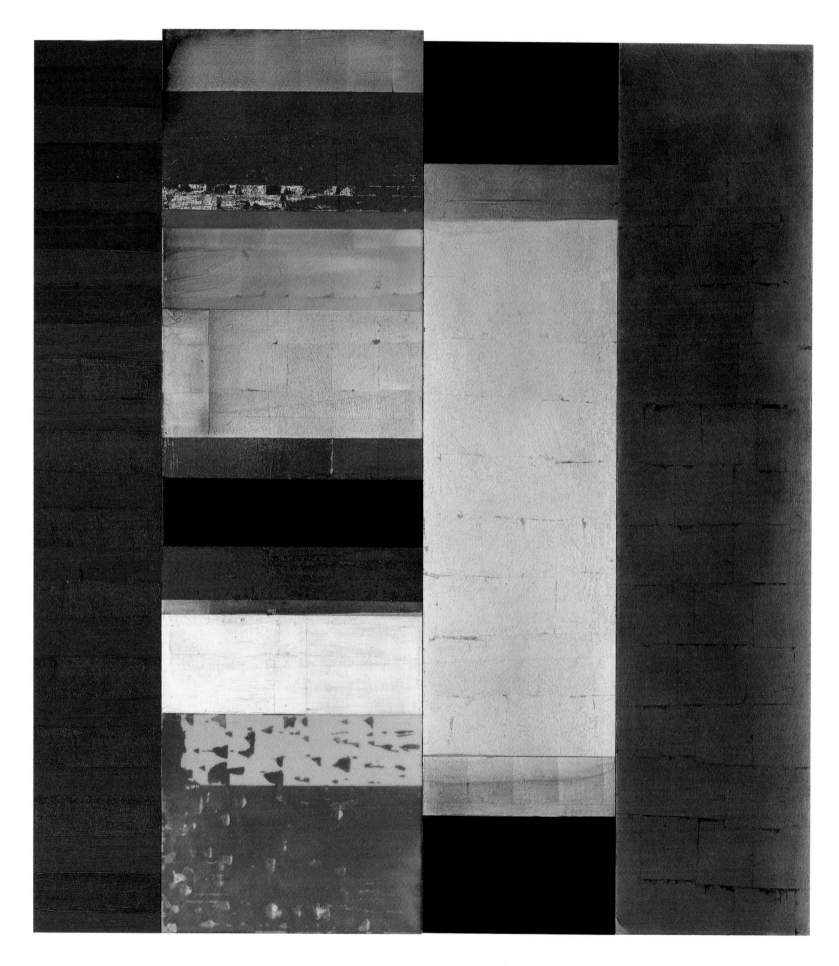

Ozymandias (Crimson King), 2006 mixed media on wood
203×191 cm, 80×75", Creighton University School of Dentistry, Omaha, USA

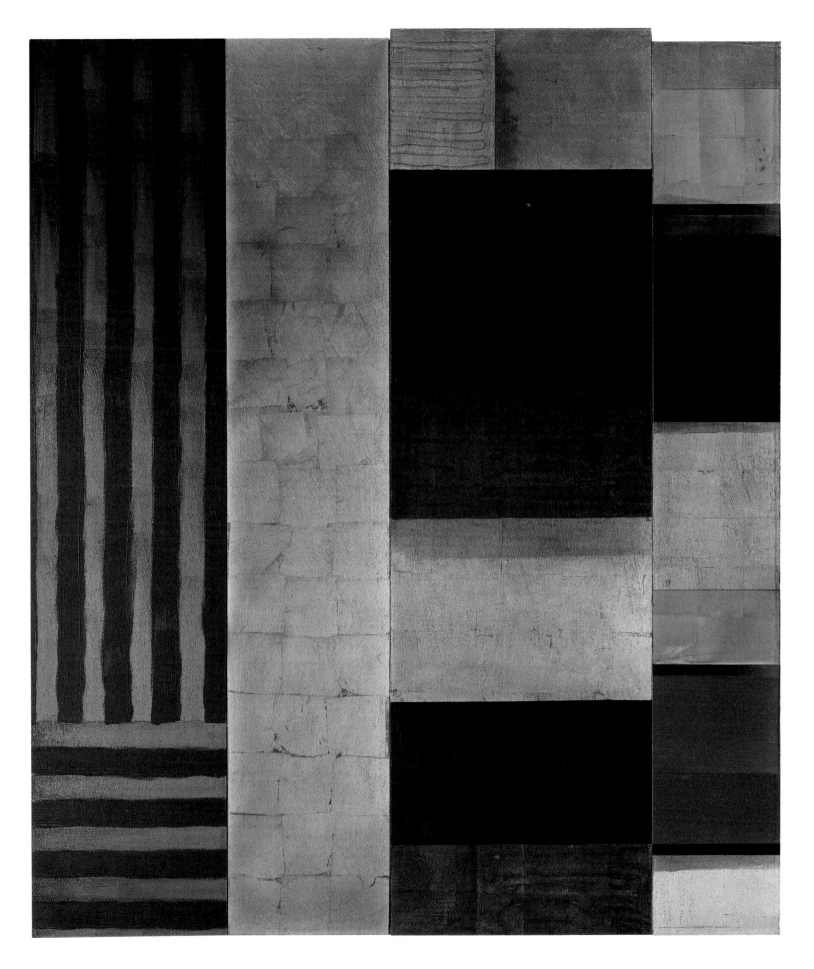

At the Court of the Crimson King, 2006 mixed media on wood
203×159 cm, 80×62 ¹/₂", private collection , USA

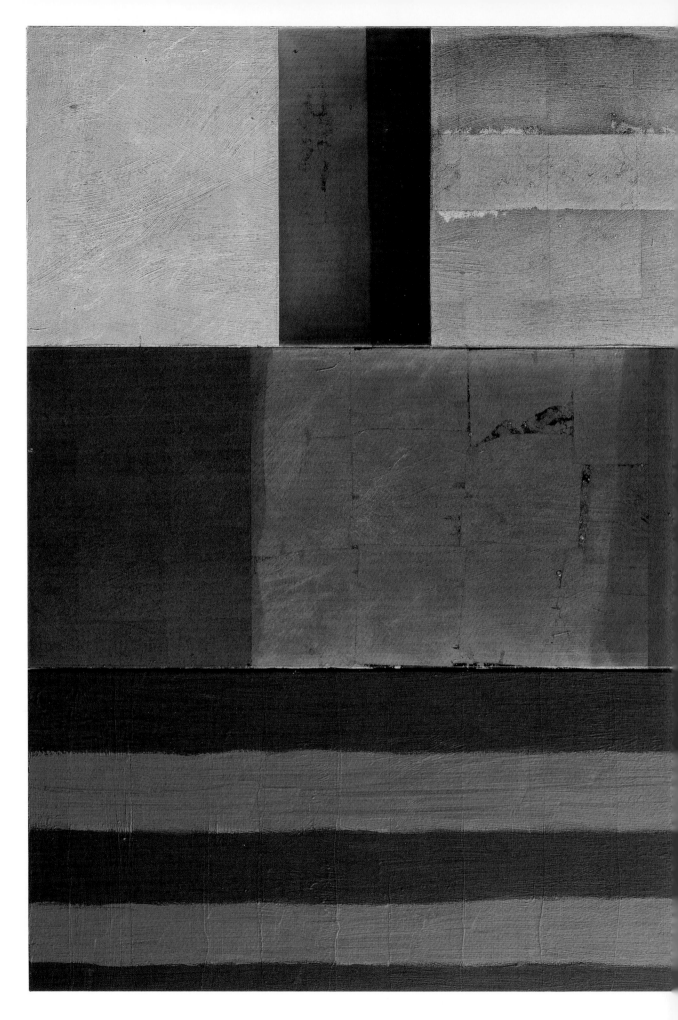

Ozymandias (Jester), 2006 mixed media on wood
137×203 cm, 54×80", private collection, Omaha, USA

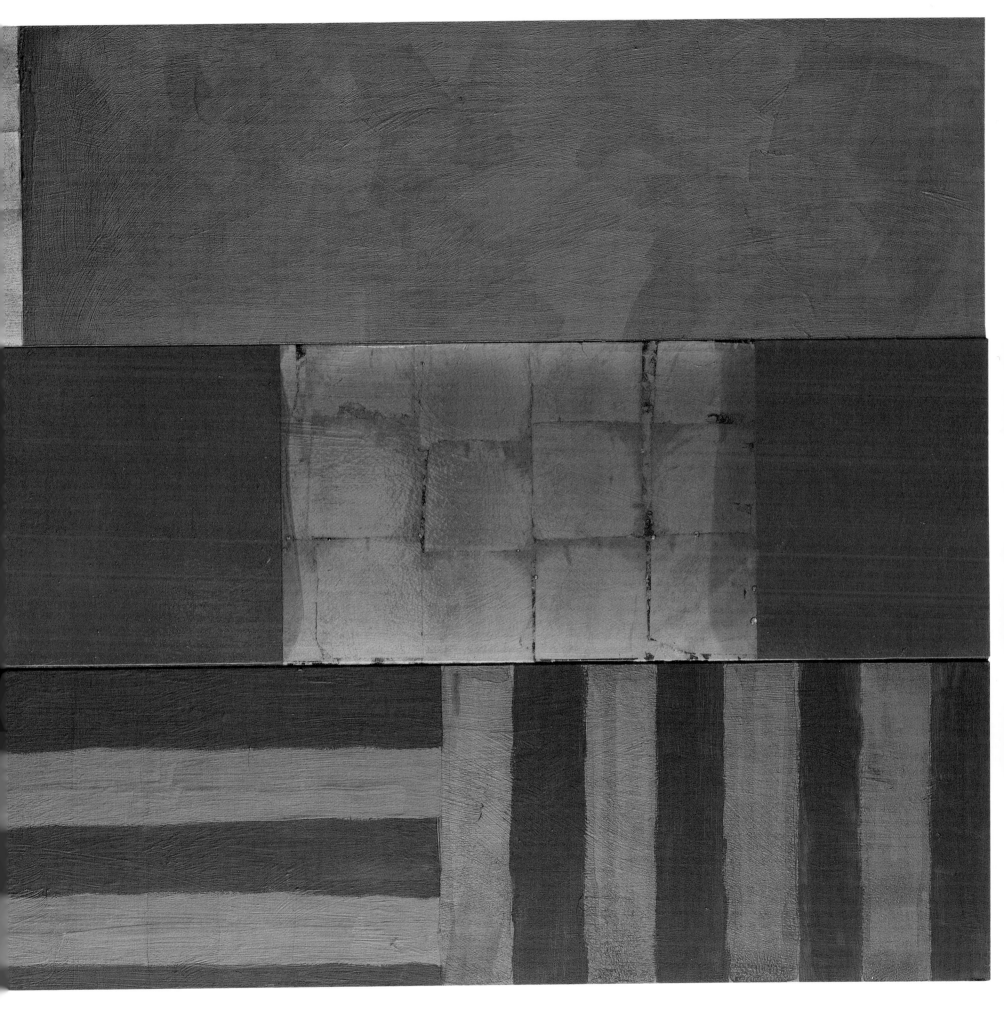

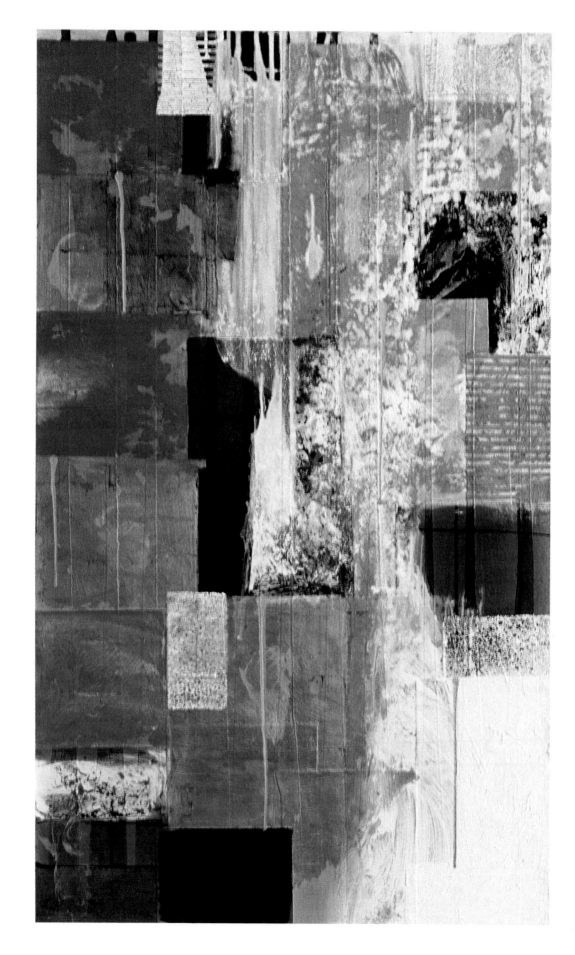

Elegy III (He Seemed Protected), 2006 mixed media on canvas
152×91 cm, 60×36", collection of the artist

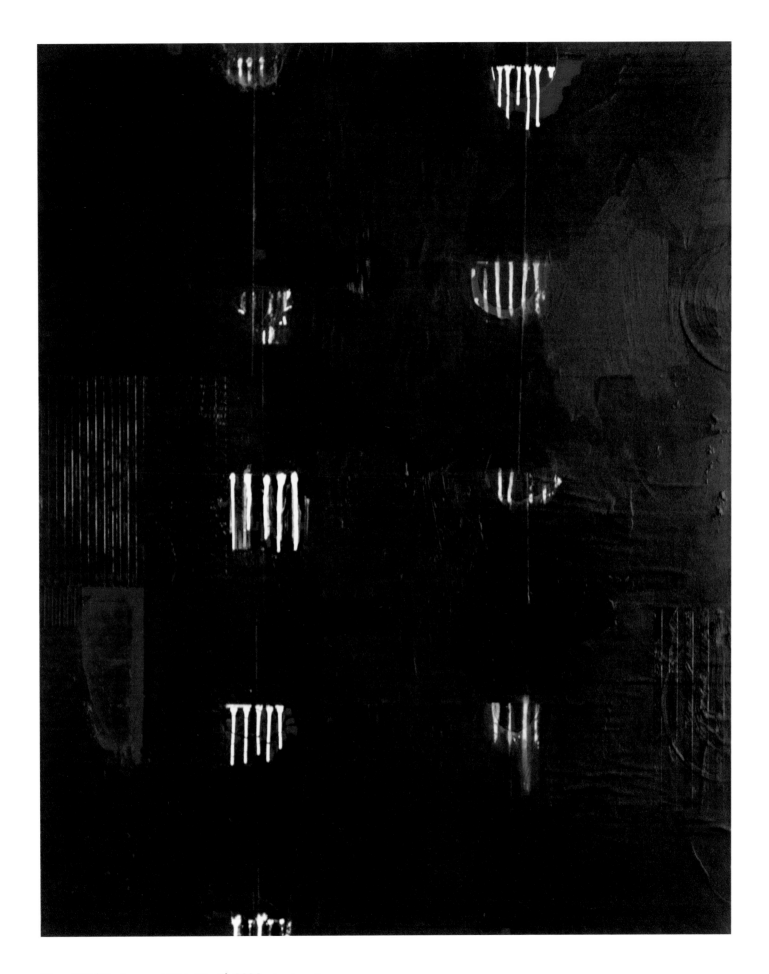

Elegy VIII (Starless and Bible Black), 2006 mixed media on canvas
153×122 cm, 60×48", private collection, Zurich, Switzerland

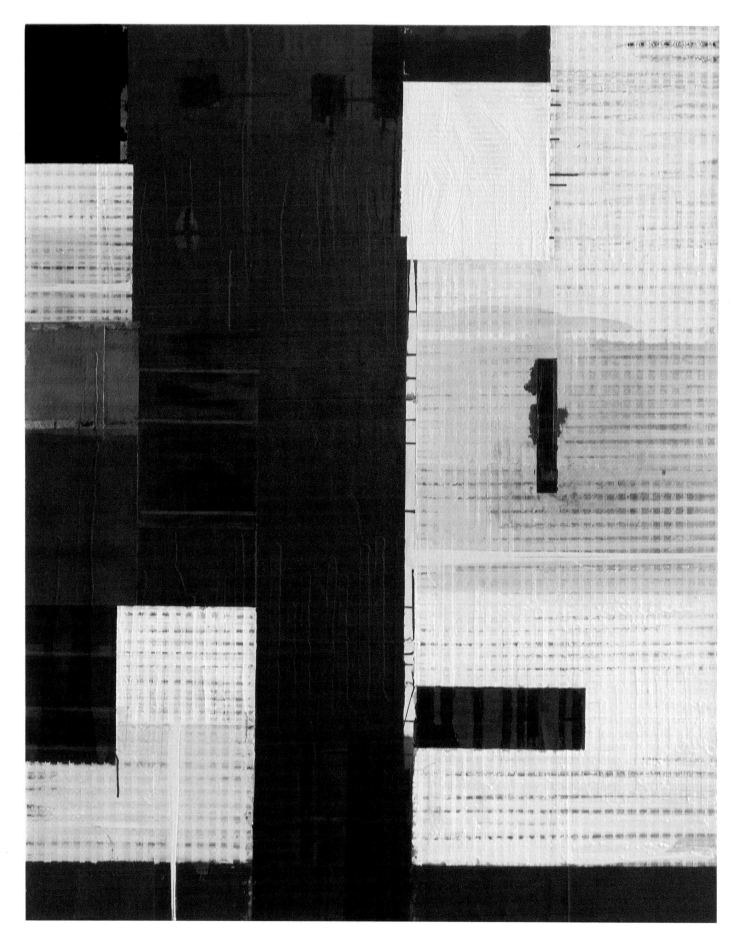

36 **Elegy X (The Daring Patterns of His High Flying Heart II), 2006** mixed media on canvas
152 × 137 cm, 60 × 54", private collection, Omaha, USA

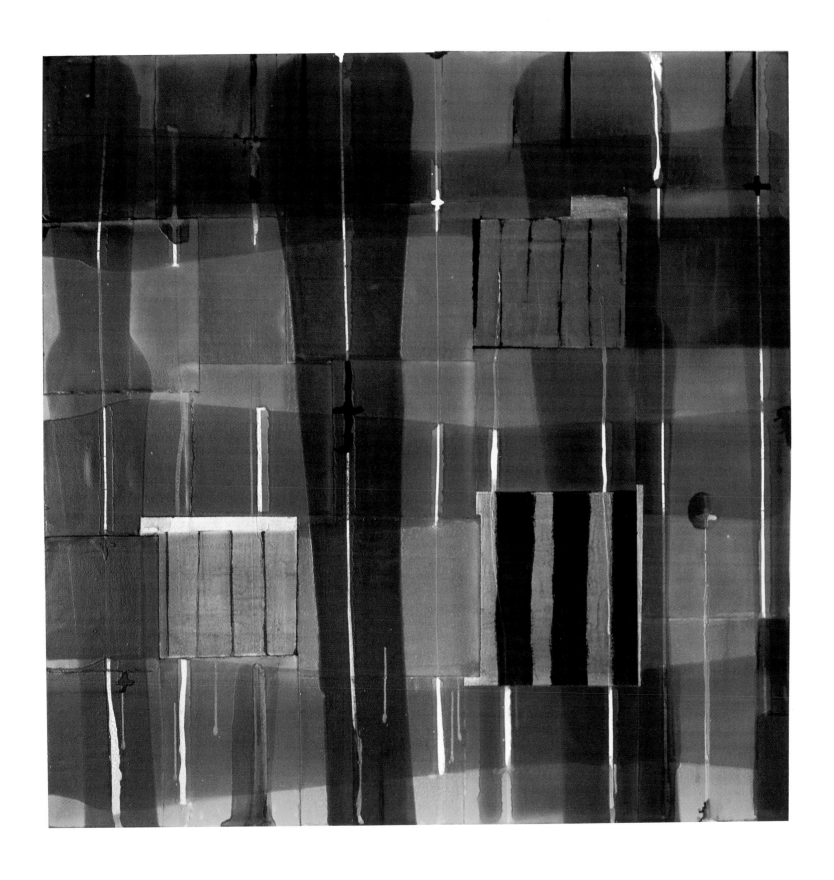

Elegy II (The Terrible One behind the Stars), 2006 mixed media on canvas
137 × 137 cm, 54 × 54", private collection, Zurich, Switzerland

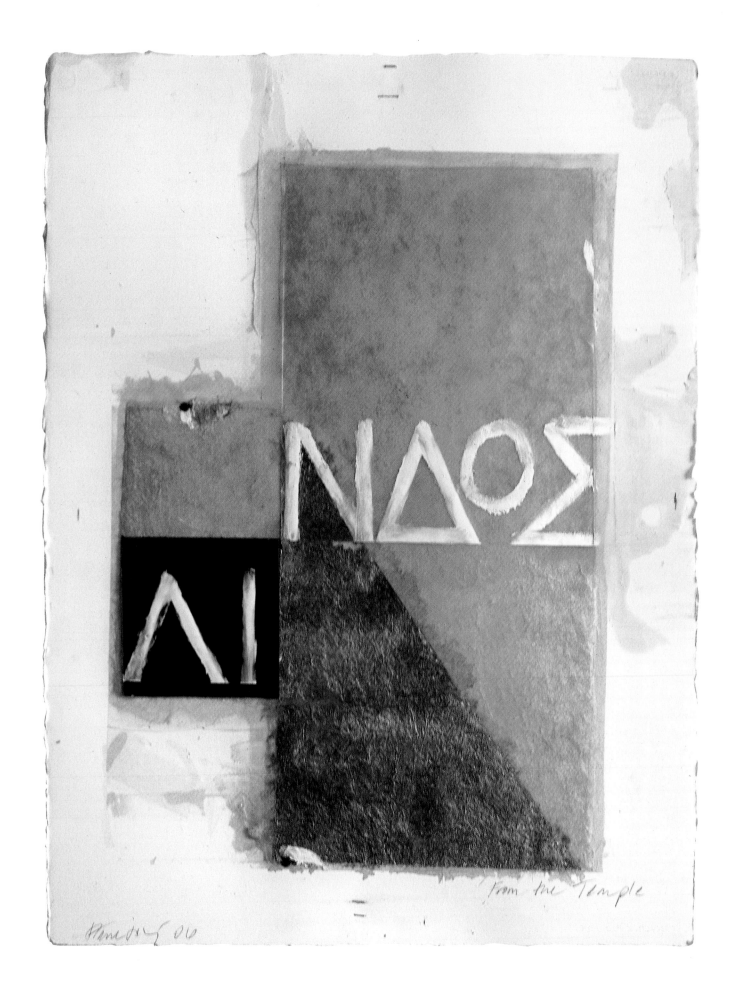

From the Temple

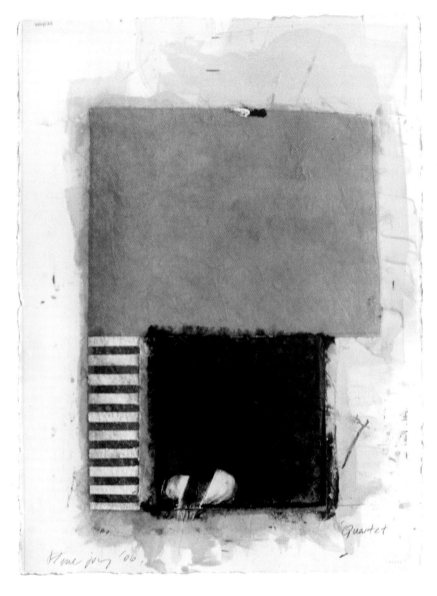

The Temple of Athene, part I, Triptych, 2006 paper
76×56 cm, 30×22", collection of the artist

The Temple of Athene, part II, Triptych, 2006 paper
76×56 cm, 30×22", collection of the artist

The Temple of Athene, part III, Triptych, 2006 paper
76×56 cm, 30×22", collection of the artist

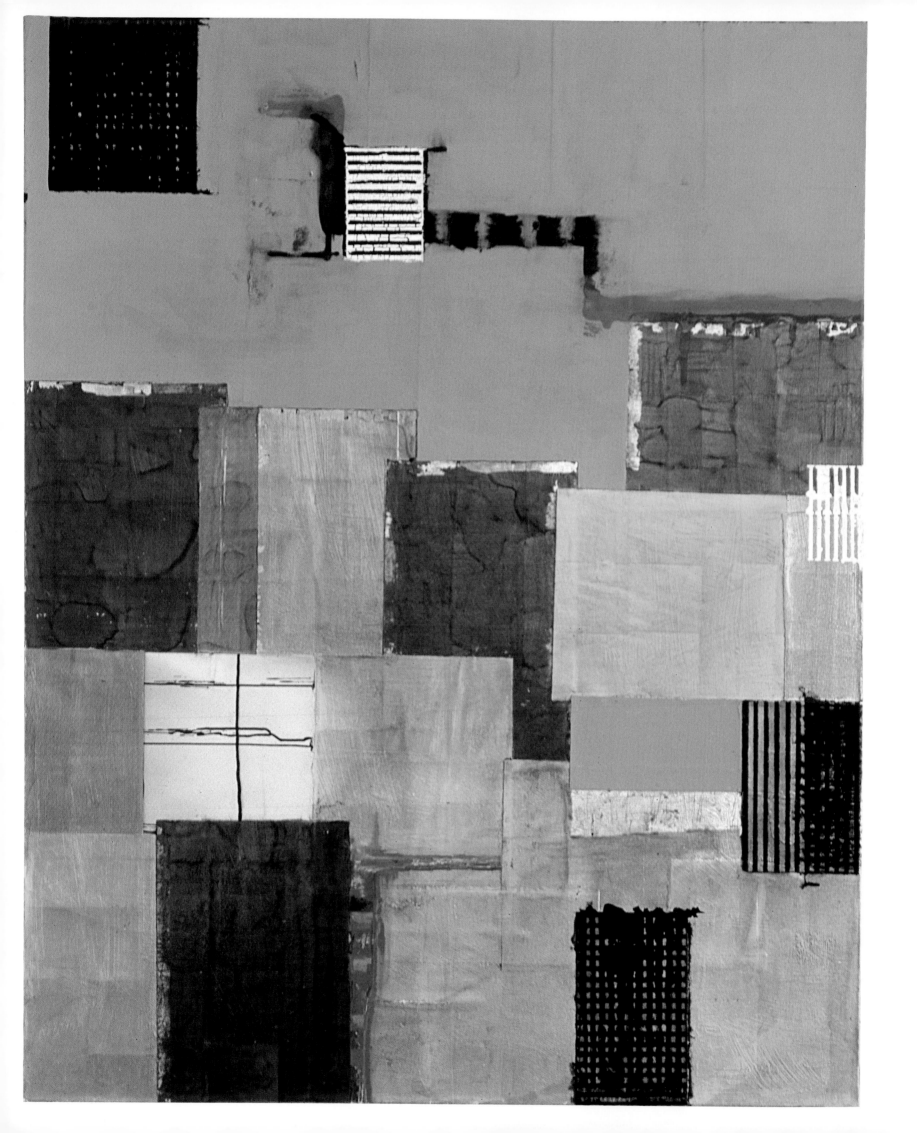

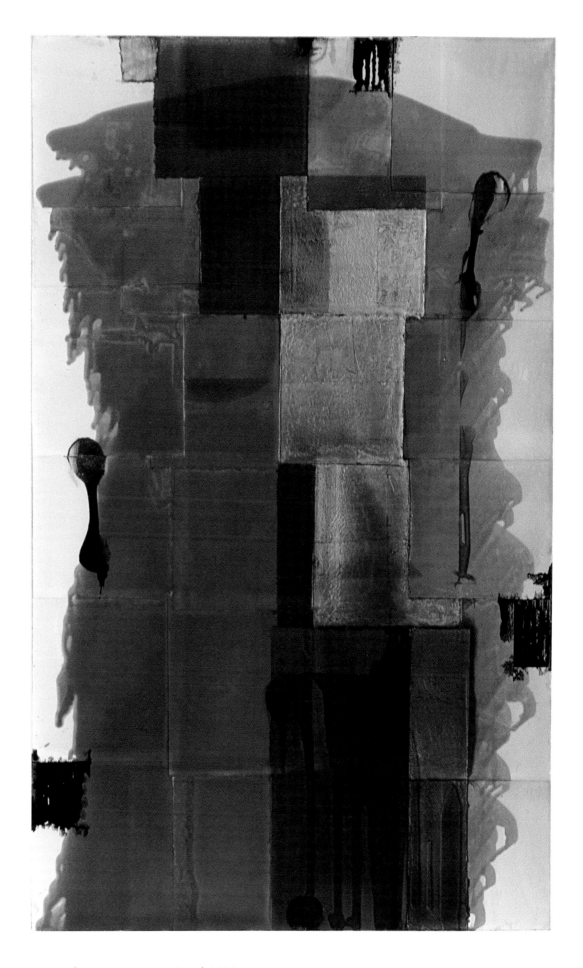

Elegy VII (Up There, Incomprehensible), 2006
mixed media on canvas
152×122 cm, 60×48", private collection,
Zurich, Switzerland

Elegy I (Every Angel's Terrifying), 2006
mixed media on canvas
152×91 cm, 60×36", collection of the artist

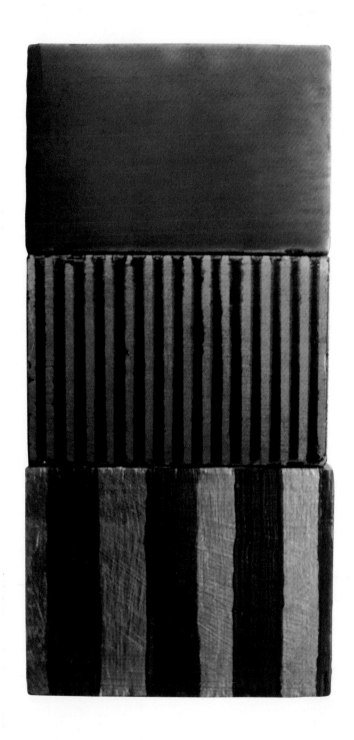

To Ramses, 2006 mixed media on wood
53×24 cm, 21 × 9 ¹/₂", collection of David and Kate Clark, Omaha, USA

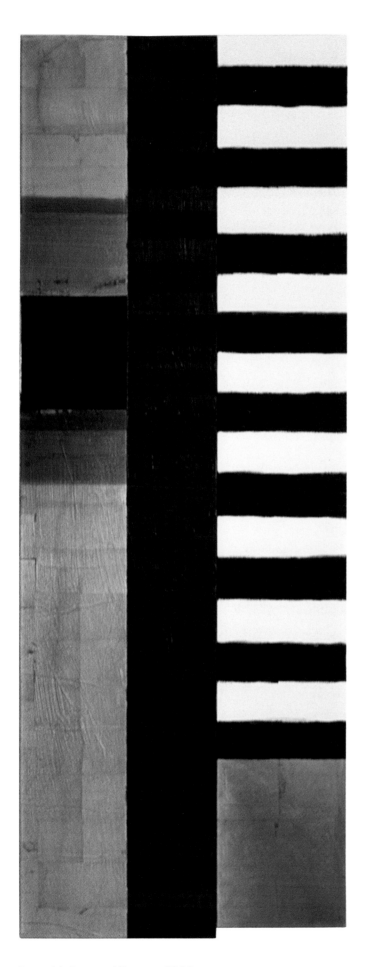

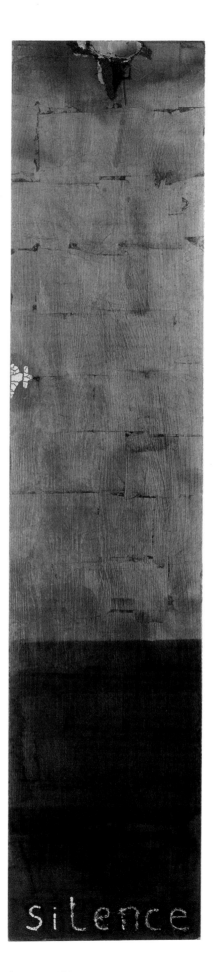

Icon with Sava and Symeon, 2006 mixed media on wood
203×81 cm, 80×32", private collection, Iowa, USA

Silencio, 2005 oil, acrylic, japanese ink, and shellac on wood
203×46 cm, 80×18", private collection, Omaha, USA

43

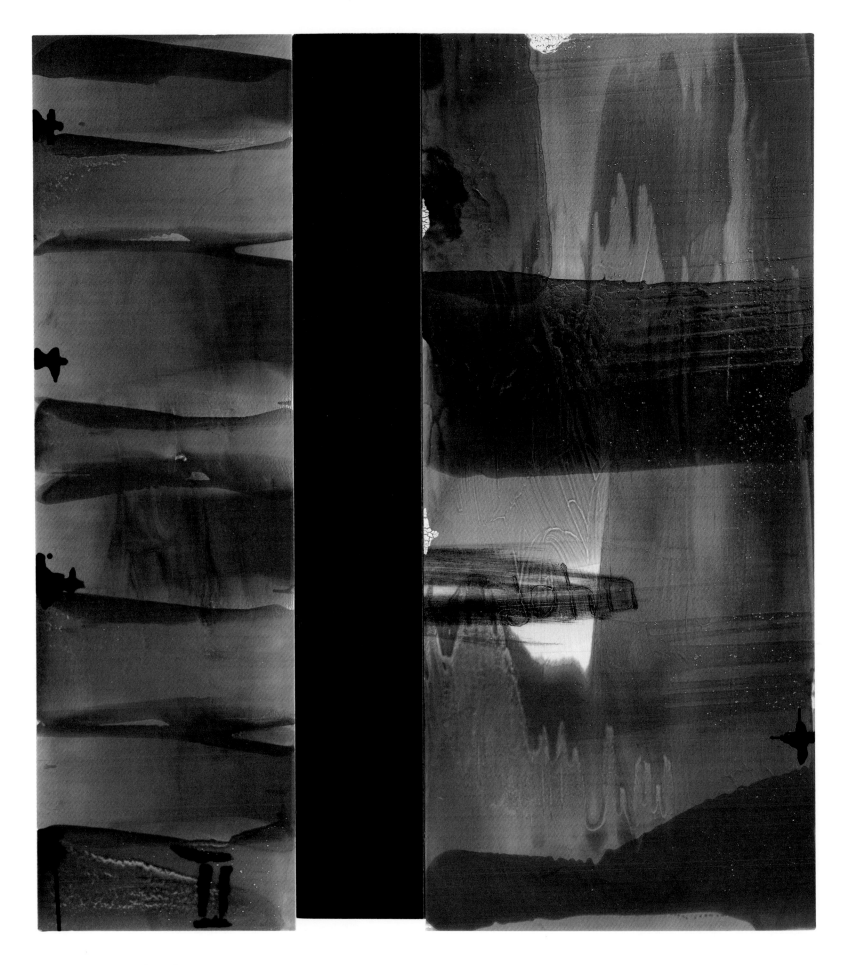

John Paul II, Diptych (part I), 2005 oil, acrylic, japanese ink, beeswax, and shellac on wood
203 × 183 cm, 80 × 72", private collection, Omaha, USA

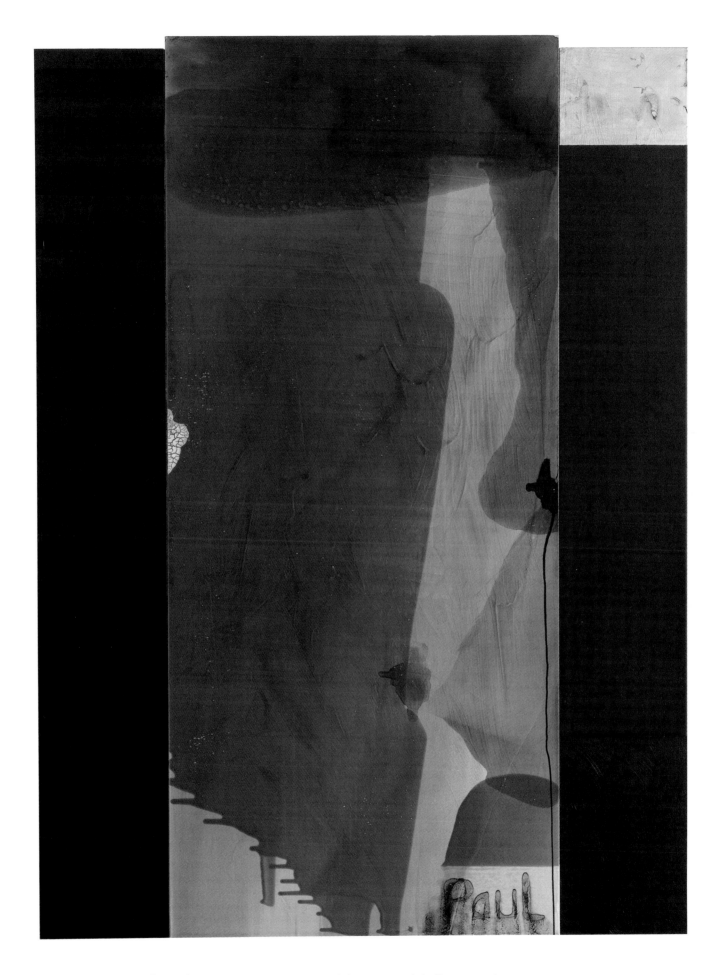

John Paul II, Diptych (part II), 2005 oil, acrylic, japanese ink, beeswax, and shellac on wood
203×147 cm, 80×58", private collection, Omaha, USA

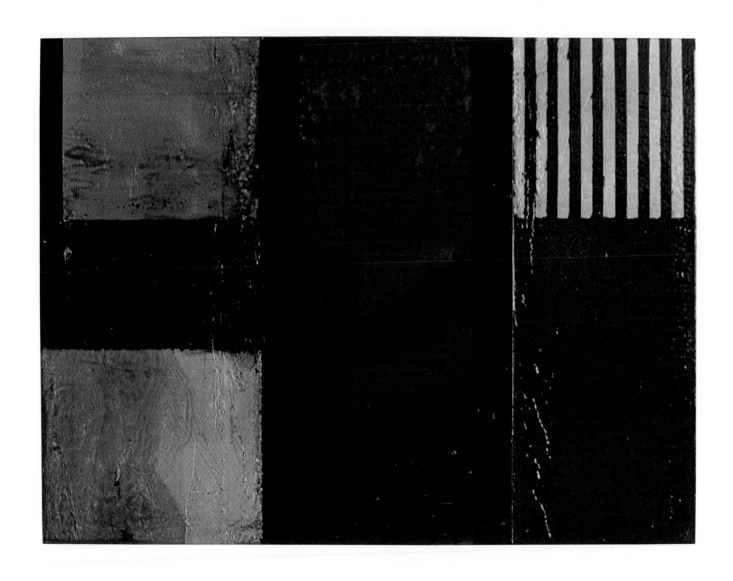

Little Greek Icon, 2005 mixed media on wood
36 × 47 cm, 14 × 18 ¹/₂", private collection, Omaha, USA

The Moorish House, 2005 gold and silver leaf, shellac,
oil paint on fire door (zinc-plated wood)
231 × 155 cm, 91 × 61", private collection, Omaha, USA

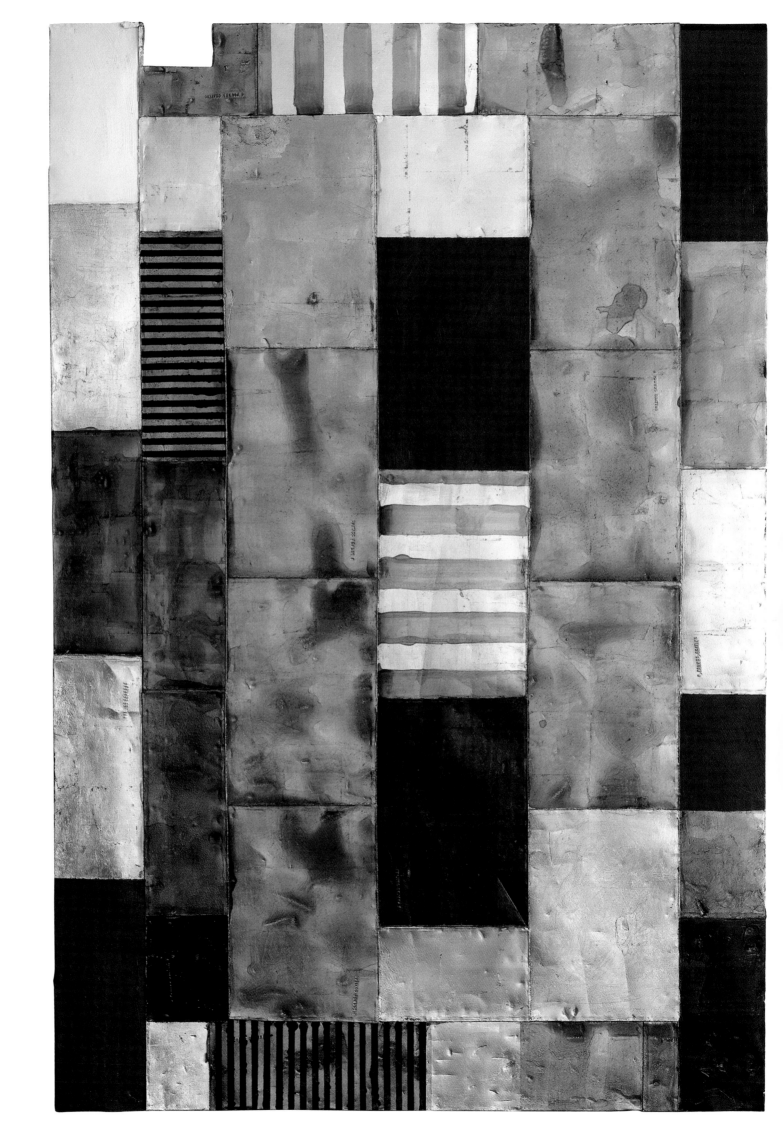

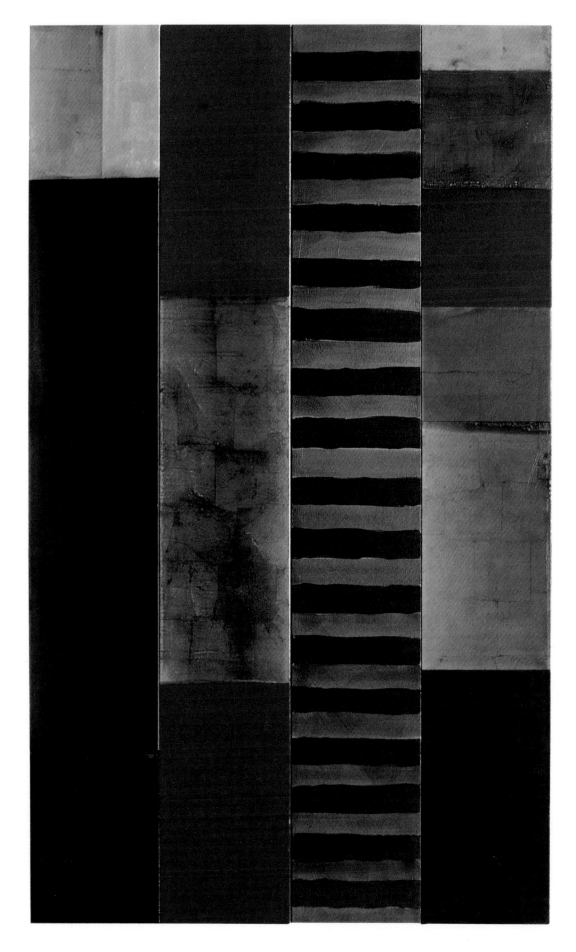

48 **Icon (Trinity), after Andrei Rubelev, 2005** mixed media on wood
203 × 119 cm, 80 × 47", private collection, Omaha, USA

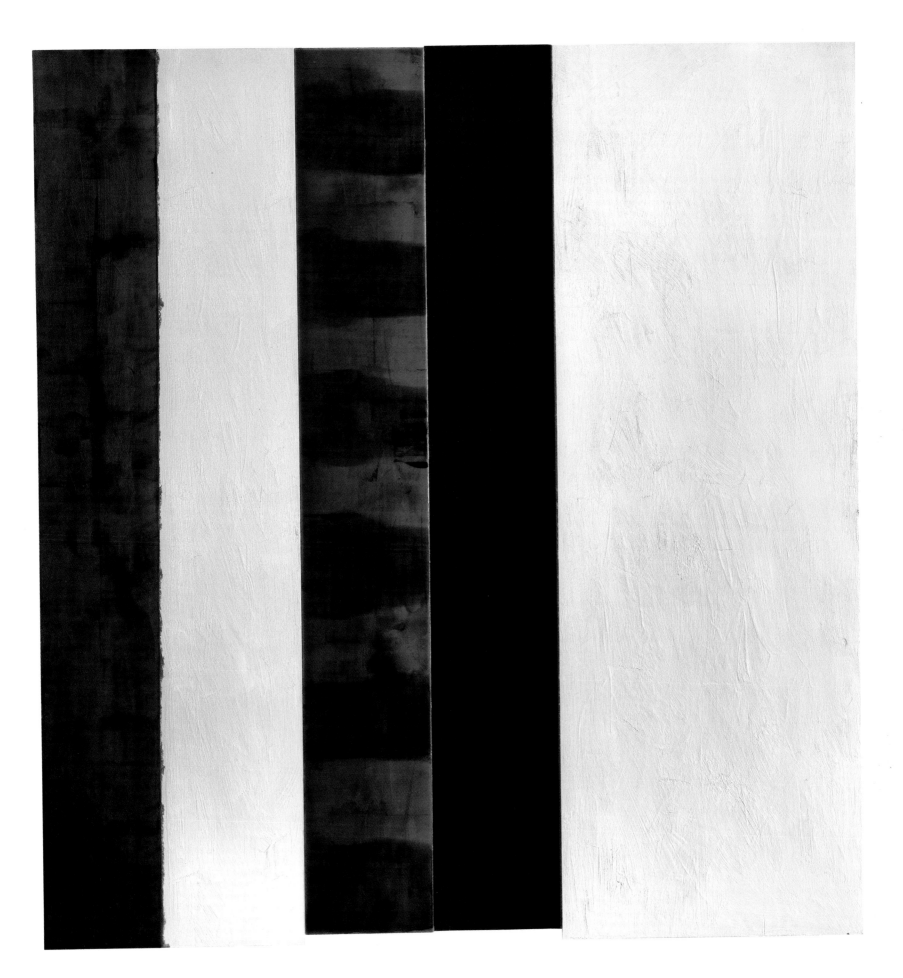

Sacra Conversazione, 2005
oil, acrylic, japanese ink, shellac, gold leaf, and beeswax on wood
203 × 192 cm, 80 × 75 1/2", private collection, Omaha, USA

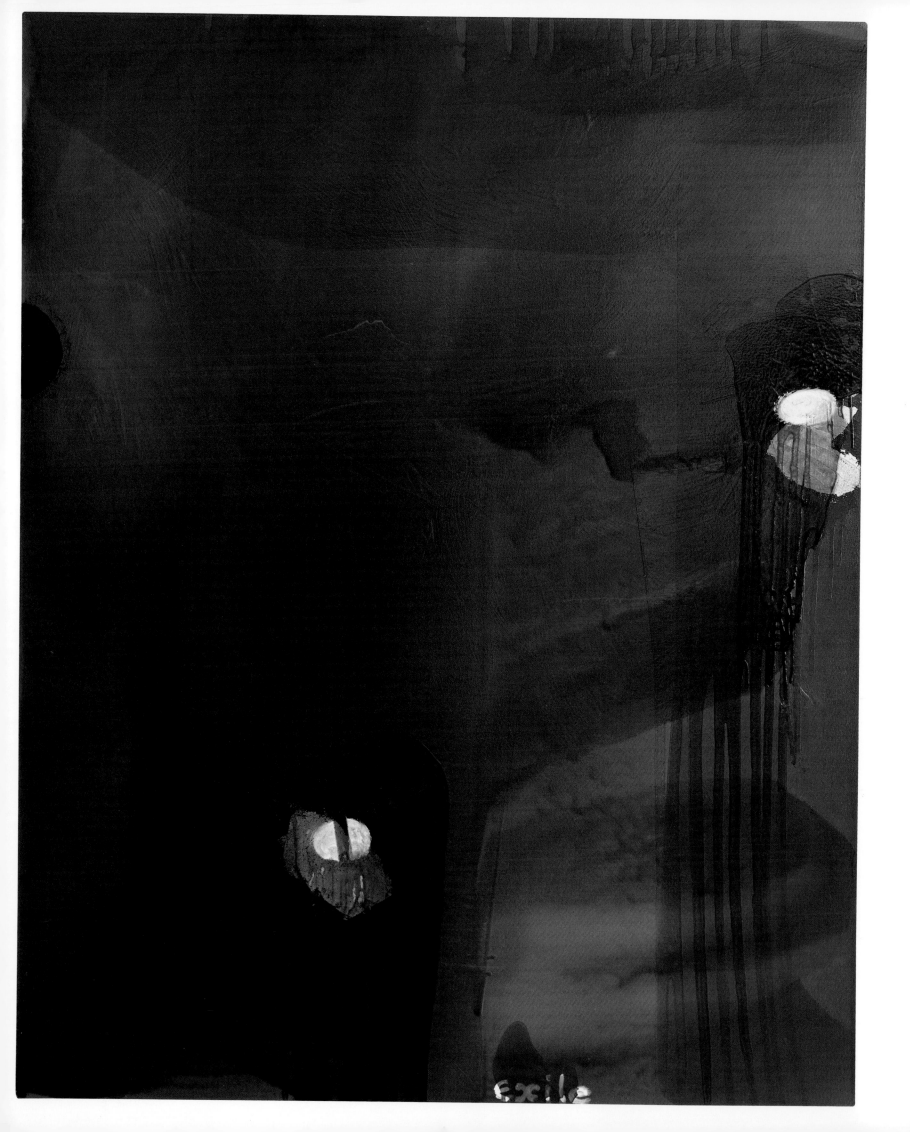

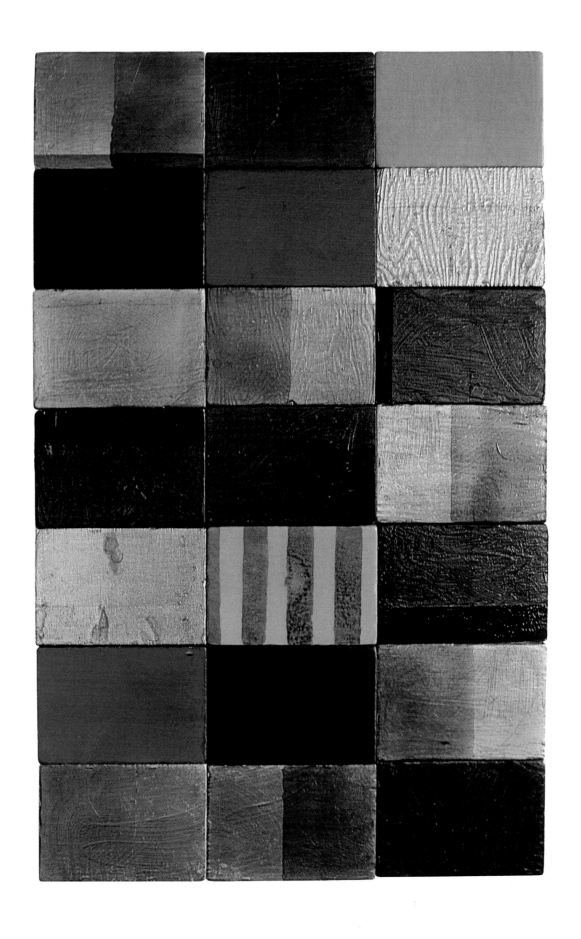

Exile and the Exotic, 2004–05
shellac, acrylic, oil, and gold leaf on canvas
191×152 cm, 75×60", private collection, Iowa, USA

Temple of the Golden Dawn (part III), 2005
mixed media on wood
112×71 cm, 44×28", Enterprise Bank, Omaha, USA

doorways to the divine: the art, iconography, and uncreated light of steve joy

KIM CARPENTER

Kim Carpenter is senior staff writer at the Bemis Center for Contemporary Arts in Omaha, Nebraska, and she has also worked at the Akron Art Museum in Akron, Ohio. She has written about art and art history for numerous publications, including *Sculpture Review*, *NY Arts Magazine*, *Ceramics Monthly*, *Review Magazine*, and *Modernism and German Life*. She earned her Ph.D. in history from Georgetown University and has been a Fulbright scholar to Frankfurt as well as a Deutscher Akademischer Austausch Dienst grantee to Munich, where she completed the research for her dissertation.

Rectangles and squares. Angles and lines. These are the shapes that dominate Steve Joy's exuberantly luminous and meticulously constructed paintings. Their prominence is such that they build upon one another and interconnect, the vertical and horizontal lines creating a union among themselves that quietly guides the viewer into harmony with the entire painting.

Featuring squares and rectangles is certainly nothing new in art. Some of the modern era's most famous painters have utilized these geometric shapes. Kazimir Malevich, Theo van Doesburg, Piet Mondrian, Mark Rothko, and Barnett Newman all famously incorporated rectangles and squares into their works, and they did so in such a way as to transform these basic forms into subjects in and of themselves. Each artist, of course, produced highly individualized results, creating works widely divergent in appearance, philosophy, and content. Even today, contemporary artists continue to feature geometric shapes prominently in their work. Most notably, Brice Marden has created rectangular works, which, although spare and monochromatic, are nonetheless highly expressive. And Sean Scully, one of Joy's close friends and mentors, uses rectangular bands and stripes throughout his paintings to produce fluidly sensuous compositions. Marden and Scully's work as well as Joy's all indicate that squares and rectangles, deceptively complex in their simplicity, continue to have artistic relevance in the twenty-first century.

Of course, this fascination—if not obsession—with geometry goes back millennia, and it is perhaps inevitable that artists should turn to such shapes for inspiration. Geometry, after all, has served as a muse to philosophers, scientists, theologians, and mathematicians, and thinkers throughout the ages have considered geometry "sacred," that is, as revealing the truth of the cosmos and providing a glimpse into the divine unlike any other scholarly discipline. In ancient Greece, Pythagoras taught that "geometry is knowledge of the eternally existent," and Plato maintained, "geometry existed before the creation." Mathematician and astronomer Johannes Kepler asserted even more strongly that "geometry is the one and shining mind of God." Not surprisingly, artists viewed mastering geometry as a requisite for producing art in its truest, purest essence. Renaissance painter and printmaker Albrecht Dürer declared that geometry served as "the right foundation" of all painting, and in a treatise that specifically addressed proportion, he elaborated, "no painting, however assiduously worked at, can be a work of art without proper proportions."[1]

Half a millennium later, artists in the modern era built upon this premise by using geometric shapes to explore the inner and outer meanings of life, and they all had their own beliefs about how their art could accomplish this. In so doing, they established an artistic framework for using abstract painting as a means for examining intellectual, philosophical, and theological questions. Art historian Sheldon Nodelman notes: "…the great early twentieth-century pioneers of abstraction—Kandinsky, Malevich and Mondrian—unanimously regarded abstraction not as a mere formal device but as a revolutionary breakthrough to a more essential language in which principles and forces governing the cosmos in its internal or spiritual and external aspects alike could for the first time be directly expressed. This expression was the 'subject matter' of their art."[2]

Kandinsky's treatise *Concerning the Spiritual in Art* was particularly influential and led many artists to consider how they could use painting as a vehicle for examining spirituality, with geometry often serving as the flashpoint for these explorations. According to John Milner, professor of art history at the University of Newcastle-upon-Tyne, Kazimir Malevich "emerged as the geometer of a new vision in which proportion and perspective were manipulated apparently without reference to imagery."[3] For his so-called *Last Futurist Exhibition '0/10'* in 1915, Malevich showed thirty-nine paintings, the most significant of which was *Quadrilateral,* more famously known as *The Black Square.*

But Malevich's painting was not "just" a square. For him, it had profound spiritual meaning, and he even claimed that he saw "the face of God" in his austere black shape. He also said, "The square is not a subconscious form. It is the creation of intuitive reason. It is the face of new art. The square is a living, royal infant. It is the first step of pure creation in art.[4]

In the Netherlands, Theo van Doesburg similarly experimented with the square's spiritual significance, but he did so in opulent, saturated colors. Van Doesburg used art as a way to organize and transform contemporary society to achieve a transcendent harmony, and he stated that "the square is to us what the cross was to early Christians."[5] Not coincidentally, his close friend and fellow Dutchman, Piet Mondrian, also used geometry to recreate the world by distilling it into its basic shape or "abstract reality." In commenting on his approach, he once pithily explained: "The vertical and the horizontal occur everywhere in nature."[6] But Mondrian was motivated by

more profound questions, and he used abstract art to answer them.[7] "Art," commented Mondrian, "although an end in itself, like religion—is the means through which we can know the universal."[8]

But it is Mark Rothko, Barnett Newman, and Brice Marden to whom Joy owes some of his largest intellectual and aesthetic debts, and all three have influenced his painting practice to some degree. Interestingly, this trio has also been responsible for creating some of the modern world's most significant spiritual art. Roberta Smith, senior art critic for *The New York Times* has observed: "No matter how you tally it, any list of great works of modern religious art made since the century's midpoint is not very long. Mine begins with Matisse's great chapel at Vence, Barnett Newman's austere *Stations of the Cross* cycle of paintings, perhaps Brice Marden's *Annunciation* paintings with their palette of tamped-down primaries, and many of Mark Rothko's evanescent canvases with their clouds of dark, glowing color intimating a diffuse otherworldly presence."[9]

Works by Rothko and Newman initially prompted Joy to consider how art could serve as a vehicle for probing existential questions. He has clearly acknowledged this artistic indebtedness, and in his artist statement for the 2004 exhibition *Olive Groves and Icons* at Galleri Elenor in Oslo, Norway, he wrote, "The initial impetus for painting came to me through exposure to the works of Barnett Newman and Mark Rothko. To this day, I remain committed to the idea of spiritual abstraction and to the development of painting and its history from the fifteenth century to today."

Coincidentally, one of Rothko's own artist statements from 1945 provides insight into the origins of Joy's thinking. "The abstract artist has given material existence to many unseen worlds and tempi,"

1 Cited in Heinz Lüdicke, *Albrecht Dürer* (New York: G.P. Putnam's Sons, 1970), 25.
2 Sheldon Nodelman, *The Rothko Chapel Paintings: Origins, Structure, Meaning* (Austin: University of Texas Press, 1997), 310.
3 John Milner, *Kazimir Malevich and the Art of Geometry* (New Haven: Yale University Press, 1996), 121.
4 Quoted in ibid., 125.
5 Quoted in Suzi Gablik, *Has Modernism Failed?* (London: Thames & Hudson, Ltd. 2004), 31.
6 Yve-Alain Bois, Joop Joosten, Angelica Zander Rudenstine, Hans Janssen, eds., *Piet Mondrian: 1872-1944* (New York: Bulfinch Press, 1994), 184.
7 Ibid, Yve-Alain Bois, "The Iconoclast," 329.
8 John Golding, *Paths to the Absolute: Mondrian, Malevich, Kandinsky, Pollock, Newman, Rothko, and Stil* (Princeton: Princeton University Press, 2000), 26.
9 Roberta Smith, "Religion That's in the Details; A Madonna and Drain Pipe Radiate an Earthy Spirituality," *The New York Times*, November 18, 1997.

wrote Rothko. "For art to me is as anecdote of the spirit, and the only means of making concrete the purpose of its varied quickness and stillness."[10] In addressing how Rothko was able to create works that functioned as that "anecdote," Mark Stevens, art critic for *New York Magazine*, points to the artist's use of basic geometric shapes: "The basic yet flexible structure of Rothko's classic work is ideally suited to relax the mind into such reflections. Rothko's simple geometry, in particular, usually puts those inclined toward religious reverie into that frame of mind. No matter how complex a religion may be in its details, it not infrequently retains a simple geometric form near its heart."[11]

Sheldon Nodelman further observes that Rothko's paintings had a "new geometric exactitude" that created "a strictly bounded, geometric surface defined by intersecting vertical and horizontal axes."[12] Rectangles emerged as the most existentially significant shapes for the artist, so much so that he utilized them for his painting series in the Rothko Chapel in Houston. When pressed about his intent regarding these paintings, Rothko declined to elaborate, other than to say that he was attempting "to paint both the finite and the infinite." Nodelman notes that these paintings are "inherently and already religious, in the sense that they take as their theme the perdurable questions of human destiny and the meaning of existence."[13]

Barnett Newman also used his paintings—most famously rectangles bifurcated by long, vertical stripes, or "zips"—as a way to get at these "perdurable questions." Newman shared much in common with Rothko, including background, education, and social circles, and like Rothko, he created a series of abstract religious paintings, and he called his *The Stations of the Cross*. In explaining Newman's attempt to create paintings that went beyond "geometric forms for their own sake," conceptual artist Mel Bochner notes that Newman used these forms because their "abstract nature carr[ied] an intellectual content."[14] This, for Newman, was paramount. In his 1945 essay "The Plasmic Image," he wrote: "The present painter is concerned not with his own feelings or with the mystery of his own personality but with the penetration into world mystery. His imagination is therefore attempting to dig into metaphysical secrets. To that extent his art is concerned with the sublime. It is a religious art which through symbols will catch the basic truth of life, which is its sense of tragedy."[15] Further on, he even equated the creation of art with the divine, writing: "…in his desire, in his will to set down the ordered truth that is the expression of his attitude toward the mystery of life and death, it

can be said that the artist like a true creator is delving into chaos. It is precisely this that makes him an artist, for the Creator in creating the world began with the same material—for the artist tried to wrest truth from the void."[16]

In contrast to Rothko and Newman, Joy has not specifically referenced Brice Marden in his artist statements. But in an interview with art historian and critic David Carrier, he has indicated that Marden's examination of the continuing impact of Judeo-Christian tradition on contemporary art influenced his own quest to express spirituality in the modern, material world. Marden's *Annunciation* series, ascetic and mesmerizing, calls to mind both Rothko and Newman's own religious series. And like them, Marden has cited geometry as a key component of his work, stating, "The rectangle, the plane, the structure, the picture are but sounding boards for a spirit."[17] But perhaps even more critically for Joy is Marden's view of painting's role for contemporary society: "I know it's tricky ground, but I like to define painting in spiritual terms. Whatever subject matter or structure I bring to the painting—and use and work through and rely on as factors, for me painting is always about getting toward something I don't know about or understand. The way I get there is visual."[18]

Through their innovative renderings of squares and rectangles, Rothko, Newman, Marden, and their forerunners all expressed the spiritual through abstract art. Perhaps their works were spiritual precisely because they were not based in physical reality, because they were, in fact, metaphysical. In any event, Joy's use of geometric forms to convey deeper spirituality has well-established artistic precedents. But although influences and similarities exist with these modern painters, Joy is by no means imitative. In fact, he has created a new genre that goes beyond the artistic traditions established by these earlier artists. And he has done so by going backwards—backwards to an older and similarly rigorous tradition, that of icon painting. While other spiritual abstractionists have in many ways broken with tradition as a way to express the sacred, Joy combines a figurative religious art form with a modern abstract one and synthesizes the two. To accomplish this, he uses not only "sacred geometry" as a basis for this artistic expansion, but also what is known in the Orthodox faith as "uncreated light."

The tradition of icon painting goes back at least a millennium, if not longer, and is most frequently associated with the Russian Orthodox or Eastern Orthodox Church, where it plays a pivotal role in worship.

the art, iconography, and uncreated light of steve joy
KIM CARPENTER

Because the material world and the divine realm are closely connected, icons serve as a link between the two. But this does not mean that followers of the Eastern Orthodox faith worship icons. Rather, icons are images that enable access to divine knowledge, serving as "a means by which both the iconographer and worshiper can participate in the realm of eternity."[19] Icon expert Linette Martin describes these sacred images as portals "designed to be doors between this world and another world, between people and the Incarnate God, his Mother, or his friends, the saints….The primary purpose of an icon is to enable a face-to-face encounter with a holy person or make present a sacred event, but icons are also 'theology in color'."[20] As such, icons are "timeless," metaphorically existing beyond time and space.[21] But they are also very much of our time, facilitating what Martin describes as a "direct communication" with the divine that goes "directly from eye to heart."[22]

This description of an icon, a "theology of color," that serves as a "door" between the earthly and divine perfectly encapsulates Joy's mature works. For an exhibition in Bruges, Belgium, at the 'tleerhuys Galerij in 1989, Joy wrote in his "Artist's Statement" that he wanted his works to be "an open [if not 'living'] door"…."I try to show my belief in abstraction. These panels, multi configurations, shapes and colours, (groundwork for abstract thought complexities) are an open door—my attempt to remain in touch with my sources."

Interestingly, these sources were not Eastern European in origin, but rather based in the city where this exhibition took place. Located in western Belgium, Bruges has changed little since the Middle Ages, and while living there during the late 1980s, Joy started to develop work that presaged his decisive turn toward spiritual abstraction. For his show at 'tleerhuys Galerij, he exhibited several paintings, including *Outsinging* (1987, see page 171) and *Signal* (1989, see page 151), which indicated this direction. *Signal*, for example, resembles the Greek cross, notable for having four arms of equal length. Despite the extra block of dark color in the top right-hand corner, the Christian-based imagery is clear. Even works that departed from this stylistic approach still hint at Joy's increasing interest in painting's spiritual applicability. *Amish House II* (1989, see page 150) is inherently religious given its subject matter, while *Chalice* (1988–89), by its title alone implies Joy's spiritual intent. And while he cited Flemish and Italian works from the fourteenth and fifteenth centuries as sources, he also noted the spiritual aspect of his work, stating: "I make these paintings in a state of surrender."

Within three years, Joy's painting practice took a decisive turn. During the autumn of 2002, he had a solo exhibition at the Galleri Elenor in Norway for which he wrote: "The most recent works are influenced by the time I spent in France many years ago and by the sublime experience and spatial and spiritual complexity of the many Cistercian monasteries and churches in the country. I have named these the *Architecture of Silence Paintings*. They are made from similar materials and techniques as were used in medieval icon painting."

During this time, Joy also began using traditional materials employed in icon painting, including gold leaf and beeswax, more extensively. But it was not until the following year that the physical method merged with intellectual process. For the exhibition *Island and Ikons: The Anegada Night Paintings* at Fluxion Gallery in Omaha, he had fully formed the theories underpinning his art, and he was no longer just employing the artistic practices of icon makers; he was also approaching painting as a sacred act in itself: "I was thinking of sacred places, abbeys and cathedrals, perhaps of darkened, candlelit rooms and of incense and spices from the East. Most of all, I was thinking of silence—the kind of silence I connect to icons, especially the great icons of the Byzantine period. In these paintings you see angels transfixed in ecstatic, petrified silence. I've often thought, 'Is it possible to produce this kind of frozen silence in a painting, the kind that comes in the form of petrified longing?'"

10 Mark Rothko, "Personal Statement, 1945," in Miguel López-Ramiro, ed., *Mark Rothko: Writings* (New Haven: Yale University Press, 2006), 45.

11 Mark Stevens, "The Multiforms 1947–1948," in Mark Glimcher, ed., *The Art of Mark Rothko: Into an Unknown World* (New York: Clarkson N. Potter, Inc., 1991), 43.

12 Nodelman, 101.

13 Ibid., 306.

14 Mel Bochner, "Barnett Newman: Writing Painting/Painting Writing," in Melissa Ho, ed., *Reconsidering Barnett Newman: A Symposium at the Philadelphia Museum of Art* (New Haven: Yale University Press, 2005), 23.

15 Barnett Newman, "The Plasmic Image," in John P. O'Neill, ed., *Barnett Newman: Selected Writings and Interviews* (New York: Alfred A. Knopf, 1990), 140.

16 Ibid.

17 Cited by Peter Fischer, "Brice Marden," in *In the Power of Painting: Andy Warhol, Sigmar Polke, Gerhard Richter, Cy Twombly, Brice Marden, Ross Bleckner—A Selection from the Daros Collection* (Zurich: Alesco AG, 2000), 108.

18 Ibid., 118.

19 Elizabeth Zelensky and Lela Gilbert, *Windows to Heaven: Introducing Icons to Protestants and Catholics* (Grand Rapids: Brazos Press, 2005), 22–23.

20 Linette Martin, *Sacred Doorways: A Beginner's Guide to Icons* (Brewster, MA: Paraclete Press, 2002), XV.

21 Zelensky, 30.

22 Martin, 204–05.

the art, iconography, and uncreated light of steve joy
KIM CARPENTER

By 2004, Joy answered this question. For another show in Omaha, this time at the Anderson O'Brien Art Gallery, he elaborated, rather tellingly, that his paintings served as "an attempt to deal with certain codes of ethics, aesthetics, and spirituality that run throughout the history of humanity. This includes the warrior code of the Samurai, the devotion and loyalty of people such as Saint Francis of Assisi, the great tradition of medieval Russian Orthodox icon painting, and finally homage to the sublime, ethereal portraits of Leonardo da Vinci."

The notion that Joy is creating contemporary icons might seem at odds with how most people typically envision these religious works: as figurative but static portraits of saints, martyrs, or Jesus illuminated by golden halos. That is, they are images of what people have seen. In contrast, Joy's paintings *are* the icons in and of themselves. They function as icons of the unseen and the divine, using the geometry and light that comprise the universe.

For as radical a departure as this might appear, Joy's contemporary imagery has more in common with the tradition of icon painting than is initially evident. Using a geometric approach is ideal for icons, because they purposefully lack depth and remain devoid of perspective. Moreover, geometric forms play an important role within the icon tradition. For example, a circle, perfect in its closed structure, represents heaven; a square—imperfect—symbolizes earth, or, more accurately, the earthly realm. According to sculptor, art professor, and advocate for the group Christians in the Visual Arts (CIVA), Alva William Steffler, the square "is the most static, non-dynamic of shapes and is therefore used to suggest balance and resolution." Steffler further points out that in the Bible the square represents the four points on the compass as well as the four corners of the earth.[23] The rectangle, too, has its own symbolism. Again Steffler provides insight, and his observations are particularly appropriate to Joy's work: "As part of the system of 'sacred geometry and proportion' in the tradition of icon production, the rectangle, based on the ratio of 4:3, is considered the geometrical symbol of harmony. Early icon painters found this order and proportion essential to conveying the spiritual meaning of the icon. The Greeks called this proportional relationship, manifested in nature, the Golden Section. It demonstrates in its essential geometry the mean between extremes. Expressed in numbers, the Golden Proportion is 1 to 1:618. Christian artists have related the proportional relationship of the Golden Section to the mystery of God; for this reason it is called the Divine Proportion."[24]

But the rectangle can also mean something else. During the Middle Ages, the world was widely believed to be flat, or rectangular, and icons often represent earth in this manner. Hence, the table at the Last Supper upon which Jesus rests his cup is a rectangle, that is, Jesus rests his cup upon the world and the fate of mankind.

Given the importance placed on certain geometric forms, the geometry that serves as the basis for the majority of Joy's paintings has critical meaning. *Icon Anastasia the Healer* and *Icon With Sava and Symeon* (see page 43), for example, feature rectangles and squares rendered in opposing blocks of color that outline spaces, enclosing and focusing the viewer's gaze. The squares, stripes, and rectangles all oppose one another in a point/counterpoint balance as do the colors. This polarity prompts viewers to stop and interact with these works on a very personal, intimate level, in effect, taking part in that metaphysical give-and-take.

This notion of "give-and-take" directly connects to Joy's paintings *Saint Anastasia the Healer*. Within the Byzantine Church, Anastasia is revered for healing illness, both bodily and spiritual, as well as for exorcising demons—i.e., this saint had the ability to "give" healing and to "take" away both physical and mental illness. In Joy's reinterpretation of this traditional icon, he uses amber horizontal stripes to balance black vertical rectangles, with the shining light of the former appearing to push the darkness of the latter up and out of the frame.

Saint Sava and Saint Symeon hold similarly sacred places within the Orthodox faith, and both are esteemed as fathers of the Church. Sava founded the Serbian Orthodox Church in the thirteenth century, and was considered one of the few to "know" God or to attain divine knowledge. Saint Symeon, an ascetic mystic, also called the "New Theologian," advocated returning to the essence of Christianity by experiencing the living Christ: "Do not say that it is impossible to receive the Spirit of God. Do not say that it is possible to be made whole without Him. Do not say that one can possess Him without knowing it. Do not say that God does not manifest Himself to man. Do not say that men cannot perceive the divine light, or that it is impossible in this age! Never is it found to be impossible, my friends. On the contrary, it is entirely possible when one desires it."[25]

the art, iconography, and uncreated light of steve joy
KIM CARPENTER

Divided by a rectangular column into two distinct components, Joy's *With Sava and Symeon* is a solemn geometric composition that serves as a metaphor for that "divine light." Over the centuries, icon painters have typically portrayed Saint Sava with white robes embellished with warm gold tones, as seen on this work's left-hand side. Sava's role as a founding father underscores the pillar-like aspect of this portion of the painting, which seems to lift out of the canvas. In contrast, in Symeon's "portion" on the right, the rectangles combine to form a ladder, a visual way to scale the canvas, a figurative way to ascend and to experience the "spirit of God."

In terms of color, this painting, as well as *Hodegetria, Madonna and Child*, and *Trinity* (see pages 70 and 72–73) contains equally powerful spiritual symbolism. As with the geometric configurations, Joy's color combinations have specific significance within the icon tradition. Many color meanings are obvious: red symbolizes blood and life as well as the sacrifice of martyrs. Green calls to mind grass, leaves, and springtime, which in turn represents life and growth. Blue signifies the divine realm of heaven. And deep, reddish-brown purple frequently represents the color of the Virgin Mary's robes and those of saints and martyrs, as well as of royalty, both earthly and divine.

Gold, however, emerges as the most meaningful color within the color tradition. It represents the sun, i.e., the color of life. Gold also symbolizes eternity and divine light. In icon paintings, a saint's background, or halo, might be gold to show that he or she is living in eternity, and faces are sometimes gold as if glowing with divine light. These halos of "divine light" are at the center of Byzantine belief. According to Orthodox author and commentator Frederica Matthewes-Green, "Throughout Scripture and Christian history there is a consistent message that God is Light, and those who belong to him are said to be illuminated by His presence." She then notes that when Jesus rose from the dead, the disciples "saw Him glow with light beyond earthly origin."[26] Gold best expresses this "eternal light of God," and in traditional icon paintings, gold depicts haloes and the radiance of Christ's robes as well as "the radiance of uncreated light."[27]

In this respect, Joy creates another even more significant layer within *Sava and Symeon*. In his writings, Saint Symeon repeatedly proclaims that one can acquire revelation of God and the Trinity by beholding the "uncreated light" or God's divine energies. "Let no one deceive you!" he exhorted in his discourse *The Light of God*, "God is light (*1 John 1:5*), and to those who have entered into union with Him He imparts of His own brightness to the extent they have been purified."[28] This purification, Symeon stated, can only be achieved through spiritual growth and devotion, i.e., through faith, love, and truth. The potential lies in each one of us, but requires personal discipline and a willingness to let go of self-centeredness and worldly ties in favor of the eternal. Once that occurs, we have "been" healed or "illuminated" with God's divine grace. Saint Sava was one such true believer, and he was said to radiate with a divine light of his own. With its brilliant panels of shimmering gold, Joy's painting of these two saints symbolizes Sava's radiance and Symeon's "uncreated light," thereby representing this apex of Orthodox mysticism on both an artistic and existential level.

In *Icon After Hodegetria*, Steve Joy employs similar symbolism. However, he does it to a very different effect. The word *Hodegetria* is Greek for "one who shows the way," and in Hodegetria icons, the Virgin Mary typically holds the Christ Child on her lap and points to him with markedly extended fingers, presenting him as "the way" to the viewer. In Joy's contemporary icon, two canvases combine, the taller one on the left representing Mary, the smaller one symbolizing Christ. Together side by side, they appear in the same outline as depicted in Hodegetria icons. On Mary's panel, crimson mirrors the deep reddish purple of the Virgin's robes, while the gold at the center, top, signifies her crown/halo. In the work's shorter section, the amber tones resemble the colors used to depict the Christ Child's garment. Central to the entire composition, however, are the three black horizontal rectangles on the left-hand side. They point, like the Virgin's elongated fingers, to the "way," a literal "sacred geometry." In *Hodegetria Virgin*, Joy uses four vertical rectangles, this time all the same size. As the viewer's eye "reads" the work from left to right, it moves from darkness to light. The left-hand column is solid black,

23 Alva William Steffler, *Symbols of the Christian Faith* (Grand Rapids, MI: Wm. B. Eerdmans Publishing Co., 2002), 80. Here, Steffler cites the Biblical passages Isaiah 11:12; Ezekial 7:2.

24 Ibid., 80–81. Steffer also notes that rectangular proportions were given for Noah's Ark (Genesis 6:14–17) as well as for the Ark of the Covenant (Exodus 25:10–17).

25 St. Symeon on Spirituality, Hymn 27, 125–32.

26 Frederica Mathewes-Green, *Entering the Sanctuary of Icons and Prayer* (Brewster, MA: Paraclete Press, 2003), 18.

27 Martin, 48.

28 *Symeon The New Theologian: The Discourses*, C. J. de Catanzaro, transl. (New York: Paulist Press, 1980), 195.

symbolizing darkness and a separation from the glory of God. But as the eye moves to the right, the colors begin to brighten. The second panel from the left is composed of horizontal stripes that again indicate the "way." The amber stripes still have elements of black, but they are gradually becoming lighter as they ascend. The white stripes move the viewer's gaze to the next panel, which is all white, or the color of light and purity.[29] The right column bursts forth into staggered shades of gold, finally moving the viewer into that divine, uncreated light.

Joy's *Virgin of Vladimir* is based on the icon painting of the same name, which dates back one millennium and is often regarded as Russia's most famous icon. This painting provides a different perspective on the Virgin and Christ Child. Here Joy uses one long panel composed of five different horizontal bands of color. The white represents both Mary's face and her purity (again topped by a golden, shining halo), and the dark brown symbolizes her robes, or earthly vestments. The longest band of gold represents the infant Jesus, which literally and figuratively anchors the painting. In contrast, the painting *Madonna and Child* (see page 70) is all light, both gleaming and subdued. Using a combination of gold and beeswax, Joy makes this work at once celebratory and serene.

Whether bright or muted, the light in these paintings pulls viewers in and completely absorbs them, and it is important to consider how light, or lack thereof, changes how one experiences them. In bright light, they tend to gleam, whereas in darker settings, they quietly glow, just as centuries-old icons do. This makes it possible to sit in a dark room with one of Joy's paintings and still see the emanations of light pulsing in the darkness. Interestingly, Joy's use of light ties in with one of his primary influences. In 1954 art critic Hubert Crehan extolled Mark Rothko's ability use the Western metaphor of light signifying the spiritual, and his comments are just as applicable to Joy's own use of color to evoke light: "Rothko's work is charged by what we mean by matters of the spirit…[like]…the Biblical image of the heavens opening up and revealing a celestial light, a light sometimes so blinding, its brilliance so intense that the light itself became the content of the vision, within which were delivered annunciations of things closest to the human spirit….Rothko's vision is a focus on the modern sensibility's need for its own authentic spiritual experience. And the image of his work is the symbolic expression of this idea."[30]

For all this emphasis on light, however, darkness carries equal weight, one that goes beyond negative symbolism. Certainly, dark colors often represent death or despair. But darkness can also symbolize "deepness," or the eternal. In *The Dwelling of the Light*, Rowan Williams, the archbishop of Canterbury and noted theologian, makes an interesting observation about the darkness prevalent in icon painting as well as Hinduism: "The dark background in which Jesus is shown is something you will see in other icons as a way of representing the depths of heavenly reality. In the transfiguration, what the disciples see is, as you might say, Jesus' humanity 'opening up' to its inner dimensions. It is rather like the Hindu story of the infant Krishna, told by his mother to open his mouth to see if he has been eating mud; she looks in and sees the whole universe in the dark interior of his throat. So the disciples look at Jesus and see him coming out from an immeasurable depth. Behind or within him, infinity opens up, 'the dwelling of the light,' to borrow the haunting phrase from Job 38:19."[31]

In works such as *Trinity* (see page 73) Joy uses dark squares and rectangles to communicate this through iconographic language. Placed in opposition to the other colors, this darkness balances the works with subtle strength. *Trinity* begins on the left side with a deep, warm brown column, which represents Christ's earthly, human nature. Two golden rectangles rest on top, divided in two. One is a darker, almost amber gold, which again symbolizes Christ's humanity; the other gold is pale, almost white, and more like "uncreated light." With the dark brown dominating this section, Joy depicts Christ's profound sacrifice made on behalf of mankind. To the right sits a rectangle divided horizontally into three, with the two longest components positioned at top and bottom. These segments are brilliant, dark crimson and represent blood, life, and sacrifice. Between them is a rectangle in dark gold, a symbolic combining of heaven and earth. The column at the far right contains all these colors in varying sizes as well as a dark, royal purple, indicating God's eternal existence and his reign over all creation. In between these latter two sits a column composed of horizontal black and amber stripes. While this may seem out of place with the notion of the Trinity, Joy's use here has roots within the icon tradition. Many Trinity icons portray the three angels who appear to Abraham in Genesis, a trinity of angels as opposed to the Trinity of Father, Son, and Holy Spirit. Medieval iconographers often depicted these heavenly messengers as carrying staffs, a metaphor for the life's journey all humans undertake from the moment of birth. Only with God by our side to guide us, they

the art, iconography, and uncreated light of steve joy
KIM CARPENTER

indicated through icons, could man successfully complete this journey and arrive into eternity.

Joy also builds upon the icon tradition in ways that go beyond form and color. In Eastern Orthodoxy, the faithful regard churches in and of themselves as "heaven on earth," and a screen covered in panels of icons separates the altar from the rest of the church. Called an iconostasis, this screen has a large door (called the "royal door") in the center flanked by two smaller doors on both sides. The iconostasis symbolically divides the divine world (the altar) from the human world (the body of the church). But it also unites the two to make them whole, because it represents a sacred gateway between heaven and earth. In Joy's interpretation, several panels, usually diptychs and triptychs, combine to form one iconostasis. Both *Hodegetria* paintings, the ones that show "the way," can be viewed as iconostases. Their panels are different lengths, directing the viewer's gaze to climb and descend across entire spans of walls. By rendering icons in the abstract, Joy tears down the traditional doorway to the divine to open a new, utterly contemporary one. But these doorways are not immediate entryways; rather, one must engage with them on a contemplative level.

All of this is well and good, but if an icon, by its definition, is an image—a sacred image, at that—then what do Joy's contemporary icon paintings represent? Contemporary interpretations of traditional icons notwithstanding, if they are abstract, can they actually be icons? It is important to take a step back and consider again what might be the goal of the icon as an object for religious reverence. What is important in icon painting is not the subject that is represented but rather the overall message that is communicated. The Orthodox Church has been specific in this regard. Over 1,300 years ago, the Trullan Council convened to discuss the nature of Christ. Attended by Eastern bishops, the council also lay down the dogmatic significance of icons, and emphasized the importance of using icons as a means for venerating and contemplating God, conceding "the possibility of making art reflect, by a new symbolism, the glory of God."[32] Artists such as Steve Joy, of course, would agree, citing sacred geometry and spiritual abstraction as means for achieving precisely this.

In recent decades, some icon scholars have agreed, acknowledging that it might be possible to recreate icons for and within a contemporary context. Noting that "historical reality" cited by the Trullan Council has traditionally taken the form of the human figure, Leonid Ouspensky, a renowned expert on the theology of icons, has argued that it is possible to create "an art new both in form and content, which uses images and forms drawn from the material world to transmit the revelation of the Divine world, making this world accessible to understanding and contemplation."[33] For this reason, the visual language of icons is not, as Linette Martin notes, "rigid and changeless, as though someone decided a thousand years ago that a picture of Christ or the Virgin should be done according to a precise recipe....The visual language of icons has developed over centuries because it is a language. Just as a spoken language develops but remains itself, so too does that of icons."[34] Additionally, she points out: "Within the iconography of Byzantine art, the possibility of new subjects allows the art of icons to remain alive. Byzantine iconography was supple enough to include new subjects. New details in icons appear from time to time, just as new words appear in a spoken language because they are needed."[35]

While craftsmen working in the Christian icon tradition have attempted to capture an "invisible God" by rendering Christ as he appeared to humankind in the flesh, Joy goes further back, past the roots of Christianity, to depict the "invisible God" through the sacredness and universality of geometry, that "knowledge of the eternally existent" cited by Pythagoras. In this respect, Joy moves icon language to evolve and adapt to a new world reality; but while this method of communicating icons is new, the "vocabulary" is not; it is, in fact, older than the icon tradition itself. By using the old symbolism encoded in sacred geometry and representing it as a "new symbolism" of sorts, Joy moves medieval icon paintings into the contemporary arena for a contemporary audience. Although these icons are clearly based in the tradition of Christian iconography, they are at once universal and a-historical, as well as personal and specific to our own age.

29 Martin, 98.
30 Cited by Irving Sandler, "The Sectionals 1949–1959," in *The Art of Mark Rothko*, 87.
31 Rowan Williams, *The Dwelling of the Light: Praying with Icons of Christ* (Grand Rapids, MI: Wm B. Eerdmans Publishing Company, 2003), 4–5.
32 Leonid Ouspensky, "The Meaning and Language of Icons," in Leonid Ouspensky and Vladimir Lossky, eds., *The Meaning of Icons* (New York: St. Vladimir's Seminary Press, 1983), 29.
33 Ouspensky, 30.
34 Martin, 4.
35 Ibid., 28.

Certainly, Malevich attempted as much with his famed *Black Square*. For the *Last Futurist Exhibition*, he hung this work high above all the others, installing it across a corner to straddle two walls, a position usually reserved in Orthodox homes for icon display.[36] But Malevich wasn't creating icon paintings, he was replacing them with his own sacred geometry. In contrast, Joy is creating icons, and he is doing so by rending apart the traditional and antiquated (if not anachronistic) model of what icon paintings are supposed to be; Joy has created a new image of the religious icon that transcends Eastern Orthodoxy. In a society that scholars continually label as "post-modern," the abstract may serve as the best means we have on a global level for a cross-cultural form of spiritual contemplation. More specifically, both the rectangle and the square remain imminently accessible irrespective of religious affiliation. One need not view a Byzantine icon of Jesus or Mary to feel closer to the divine. Whether Muslim or Christian, Hindu or Jew, Buddhist or Sikh, the geometric iconography of these shapes is immediately understood on a very basic, very human level. These are elemental shapes that exist across cultures and neutralize any fundamentalist belief system. As Plato wrote in *The Republic*, "Geometry will draw the soul toward truth and create the spirit of philosophy. The knowledge of which geometry aims is the knowledge of the eternal."

For all these reasons, Joy's paintings exist simultaneously as art and icon, observation and prayer. As art, the observation provides for contemplation in the abstract; as icon, the prayer opens a window into the eternally universal. And in this regard, Joy gives his viewers an intimate experience of reverential meditation, one that is ultimately resistless and unquestionably, utterly timeless.

36 Milner, 127.

the art, iconography, and uncreated light of steve joy
KIM CARPENTER

2005–2000

new york

omaha

morocco

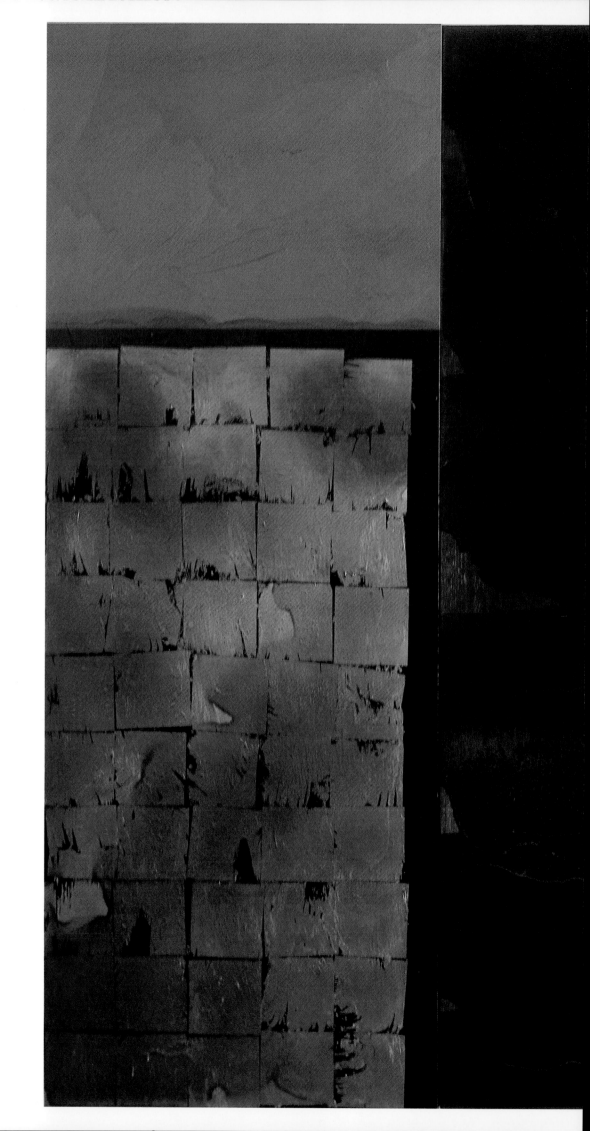

Samurai Painting (Red Robe), 2004 mixed media on wood
203 × 381 cm, 80 × 150", Creighton University School of Dentistry,
Omaha, USA

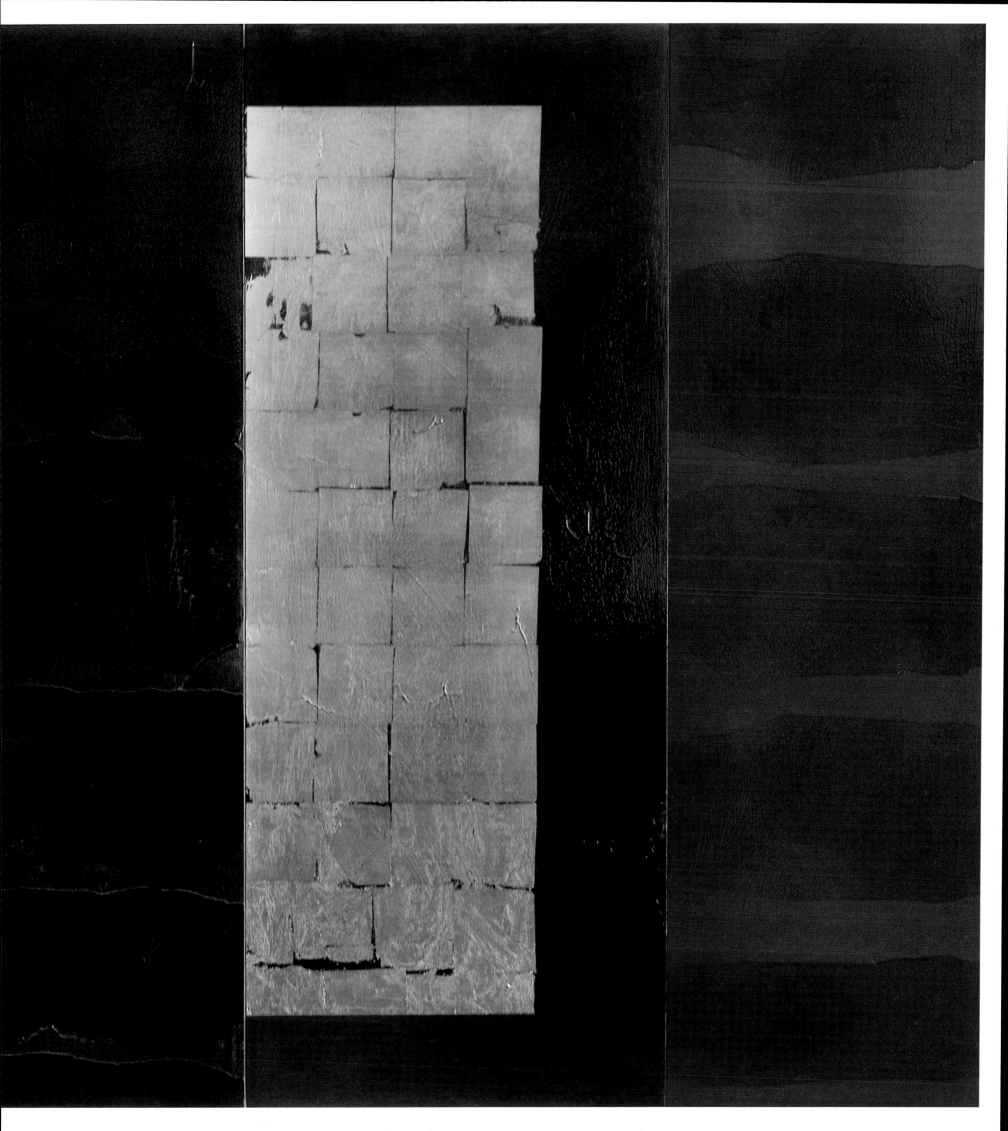

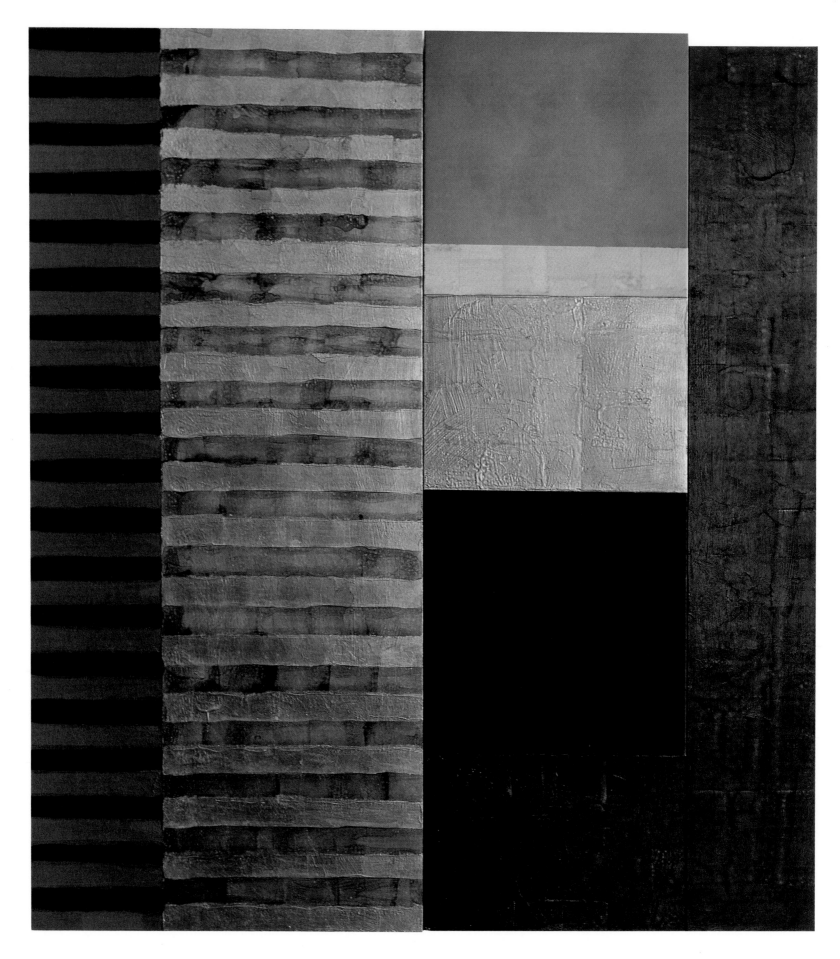

Samurai Painting, 2004–05 mixed media on wood
203 × 193 cm, 80 × 76", collection of Union Pacific Railroad Headquarters,
Omaha. USA

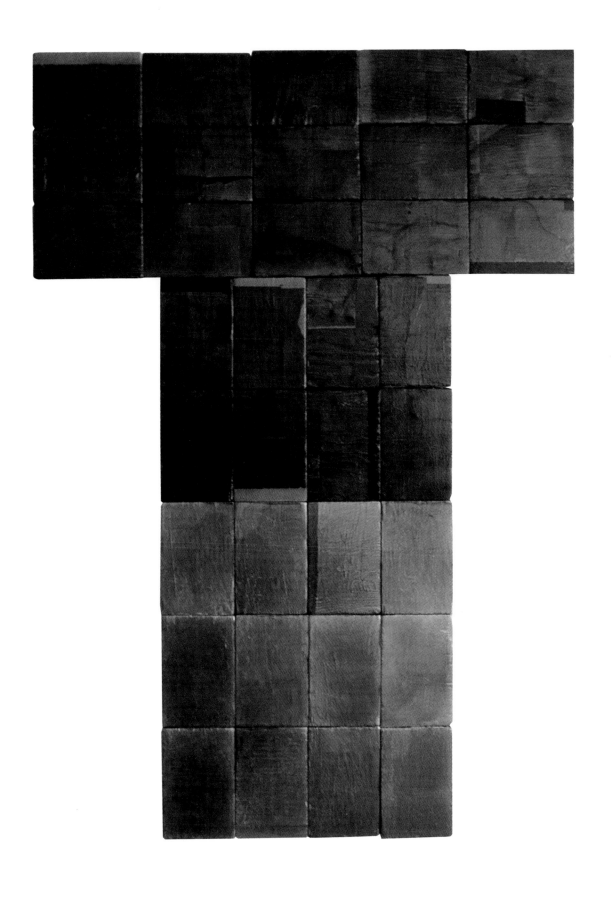

Samurai Painting (Yellow Robe), 2004 mixed media on wood
170 × 119 cm, 67 × 47", private collection, Omaha, USA

The Lady with an Ermine, 2004 mixed media on wood
24 × 33 cm, 9 1/2 × 13", private collection, Zurich, Switzerland

La Belle Ferronnière, 2004
mixed media on wood
24 × 33 cm, 9 ¹/₂ × 13", private collection,
Zurich, Switzerland

Madonna and Child, 2004
mixed media on wood
24 × 33 cm, 9 ¹/₂ × 13", private collection,
Zurich, Switzerland

Ginevre di Benci (after Leonardo), 2004
mixed media on wood
24 × 33 cm, 9 ¹/₂ × 13", private collection,
Küsnacht, Switzerland

Annunciation, 2004
mixed media on wood
24 × 33 cm, 9 ¹/₂ × 13", collection of
Nicole Bruneteau, Omaha, USA

Trinity, 2004 mixed media on wood
24 × 48 cm, 9 × 19",
private collection, Oslo, Norway

73

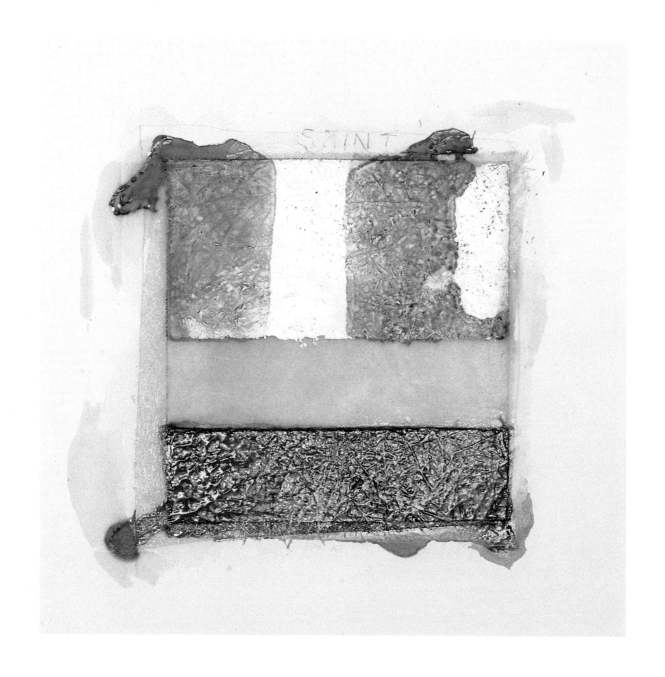

Quartet: St. Francis of Assisi I (Saint), 2003
fiberglass on paper
56×76 cm, 22×30", private collection, Omaha, USA

Quartet: St. Francis of Assisi II (Francis), 2003
fiberglass on paper
56×76 cm, 22×30", private collection, Omaha, USA

Quartet: St. Francis of Assisi II (of), 2003
fiberglass on paper
76×56cm, 30×22", private collection, Omaha, USA

Quartet: St. Francis of Assisi IV (Assisi), 2003
fiberglass on paper
56×76 cm, 22×30", private collection, Omaha, USA

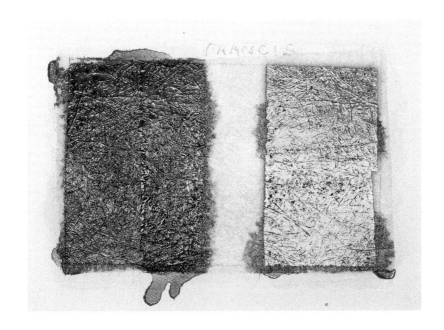

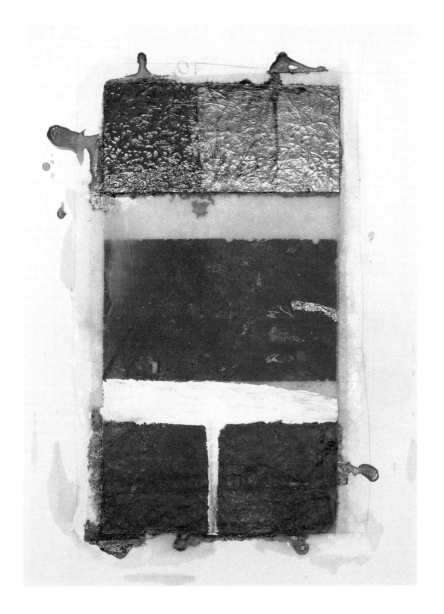

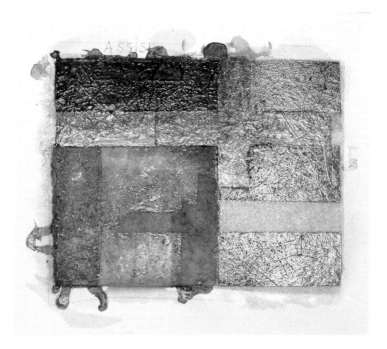

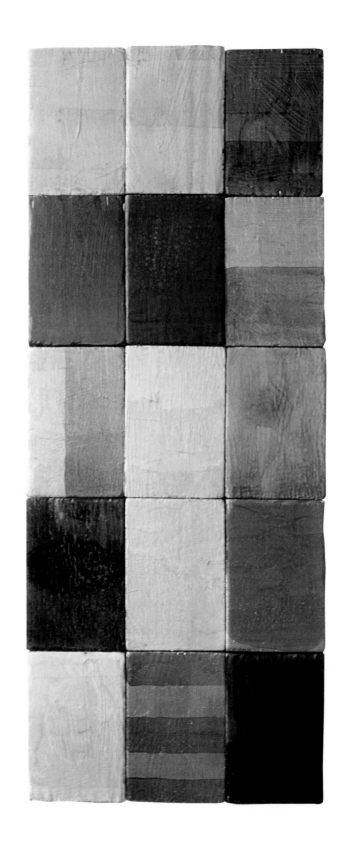

Olive Grove, 2004 mixed media on wood
124×53 cm, 49×21", private collection, Omaha, USA

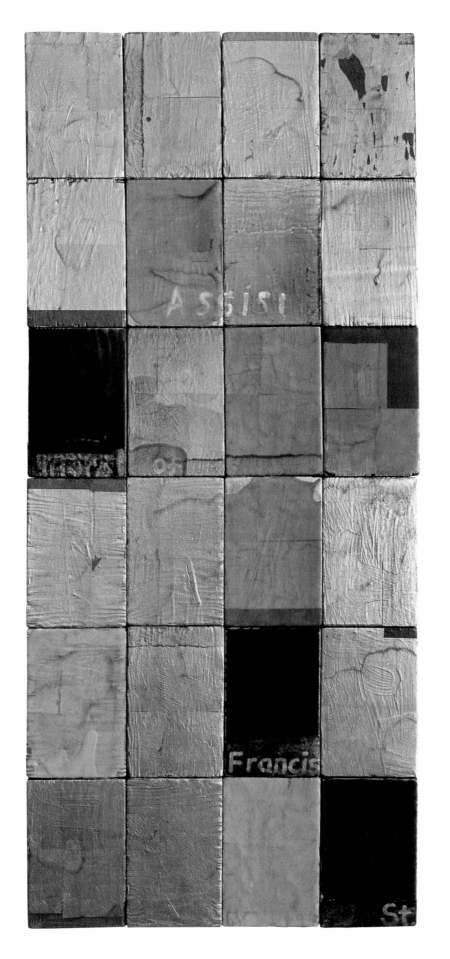

St. Francis of Assisi, 2004 mixed media on wood
145×51 cm, 57×26", private collection, Omaha, USA

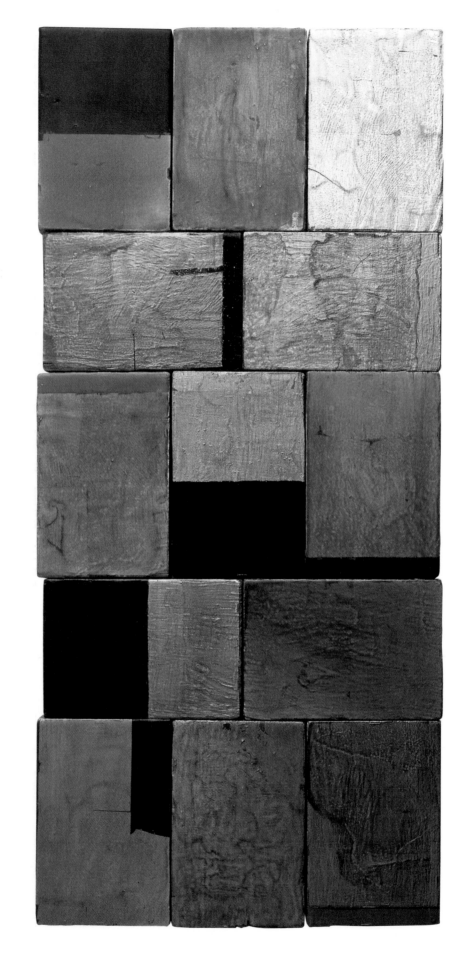

Olive Tree, 2003 mixed media on wood
102 × 48 cm, 40 × 19", private collection, Omaha, USA

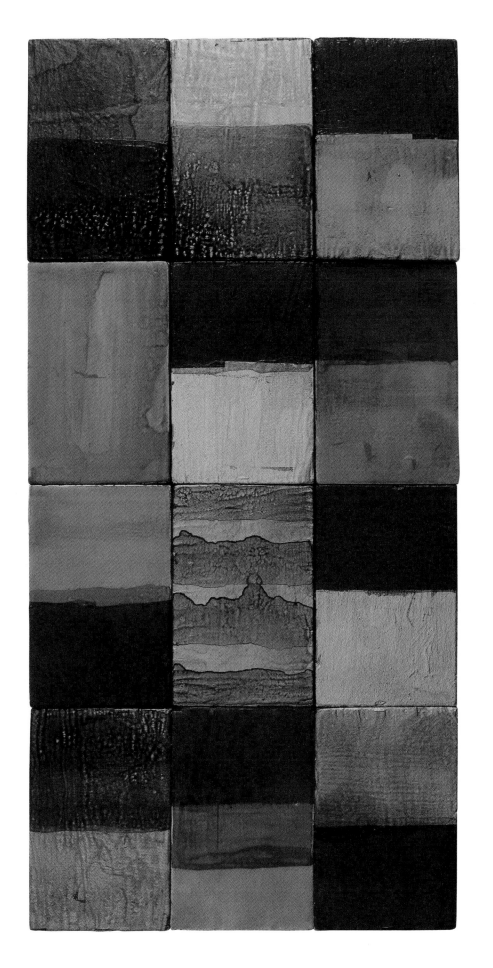

Coba, 2003 mixed media on wood
97×51 cm, 38×20", private collection, Omaha, USA

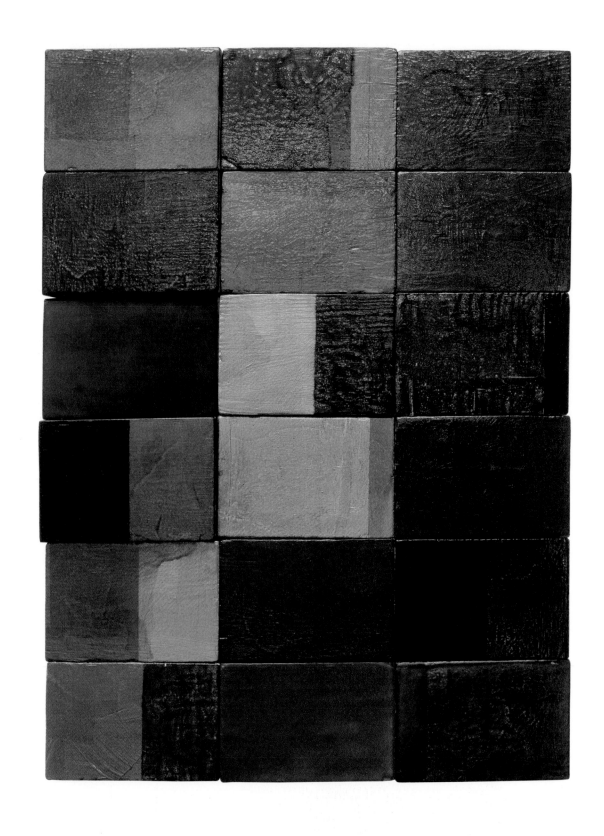

Anegada Night, 2003 mixed media on wood
102 × 72 cm, 40 × 28 ¹/₂", private collection, Omaha, USA

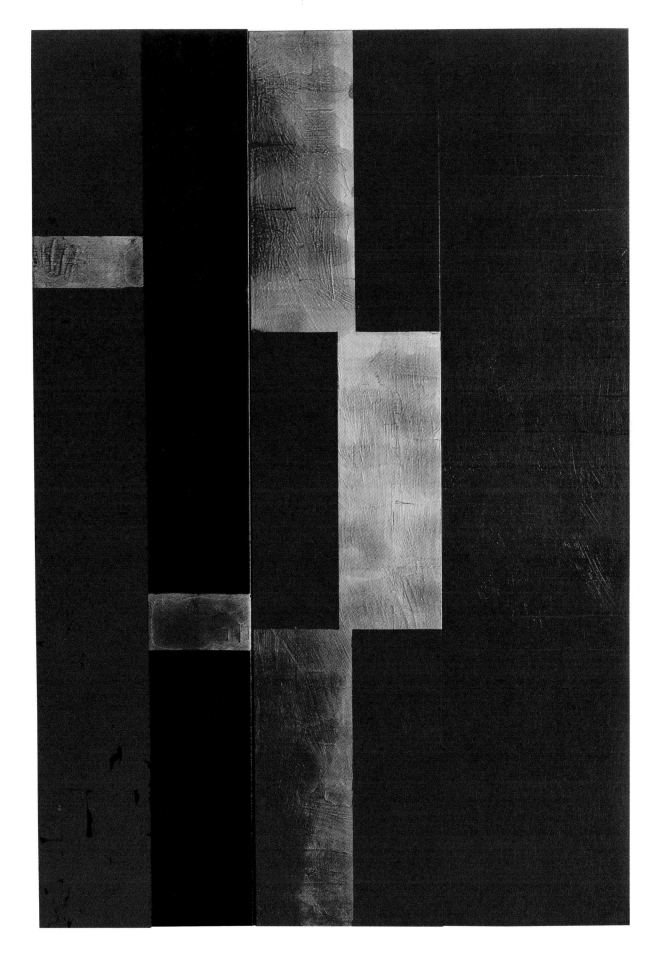

Desert Poem (Mali), 2003 mixed media on wood
203×137 cm, 80×54", private collection, Omaha, USA

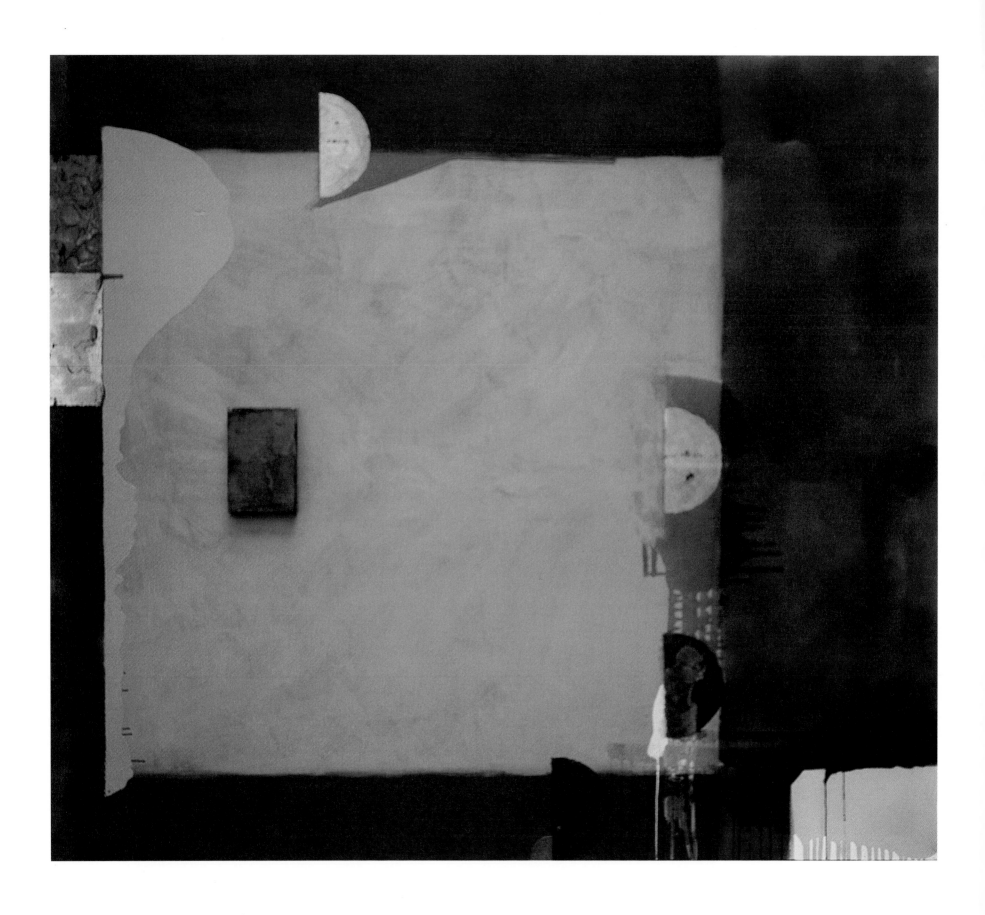

Morocco, 2000 acrylic, oil, gold leaf, and varnish on canvas
213×244 cm, 84×96", Buena Vista University, Storm Lake, Iowa, USA

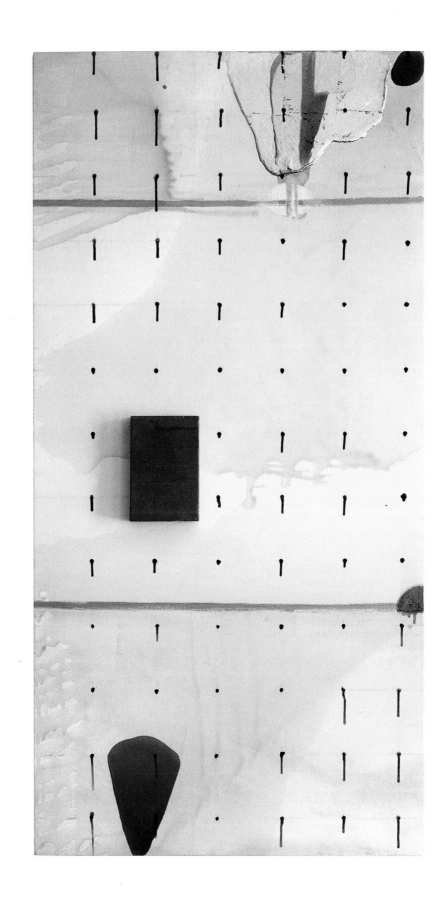

The Veil, 2001 mixed media on canvas
173 × 127 cm, 68 × 50", private collection, Omaha, USA

83

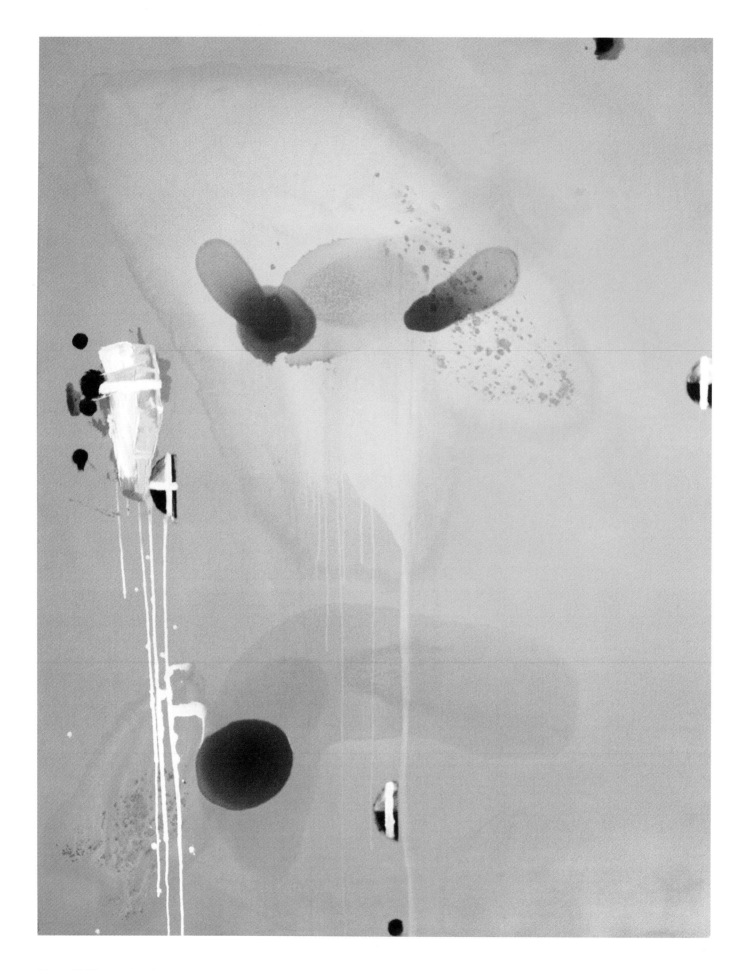

Mask, 2000 mixed media on canvas
208 × 175 cm, 82 × 69 ", private collection, Zurich, Switzerland

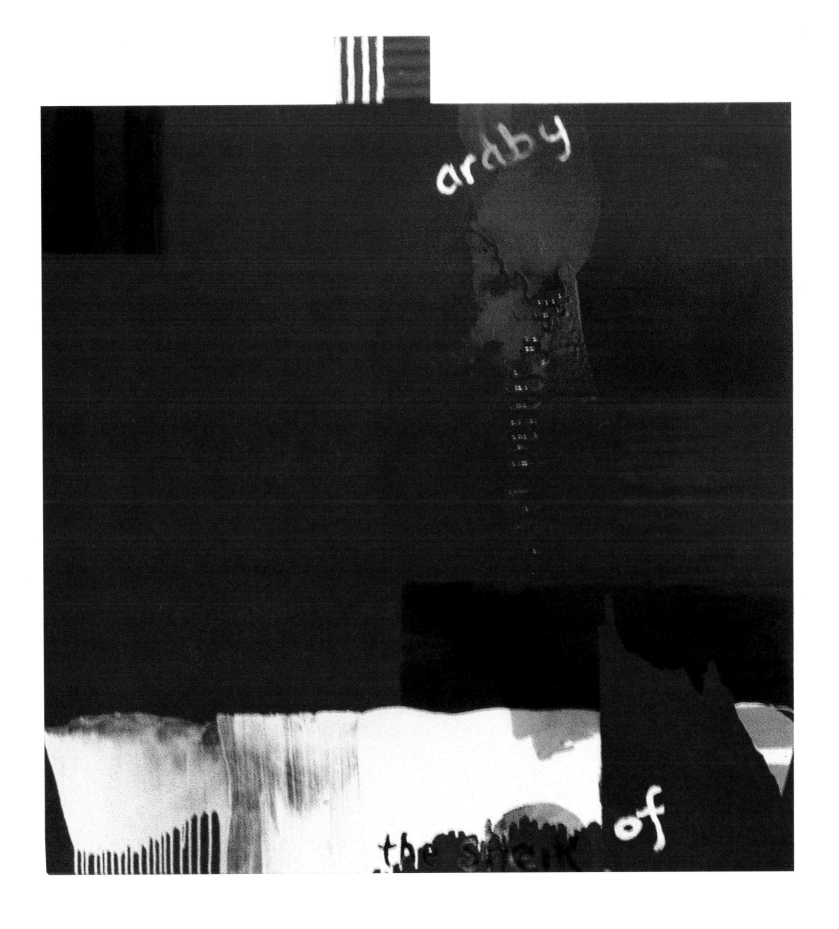

The Sheik of Araby, 2000 acrylic and oil on canvas
203 × 193 cm, 80 × 76", private collection, Omaha, USA

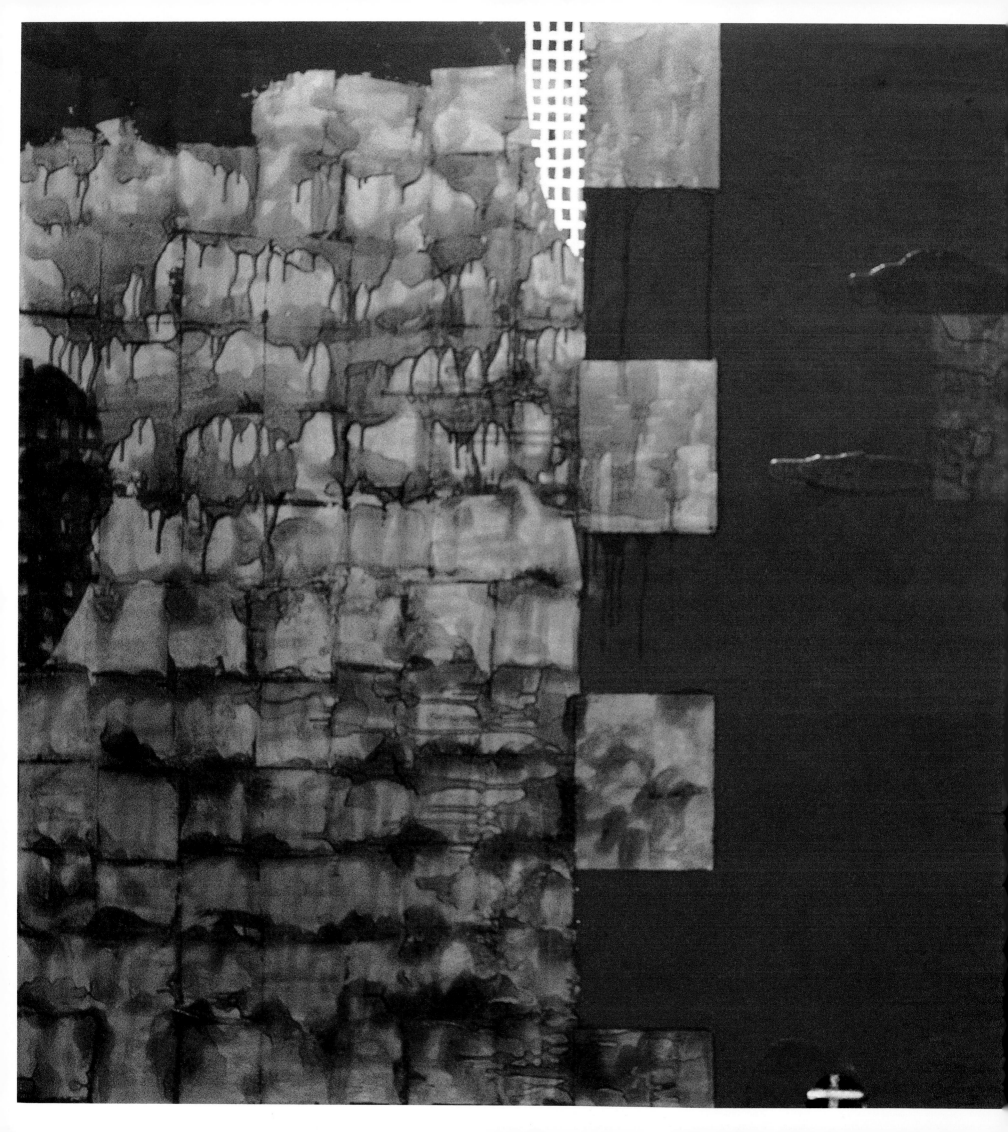

Red Fort, 2000 mixed media on canvas
178×213 cm, 70×84", Erich Storrer Gallery, Zurich, Switzerland

2000–1998

new york

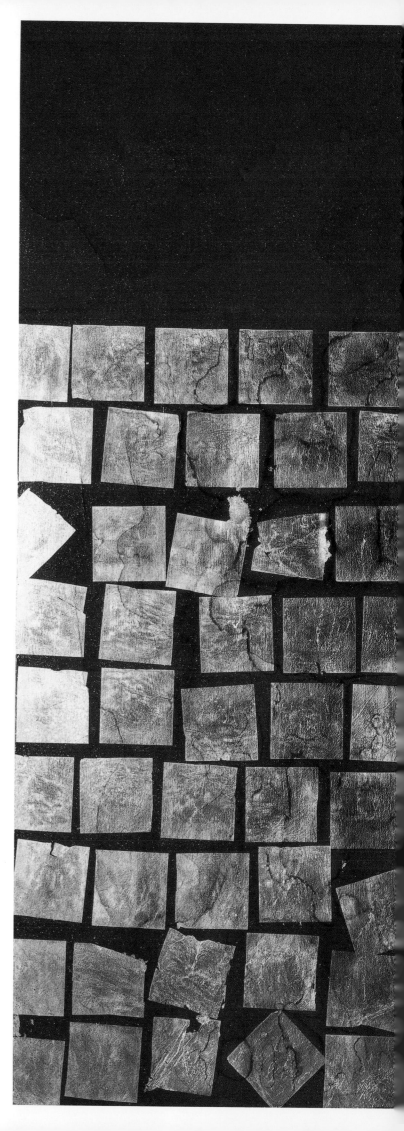

90 **Tiger Hunt, 1999** acrylic, gold leaf, beeswax,
and Japanese ink on wood panels
203 × 239 cm, 80 × 94", private collection, Omaha, USA

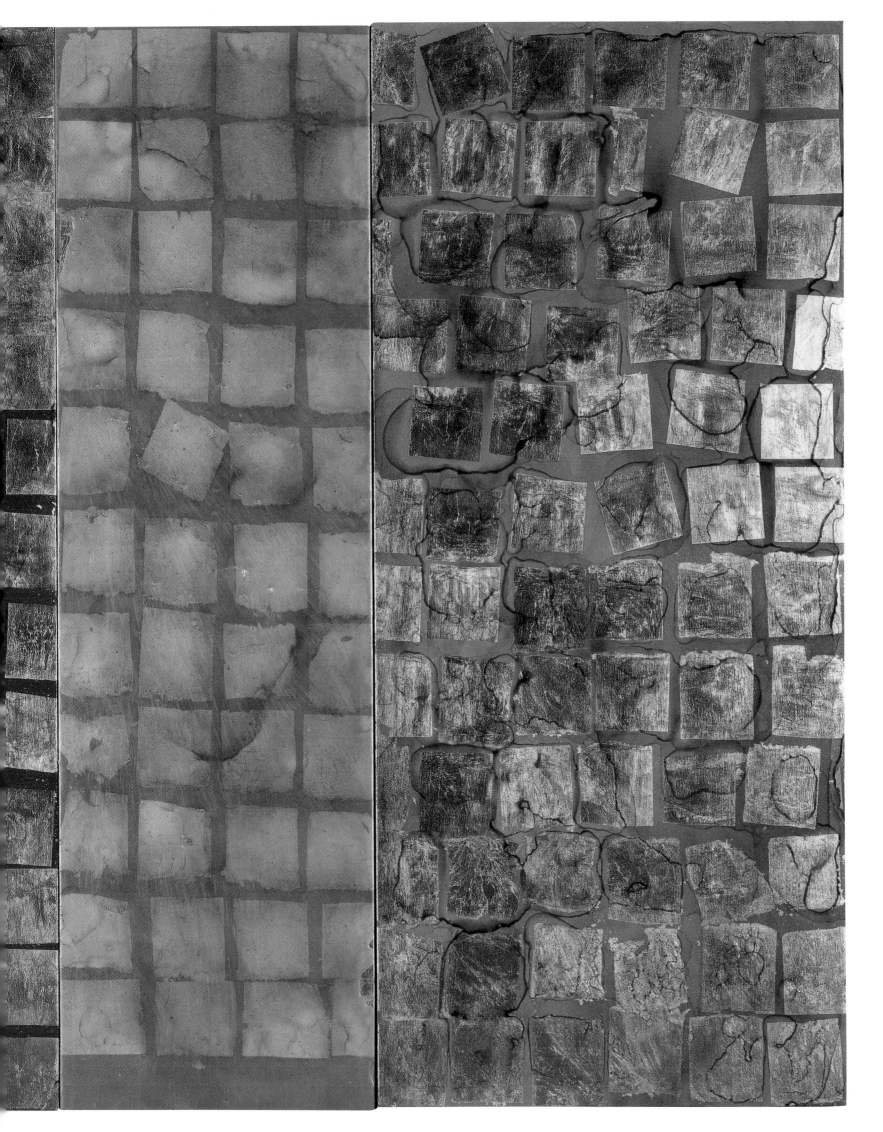

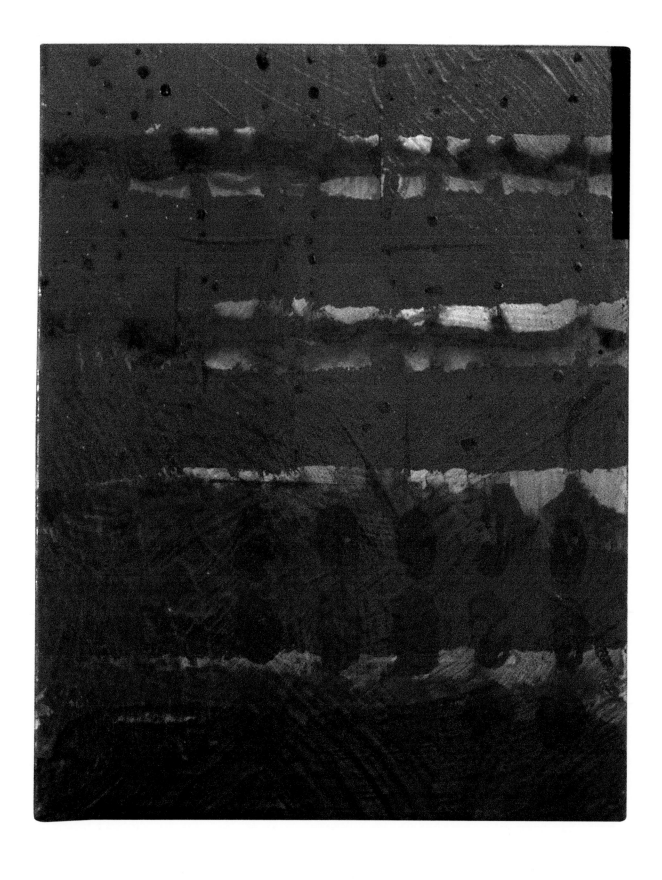

Cardinal II, 1999 mixed media on canvas
35×28 cm, 13 1/2×28", private collection, Switzerland

Cardinal I, 1999 mixed media on canvas
35×28 cm, 13 1/2×28", private collection, Switzerland

Cardinal III, 1999 mixed media on canvas
35×28 cm, 13 1/2×28", private collection, Switzerland

Cardinal V, 1999 mixed media on canvas
35×28 cm, 13 1/2×28", private collection, Zurich, Switzerland

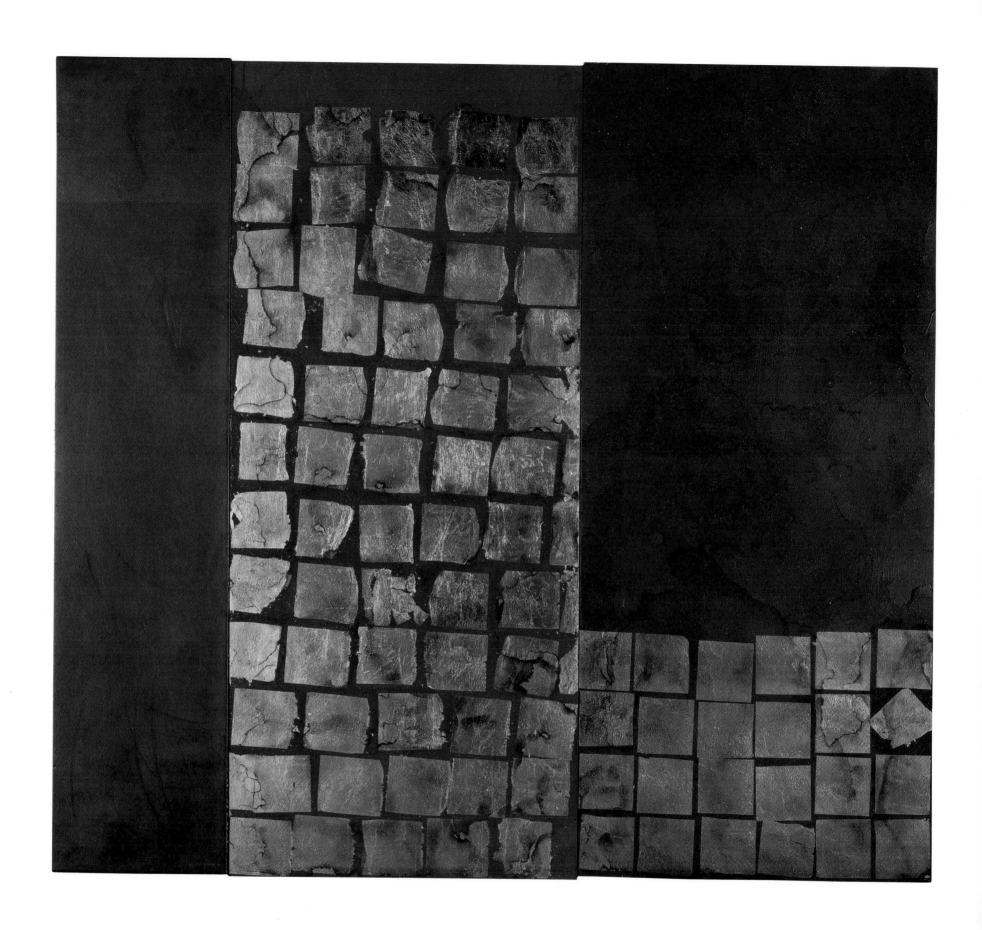

94 **Listen to the Lion, 1999** acrylic, gold leaf, beeswax,
and Japanese ink on wood panels
203×229 cm, 80×90", private collection, Omaha, USA

Shanghai Mansions, 1998 beeswax, oil, acrylic, gold
and copper leaf on wood panels
203×229 cm, 80×90", Joslyn Museum, Omaha, Nebraska, USA,
Gift of Thomas Huerter, 1998

Aquasparta, 1998 acrylic, gold and silver leaf,
and Japanese ink on wood panels
203×244 cm, 80×96", private collection, Council Bluffs, Iowa, USA

Painting, by its impressive example of inner freedom and inventiveness and by its fidelity to artistic goals, which include the mastery of the formless and accidental, helps to maintain the critical spirit and the ideals of creativeness, sincerity, and self-reliance, which are indispensable to the life of our culture.[1]

MEYER SCHAPIRO, 1957

steve joy: his life in art

DAVID CARRIER

David Carrier is Champney Family Professor, a position divided between Case Western Reserve University and the Cleveland Institute of Art. His books include *Artwriting* (Amherst, 1987), *Principles of Art History Writing* (University Park and London, 1991), *Poussin's Paintings: A Study in Art-Historical Methodology* (University Park and London, 1993), *The Aesthete in the City: The Philosophy and Practice of American Abstract Painting in the 1980s* (University Park and London, 1994), *Nicolas Poussin. Lettere sull'arte* (Como, 1995), *High Art. Charles Baudelaire and the Origins of Modernism* (University Park and London, 1996), *England and Its Aesthetes: Biography and Taste* (Amsterdam, 1997), *Garner Tullis. The Life of Collaboration* (New York, 1998), *The Aesthetics of the Comic Strip* (University Park and London, 2000), *Rosalind Krauss and American Philosophical Art Criticism: From Formalism to beyond Postmodernism* (Westport, Connecticut, 2002), *The Art of Artwriting* (Allworth Press, 2002), *Sean Scully* (London, 2003), and *Museum Skepticism* (Durham, 2006). His latest book is *A World Art History and Its Objects*, forthcoming.

Very often visual artists travel. And sometimes they travel to see the most important earlier works of art. In the seventeenth century northerners came to Rome to study the sculpture of antiquity and Renaissance painting. And they traveled to see places with art historical associations. When Claude Lorrain and Nicolas Poussin moved from France to Rome, for example, they found the landscape settings that appear in their paintings. The French government institutionalized this travel, creating an academy in Rome. And then other nations echoed this gesture. When the center of the art world shifted, so too did these travel patterns. In the nineteenth century, ambitious students from America and everywhere in Europe traveled to Paris to visit the Louvre and attend the French art schools. And since the mid-twentieth century artists from all parts of America and Europe have come to New York, the Rome of our art world, to visit museums and galleries, and meet American artists.

When he was an art student, Steve Joy was intensely attracted by American painting.

All of the great American painters showed me, when I was at art school, the necessary starting point and also the way forward.[2]

He was inspired by the Abstract Expressionists and their successors.

The American painters, i.e. Rothko, Newman, Pollock, de Kooning, then later Marden, Agnes Martin, etc., they gave us the courage to break through what we thought of as the two limiting aspects of British Painting—which seemed to be either completely representational (Hockney, Freud, Bacon) or an overly literal (and literary) lyrical form of abstraction, i.e., Howard Hodgkin.

Mostly he learned about this art from reviews, but there also were some significant exhibitions in London. My epigraph from Meyer Schapiro explains, nicely enough, how many people in New York and England, including Joy, understood the moral importance of Abstract Expressionism. Some Western artists also traveled outside Europe. In the seventeenth century, the Italian Giuseppe Castiglione (1688–1766) went to Beijing. Seeking to convert the Chinese, this Jesuit learned to paint in the Chinese style. And in that age of imperialism, Europeans went to newly colonized territories, to India and to North and South America, in search of exotic subjects. In the late nineteenth century Paul Gauguin went to the South Pacific, and Orientalists traveled to the Islamic world. Gauguin depicted the peoples and landscapes of Tahiti; the Orientalists showed Islamic decorations and desert scenes. And in the early twentieth century Henri Matisse found essential inspiration in Morocco and in Russia. Often, of course, such travel also was a way

for artists to find themselves. Visual multiculturalism matters, Arthur Danto suggests, because to be fully aware of your own culture, you need to know others.

"One…would attain no *consciousness* of the quality of a life if one knew only one's own….Consciousness comes through contrasts with other forms of life or through changes in one's own (it being no accident that [Herodotus] the Father of History was a famous great traveler)."[3]

As Herodotus wrote:

"Everyone without exception believes his own native customs, and the religion he was brought up in, to be the best."[4]

Travel, of course, often destroys that facile way of thinking. You learn much about both yourself and your own visual culture by stepping outside it. Steve Joy is an unusually widely traveled artist. After studying in Japan, he painted for long periods in Belgium, Italy, Norway, and Spain, and, more recently, in Omaha, Nebraska. But in some important ways, his journeys differ from those typical of earlier Western artists. Although Joy was extremely attracted by American painting, he did not live and work in New York until he was thirty-seven, relatively late in his formative years. And in his travels, he was not in search of exotic subjects. Since making figurative images is not the concern of an abstract painter, he never depicted the places where he lived. In his voyages, so we will see, Joy certainly learned much about himself.

Joy is interested in many visual traditions—in Greek icons and the early Renaissance painting of Umbria, but also in Japanese calligraphy. His essential goal was to find ways that an abstract painter could use these diverse visual cultures. From the start, Joy wanted to make art with historical resonance.

If you really think about all of art history from the beginning, probably right up to Abstract Expressionism, it was about place, a sense of place, you can't look at a Giotto in Italy, a van Eyck in Flanders, or a Vermeer in Holland without thinking about the history and culture of these countries.

He wanted that this sense of place, of many places, be revealed within his art. Since he was painting abstractly in such diverse places, in Japan and Norway but also in Spain and Italy, doing that was not easy. The visual cultures of places Joy has traveled to see have been very varied. In his generation many ambitious younger English artists sought to escape from the limits of their country's art world. In America, Joy knew, you could find

Pollock, Newman, Rothko, a strange cross-section of society, all in New York City.

England remained primary concerned with figurative art. And

so when at age twenty-five he decided to become an artist, he knew that he had to travel. When he traveled, he was not just an art tourist—he lived and worked in foreign places with very unfamiliar cultures. It was impossible to know in advance how his painting would benefit. That was part of the risk of these travels.

All of the places I'd lived had great art historical context, they also were places where intellectual and philosophical battles had been fought. I had to feed things from those places into my art.

After the prolonged travels in continental Europe, in 1997 he choose to paint and work in Omaha. It may seem as if he had deliberately picked an unfashionable location. Unlike Norway, Spain, or Italy, this city had no associations with art history. But, here as earlier, there was a sophisticated logic in his choice of where to live. In America Joy's fascination with spiritual concerns was widely shared. Sometimes a place with less of an artistic tradition is a better site for an artist.

Since I came here things have been narrowing down a lot, that wasn't a choice, it was a reflection of being in one place longer. It was never my intention to develop one style and stick with it, I saw other people doing that much more successfully. I don't have the kind of freedom here that I had in Italy. In America there is always the weight of twentieth-century modern masters to compete with.

When he was younger, and he traveled, his art went through a lot of changes. Even when he settled in Omaha, Joy didn't want his art to settle down. These very extensive travels meant that it took him a long time to find himself as an artist.

I was never in a hurry, I wanted my work to reach a point where it was less influenced by other artists.

As we will see, his very long journey proved to be worthwhile because it allowed him to create marvelously unclichéd art.

1 Meyer Schapiro's account of abstract art in his *Modern Art. 19th and 20th Centuries. Selected Papers* (New York: George Braziller, 1978), 226.

2 The quotations of Joy come from interviews in his Omaha studio, 13 and 14 June, 2006; and from our correspondence. Around 1980, inspired by Joseph Masheck's visionary essays on iconicity reprinted in his *Historical Present: Essays of the 1970s* (Ann Arbor, Michigan: UMI Research Press, 1984), I became an art critic. My analysis of Joy's uses of the icon tradition owes a great debt to Masheck's writings.

3 Arthur C. Danto, *Narration and Knowledge* (New York: Columbia University Press, 1985), 296.

4 Herodotus, *The Histories*, trans. Aubrey de Sélincourt (London: Penguin Books, 2003), 187.

But this catholic range of interests has meant that it took Joy an usually long time to find himself. How, then, did Joy learn in his extensive travels how to do this? The central aim of this book is to answer that question. George Kubler, the great historian of Spanish-American art, has a highly useful concept of what he calls the artist's entry point:

"Each man's lifetime is also a work in a series extending beyond him.... To the usual coordinates fixing the individual's position—his temperament and his training—there is also the moment of his *entrance*.... Of course, one person can and does shift traditions, especially in the modern world, in order to find a better entrance."[5]

Had Joy gone to school a few years earlier, he could not have learned about Abstract Expressionism as it would be unlikely that it would have been taught. Perhaps he would have become a figurative artist. When he entered the English art world, there was great interest in American painting; but because Joy arrived a generation before the Young British Artists, who became famous and, in a few cases, very prosperous, he had to work hard to gain support for his art. Joy was born in Plymouth, England, in 1952, into a tight-knit working-class English community. There was no visual art in his world, but there was nature, the sea, lots of mechanical things, I remember my father stripping down old motorcycles, on the floor, that led me to an engineering background in the Air Force.

When he joined the Royal Air Force at sixteen, his travels started. I lived in Germany, Cyprus, Hong Kong, Malaysia, I got to go to Sri Lanka, I got to the Maldives.

And he was influenced by his father's job. My father was a shoemaker, who unfortunately opened his own business at the time cheap fashion shoes were available, so no one wanted to pay to have a shoe repaired. It may well be that my father's craft of shoemaking instilled in me the notion of pride in craft and small industry.

Joy was a sympathetic observer of a variety of non-Western cultures, including the Arab Middle East. What later would affect his art was not so much anything he saw but this experience of many exotic cultures. And while he was in the Air Force, he spent a lot of time reading. I was always investigating things. As a child I was a little outside of everything, I think I carried that on within the Air Force; I remember having a shelf of books about Solzhenitsyn, that was pretty strange in those days during the Cold War.

Joy was greatly influenced by Emile Zola's *The Masterpiece*, which he read in 1973. The novel presents Claude, an artist modeled on Zola's childhood friend Paul Cézanne, who tries desperately to paint the subjects of modern life but fails completely. When you are a young budding artist, ambitious failure can seem very romantic. Although American Abstract Expressionism was famous in England, and much shown in that country, no equivalent indigenous tradition developed.

Joy himself wanted to create more accessible art. It took him a long time to learn how to do that. But when he did, he found that his early art provided a great starting point. My early student paintings were quite mature and focused and already edging toward what would later become a realization of my affinity with icon painting. I knew I could use painting as a groundwork for my own spiritual development.

He discovered the art of painting a little earlier, when he was on leave in Holland with friends from the Air Force. It was a rainy day, we were lost, standing outside what happened to be the Stedelijk, I said, let's get out of the rain, that's where I stumbled onto the Barnett Newman, I was absolutely bowled over, I bought the monograph by Thomas Hess, and was astonished to find these paintings were made by an urbane rather sophisticated New York gent.

Joy was twenty-four—and he hadn't gone to art school. But at that moment his life changed. One reason, I think, that he associates art with religious experience is that then he himself was converted. Inspired by the spirituality of Newman's art, he wanted to be an abstract painter. In his own painting, Joy pays tribute to Newman, and to other admired artists. The title of *Mirror* (*For Tarkovsky*) (1989, see page 156), with its Barnett Newman-esque stripes, alludes to the great film director Andre Tarkovsky. His films were a huge influence on me as far back as student days, not only *Andrei Rubelev*, but also *Stalker* and *Mirror*.

The paintings *Mirror* and *The Bell* (see page 159), were made in memory of and as a tribute to Tarkovsky. *The Bell* was inspired by a scene from *Andrei Rubelev*—and by my fascination with bell-making of the time, most of it being based on intuition and a sense of rightness only the great bell-makers could fathom. Sometimes the ingredients in painting, especially medieval icon painting and early Renaissance works, seem connected to that same form of alchemy.

steve joy: his life in art
DAVID CARRIER

Most aspiring painters go to art school in order to discover what kind of painter they want to be. Joy, who was older than such students, thought about education in a very different way:

I ended up going to art school with quite a firm knowledge of what kind of painter I wanted to be, but no schooling in the knowledge of how to do it. It was a pure desire, almost like a religious conversation.

This conviction, acquired early on, has always sustained his art. Here, then, we get to the origin of the paintings Joy made in 1980–1981, the *Sunstones* (see pages 188–191).

I made a trip across the northern part of Spain riding a bicycle from Santander to Barcelona through what was then quite wild country. At the time I was reading Antonio Machado, especially, and Lorca. And Cesar Vallejo (Peruvian), and most importantly for this series of paintings, the poem "The Heights of Macchu Picchu" by Pablo Neruda, in which there is a line "stones of the sun."

These *Sunstones* mark a real transition in his career.

The work I was doing before these at graduate school in Chelsea, London, was almost colorless, very minimal and very tough. But the paintings had forms in them or some sort of geometry or spatial configurations. For the *Sunstones* I wanted the paintings to be without any kind of image. To be read only as objects that might contain feelings, not necessarily my own. I wanted them to look like something that had been lying around in the dirt and had been suddenly discovered.

These, then, were the influences behind Joy's *Sunstones*.

I did want them to be dark and mysterious, but in the Spanish way, like in the poems I was reading, or *Don Quixote*. I wanted them to be close to the earth in feeling. These paintings contained much intuition of what would come later in my life, both intellectually and emotionally, but especially aesthetically. There was a lot of ritual in their preparation, there was a lot of patience and discipline and waiting for that moment of readiness.

Then in 1980 Joy went on to gain a Master's degree at the Chelsea College of Art, a very good school. At Chelsea Joy did very severe art:

I was making paintings with about two hundred layers of black acrylic with a certain amount of over-pigmentation, so my paintings looked like blocks of stone. They were based upon the poetry of Rilke. The work was very difficult.

Then one exhibition had an enormous effect. *Brice Marden: Paintings, Drawings and Prints 1975–80* at Whitechapel Art Gallery (1981) was very impressive, both for the quality of art and for Stephen Bann's extremely original essay, "Brice Marden: from the

Barnett Newman, *Who's Afraid of Red, Yellow and Blue IV*, 1969–70, oil on canvas, Nationalgalerie Berlin

Material to the Immaterial," which framed the introduction of Marden's early encaustic paintings to an English audience. Bann argues that Marden's *Annunciation Series* (shown the previous year at the Pace Gallery, New York) presents the spirit made flesh in what amounts to a radical rejection of Clement Greenberg's vision of abstraction. Facing his essay is a large reproduction of Piero della Francesca's *The Annunciation* (1455) from Arezzo, which gives a clear introduction to this interpretation of these abstract paintings. The annunciation, Bann says, is "the incarnation of spirit in the material world,"[6] and that is what Marden's paintings offer. Joy has a most vivid recollection of the influence of this exhibition and Bann's catalogue:

After the student paintings were made and I had been away in Japan, I began to see my works' history being linked to what later became known as fundamental painting, of which Marden and several of his contemporaries were thought to be a part (mistakenly in Marden's case).

5 George Kubler, *The Shape of Time: Remarks on the History of Things* (New Haven and London: Yale University Press, 1962), 6.

6 Stephen Bann, "Brice Marden: From the Material to the Immaterial," in *Brice Marden: Paintings, Drawings and Prints 1975–80*, exhibition catalogue (London: Whitechapel Art Gallery, 1981). I discuss the early interpretations of Marden in my *Artwriting* (Amherst: University of Massachusetts Press, 1987).

Nick Samsworth, Steve Joy, and Alex Booker at Exeter College of Art, England, 1979,
Paintings in the background by Nick Samsworth.

Joy's generation of painters was, so Bann suggests, trapped:
"between the ultimate spasms of a reductive late Modernism and the
deceptive dawn of a reactionary realism."

Bann, Joy adds, in describing the possibilities for Marden,
might also have been speaking of my ideals at the time when he said
"One might wish for a serious examination of the Western Judaeo-
Christian tradition in so far as it determines not only our response to
the Old Masters, but also our awareness of the art of our own time."
These implications were taken up especially by Marden in his series of
paintings, the *Annunciations*.

Again, to quote Bann's phrases which spoke to Joy,
"Perhaps these paintings most come to signify not simply a type of
iconography or particular formal theme, but the incarnation of spirit in a
material world."[7]

Joy found this analysis immensely important because it sug-
gested how he should proceed.
For me this seemed a way of working that was entirely within the context
in which Western painting had developed.

This way of thinking was an important lasting influence for Joy.

I was tremendously influenced by Marden's now famous statement: "The
rectangle, the plane, the structure, the picture are but sounding boards
for the spirit."

At this time, when the limitations of Greenberg's ways of think-
ing had become clear and Marden had become famous, critics were
offering quite different ways to understand his art. Jeremy Gilbert-
Rolfe, for example, in claiming that Marden was a radical materialist,
linked him with Karl Marx and Bertolt Brecht. Bann's essay marked,
then, an intervention in art criticism, a way of linking abstraction to
the traditions of sacred art. This way of thinking was also presented
by Joseph Masheck in his "Iconicity" essays published in *Artforum*.
Masheck, it is worth noting, put a Scully painting on the cover of
Artforum when he edited that influential journal in the late 1970s.
This parallel between Byzantine and early Renaissance spiritual art
and Modernist literal abstraction was not entirely original; it had
been presented very briefly already in Greenberg's *Art and Culture*.
In the end, neither Bann's nor Masheck's ways of understanding
abstraction inspired conviction. The concerns of art critics turned
elsewhere. And although Marden continues to have a splendid career,
later commentators such as Klaus Kertess have not pursued Bann's
line of thinking. Marden's own art changed dramatically in the early
1980s, in ways that severed this link with Byzantine painting. And Joy
himself, although he continues to admire Marden, now has become
more critical about this account of late Modernism. But these are
small contentious points of detail. Joy gained from this exhibition a
way of thinking about abstraction and spiritual values which remains
of lasting value. In 1981 Joy had a show at the Serpentine Gallery,
London.

A reviewer
thought that my work was Kafka-esque, though Kafka had nothing to do
with it. The pictures must have looked dark and grim. They were on deep
stretchers, black, blue-black, never in color, pretty extreme.

But thanks, in large part to this show, he got a prestigious fel-
lowship to study in Japan.

steve joy: his life in art
DAVID CARRIER

Joy's paintings do not employ calligraphy, and apart from the gold backgrounds he sometimes uses, they do not look particularly Japanese. But being in Japan was very important for him, for he learned the importance of ritual. What he discovered about the value of impersonality became important for him later when he became deeply fascinated with icon painting. And this stress on the value of impersonality was an especially important lesson for an artist who, early on, was much taken with Abstract Expressionism, for many artists in that tradition were centrally concerned with personal expression. Joy, it is worth recalling, was initially fascinated by Barnett Newman's impersonal form of Abstract Expressionism, not the painterly pictures of Willem de Kooning or Joan Mitchell, however much he admires them from a distance. He keeps his studio almost obsessively neat; it is not a paint-spattered workplace. Ritual is important in Japan, but it also matters in the West. For Catholics, for example, what matters is that the ceremony of the Mass be properly performed; they are not involved, as believers, with the merely personal concerns of the priest. Joy thinks of art-making in a similar way. This is important, for in our culture, unlike traditional Japan or the world of Eastern rite Christianity, the idea of art as personal expression is often taken for granted.

Living in Japan for a year was very exciting, but that country could not have been Joy's permanent home. And so, soon after returning to London, he moved to Norway, where he met and later married a Norwegian. In Norway Joy lived on the west coast on Viking Tysnes, a burial settlement, in a little wooden cottage on a fjord **for about a year, then I moved to Oslo where I was offered a job in the art academy in Trondheim.**

And so he was able to support himself.

As earlier in his life, Joy turned back onto himself.
In Norway, I was isolated from the mainstream contemporary art world and I immersed myself in art history, particularly the art history of pre-Renaissance and Renaissance painting. This would become a time of preparation for what would later turn into my own version of a European Grand Tour, I was not able to paint in Japan, but the experience of study there made me realize that I was completely a product of Western art education.

Now he was ready to incorporate the lessons learnt in his travels into his art.
I had rarely, if ever, drawn or tried to paint representationally and didn't know if I could draw or not, and certainly my use of painting materials was limited to whether or not it suited my concept. I was dissatisfied with the conceptualism of my work and this was the beginning of the 80s, when people were starting to paint again, i.e., Julian Schnabel whom I liked and admired in the face of the fact that no one else seemed to. This was also the emergence of Baselitz and other German painters, such as Kiefer. So I rented a big studio in Oslo and experimented for a year.

Equally important as these developments in contemporary painting were Joy's developing interests in the painters of the pre-Renaissance.
My painting from that time contains segments of images from Duccio, Giotto, and Piero della Francesca, among others. I was trying to find out if I had any traditional skills.

Piero della Francesca, *Annunciation* from the *Legend of the True Cross*, detail, c. 1450, fresco, Arezzo

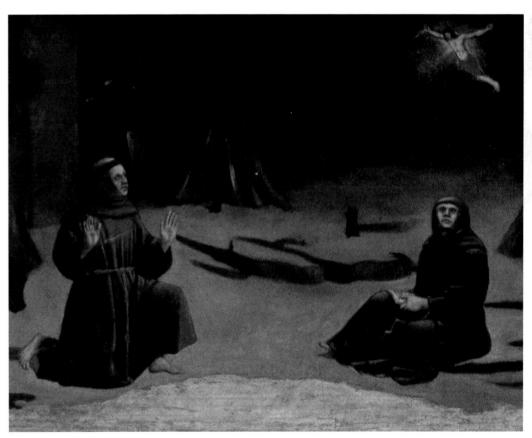

7 Ibid.

This teaching in Norway might have seemed an ideal situation. I made huge canvases, I tried to reinterpret the spirit of Giotto. I painted a shrouded woman rising from a fishing boat, straight from Giotto. They led up to the idea of a Grand Tour, they led me away from the concerns of the art world at the time.

Clearly it was time for a radical change, which required another move. As Joy has said:

for me the primary goal was to keep my life simple enough that I could always paint.

And so he moved to Italy, to an isolated town near Perugia:

I moved to where Piero had lived.

Here, as was not the case in Japan or Norway, he lived near the sources for his own art. Freed from the demands of teaching, Joy could focus on making art.

I packed a car, I moved there, I'd heard of a place that was for rent out in the mountains, it turned out to be a castle, Castello di Polgeto.

Although it was in an out-of-the-way place for an abstract painter, this site had great historical significance.

The area was a conscious choice, just a few miles from Citta de Castello. It was Piero that interested me, and Fra Angelico. I liked the restraint of color, I moved to an area where he and a lot of other painters had really evolved. You could see these pieces in churches.

And it was a great place for seeing art:

I had the good fortune to move to Italy when Piero's *Madonna del Parto* was still in a chapel. Now it's in a museum.

At this time, Joy painted *Living in the Abstract* (1988, see page 167). Giving up teaching proved to be liberating, both for his everyday life and for his art.

I lived in a seventeenth-century castle and painted in a simple barn, in the mountains of Umbria. It was wonderful to have the chance to work with complete freedom, and the life was direct and simple with great spiritual grounding both in the surrounding landscape, old monasteries and churches, and being able to see paintings by the great Renaissance painters of Italy with such ease.

After his experimentation in Norway, he wanted in paintings like *Living in the Abstract* and *Broken Vase* (1987, see pages 167 and 177).

to return to a way of painting which had more in common with my student work, that is to say, quite reductive forms, a simple geometry and with emphasis on the layering of paint and uniqueness of surface quality.

He now could respond directly to the incredible visual history found all around him. Working with olive groves surrounding the studio, Joy's concerns began to change.

Here I began to move away from the Marden/Ryman/Martin influences, wondering if it was possible to make a reductive, contemplative painting and then add images or references to this, almost destroying the painting by doing so, and yet just pulling it back to that fine line where it might work. At that time I didn't know if anyone was really trying to do this, and it really set the tone of my work for some years, certainly until I found that much later I was able to return to a purer form of abstraction and yet invest it with the power of content and subject matter.

And one Modernist Italian artist also then became important for him.

I was very influenced by the still lifes of Georgio Morandi, and especially by his simple, pure, and dedicated way of life and by his self-imposed isolation away from the influences of the art world at the time.

Broken Vase (1987) shows how much Joy was influenced by this Italian environment. In Italy Joy made some wonderful pictures and of course there was great painting to look at on his daily bicycling trips.

The painting *Burmese Days* (1997, see pages 116–117), represents the very first of the paintings that would lead to what I think of as my main body of work—the pieces that embody the history and tradition of icon painting. *Burmese Days* is a very simple painting both structurally and materially—the surface covering of beeswax, profoundly beautiful, veils, the leaf structures beneath. The veiling contributes to the feeling that this emanates, of reaching out, touching the spirit, and yet at the same time not giving all away fully.

Here Joy's art historical interests and his concern with abstraction all come together,

and the main focus of the work can be seen in, for example, *Icon Trinity* (2005, see page 48) and *Starry Night Rhone* (2005).

But he needed more stimuli. And so, after working in Italy for two years and traveling regularly to Belgium, in 1989 he moved to Spain.

steve joy: his life in art
DAVID CARRIER

At this time Joy started making a continuing series of what he calls word paintings, such as *Communication* (see page 128), *Matador*, and *Salvem Es Prat de Son Bon* (1988, see page 129). These paintings were influenced by Robert Motherwell (see page 106).

Generally, the work at this time was steadily in transition from the Italian period, my mind was already moving away from including images or visual references.

These works of art brought together his growing fascination with icons and his interest in Modernist abstraction. And they extended Joy's need for experimentation.

I liken them to, say, a classical guitarist who might once a month join a set with a jazz musician, keeping the technique going, perhaps having some fun, surprising oneself, and even using the knowledge gained technically in the main body of work at a later date. Or like a writer, taking time out to write a short story from the rigors of a novel. These unusual paintings of mine, perhaps like a short story to a novelist, are like guideposts to my heart, they are a more intimate sharing of my sources. This was the method by which I had hoped that my work might reach a wider audience. This would lead to the paintings I thought were closest to what I was trying to do. For example, *Timanfayo* and *Samarkand* (see pages 121 and 116).

In Spain, his lifestyle changed.

Until this time I was splitting my time between studios in Italy, New York, and Menorca in the Balearic isles. I would need the relative stability of the studio in Barcelona and especially the stimulus of other artists, particularly Sean Scully who lived across the hallway—and I would also need the stimulus of a major cultural center as Barcelona was. I had perhaps spent a little too much time in isolation from what was going on. There had to be some discipline and focus.

The painting *Communication* (see page 128), brings together these influences. The words came from a small piece of paper that he found on the street in Oslo.

It was a small child's writing, not making sense, but trying to form the words as they appeared in the head—not so different in many ways from the formation of an idea to the finished work in a painter's mind. I literally copied the text, enlarging it to fit the canvas, which itself contained many of the elements of my work from Italy, i.e., the panel within the panel or a smaller framed picture mounted onto a canvas—many complex layers of paint—and finally a complete coat of clear beeswax, which would later become very important.

The book *Byzantium: Faith and Power 1261–1557*, an exhibition catalogue from the Metropolitan in New York, has an essay "Images – Expressions of Faith and Power" by Annemarie Weyl Carr which perfectly illustrates Joy's ways of thinking at this time. Consider the account of what she calls "probably the single most striking aspect of the Late Byzantine icon":

"We have spoken of the growing importance of the panel painting, in number and scale, and watched the ways in which images played across their surfaces, often in responsive clusters that surprise our expectation of the icon as a single figure or image. Accompanying these is a third important development in the treatment of icons in the Late Byzantine centuries. One finds a self-referentiality in the images at this point that is new and full of import for the future."

In icons that show icons, she explains,

"The significance of the event is summed up not by the historical figures who accomplished it but in the great frontal icon that dominates the upper register, an icon as frontal as any saint, compelling the viewer's recognition and respect. To view the icon of the Feast of Orthodoxy is to acknowledge the icon within it, and so to acknowledge the validity of icons themselves."

In Barcelona Joy

first started making the wax and leaf paintings, like *Burmese Days* (1997, see page 116–117, silver red coated in beeswax), in the studio at the same time as *Communication* (1995, see page 128).

Now, finally, Joy was ready to move to Manhattan. In 1989, he lived and worked in New York, where he showed at the Ruth Siegel Gallery. His way of working was well established, and so he had a chance, finally, to be in the center of the contemporary art world. In moving to America, Joy followed his great friend Sean Scully.

Scully was born in 1945, seven years before Joy.[8] Around 1984, Joy and Scully became close friends, looking at art together and frequently traveling together. Part of their bond was their shared awareness of the central importance of Abstract Expressionism. And they shared a belief in the importance of art history. When many artists of the next generation rejected this way of thinking about history, Joy realized that he needed to defend it.

8 My full account of Scully is my *Sean Scully* (London: Thames and Hudson, 2003). I lift a paragraph describing his art from my "Marcel's Studio Visit with Elstir," *ArtUS* 9 (July–September 2005): 29–39.

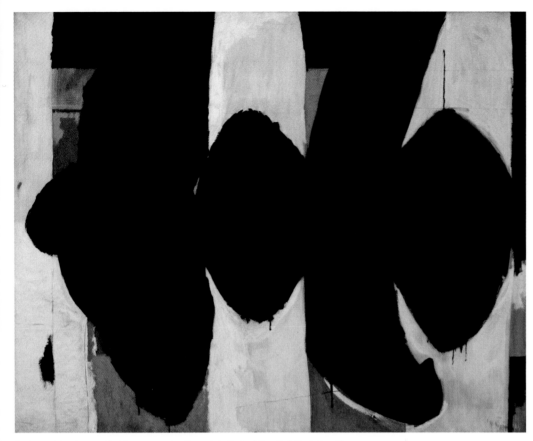

Robert Motherwell, *Elegy to the Spanish Rebublic*, 1953–54, oil on canvas, Albright-Knox Art Gallery, Buffalo (N.Y.)

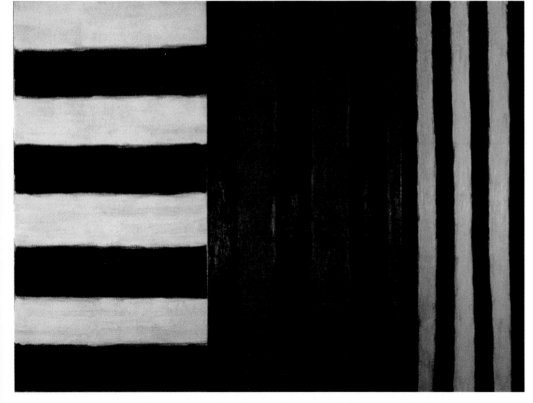

Sean Scully, Maesta, 1983, oil on linen, Smithsonian American Art Museum. Washington, DC

Like Joy, Scully had a long apprenticeship, breaking through only in 1981. For Joy, Scully was

always a huge influence and his formidable talent became a marker for what could be achieved with an abstract painting.

What then is most revealing is how very different Joy's art is from Scully's, even when it too makes use of stripes. Like Joy, Scully is fascinated by icons and early Renaissance art. His *Boris and Gleb* (1980) mimics the structure of a fourteenth-century icon, *Saints Boris and Gleb*. And his *Maesta* (1983) is an abstract version of Duccio's *Maestà* (1308–11). But although Scully's art sometimes alludes to such precedents, it has always been very explicitly attached to contemporary life. His paintings from the 1980s metaphorically employ the rhythms of everyday urban experience. The streets and office buildings are filled with repeated architectural forms and the forms of pop music. And so, as he explains:

The relationships that I see in the street in doorways, in windows between buildings, and the traces of structures that were once full of life, I take for my work. I use these colors and forms and put them together in a way that perhaps reminds you of something, though you're not sure what.

After seeing stripes standing for urban rhythms in Scully's art, we return to see streets and hear the music differently. In the 1990s Scully helped us interpret his art when he made photographs of Moroccan houses that look like his paintings. Seen literally, his paintings present abstract stripes. But viewed metaphorically, these images allude to the rhythms of urban life, and so suggest how to see our cities. His abstract art thus gains essential power from its attachment to urban life. Scully almost always has worked in or near cities. He needs city life, for his pictures frequently show urban conflicts. Joy, too, often uses stripes, but his concerns always are very different. He has mostly preferred working in isolated rural locations, or smaller cities like Omaha. And as Joy notes, he and Scully use their art historical sources in very different ways.

Most of my work of the last few years has kept within the strict limits imposed by available colors in leaf and varnishes and traditional Japanese inks.

In the 1970s Scully painted severe minimalist pictures, with narrow stripes, which commentators like Masheck readily linked to icons. But since 1981 he has usually worked in a different, much more sensual style. The titles of recent Scullys sometimes allude to sacred works, but for him the key influences are three Modernists: Matisse, Mondrian, Rothko. Joy, by contrast, continues to be much influenced

by the tradition of icon painting, though Joy himself certainly is not an ascetic personality.

Ever since its origin in the early twentieth century, abstract painting has very often been connected with spiritual experience. Kandinsky and Mondrian linked their painting with theosophical writings, and very often exhibitions of abstraction have associated it with religious ideals. For Joy this particular way of thinking has not been influential. But he does link his abstractions with the spiritual tradition of icon painting.

I've always been interested in and read deeply about the mysteries of the varnishing techniques of the great masters of musical instrument-making such as Stradivarius—and thinking of the nature of alchemy and the use of "substance" in painting, there are similar rules or, if you like, lack of rules as to how to achieve the magic of sound in a violin or a cello, to those mysterious formulas that when put together in the right way hit the right note with the viewer. Although I would say that painting, as with violin-making, a good deal of this mystique might accrue with the passing of time.

The discussion of "the studio as a kind of psychosis" in James Elkins' *What Painting Is* greatly interests Joy.

I agree that it is important to never forget how crazy painting is, and that in order to produce a piece, the artist has to spend time shut up with oils and solvents for long periods of time, etc. Elkins writes: "writers and composers are much closer to the finished product, their words and notes appear cleanly on page and there is no struggle forming the words A, B, and C. But painters have to work in a morass of stubborn substances."

But then Joy points to some ways in which his studio practice is different.

I would disagree with his interpretation of the work in progress. The struggle for me is in my mind before I approach the painting and the studio practice itself is often, though not always, a very clean and thought-out process. Again, this may be due to the passing of time and gaining of experience, but I've always regarded the studio as more of a laboratory of the mind than a working environment. And in this way, due to the amount of ritual and preparation in my work, I feel more aligned to the monks of Byzantine monasteries than to the working methods of the Abstract Expressionists.

Russian Icons from Tretyakov Gallery, published by Fundació Caixa, Catalunya, 2001, speaks to these concerns:

"The work itself unfolds like a sacramental liturgy, the preparation of the panel destined to receive the painting is compared to the altar where the divinity will be revealed. To choose the colors and to apply the gold leaf, etc., the artist crosses himself, prays and meditates. Thus, art is a true spiritual way by which man casts off his ego and allows himself to be filled with the affinity in an act of divine activity. Indeed, the work of any sacred office is a continuation of the act of creation."[9]

The icon, this book argues, presents universal ways of thinking which people from all religious traditions can understand. Joy thinks of his abstract paintings as also doing that.

Through the icon, there is an attempt to see the invisible, because the invisible is shown.

Here we find an anticipation of Joy's way of thinking. But how, it might be asked, is it possible to be an icon painter in the twenty-first century? Joy's answer to this question goes back to critical consideration

of the relatively primitive techniques of the early modern masters from Rothko, Barnett Newman, etc. It seems to me that not only have successive movements in the twentieth century by and large failed to incorporate much in the way of technical innovation, so also did they often glance over very important philosophical and historical issues in the never-ending requirement to always be at the cutting edge of intellectual developments.

Joy wants to rethink these issues from his early twenty-first-century perspective because he thinks that earlier artists passed too quickly over these concerns.

My desire is to reinvestigate, as I see it, the question of man's relation to spirituality whether in the form of conventional religion or personal meditation. It is still one of the central questions of our time.

Icons depict sacred subjects and are found, normally, in churches; they are not works of art, although sometimes they are displayed in museums. Hans Belting gives a very clear account of the development of art in this tradition of what he calls "the image before the era of art." For the icon maker,

"God's distance prohibits his presence in a painted representation, sensually comprehended.... Art becomes the sphere of the artist, who

9 Jean Hani, "Symology and Transcendence," *Russian Icons from Tretyakov Gallery* (Fundació Caixa, Catalunya, 2001), 43–44.

assumes control of the image....The surrender of the image to the beholder is tangibly expressed...in the emergence of art collections, in which pictures represent humanistic themes and the beauty of art."[10]

Or as this distinction between works of art and icons is made by the English composer John Tavener, whose music Joy admires greatly:

"A religious picture, however great, is an altogether different thing from a liturgical icon. One is of this world: it speaks of this world and leaves you in it....The icon addresses itself to human nature universally, to man's thirst for something beyond."[11]

But in some important ways, Joy's situation differs from Taverner's. Tavener, who converted to the Orthodox faith and moved to Greece, composes liturgical music. Ideally, he has said, his compositions would be performed in churches. Joy is painting for collectors and museums, not churches; and although he is deeply interested in religious tradition, he is not doing religious subjects. His paintings do not show saints—these abstract pictures are not icons. Although Joy would love to display his art in a very austere setting. A version of Rothko's chapel or, even, of Donald Judd's *Marfa*, this still would be a gallery, not a church. Why then does Joy think that his art can be linked with this Byzantine religious tradition? We may, if we wish, link the response to abstract paintings with sacred images.

In pure abstraction, you have to come up with something that draws people in, a spirit that I think is connected to surface, texture, material, through history there is a lot of painting with such forms. I've always tried to connect my work to these great materials, the ones that make people sympathetic to what the artist was trying to do.

But in obvious ways, the situation of any modern-day painter, whatever their personal beliefs, differs from that of an icon maker. Icons are not works of art. When Renaissance altarpieces are set in modern museums, there is an obvious strain, for these sacred pictures were not made as works of art.

In the 1970s some American painters became interested in Islamic patterns, which they appropriated for their own purposes. More recently, Philip Taaffe worked in a similar way. But these artists did not become Muslims. Nor did they study Islamic history or the history of decoration in a serious way. Finding these patterns attractive, they used them for their own purposes, in paintings that responded to the concerns of contemporary secular art. A generation earlier, similarly, when Barnett Newman did his *Stations of the Cross*, he used a traditional sacred motif to make a series of abstractions without really linking his pictures to Christian tradition. You could, I suppose, pray before them, but would feel strange because these paintings hang in the National Gallery, Washington, not a church. How then is Joy's use of the icon tradition any different?

An icon (we start with generalizations, which then will be refined) is a representation setting sacred figures against a gold background. Landscapes or interiors are presented only in minimal ways, with just enough details given for viewers to comprehend the story. Starting with Cimabue, what defines the history of European painting is progress in naturalism. Giotto makes possible Masaccio, who in turn prepares the way for Raphael: this, the story told by Giorgio Vasari's *Lives of the Painters, Sculptors, and Architects* (1550), is echoed by modern scholarship. And soon enough, then, the whole tradition becomes secularized when we get to Modernism. By contrast, icon painters do not aim for development. Rather, they reject naturalism because their goal is to make pictures that are distinctly not lifelike. Here, of course, they responded to the debates within the Orthodox Church about iconoclasm. Presented visually, Christ looks like a mere man. And so the icon maker must remind us that He truly is God Incarnate. The less an icon presents its sacred subject in a naturalistic way, the less confusing it will be for worshipers. Within the Western tradition, there was a gradual movement from primary concern with sacred scenes to the development of secular subjects: genre scenes, landscapes, and portraits. There was no equivalent movement within the Orthodox tradition.

In Western tradition, as described by Vasari and his successors, there is a premium on originality. A great artist distinguishes himself from his lesser contemporaries by his radical inventiveness. Icon painters, however, seek to be anonymous. This is why they do not sign their pictures. Icons, to put this contrast in dramatic suggestive terms, are really not works of art but artifacts used for liturgical purposes. The Western and Orthodox traditions were joined at the start of European art history, for Cimabue and Giotto learned from direct awareness of icons. But then as Western art developed, the traditions dramatically diverged. According to the older canonical account of Modernist painting, as developed by Greenberg, abstraction developed out of the naturalistic tradition by flattening the illusionistic picture space. But since Byzantine works of art were flat to start with, they looked similar to Abstract Expressionist paintings. As Greenberg noted in 1958,

steve joy: his life in art
DAVID CARRIER

"The Byzantines dematerialized firsthand reality by invoking a transcendent one. We seem to be doing something similar…insofar as we invoke the material against itself by insisting on its all-encompassing reality."[12]

This parallel, he concludes, is not ultimately revealing, for Byzantine sacred icons and Modernist painting are very different. Now if we look at a group of Joy's paintings, we find gold reflective panels, as in icons.

The recent *Icon* (*Trinity*) (2005, see page 48), for example, composed of four narrow vertical rectangles, some with stripes, others with gold or subdued colors, glows in the dark. And *Portrait of a Lady* (2005), with its five vertical rectangles, has a similar structure. Obviously these pictures, like Joy's early paintings, do not look much like icons. Here, emulating Ad Reinhardt, another painter who was interested in spiritual art, we might characterize Joy's works of art by noting what they do *not* contain. Unlike most of the Abstract Expressionists, Joy does not use painterly brushwork. As he has said, although he has looked with great pleasure

at the great Spanish painters, I was never influenced by them. I never used much brushstroke. In Spain I preferred little collections, such as in Barcelona, the Romanesque art in the Catalan National Museum.

For Joy the elements of abstract painting are basically pretty simple:

You had to be consciously working with the language, but often it was left too much to the audience, to ask them to accept that any mark on the canvas could be art. I was trying to be more specific.

Joy does not employ shaped canvases. His pictures are rectangles, for example, *Samurai Painting* (*Red Robe*) (2004, see page 64–65), Nor does he make monochromes. Joy always subdivides the canvas.

But in one significant way, Joy works like icon painters,

My paintings are less painted, kind of built. Elements of painting tend to be added at the end. The building of layers is laborious and I don't have a system. Pouring wax, shellacs, there are lots of technical issues that can go wrong.

And Joy wants his paintings to receive the kind of attention that traditionally has been given to icons.

Painting is an option that's wide open, wanting to contribute to society at a level of deeper meaning. I don't want my paintings to be seen in a purely secular way, but in relation to the question of the notion of God, what God may or may not be. The overwhelming question, my paintings

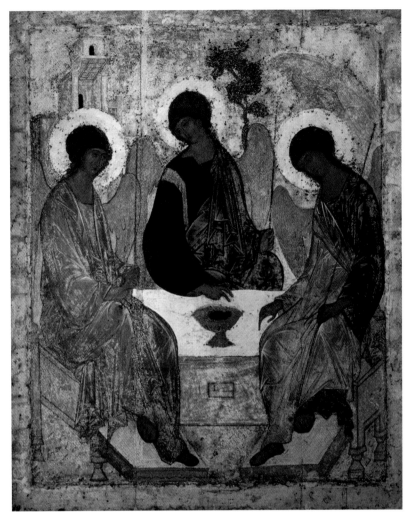

Andrei Rubelev, *Old Testament Trinity* (Holy Trinity), c. 1411, tempera on wood, Tretjakov Gallery, Moscow

are markers for that way of belief, like mediators, it's why I feel connected to icon painting, an icon really does represent God here on earth, not really intended like Renaissance painting to lead you to a concept of God.

Like icons, his paintings stand a little ways outside the everyday practical world. Describing them that way may make them seem like European pictures, which asks that we take an aesthetic distance. But for someone interested in icons, the situation is different.

10 Hans Belting, *Likeness and Presence. A History of the Image before the Era of Art*, trans. Edmund Jephcott (Chicago and London: University of Chicago Press, 1994), 15–16.

11 John Tavener, *The Music of Silence: A Composer's Testament* (London and New York: Faber & Faber, 1999), 113.

12 Clement Greenberg, *Art and Culture: Critical Essays* (Boston: Beacon, 1961), 169.

For Joy, it might be said, the sacred stands for the non-utilitarian. Consider, for example *Icon (Trinity)* (2005, see page 48). Joy, who feels a real shared interest with the picture makers of the Orthodox tradition, feels that our present-day focus on technology leaves out important values.

Without defining this notion of the spiritual, is there anything in life we don't understand that we're not supposed to understand that will leave us in a state of mystery or wonderment? Painting can do that.

Here we return to the interest in ritual he gained in Japan.

The discipline, dedication, humility, perseverance, and spiritual *gravitas* all being—to some degree, at least as far as one can without becoming a monk—qualities that are still important to me now. The series of paintings named after Samurai, *Samurai Painting (Red Robe)*, for example, were also very much about these principles.

Icons, he suggests, have a universal power, which is accessible even to people who are not believers and perhaps know nothing of this religious tradition. Joy's *Icon after Hodegetria* (2005), to cite one important example, is inspired by an icon.

Often if I go into a theme, I am trying to rework the intent and feeling. The thirteenth- and fourteenth-century artists worked in a similar way, with gold leaf, shellacs, and varnishes, covered in a final layer of beeswax.

In the past couple of decades, some aspects of the art world have turned from painting and other traditional art forms to art based upon technology. Very often painters have felt beleaguered. But Joy sees this change as a good development. And this means that painting is free to develop in comparative freedom. The fact that painting now is marginalized within the art world should, he thinks, be liberating. Awareness of this problem, the concern with the craft of art-making, has influenced Joy's concern with technique. He is interested in

medieval materials, mixed pigments, shellacs, varnishes, pure beeswax, gold leaf from Japan, oil-based inks. The conscientious effect is that the paintings give out light rather than soak it in. If you combine those Byzantine materials with oil paint, you get a huge contrast between reflection and absorption.

Icons, so the Orthodox theologian Leonid Ouspensky has explained,

"are intermediaries between the represented persons and the praying faithful, causing them to commune in grace. In a church during a liturgy, the faithful, through the intermediary of icons and liturgical prayers, enter into communion with the heavenly Church, forming with it a single whole."[13]

These sacred concerns are developed in many cultures. In many Cistercian churches in France, Joy notes, all that's left is the space, which thus retains its religious significance even without Christian decorations. Joy is fascinated by the idea of sacred spaces. An art gallery or museum is not a church but, so Joy says,

I'd like to see them as contemplative, sacred places, as they've been until recently. I am a little tired of the way art's become just another activity on the information ladder, another form of entertainment. I was thinking about the way you can go into a little Byzantine church in Greece, there's nothing left of the paintings but the wood support and the gold leaf, I'm intrigued, they still hold you spellbound. You don't need the whole image.

Although icons were made for the Orthodox Church, in some ways which are especially relevant to an abstract painter they can imply universally valid visual concerns. Consider, for example, *Portrait of a Lady* (2005) with its five vertical rectangles. How can abstract painting appeal to the larger public? Old Master painting mattered because it told stories. What equivalent attractions does abstract art have? In part, Joy appeals to the historical resilience of spiritual ways of thinking about painting.

What does last? We keep coming back to this element of spirituality.

When first I looked at Joy's paintings, they seemed eminently accessible. The stripes reminded me of Scully's, and I associated reflective colors of the gold backgrounds with any number of 1980s abstract artists. And so it took some time for me see how dazzlingly original is Joy's art. And how intellectually challenging it is. In contrasting the art created by Renaissance painters and icon makers, John Tavener writes:

"The one is the creation of someone's artistic talent, the other the reflection and flower of liturgical life. The one is of *this* world and that's where it leaves you. The other rises up from the deepest level at which everything in man is united."[14]

This distinction gives the key, as I see it, to Joy's art. I used an epigraph from Meyer Schapiro's "Abstract Painting" (1957) to explain the reason traveling was so important to Joy. Earlier in that essay Schapiro says something which nicely anticipates what, as it turned out, became Joy's goal. Painting and sculpture, he says

"offer to many an equivalent to what is regarded as part of religious life: a sincere and humble submission to a spiritual object, an experience

steve joy: his life in art
DAVID CARRIER

which is not given automatically, but requires preparation and purity of spirit."[15]

This, in one sentence, is what Steven Joy's art is about. We in the contemporary secular art world cannot return to the tradition of icon-making. And so, as I see it, only a long-term historical perspective shows us how to place Joy's art. The mainline Western tradition, the development of painting from Cimabue to Jackson Pollock, showed how to first secularize painting and then create abstraction. In a long development from around 1300 to 1950, artists discovered that they could replace the older subjects, saints and sacred scenes, with landscapes, still lifes, and genre scenes. And, then, they found that they could do purely abstract pictures, and still maintain the tradition. In this process, as Greenberg showed, it was possible to maintain the values of the tradition whilst the social context of art changed radically. Hans Belting indicates how dramatic was the change taking place in the early Renaissance:

"The image formerly had been assigned a special reality and taken literally as a visible manifestation of the sacred person. Now the image was…made subject to the general laws of nature…and so was assigned wholly to the realm of sense perception….It became a simulated window."[16]

Once that development took place, further radical changes were in the offing. Cimbue painted for churches, and Pollock for galleries and museums. When that happened, the visual qualities of the work of art changed very dramatically, for it was discovered that we could appreciate art purely aesthetically, detaching it from its sacred functions. But, still, there was enough continuity to speak of one artistic tradition.

While Western painting was thus modernized by radical innovation, Byzantine art was not. Today, as in Cimabue's time, icons are sacred artifacts. In part, no doubt, this radical divide between the histories of Eastern and Western art reflects the political realities. The fall of Constantinople to the Muslims in 1453, as the modern historian of Greece C. M. Woodhouse notes,

"is rightly chosen to mark the end of an era. For the city on the Bosporus was the one fixed point in the Empire, its physical heart and spiritual soul. While it survived, no one could call the Empire defunct."[17]

After 1453 the areas associated with the former Eastern empire became an intellectual backwater, the Orthodox Church surviving but the culture and the art world incapable of radical innovation. Today, indeed, you can see this history condensed in the National Gallery, Athens. After the fall of Constantinople, the curator Marina Lambraki-Plaka writes, some artists in Crete, which remained outside the Ottoman Empire,

"could paint either *alla Greca*, or *alla Latine*, that is in agreement with the western Renaissance style. Sometimes the two styles existed side by side."[18]

And of course one great painter, Dominikos Theotokopoulos, who in the West is called El Greco (1541–1614), moved from Crete to Italy and then Spain, becoming in the process a wonderfully exotic artist in the European tradition. But he is a very special case. When after 1832 an independent Greek state was created, ambitious artists traveled to Munich and Paris and produced art, including Orientalist pictures, very much in the Western tradition. Most of the pictures in the National Gallery, Athens, could, at first sight, be taken for paintings by Western artists. In the early twentieth century a few Greek artists tried to revitalize the Eastern tradition, drawing upon the concerns of icon painting, but for them, too, it had become too exotic to yield solid results. And, more recently, when Greeks painted abstractly, they did so in a manner borrowed from France and the United States.

13 Leonid Ouspensky, *Theology of the Icon* (Crestwood, NY: St. Vladimir's Seminary Press, 1978), 168.
14 Tavener, 56.
15 Schapiro, 217–18.
16 Belting, 471.
17 C. M. Woodhouse, *Modern Greece: A Short History* (London: Faber & Faber, 1998), 97.
18 Marina Lambraki-Plaka, *National Gallery. Alexandros Soutzon Museum. Four Centuries of Greek Painting* (Athens: National Gallery and Alexandros Soutzos Museum, 2000), 46.

Here I apply to Joy's painting ways of thinking developed in my forthcoming study of world art history. What I argue, to simplify an elaborate analysis, is that we need to present the timelines on which the various artistic traditions develop, and then understand what happens when one tradition influences another. So, for example, if we present the development of European art on this line,

Cimabue Masaccio Pollock

then the story of art in China takes place on another, mostly parallel line, influenced by the West only starting in the seventeenth century. A timeline is very useful because it marks out, left to right, the development of an artistic tradition.

One part of this analysis is of particular relevance to Joy, the contrast between the ongoing development of Western European painting, and the tradition of icon-making associated with the Eastern Church, which was effectively marginalized when in 1453 the Muslims conquered Constantinople. Icons continued to be made, but because the power of the Orthodox Church was so dramatically undercut, that development was much less vigorous than in the West. If the tradition of icon-making then became relatively static, that was not just because the Eastern artists were not interested in development, but also because the difficult political position of the Orthodox Church made its patronage relatively unimportant. Under Muslim rule, the Eastern rite Christians had often to struggle to survive. Not until 1823 did Greece become an independent country.

Scully's abstractions develop out of a long Western tradition, whose power he has acknowledged. This, then, is his timeline:

Cimabue Piero Matisse Scully

If Joy's use of the icon tradition for abstract painting is, by contrast, relatively difficult to understand, that is in effect because after 1453 the Eastern tradition becomes weakened. This, then, is his timeline, with the break between the old icons and his abstract paintings:

Icons 1453 1823 Joy

Originally these two timelines were linked, with Cimabue and his immediate successors learning from icon painting. But after 1453, they in effect became separate traditions. It is important, of course,

not to describe this complex history of Joy's development in an overly intellectual way. He is a painter, not an art historian. Only after the fact can we understand how and why he developed.

Is it inherent in the nature of icon painting for this art form to develop? That question is impossible to answer. Had Constantinople not fallen, who knows whether Eastern art might have developed its own Masaccio, Piero, and Constable, equivalents to the great figures of the Western tradition. All we can say is that because of these broad historical differences between East and West, Western art developed, while the Eastern tradition did not. Joy's real achievement, then, is to aestheticize the ways of thinking associated with icon painting, extending that sacred tradition into a modern secular world. In his art, in a grand historical leap, we move from the religious world of icons to a form of abstract painting which, indebted as it is to Abstract Expressionism, extends this Eastern tradition. Tavener describes himself as an Orthodox composer who happened, by accident, to be born in England. Joy, one might say, is someone similar, an icon painter who happened also to be born in England. Obviously no one artist can extend or revive an entire tradition. But Joy's good fortune was to become a painter when, as Greenberg explains, the Western tradition of abstraction had converged, in an independent way, with the Byzantine visual culture. Moving westwards from Europe to New York City and Omaha, he landed in the Eastern world of icon painting.

In his very beautiful book, *The Light of Early Italian Painting*, Paul Hills links the origins of Renaissance painting to the light of central Italy:

"Between 1250 and 1430 Italian artists rediscovered pictorial space and pictorial light.... Light is as necessary to vision as breathing is to life; yet, just as for much of the time we are unaware of our breathing, so we do not always attend to the light by which we see.... We should consider how light impinges upon consciousness."[19]

Joy too is fascinated with light, and the way it links visual art to a setting.

I don't want fixed light. That goes back to the idea of the paintings being objects of veneration. I feel differently looking at my paintings in the morning than in the evening. I love the Byzantine churches where the paintings are practically in the dark.

Interestingly, Tavener also talks about visual art and light:

"The icon is there in front of you and you can see it, comforting and clear,

steve joy: his life in art
DAVID CARRIER

day and night. Whether your eyes are open or shut, you do not lose the presence of the uncreated light."[20]

Part of Joy's present attachment to Nebraska comes from the light he finds there:

The question of light is an interestingly personal one. Nebraska some days is not so different from Greece.

For a painter, the light associated with a place is essential, for it reveals what kind of art can be made there.

I'd always chosen places according to how beautiful they were, I drove out to the four corners of Nebraska, pretty wild there, struck by the Sand Hills, I was reminded of the Mediterranean, long beautiful roads, as you came over every hill you expected to see the ocean. The light made you feel you were near the ocean. In a curious way it satisfied the craving of light I grew up with.

Travel can sometimes yield very strange results, for in trying to get to one place we arrive at another. But in the end, as Joy says:

my paintings are fundamentally simple.

And so we need to understand his travels in simple ways.

My goal, what I'd set out to do, was make a painting that could put someone in a certain time or place or mood or feeling, without illustrating it, without physically traveling to that place.

Here, for now, is a point of resolution:

It's taken me a long time to get there, but I now find myself in a position where I could make these paintings infinitely for the rest of my life.

This happy ending-point shows that Joy's long journey was eminently worthwhile.

19 Paul Hills, *The Light of Early Italian Painting* (New Haven and London: 1987), 3–4.
20 Tavener, 118.

1998–1993

france

spain

norway

india

Burmese Days, 1997 oil, gold leaf and wax over wood
180×188 cm, 70×74", private collection, Zurich, Switzerland

Amelia, 1996 oil, wax, and leaf on canvas over wood
180×188 cm, 70×74", Erich Storrer Gallery, Zurich, Switzerland

Noonan, 1996 oil, acrylic, gold leaf, and beeswax on canvas over wood
195×228 cm, 77×90", private collection, Switzerland

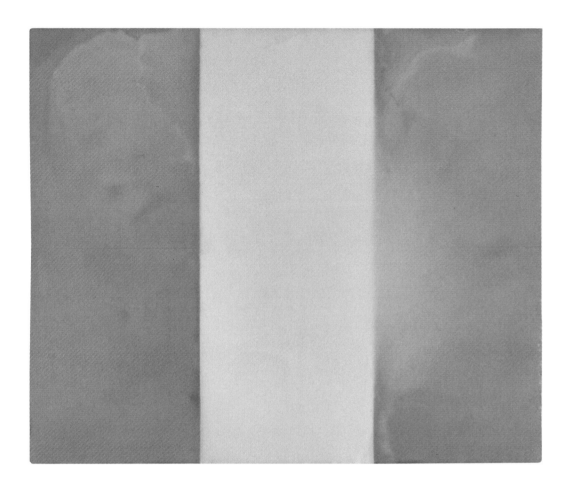

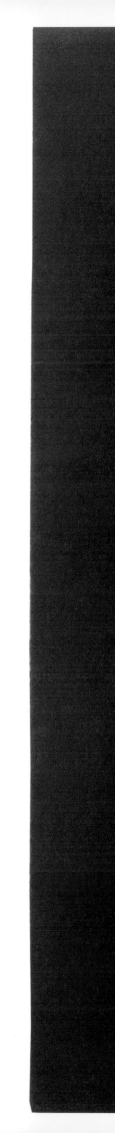

Timanfayo, 1997 oil and wax on wood and canvas
61 × 81 cm, 24 × 32", private collection, Oslo, Norway

Samarkand, 1996 oil and wax on canvas
192 × 192 cm, 75 1/2 × 75 1/2", private collection, Switzerland

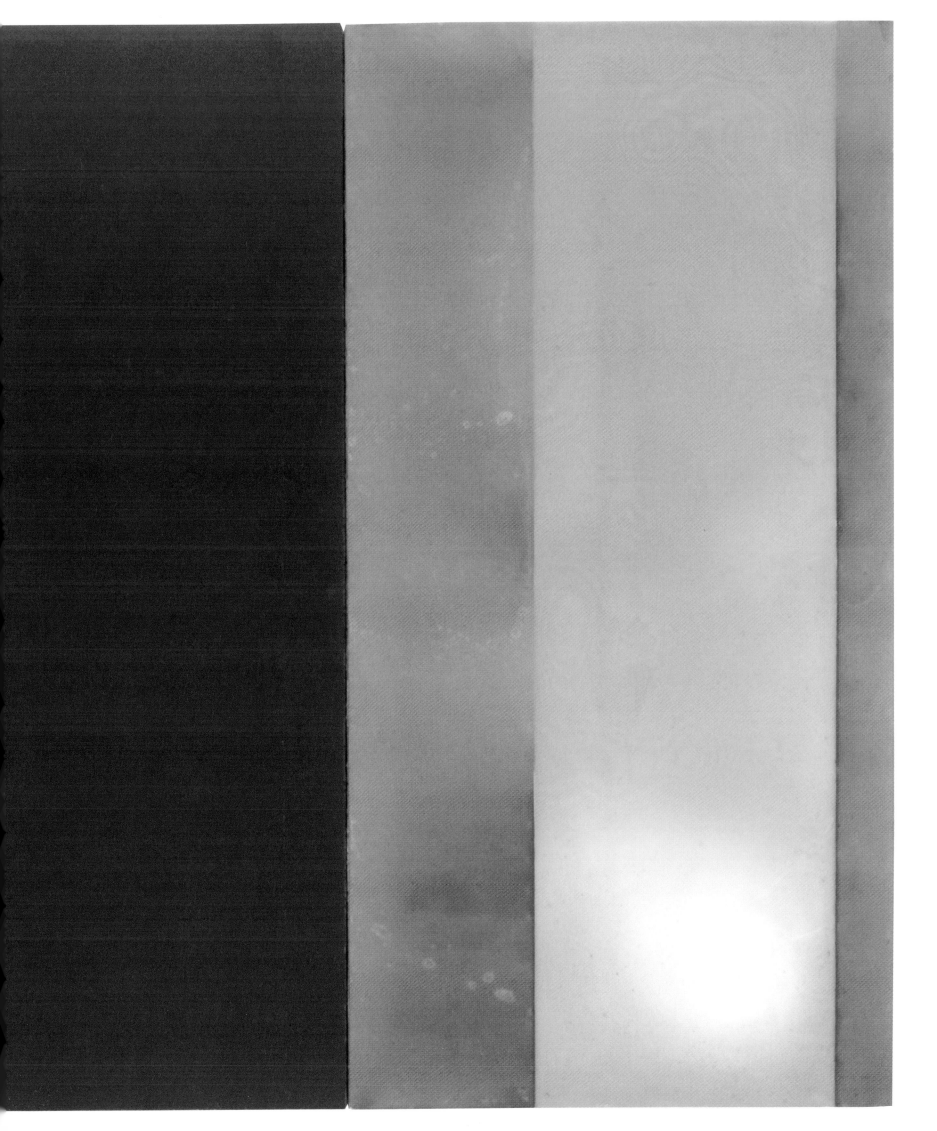

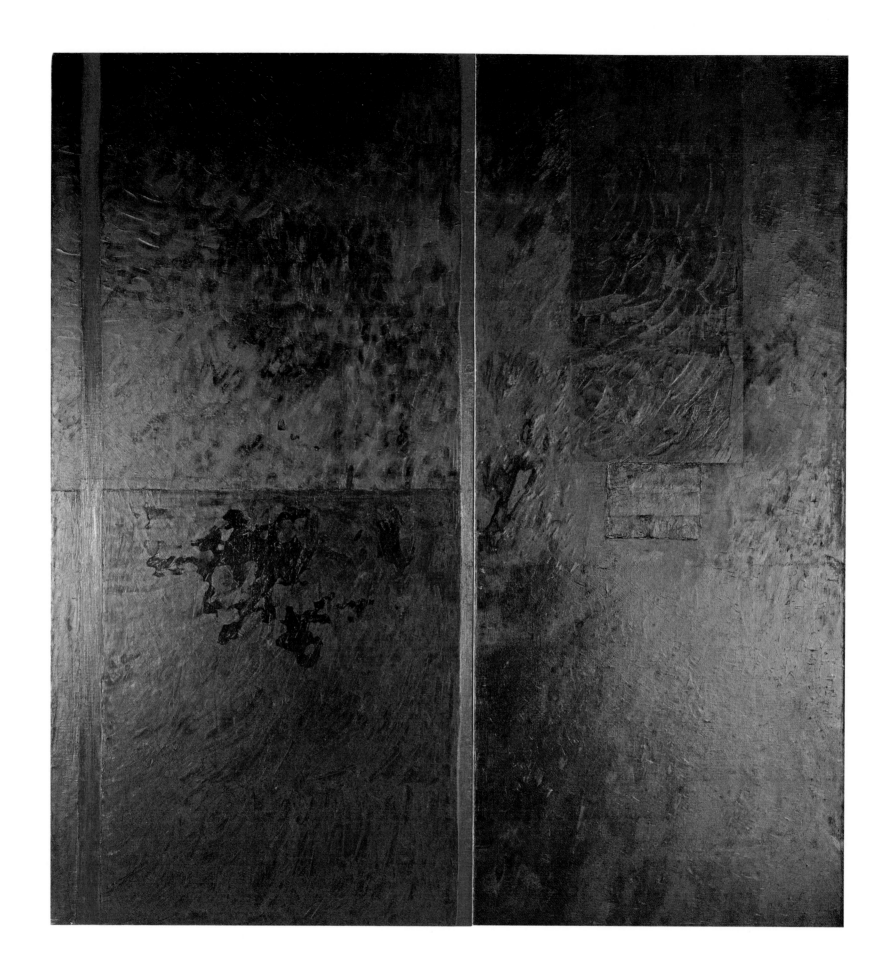

Zone, 1996 mixed media on wood
178 × 185 cm, 70 × 73", private collection, Switzerland

India, 1996 oil and beeswax on wood
180×188 cm, 70×74", private collection, Zurich, Switzerland

123

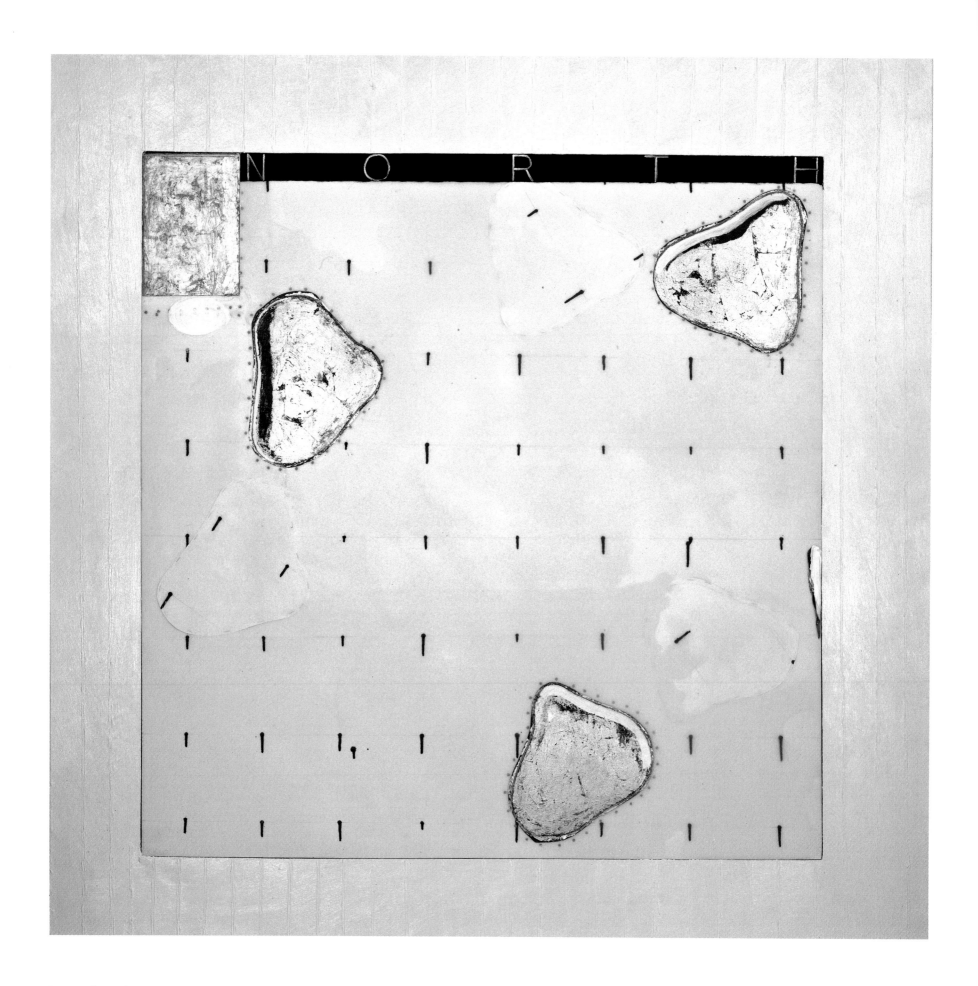

124 **Journey (North), 1996** oil, wax, gold and silver leaf on canvas over wood
180×184 cm, 70×72 ¹/₂", private collection, Zurich, Switzerland

Salvem II, 1995 oil and wax on wood
117×86 cm, 46×34", private collection, Zurich, Switzerland

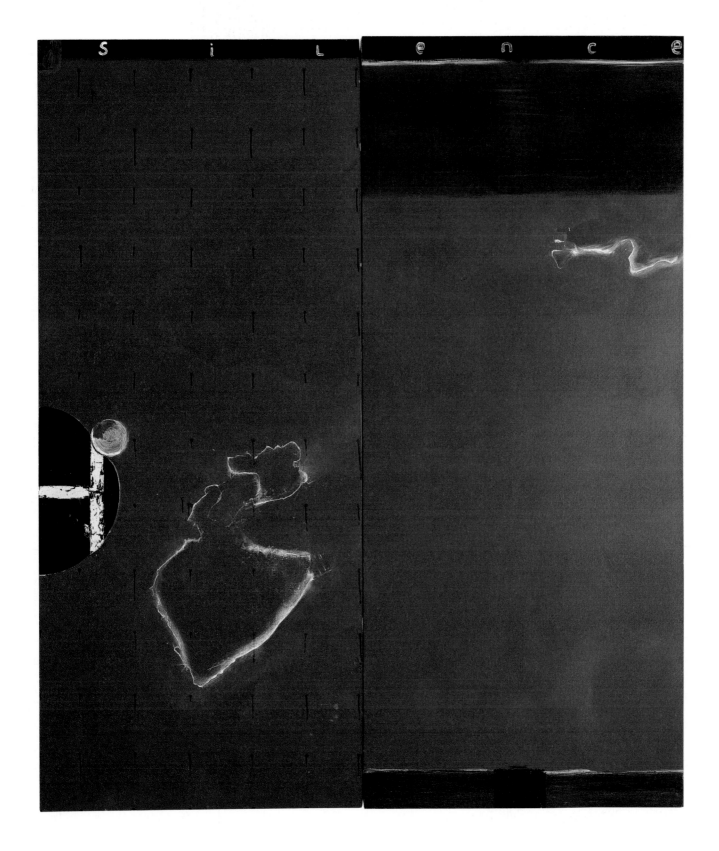

Silence, 1995 oil and wax on linen over wood
233×200 cm, 91 ¹/2×78 ¹/2", collection of the artist

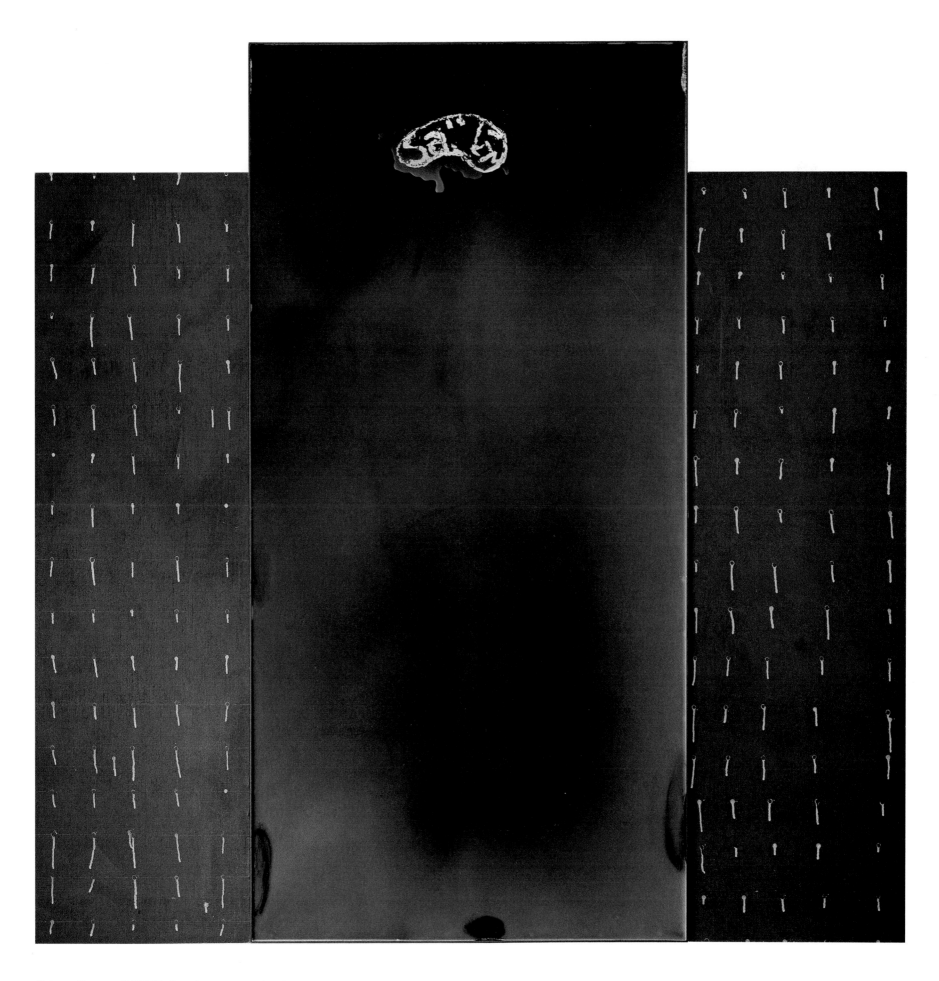

Salvem (Leonard), 1995 oil and wax on wood and canvas
240×250 cm, 92×108", collection of the artist

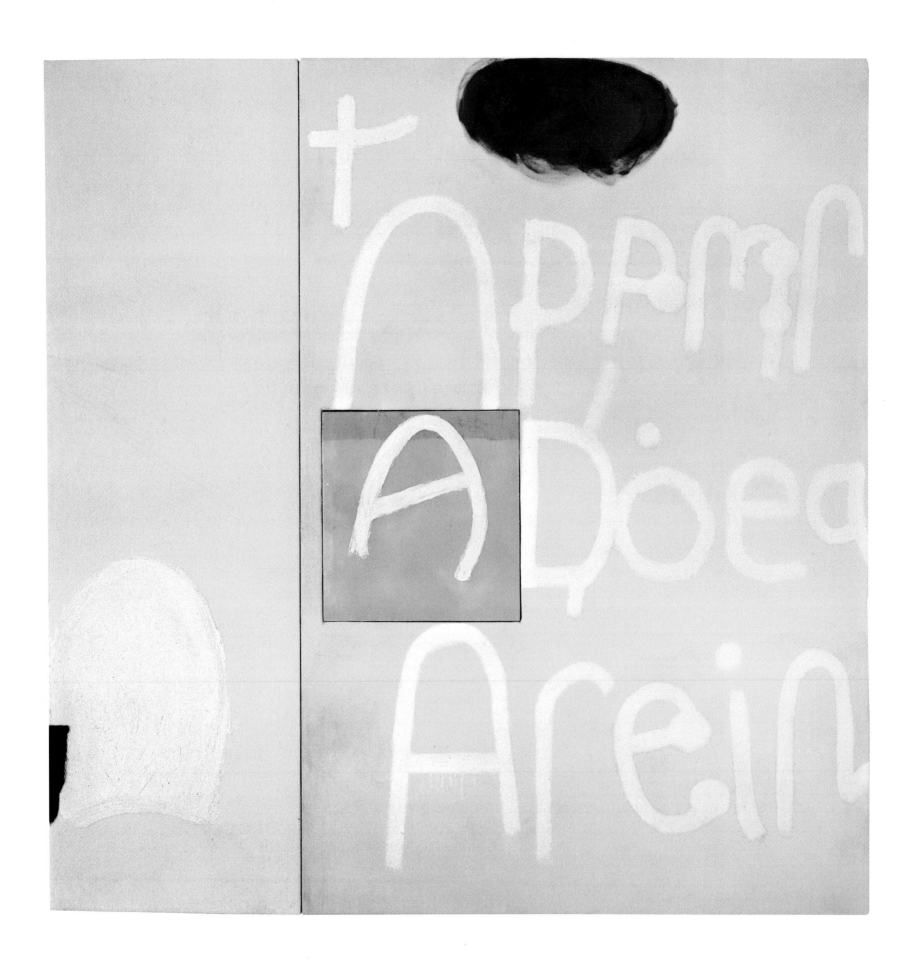

128 **Communication, 1995** oil and wax on linen over wood
179 × 177 cm, 70 1/2 × 69 1/2", private collection, Charlotte, NC, USA

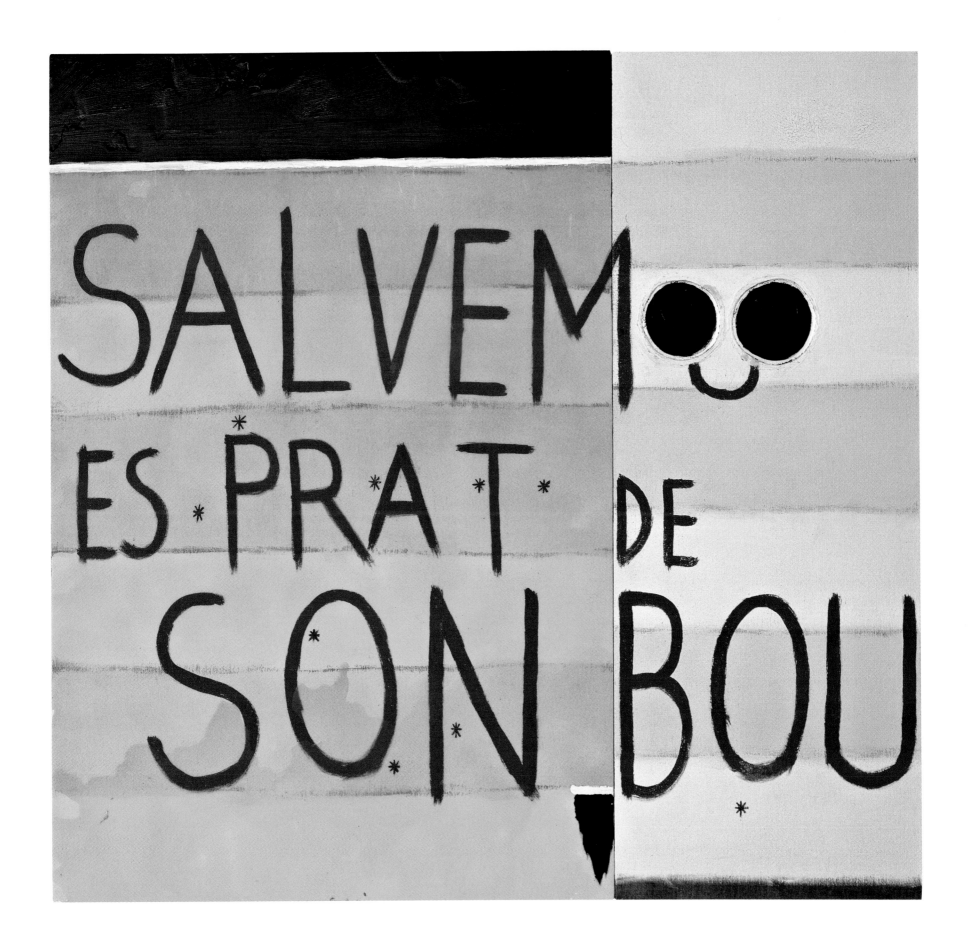

Salvem Es Prat de Son Bon, 1995 oil and wax on canvas over wood
178×190 cm, 70×75", Erich Storrer Gallery, Zurich, Switzerland

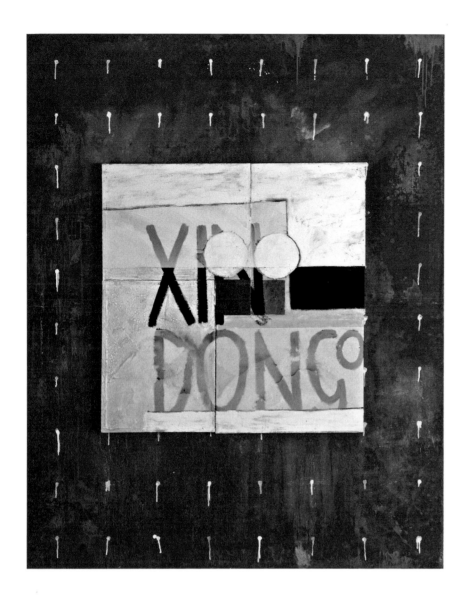

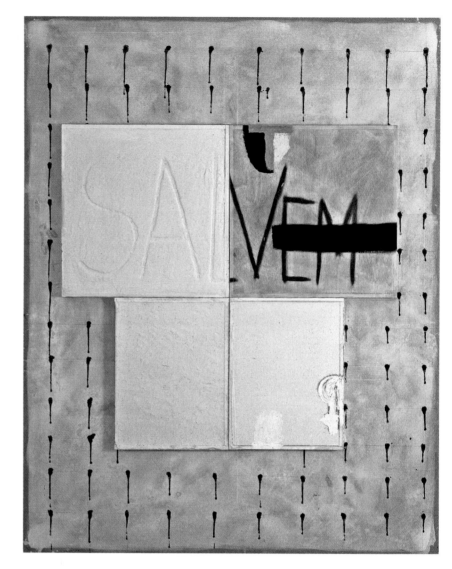

Xin Dongo, 1993 oil, plaster, and wax on wood panels and canvas
200 × 160 cm, 79 × 63", private collection, Switzerland

Salvem, 1993 oil, plaster, and wax on wood panels and canvas
200 × 160 cm, 79 × 63", private collection, Zurich, Switzerland

Genie, 1993 oil, plaster, beeswax, and wax on wood panels and canvas
200 × 160 cm, 79 × 63", private collection, Switzerland

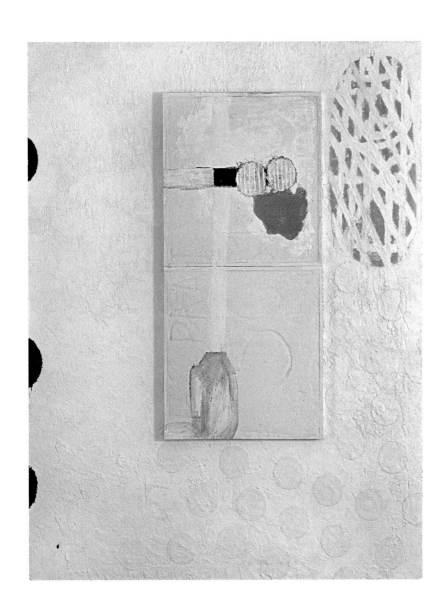

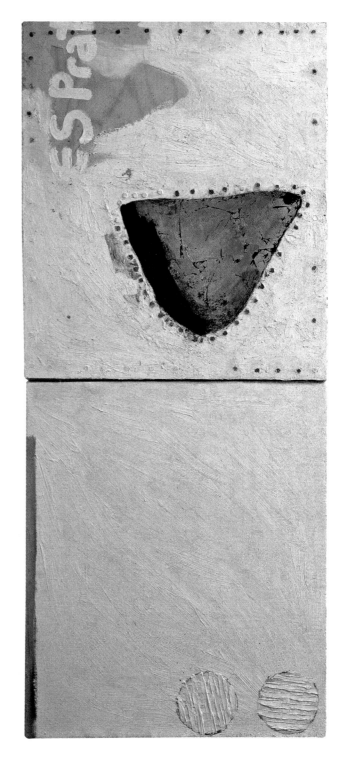

Es Prat (Salvem), 1994 oil on wood
101 × 44 cm, 40 × 17", private collection, Switzerland

131

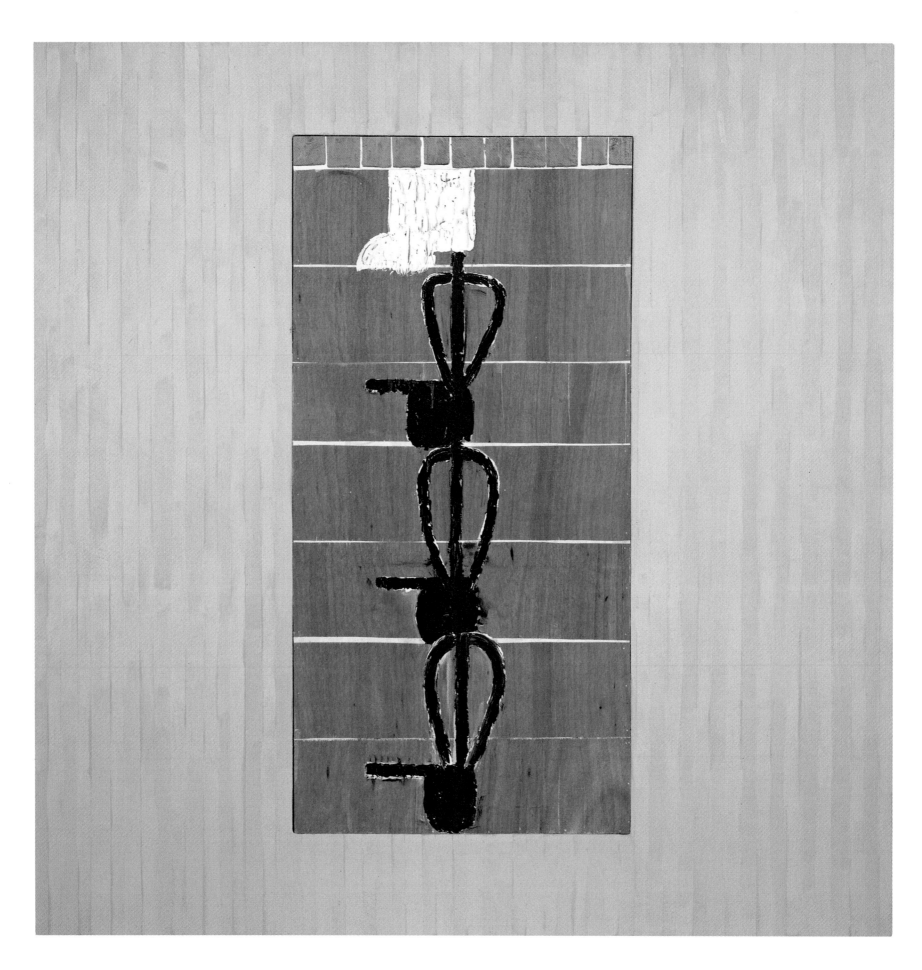

Lake Palace "Udaipur," 1994 oil and wood on canvas
182 × 181 cm, 71 1/2 × 71, private collection, Zurich, Switzerland

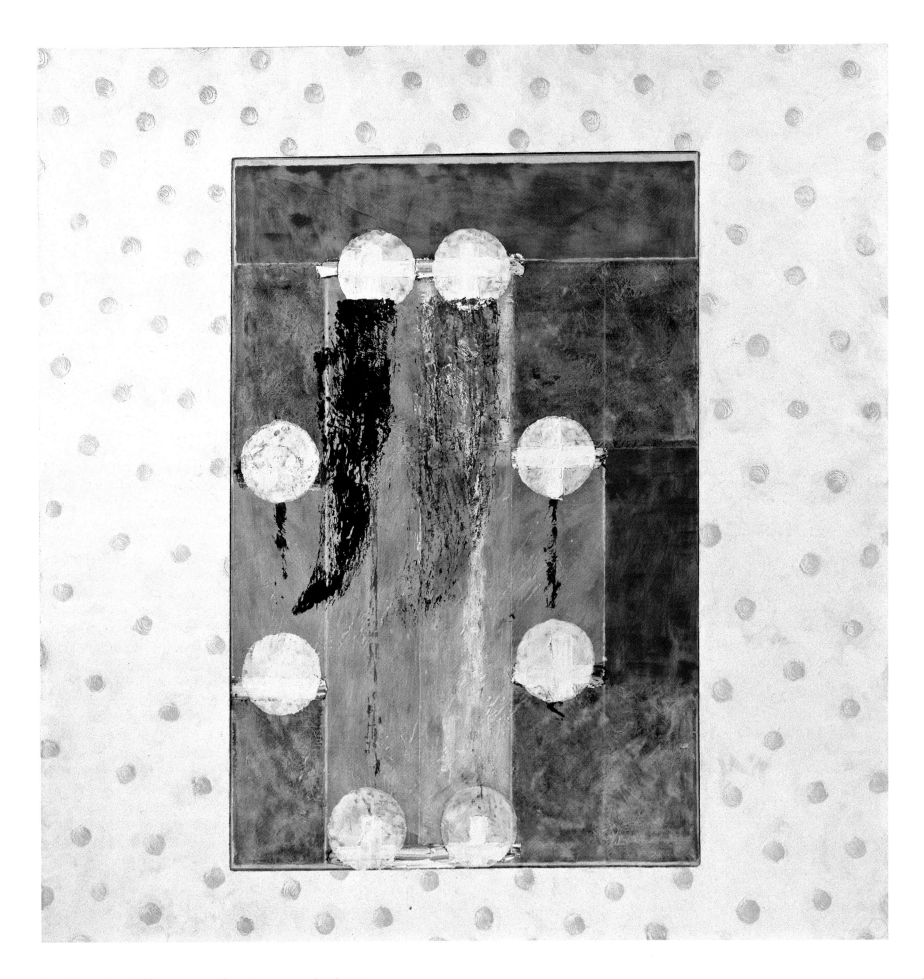

Hotel des Indes, 1993 oil, wax, and fibreglass on wood and canvas
200 × 200 cm, 78 1/2 × 78 1/2", Erich Storrer Gallery, Zurich, Switzerland

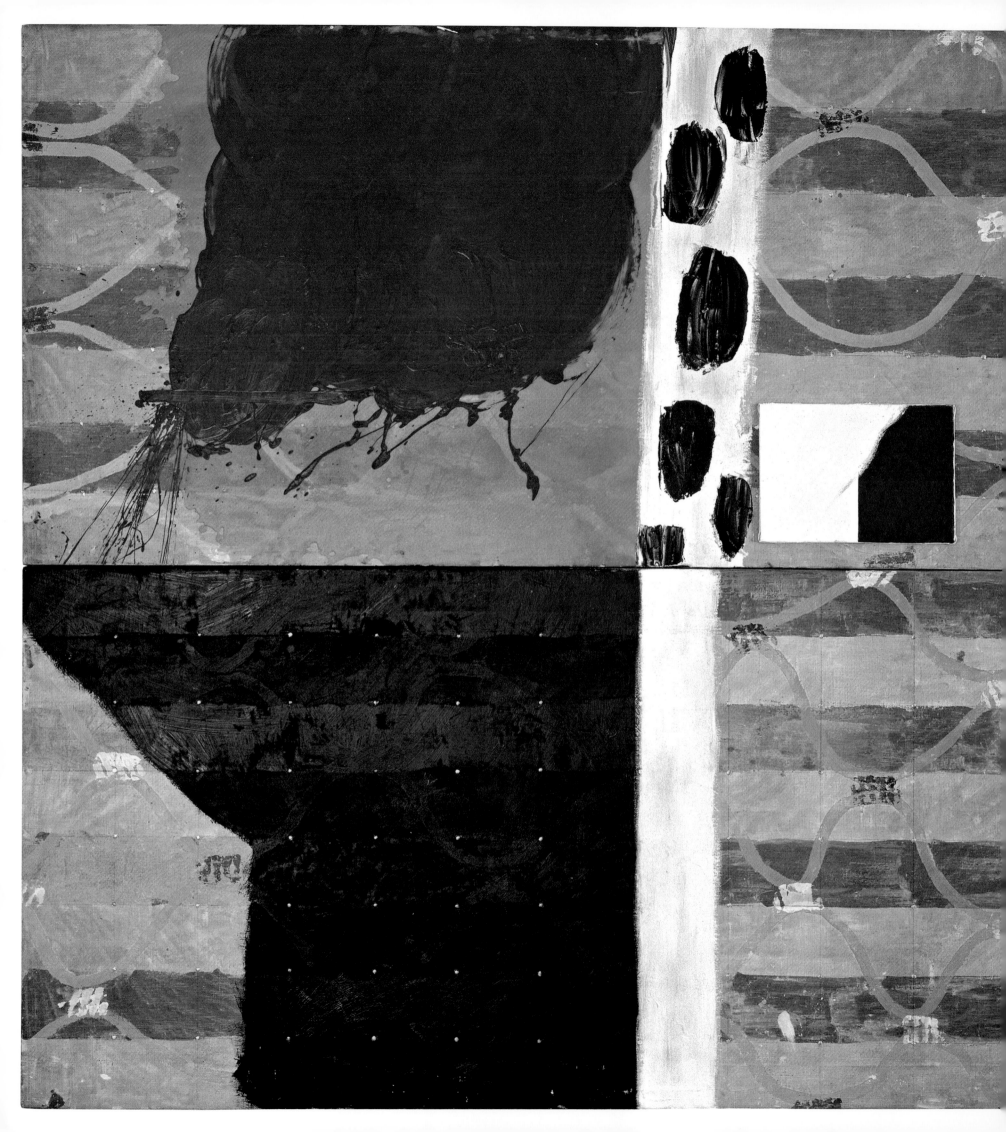

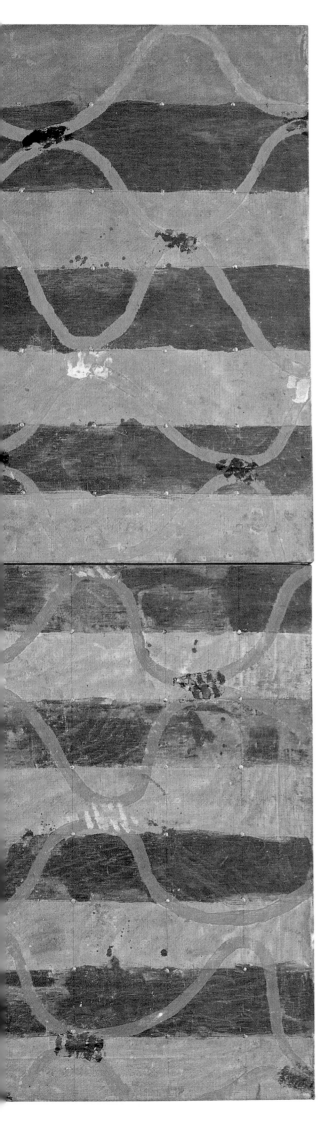

Generalitad, 1993 wax and oil on canvas over wood
188×237 cm, 74×93", private collection, Switzerland

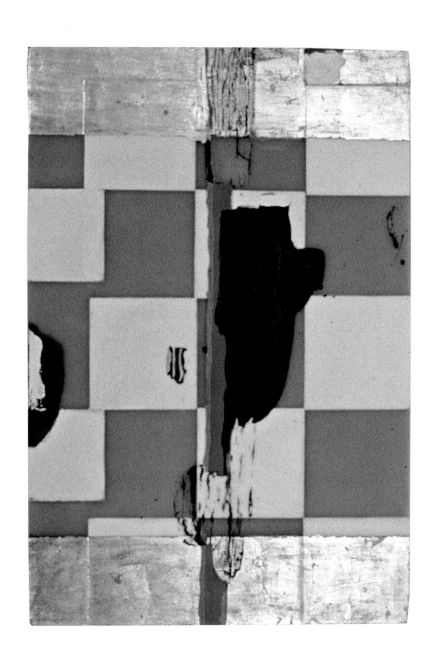

Stabat Mater, 1992 mixed media and wax on wood
69 × 48 cm, 27 × 19", private collection, Polgeto, Italy

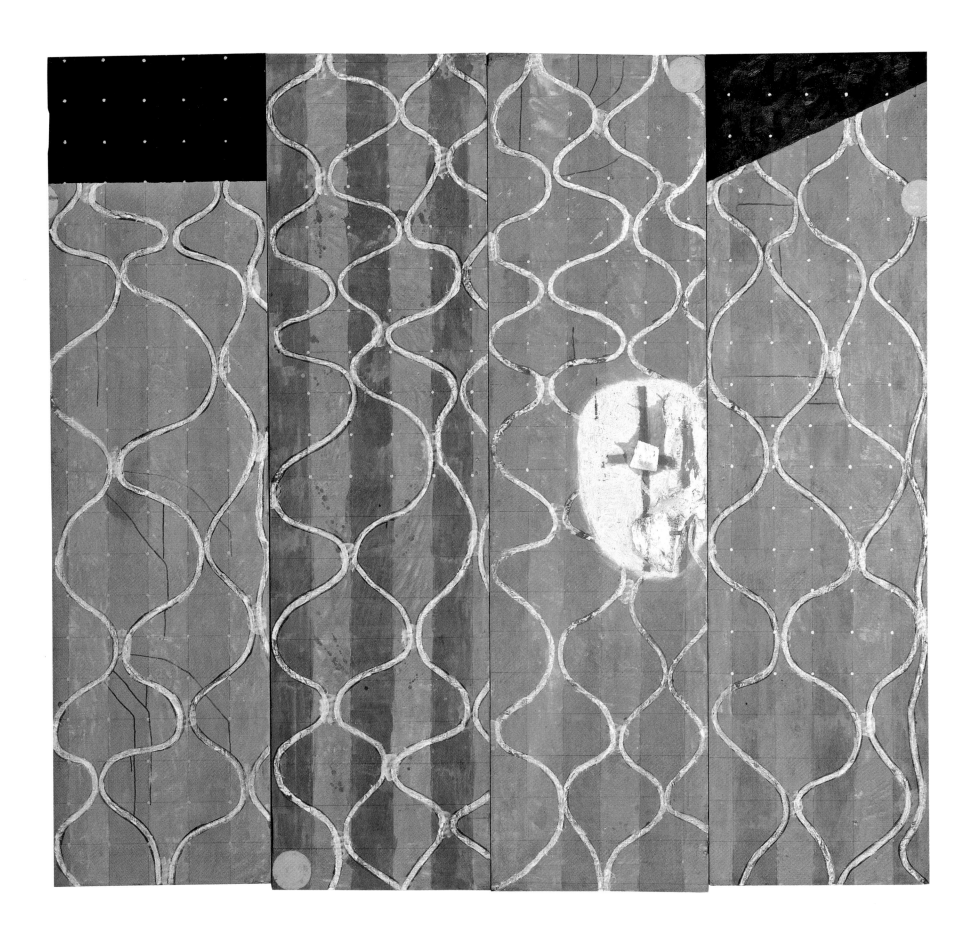

Night Sky (Tunisia), 1992 oil, wax, gold leaf, and acrylic on canvas on wood
236×257 cm, 93×101", private collection, Schaffhausen, Switzerland

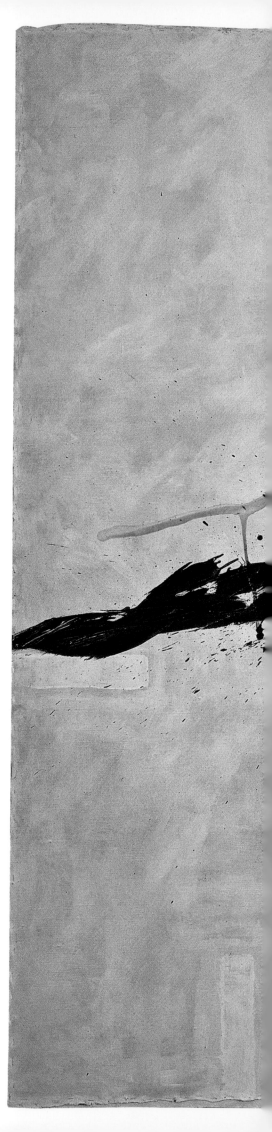

138 **Last Days of the Raj, 1992** oil and wood on canvas
220 × 178 cm, 86 ¹/2 × 70", private collection, Zurich, Switzerland

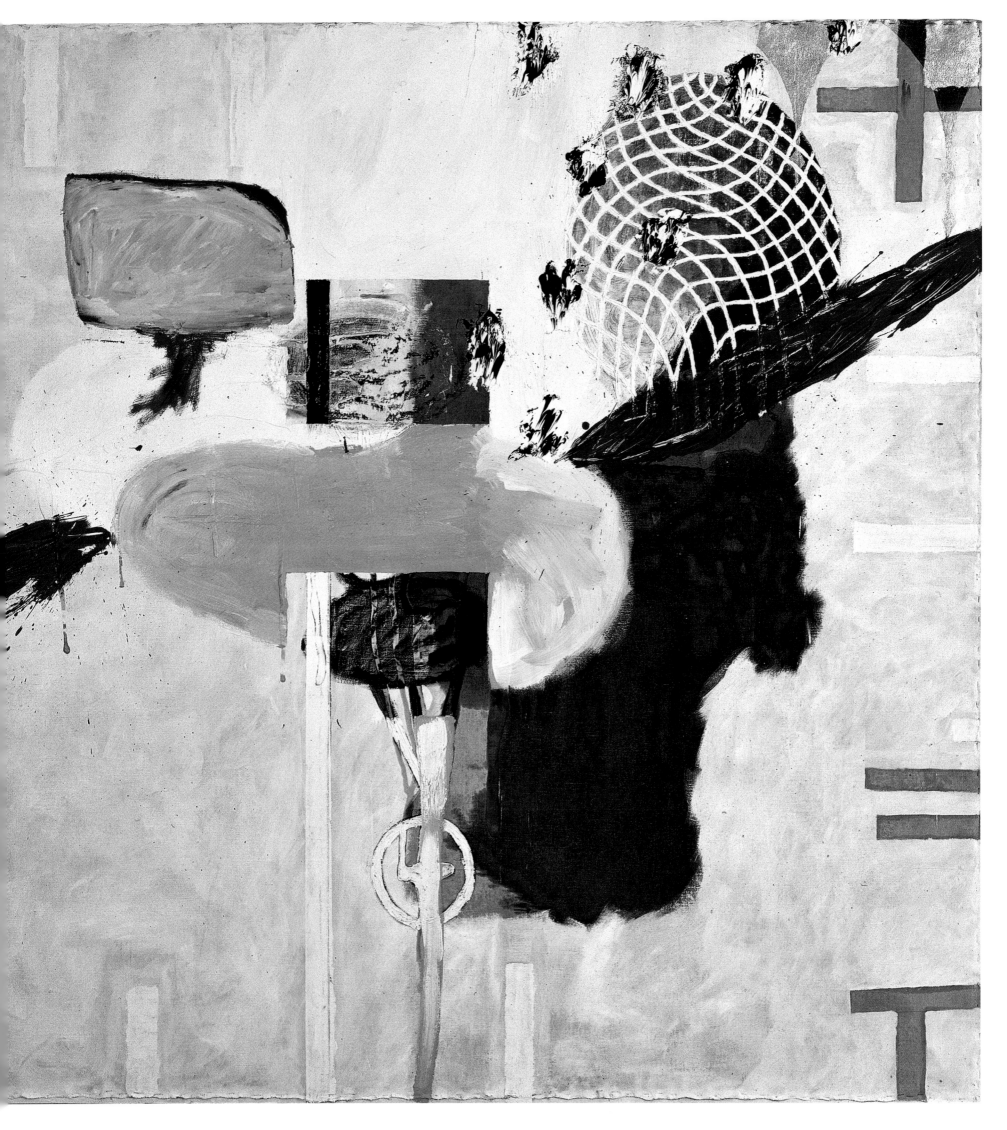

1993–1989

new york

belgium

142 **Tiger Hunt, 1989** gold leaf, oil, acrylic, and beeswax on fibreglass on paper
56×76 cm, 22×30", private collection, Zurich, Switzerland

Dinner Service, Raffles Hotel, 1991 mixed media on fiberglass on paper
76×56 cm, 30×22", private collection, Germany

"Dinner Service" (Hotel Raffles - Singapore) Plowfong '91

Goth, 1989 oil and acrylic on canvas
235 × 195 cm, 92 ¹/₂ × 76 ¹/₂", private collection, Zurich, Switzerland

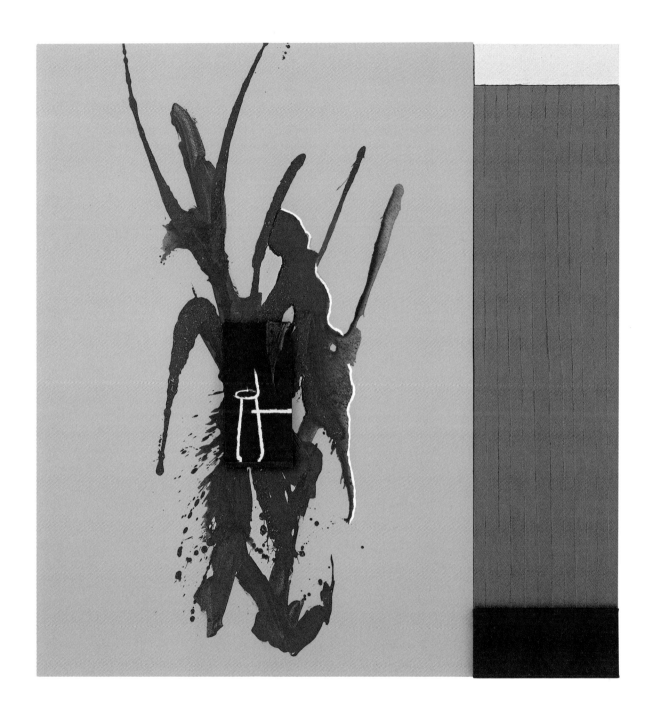

Lizard Point, 1990 oil on canvas
213×203 cm, 84×80", New York Public Library, New York, USA

146 **Passion, 1990** oil on wood, velvet, and canvas
152 × 213 cm, 60 × 84", New York Public Library,
New York, USA

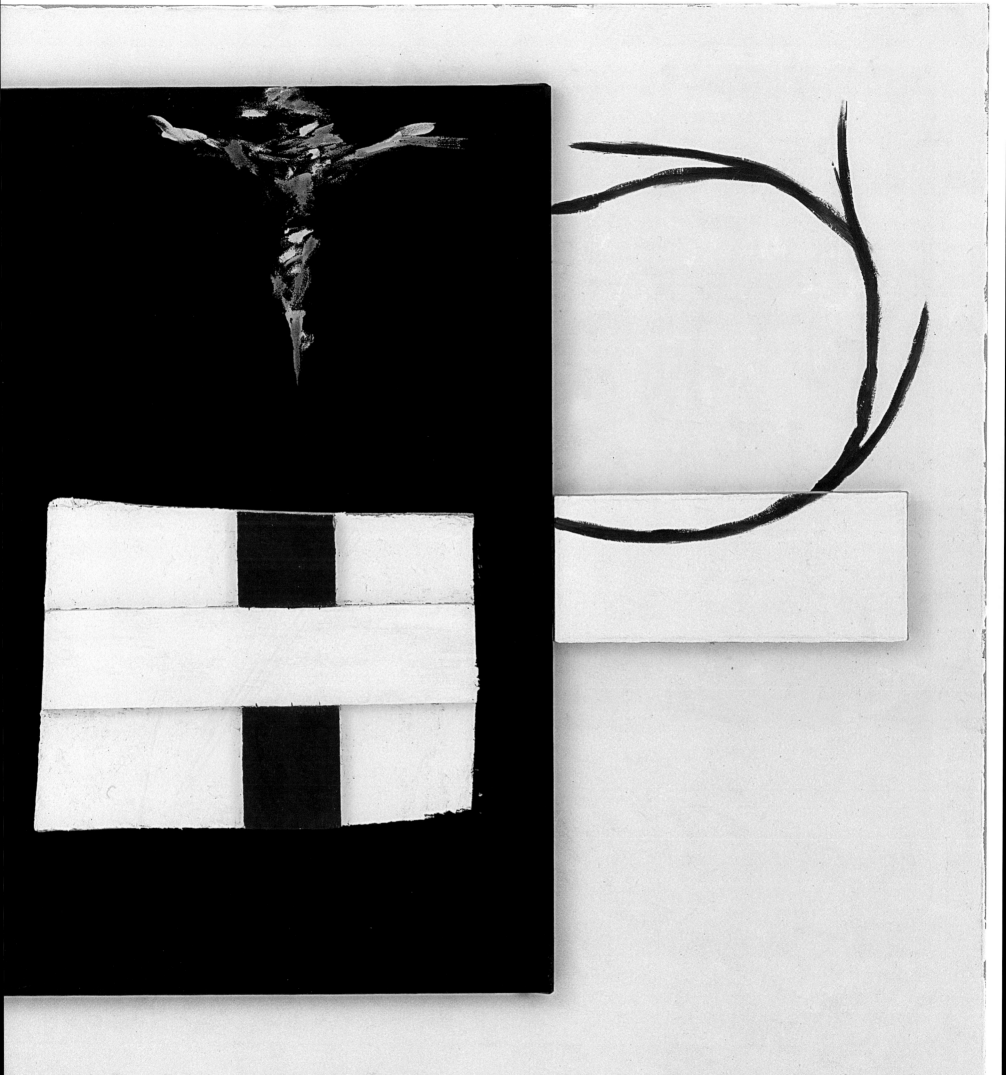

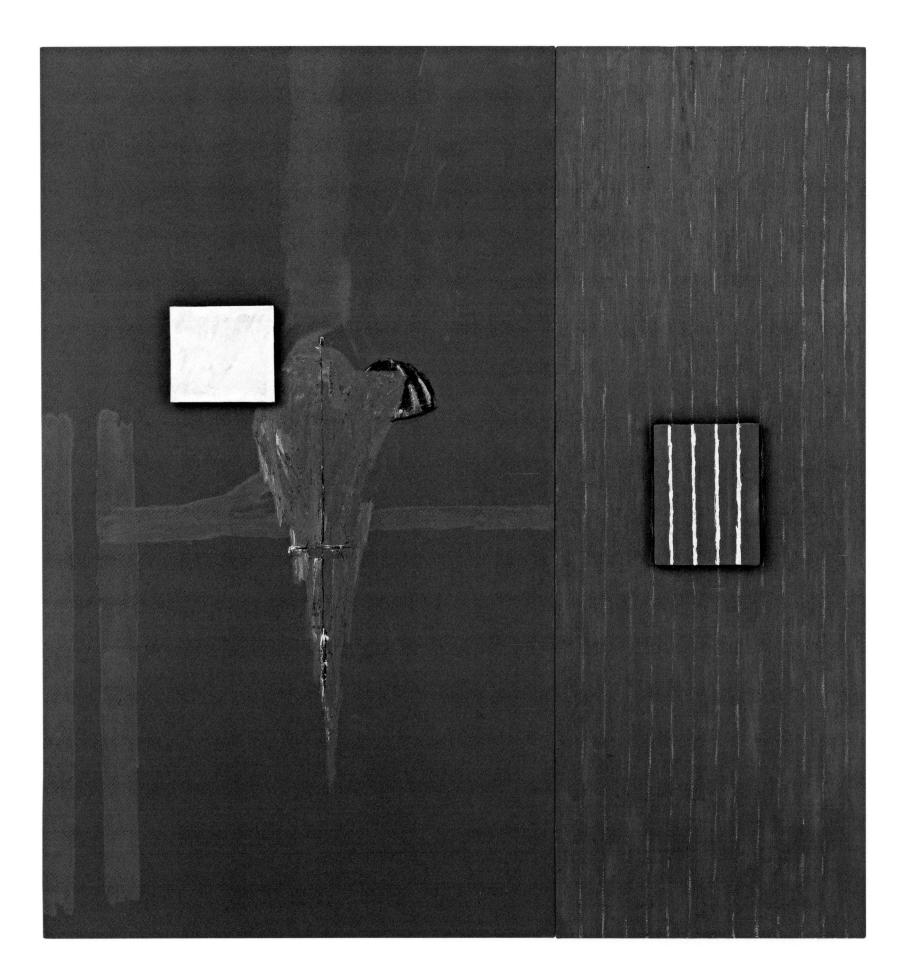

Back to School, 1990 oil on canvas
213×203 cm, 84×80", New York Public Library, New York, USA

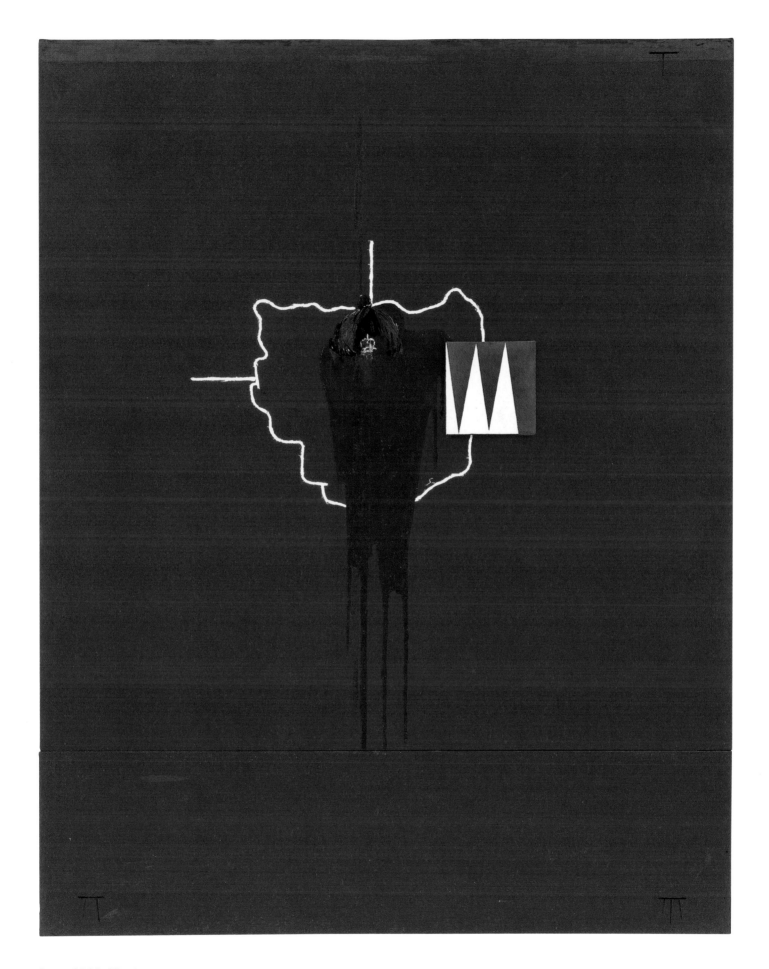

Drum, 1989-90 oil on canvas
249×198 cm, 98×78", New York Public Library, New York, USA

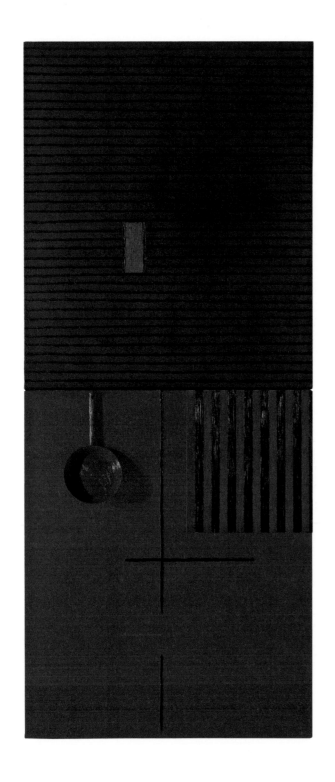

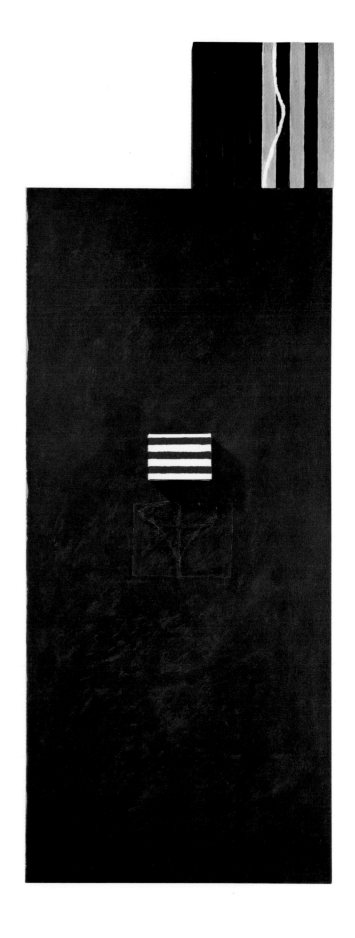

Amish House II, 1989 oil and acrylic on canvas with frying pan
211×91 cm, 83×36", private collection, Bruges, Belgium

Adams Peak, 1989 oil and acrylic on canvas
235×87 cm, 92 ¹/₂ × 34", private collection, Bruges, Belgium

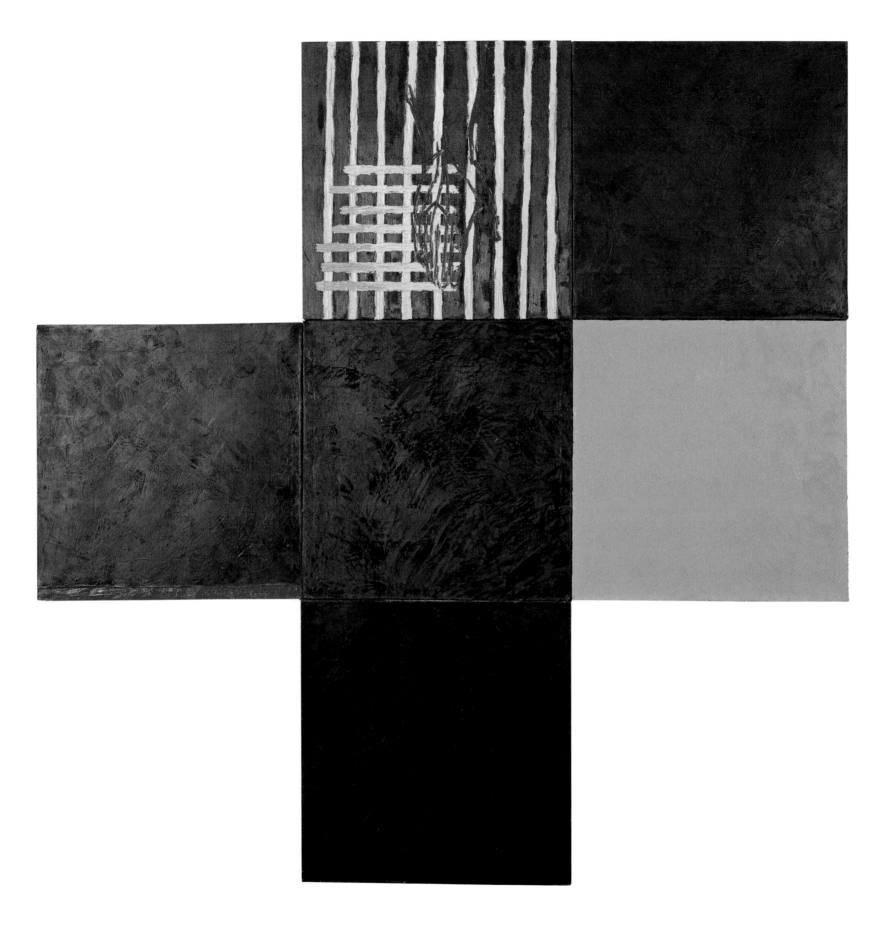

Signal, 1989 oil and wax on canvas
195 × 195 cm, 77 × 77", private collection, Switzerland

1989–1986

italy

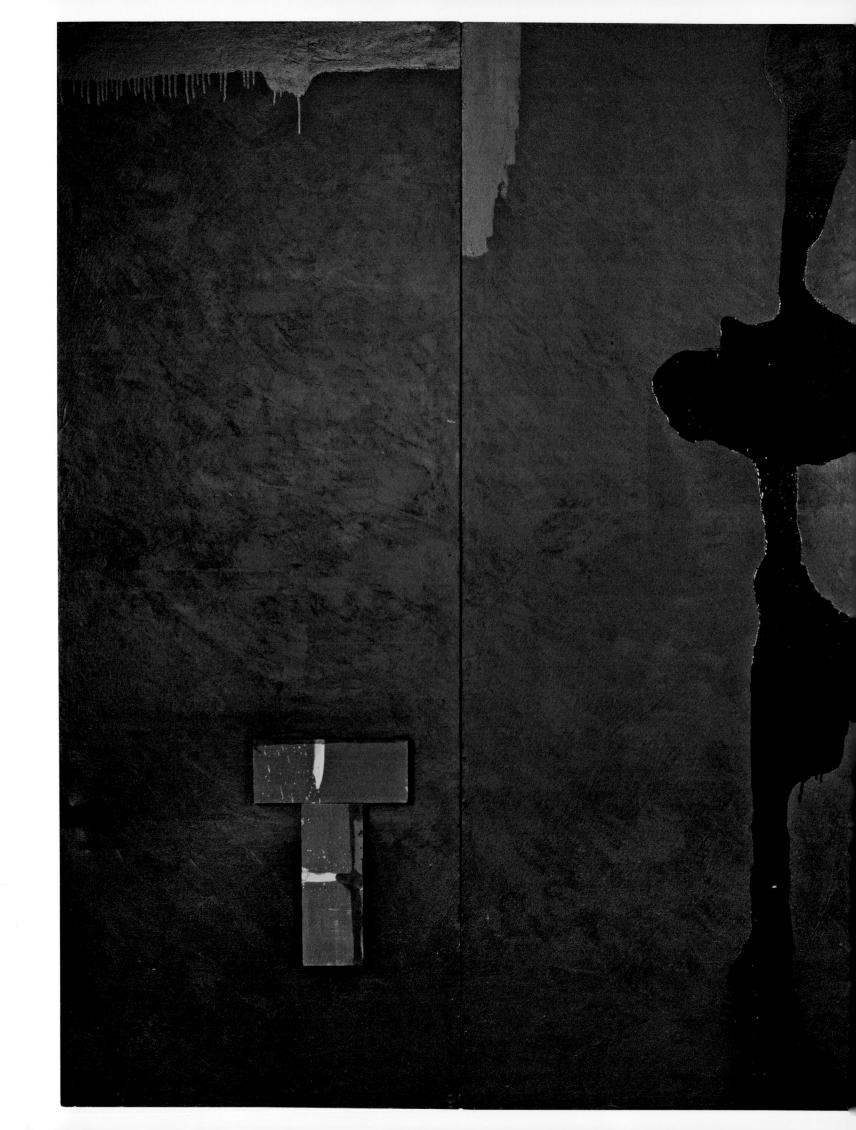

Catalan Painting, 1989 oil and acrylic on canvas
176 × 185 cm, 69 ¹/₂ × 73", Erich Storrer Gallery, Zurich, Switzerland

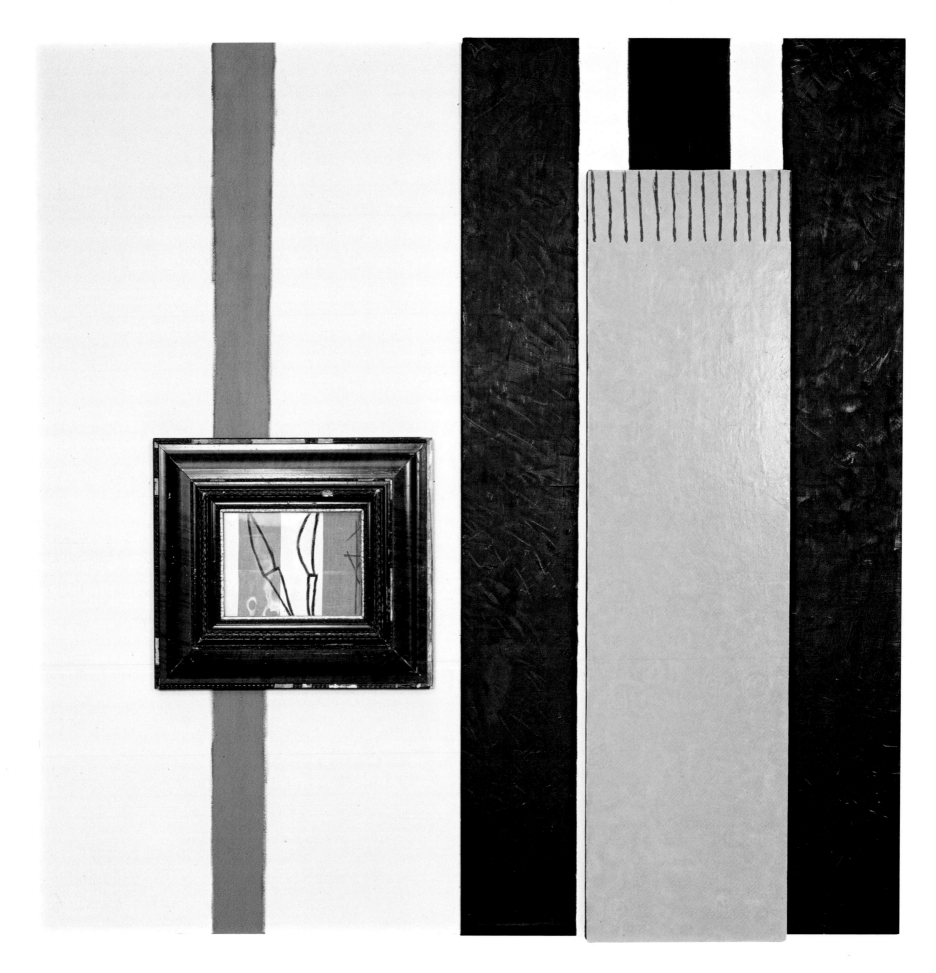

Mirror (for Tarkovsky), 1989 oil and acrylic on canvas and wood frame and glass
177 × 177 cm, 69 1/2 × 69 1/2", private collection, Herrliberg, Switzerland

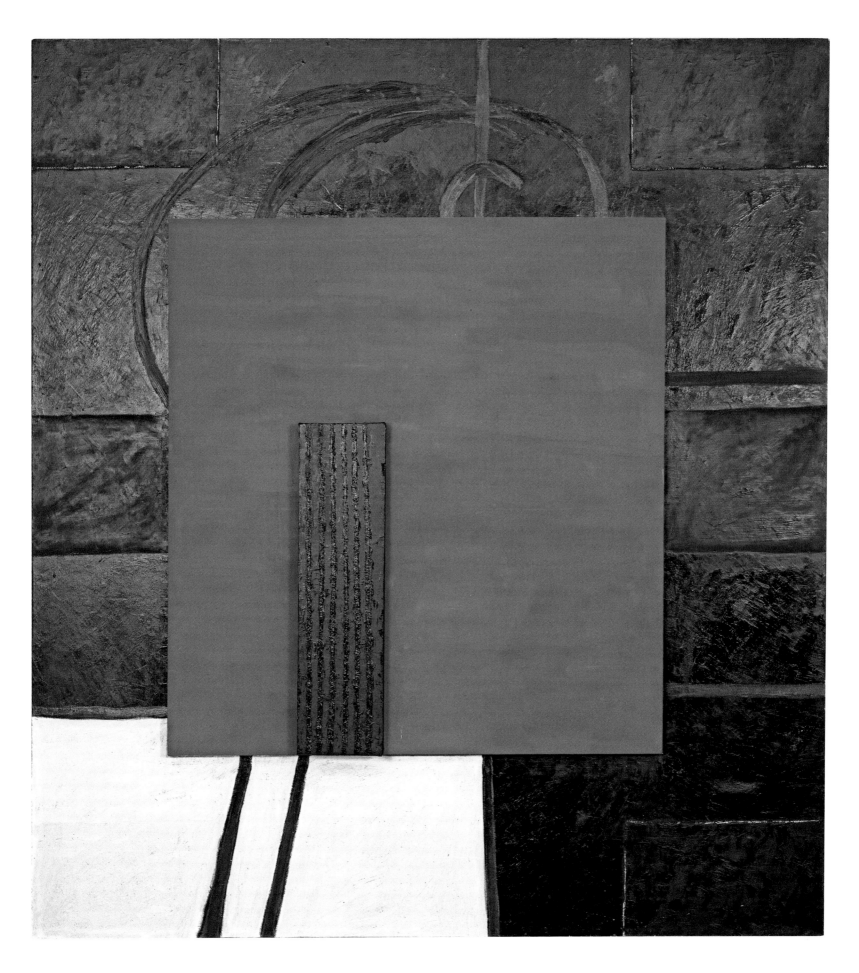

Mozart at the Piano, 1989 oil and acrylic on canvas
176 × 161 cm, 69 ½ × 63 ½", private collection, Zurich, Switzerland

157

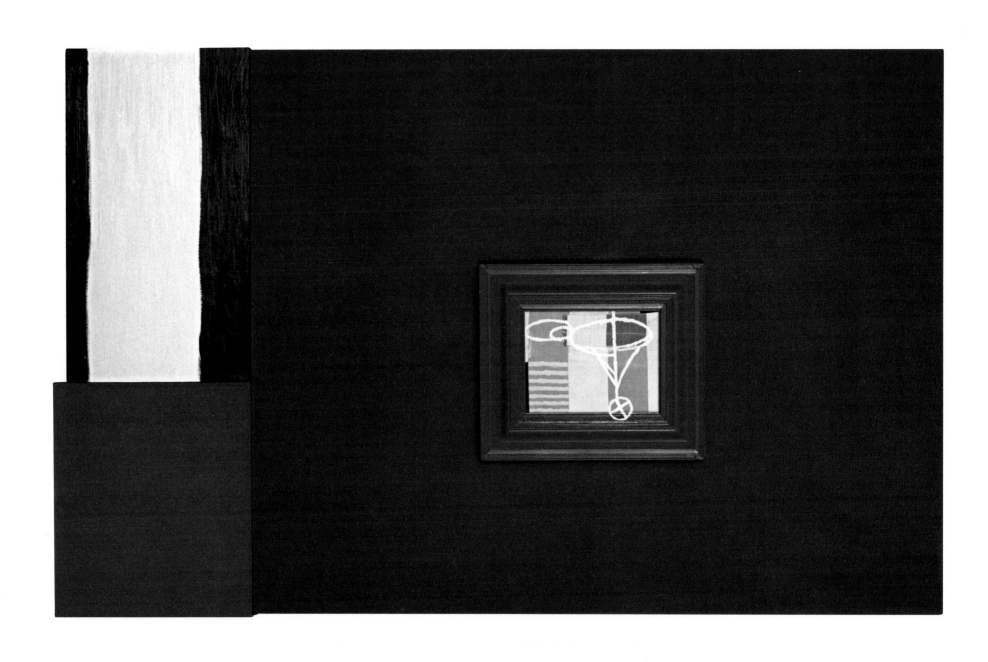

Passion, 1989 oil and acrylic on canvas and wood frame
120×193 cm, 47×76", private collection, Küsnacht, Switzerland

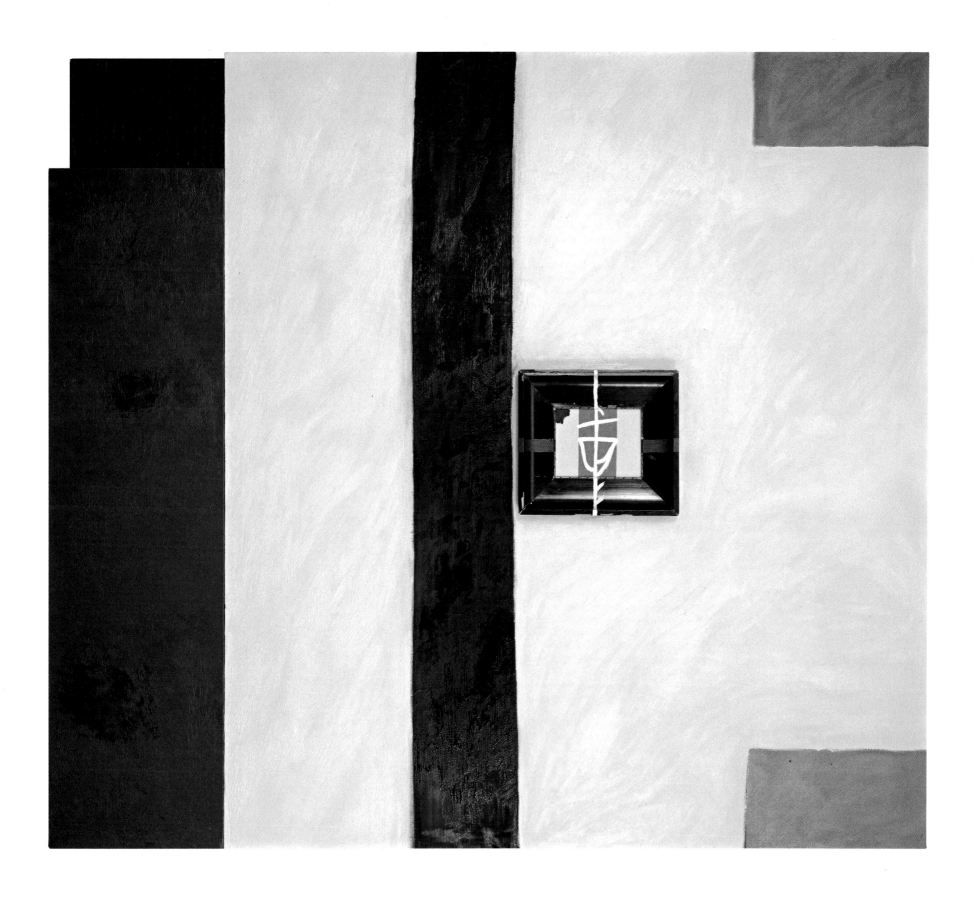

The Bell for Andrei Tarkovsky, 1989 oil on canvas and wood frame
176×201 cm, 69 ¹/2×79", private collection, Schaffhausen, Switzerland

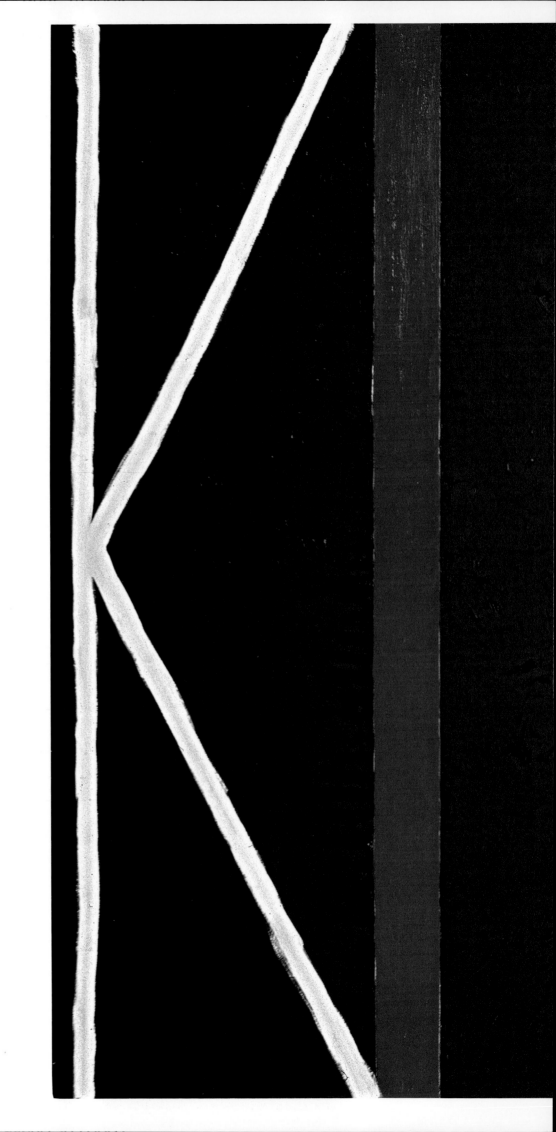

160 **Offering, 1989** oil on canvas, wood object
122 × 170 cm, 48 × 67", private collection, Zurich, Switzerland

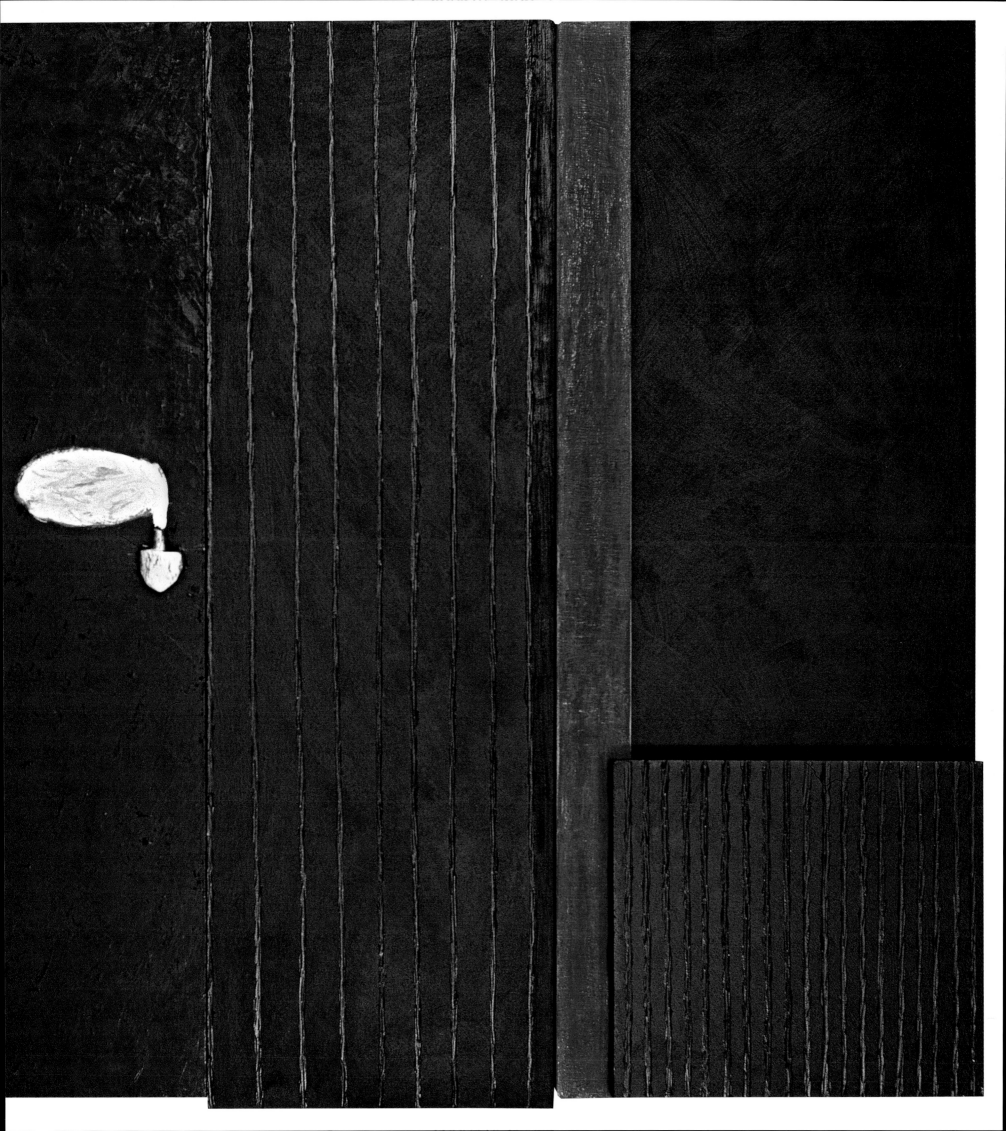

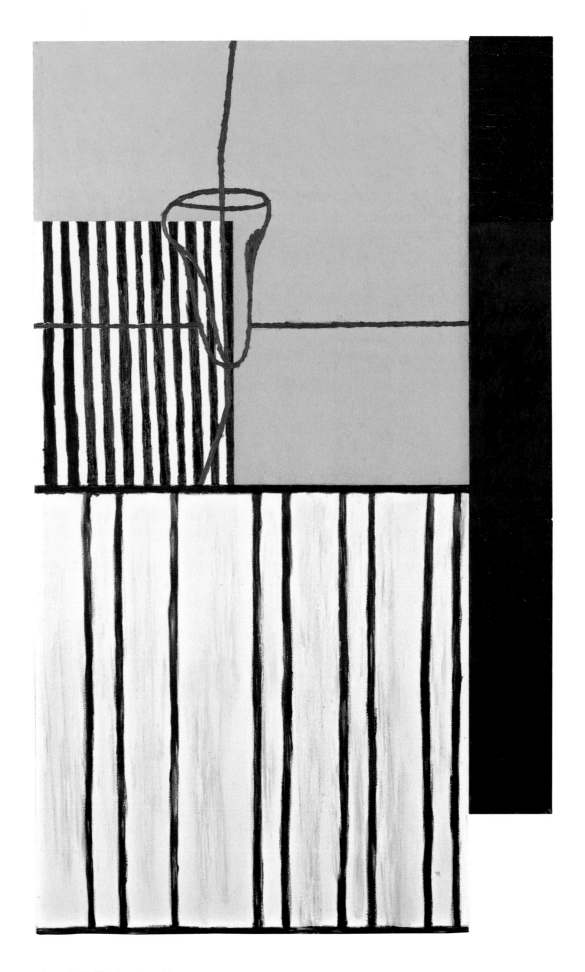

Metrofan, 1989 oil and acrylic on canvas
191 × 180 cm, 75 × 71".
private collection, Hamburg, Germany

Vessel, 1987 oil and acrylic on canvas
200 × 118 cm, 78 1/2 × 46 1/2", private collection,
Germany

163

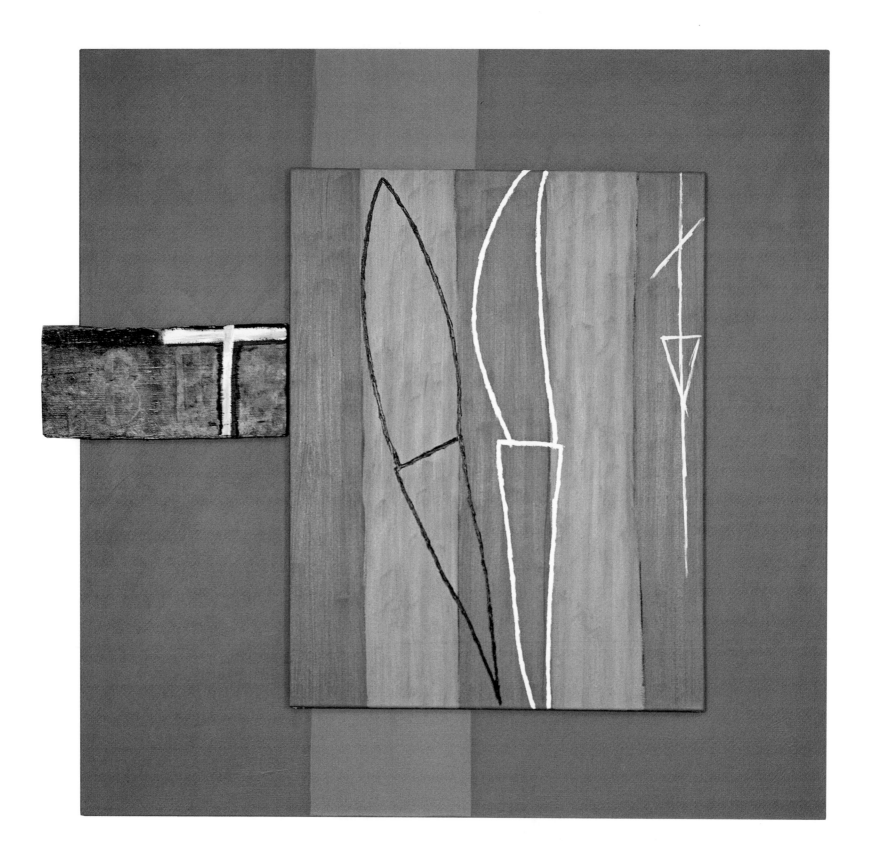

164 **Harvest, 1989** oil and acrylic on canvas
147 × 154 cm, 58 × 60 ¹/₂", private collection, Switzerland

Knife, 1989 oil and acrylic on canvas
229 × 194 cm, 90 × 76 ¹/₂", private collection, Schaffhausen, Switzerland

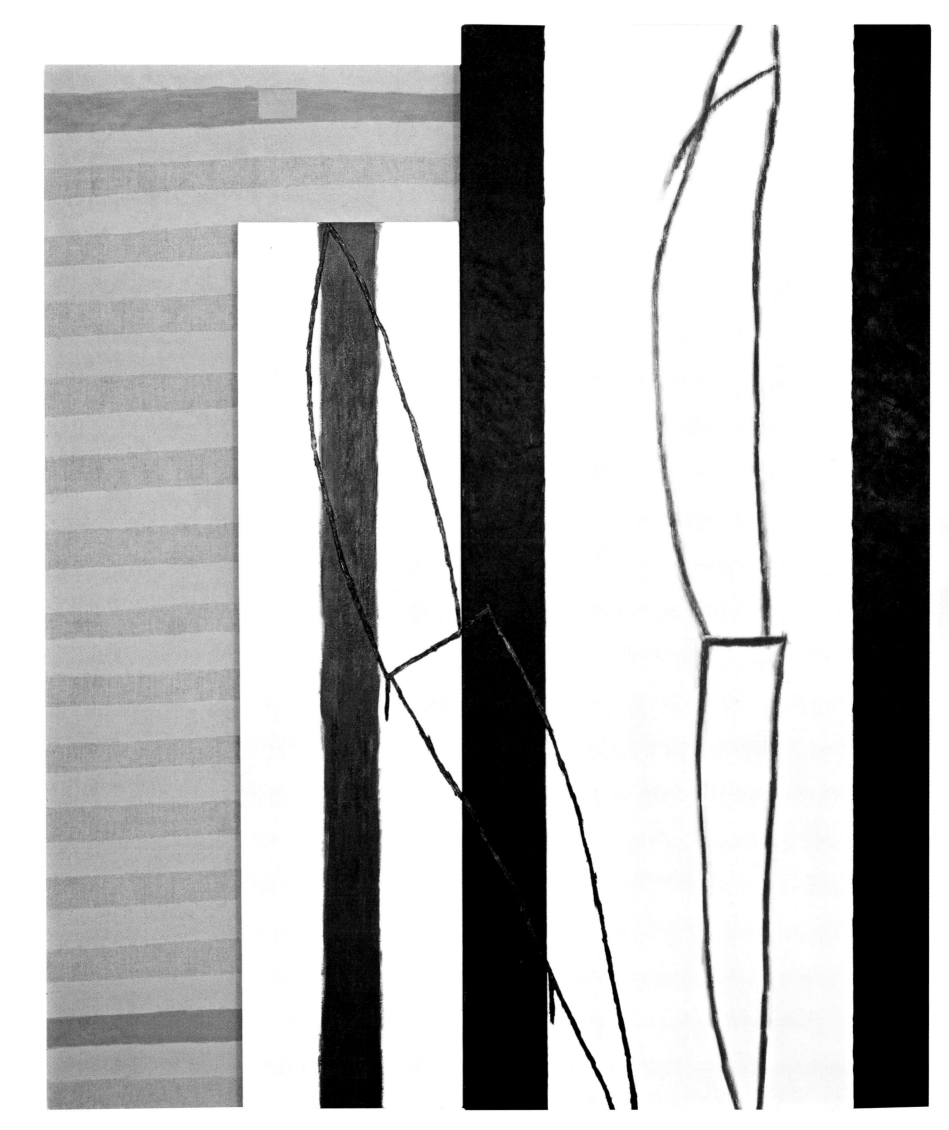

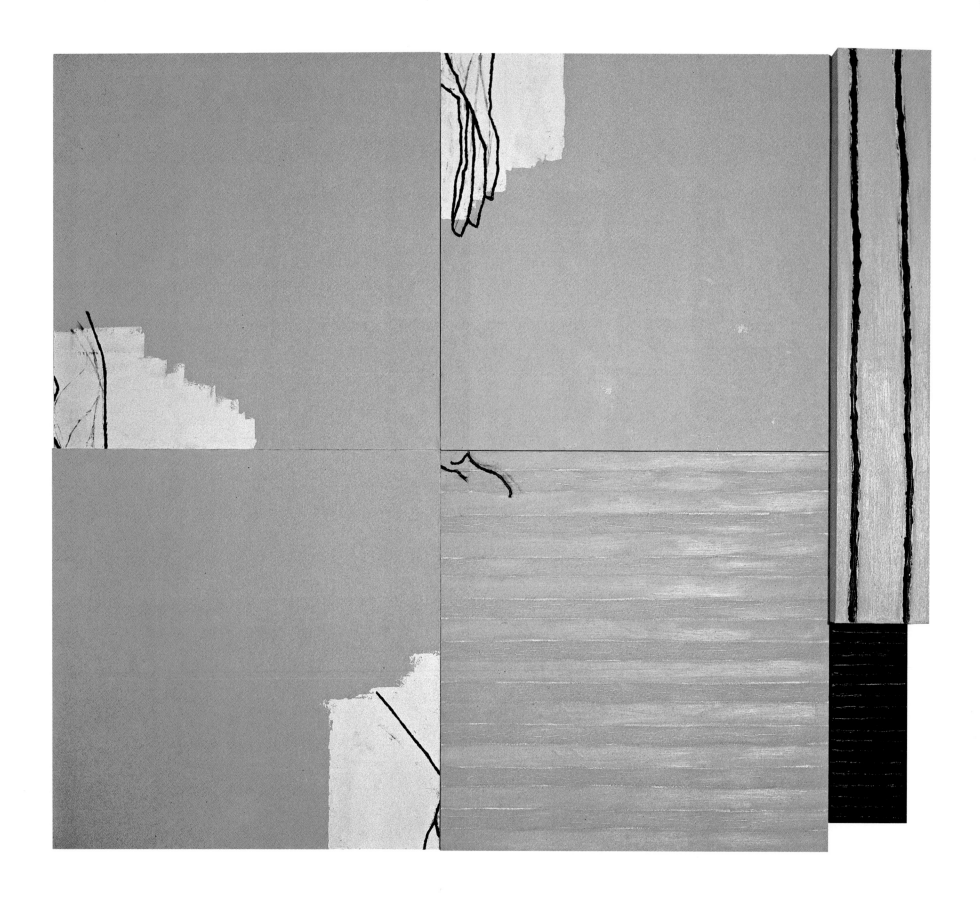

166 **Banana Hand, 1988** mixed media on canvas
165×182 cm, 65×71 ½", private collection, Lausanne, Switzerland

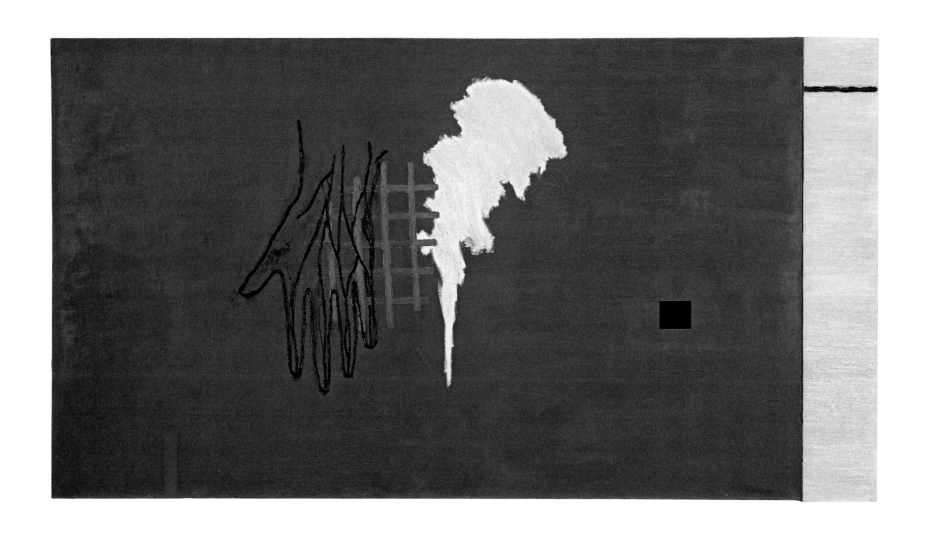

Living in the Abstract, 1988 oil on canvas
100 × 210 cm, 39 ¹/2 × 82 ¹/2", private collection, Stockholm, Sweden

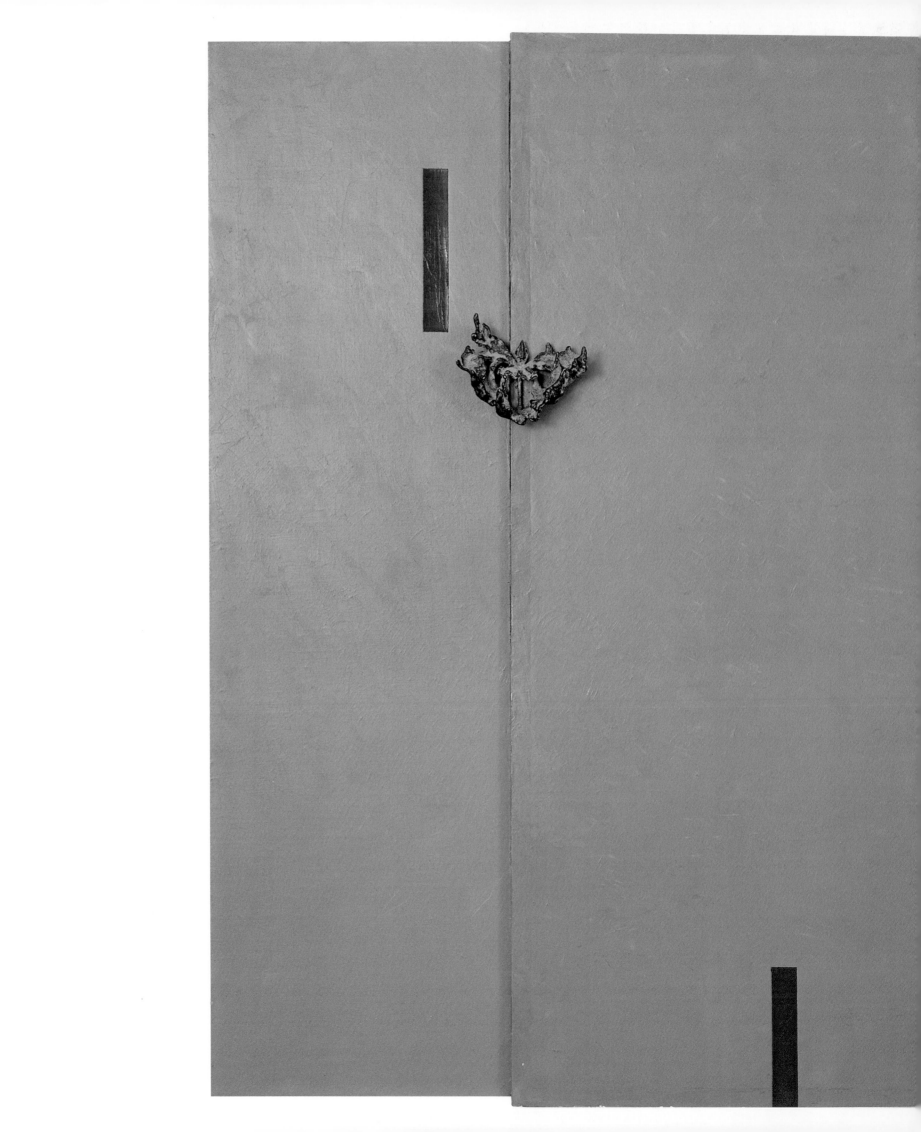

Alexis' Garden, 1988 bronze cast, oil, and acrylic on canvas
120×127 cm, 47×50", private collection, Zurich, Switzerland

Vase (Oceanic), 1988 oil and acrylic on canvas
235×156 cm, 92 1/$_2$×61 1/$_2$", private collection, Herrliberg, Switzerland

Outsinging, 1987 oil, acrylic, and wax on canvas
200 × 182 cm, 78 1/2 × 71 1/2", private collection, Switzerland

The Wait (for Robert Motherwell), 1989 oil and acrylic on canvas
177×221 cm, 70×87", private collection, Switzerland

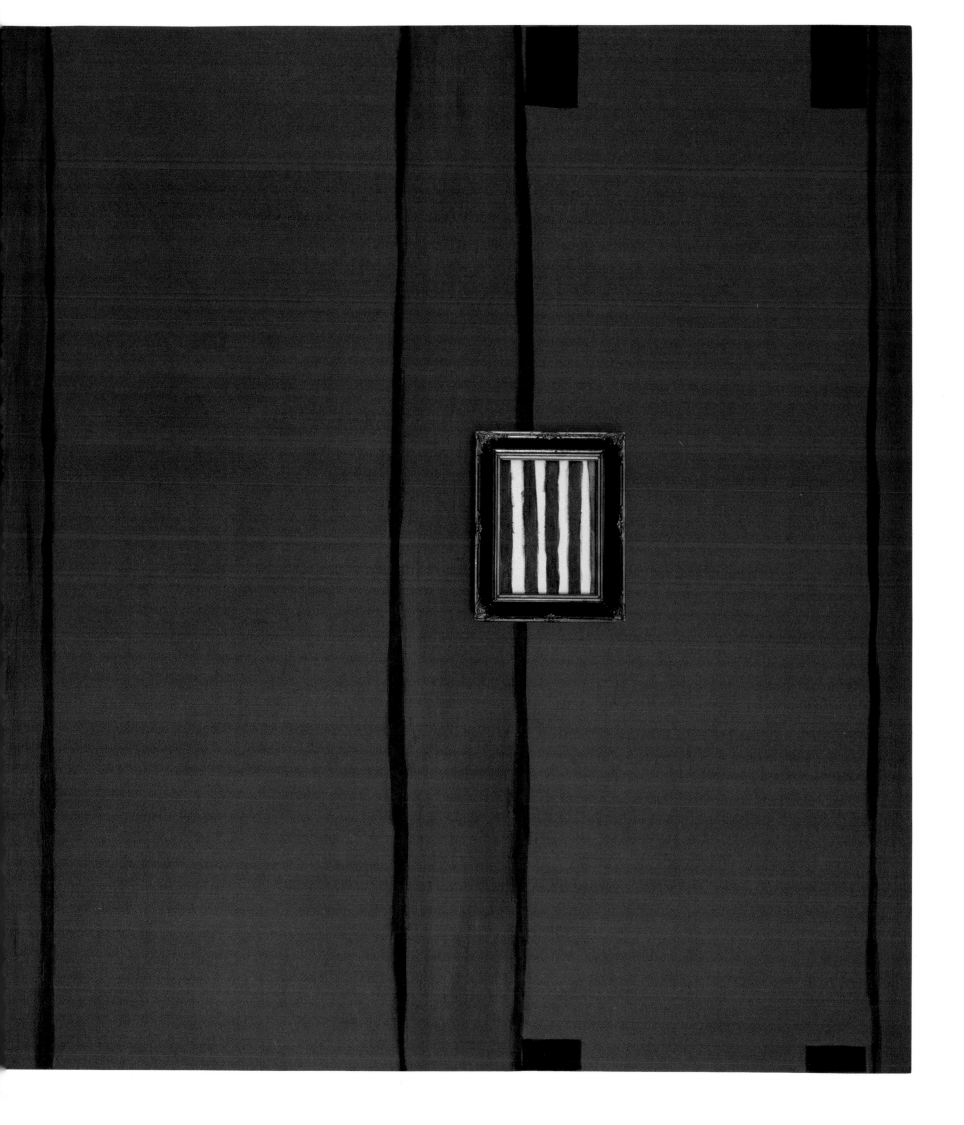

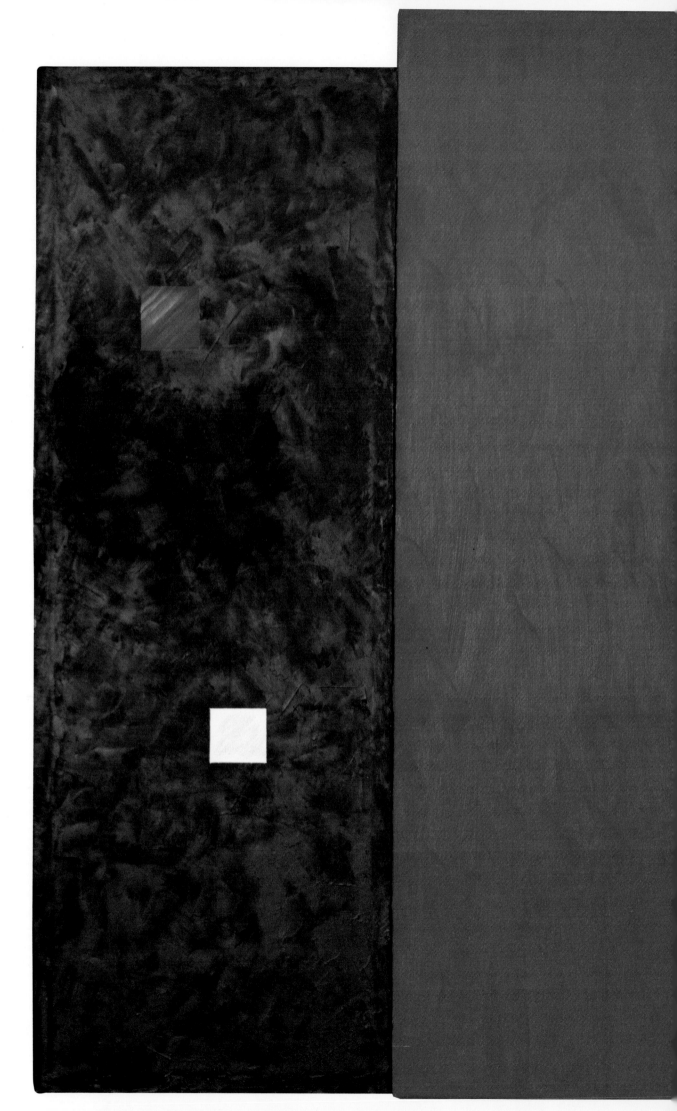

174 **Hunter, 1987** oil and bronze sculpture on canvas
137 × 188 cm, 54 × 74",
private collection, Switzerland

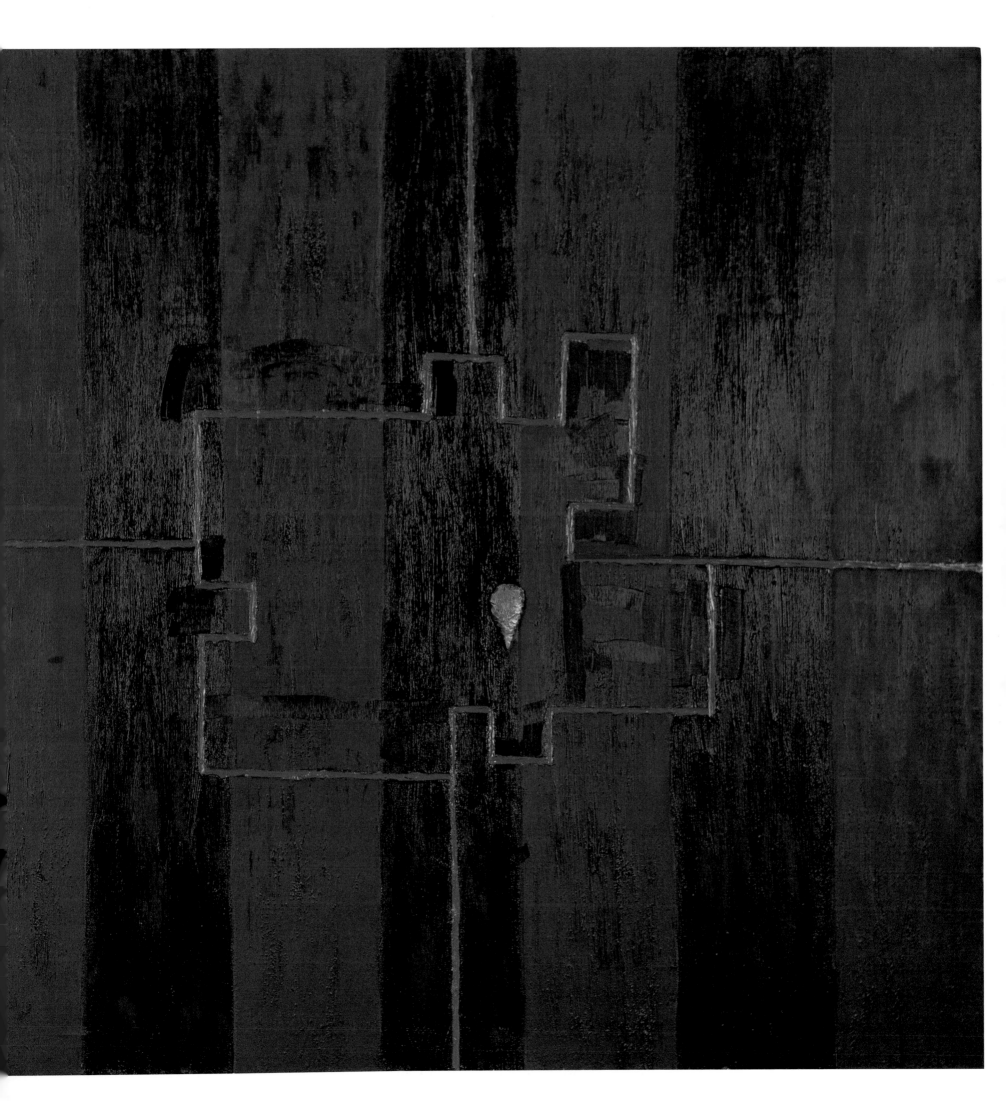

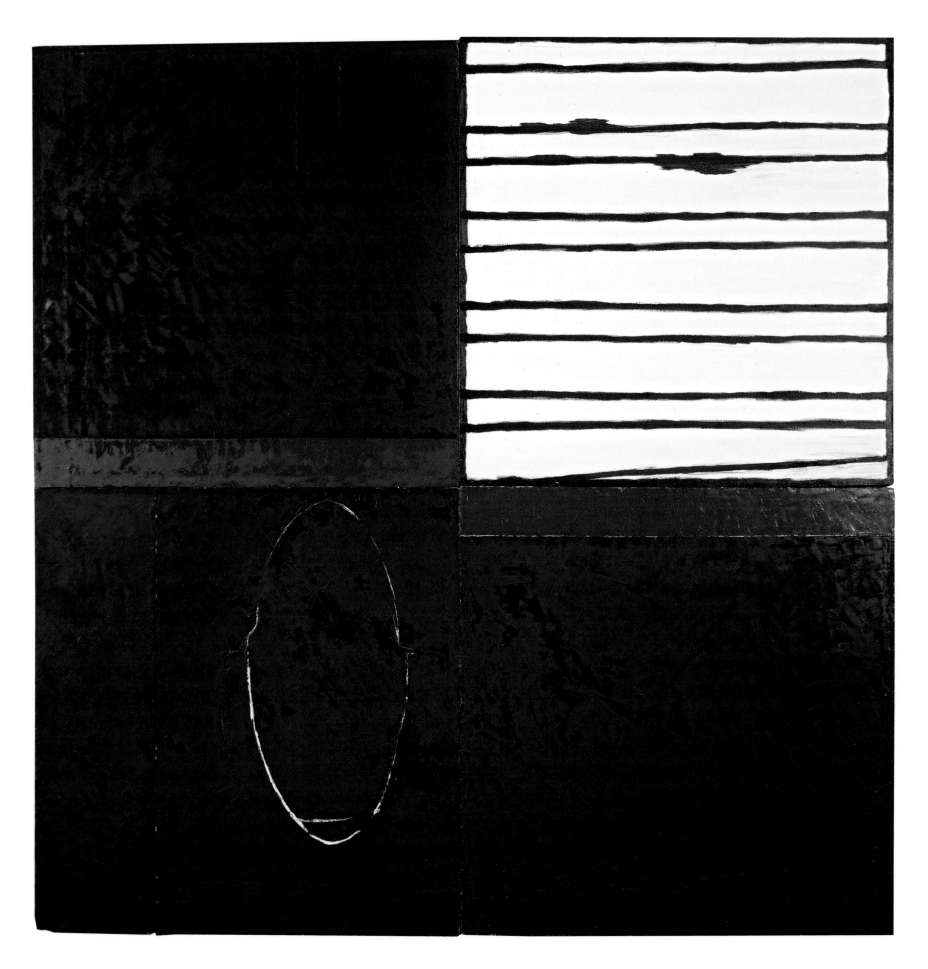

Prairie Night, 1987 oil on canvas
200×200 cm, 78 1/2×78 1/2", private collection, Küsnacht, Switzerland

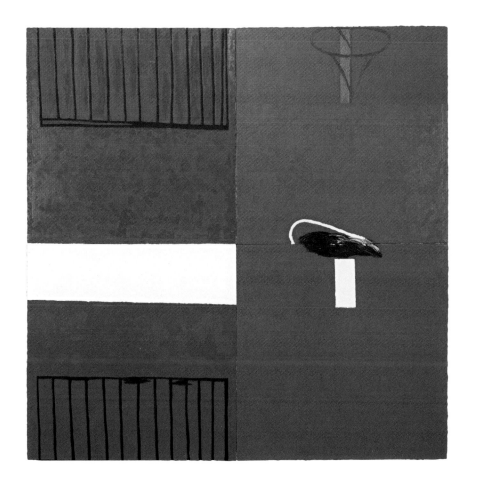

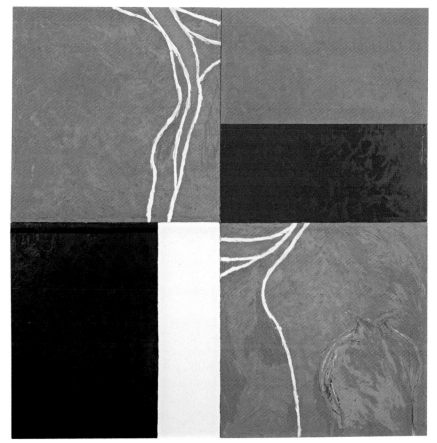

Marsillio's Gate, 1987 oil on canvas
200 × 200 cm, 78 1/2 × 78 1/2", private collection, Hamburg, Germany

Broken Vase, 1987 oil on canvas
200 × 200 cm, 78 1/2 × 78 1/2", private collection, Stockholm, Sweden

177

1986–1981

england

japan

norway

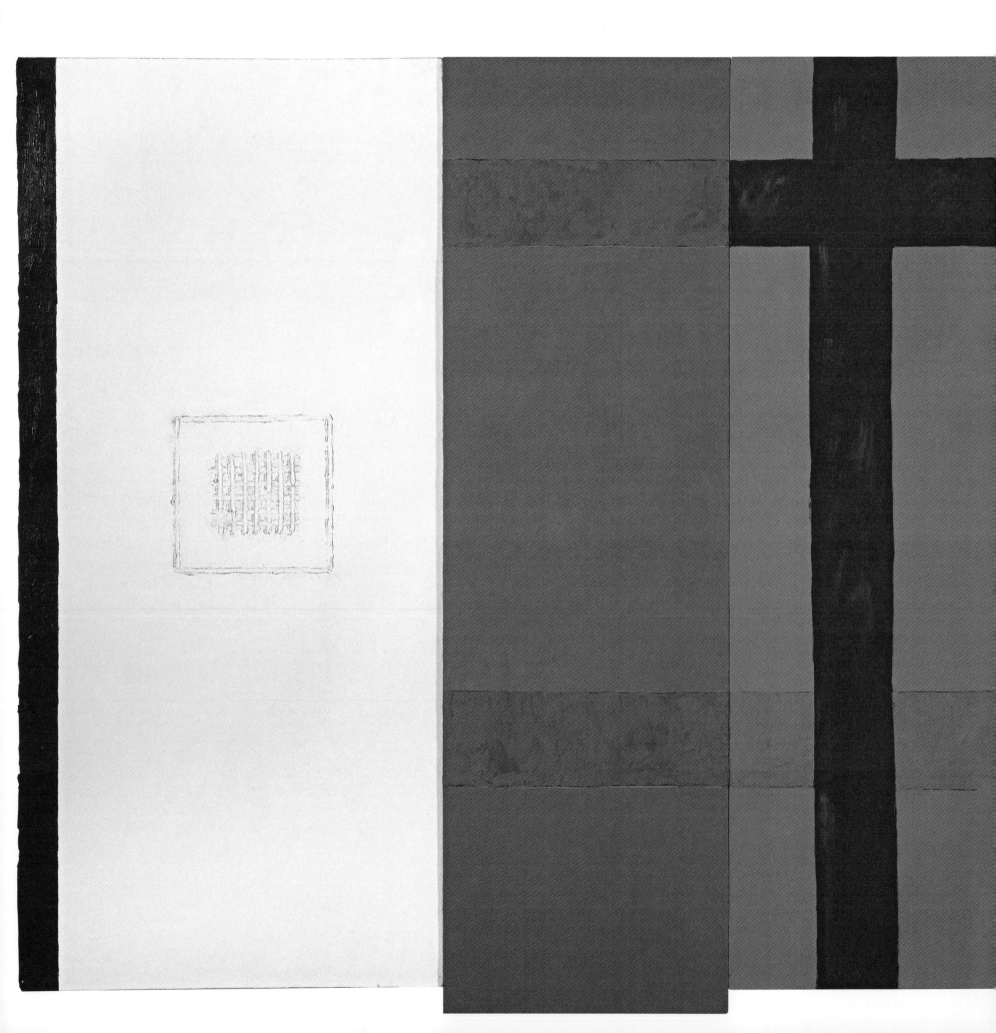

Confession, 1987 oil and wax on canvas
250 × 360 cm, 98 $^1/_2$ × 141 $^1/_2$", private collection, Zurich, Switzerland

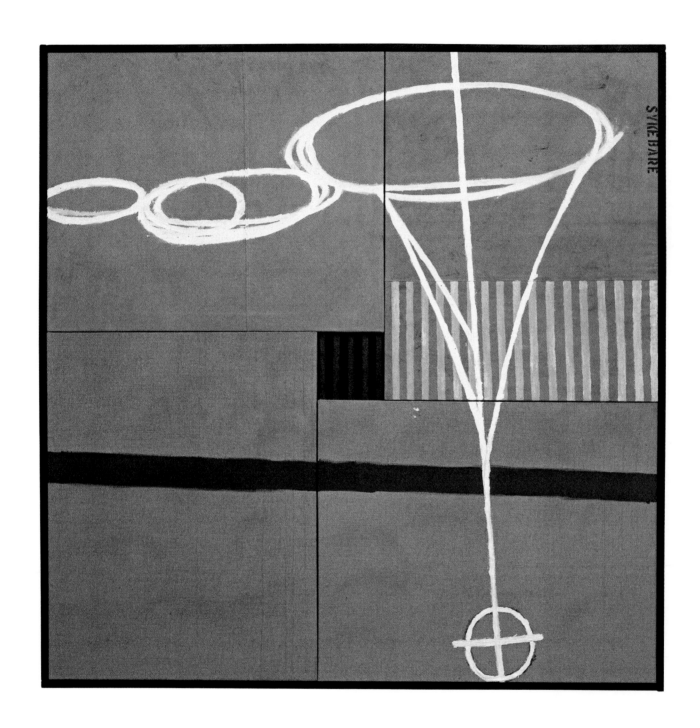

Stretcher II, 1985 oil and acrylic on canvas, wood object
183 × 183 cm, 72 × 72", private collection, Switzerland

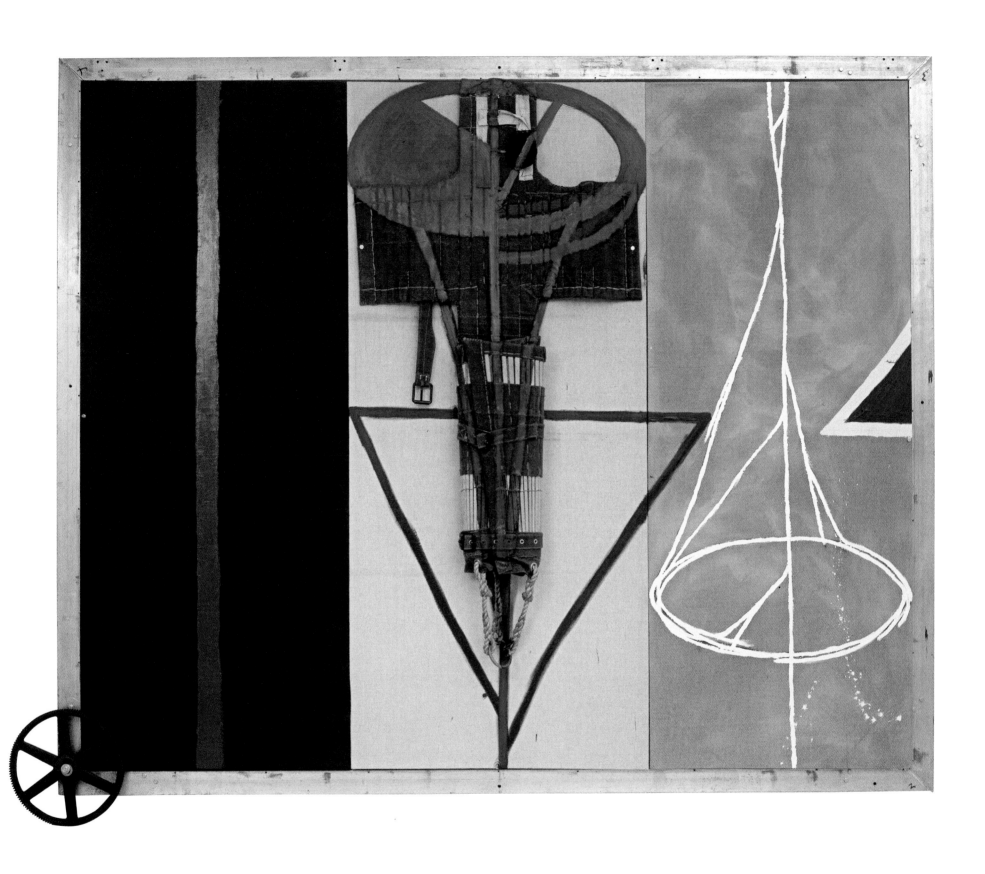

Stretcher I, 1985 oil, acrylic, iron wheel (Norwegian military rescue
equipment from the 1950s) on canvas
274 × 330 cm, 108 × 130", private collection, Switzerland

183

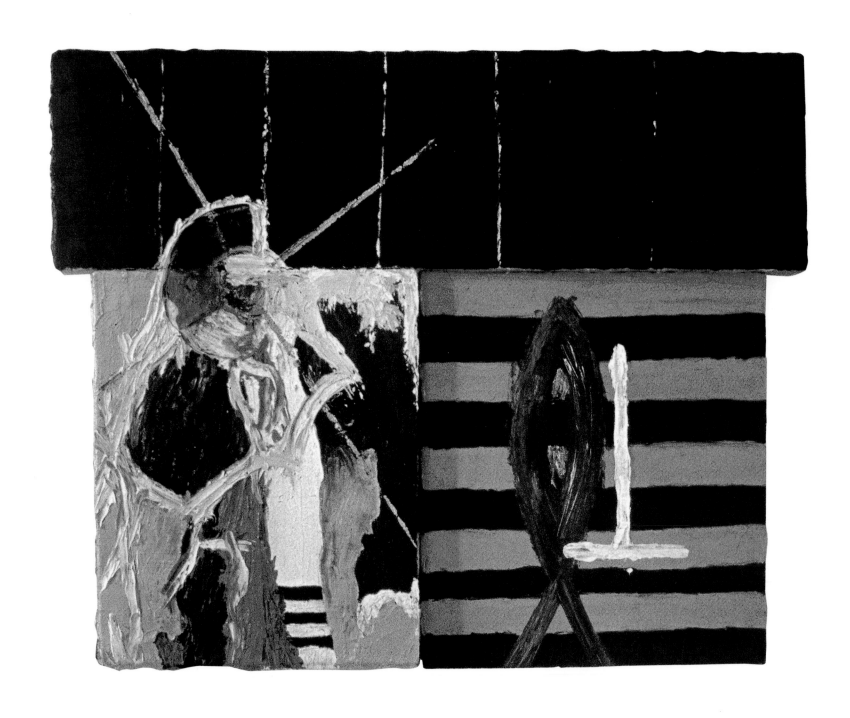

184 **Ikon (I), 1985** oil on canvas
64×89 cm, 25×35", private collection, Oslo, Norway

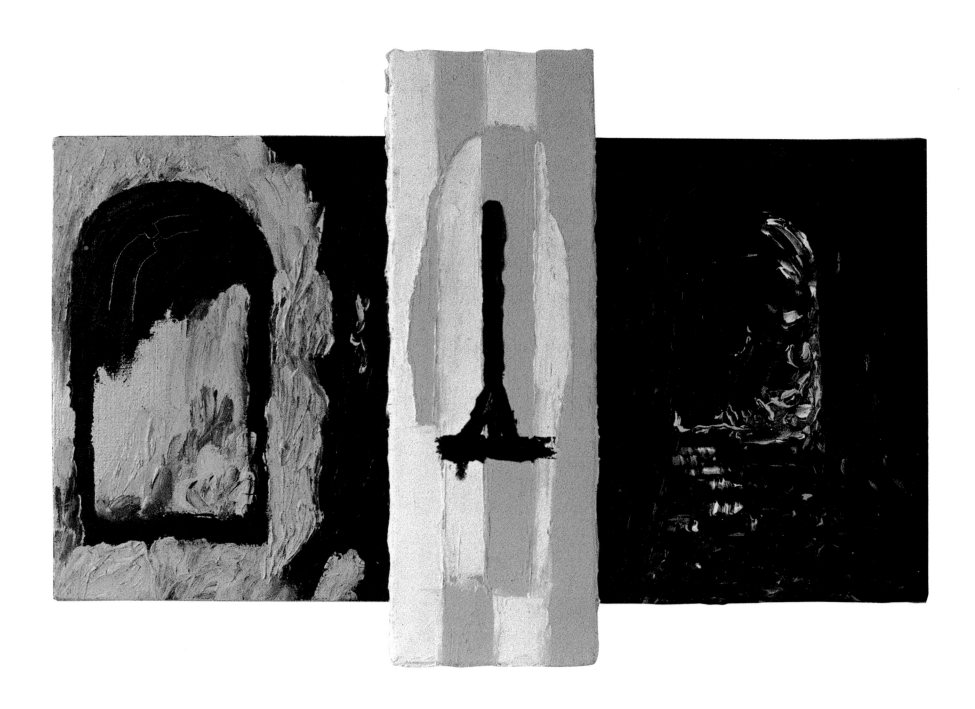

Ikon (II), 1985 oil on canvas
61 × 91 cm, 24 × 36", private collection, Oslo, Norway

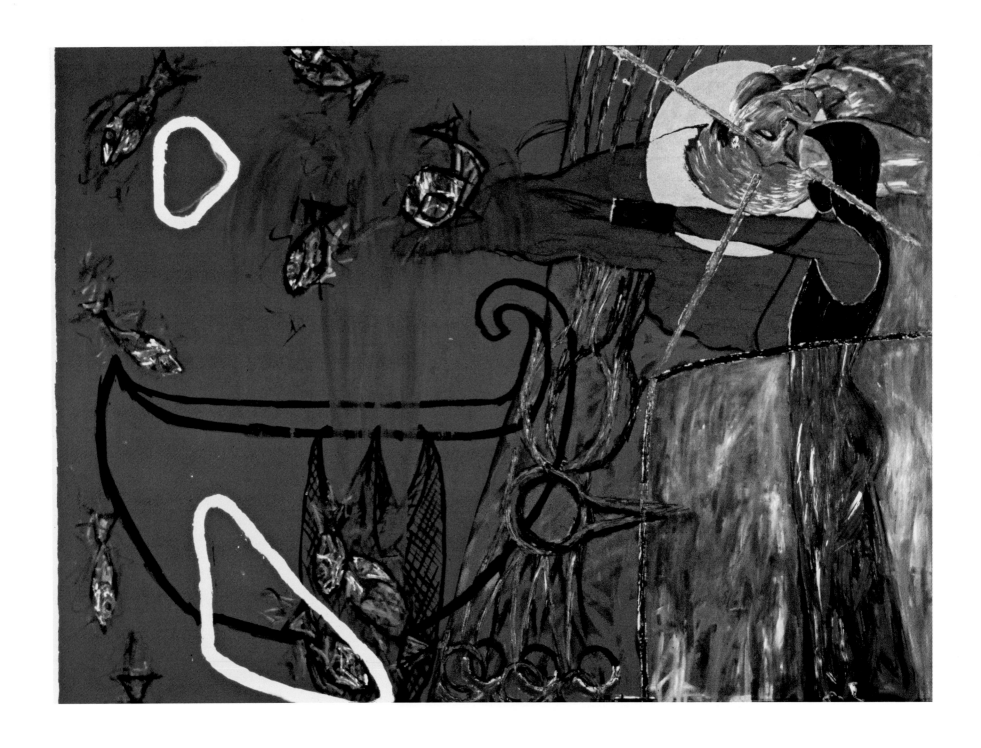

Dreaming, Fever, Dozing III, 1985 oil on linen
244 × 274 cm, 96 × 108", collection of the artist

Dreaming, Fever, Dozing I, 1985 acrylic and oil on canvas
244 × 274 cm, 108 × 96", collection Trondheim's Kunstforening, Trondheim, Norway

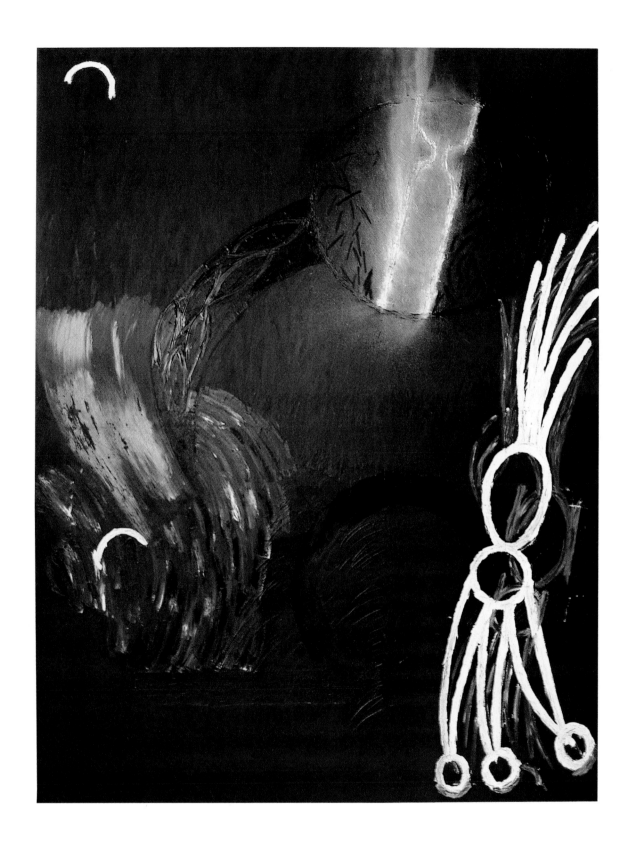

The following pages:

Rose of Watching, 1981
Installation at the Serpentine Gallery London, acrylic on linen
213×61 cm, 84×24", collection of the artist

Sunstones I and II, 1981 acrylic on canvas
76×38 cm, 30×15", Lisson Gallery, London, Great Britain

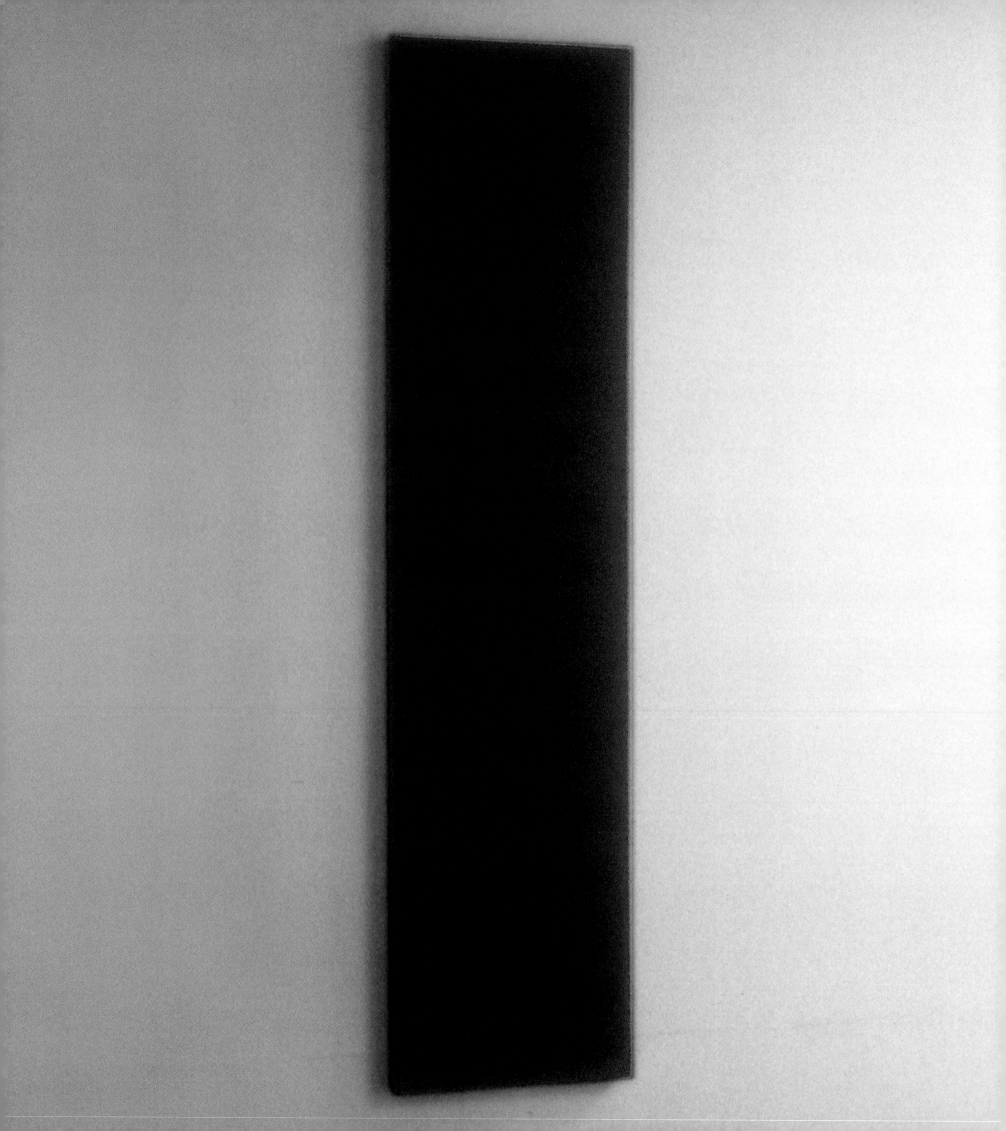

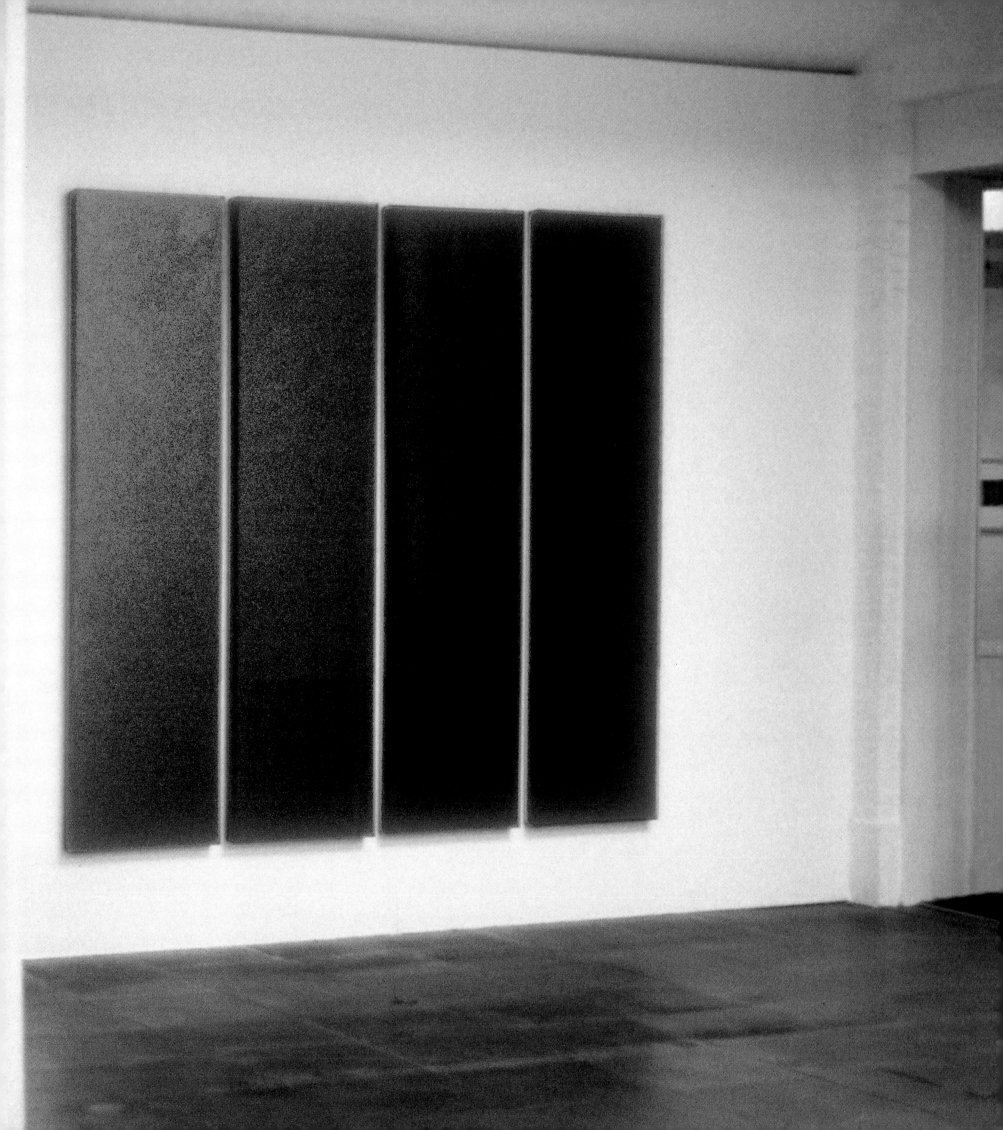

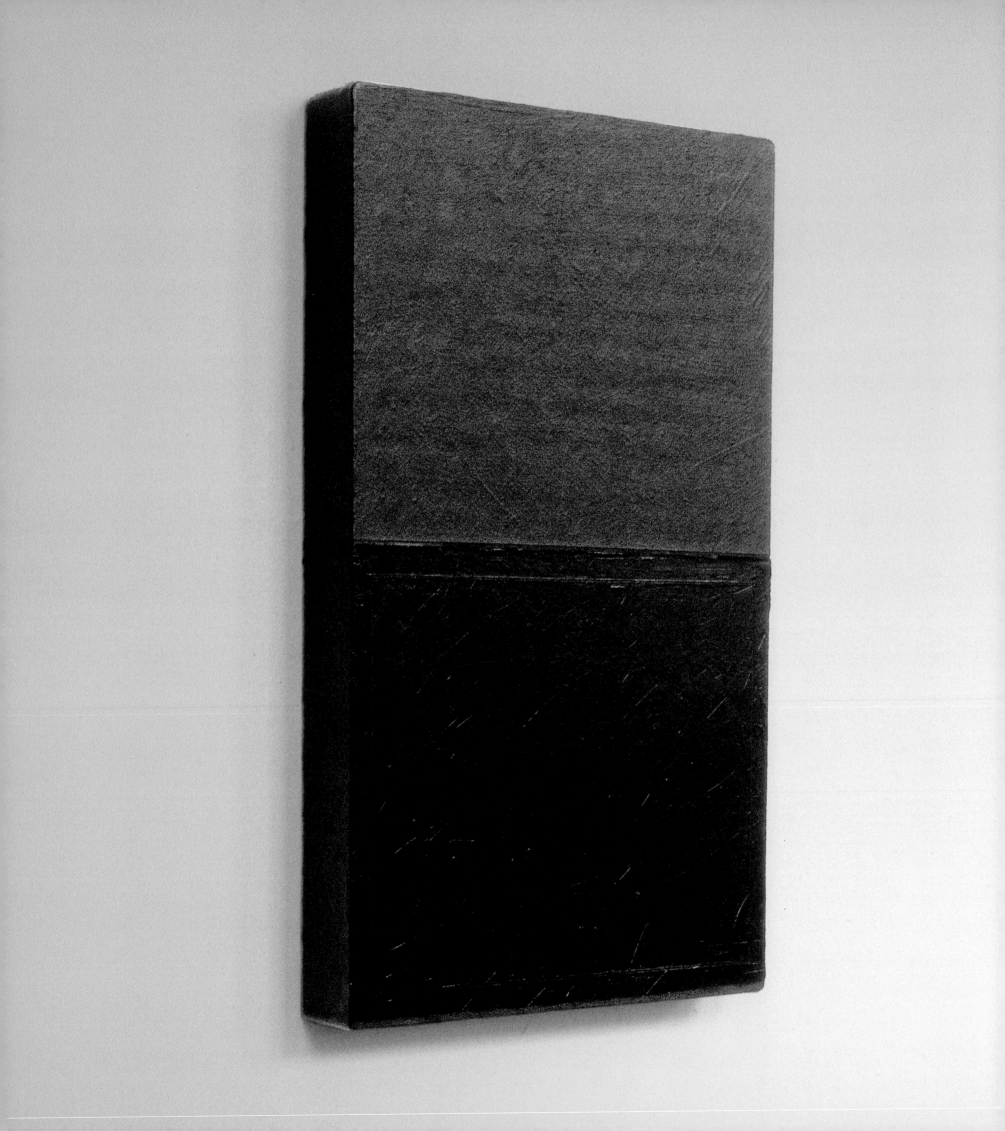

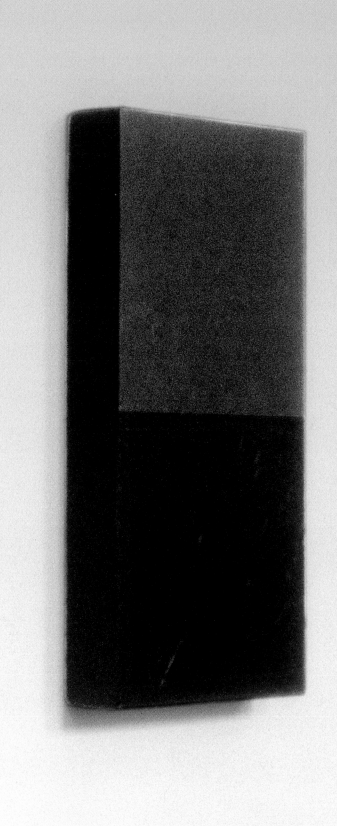

german texts

inhalt

vorwort

Zwar habe ich die meisterhafte Individualität von Steve Joys Gemälden schon seit langem bewundert, doch erst anlässlich seiner kleinen Ausstellung der *Pope*-Bilder im Old Market in Omaha vor zwei Jahren wurde mir klar, wie sehr eine Werkretrospektive dieses Künstlers im Joslyn Art Museum an der Zeit ist. Nach einer zwanglosen Begegnung, die auf äußerst angenehme Weise von unserem gemeinsamen Freund, dem Sammler Dr. Thomas Huerter, organisiert worden war, erkannte ich, dass Joy über die profunde Fähigkeit verfügt, durch das, was in diesem Buch als „spirituelle Abstraktionen" oder als nicht-objektive Gemälde bezeichnet wird, eine Hierarchie schwer fassbarer, transzendenter Gefühle zum Ausdruck zu bringen.

Für das Joslyn Art Museum ist es eine große Freude und Ehre, die künstlerischen Leistungen Steve Joys in dieser ersten umfassenden Retrospektive seiner künstlerischen Laufbahn würdigen zu können. Die Ausstellung umfasst beinahe drei Jahrzehnte seiner künstlerischen Tätigkeit, enthält über fünfzig Gemälde und zusätzliche Zeichnungen mit in- und ausländischen Leihgaben aus öffentlichen und privaten Sammlungen.

Inspiriert von solch bahnbrechenden Vertretern der abstrakten Malerei wie Wassily Kandinsky, Kasimir Malewitsch, Mark Rothko, Barnett Newman und Brice Marden, hat Joy sich intensiv der Herstellung nicht-objektiver Ikonen oder Andachtsbilder gewidmet und sich dabei breiter Oberflächen aus Farbe und Gold bedient, die durch reichhaltige Töne, die an die figürlichen Ikonen und religiösen Gemälde einer früheren Zeit erinnern, zusammengehalten werden. Seine Gemälde sind für uns pikturale Brücken zu den Quellen seines Themas, des Themas der christlichen Ikonografie und ihrer Vorläufer, der geometrischen und figurativen Formen der Antike, welche die Kunst Mesopotamiens, Ägyptens und Griechenlands prägten.

Die Titel seiner Werke legen vertraute Motive wie die Dreifaltigkeit, Maria mit Kind sowie die *Gottesmutter von Wladimir* nahe, doch ihre formale Präsentation ist tief verwurzelt in Joys intuitiver Konfiguration abstrakter geometrischer Oberflächen, tonaler Hierarchien und Matrizen senkrechter und waagrechter Felder. Derart faszinierend sind diese Werke, dass man magisch von ihnen angezogen wird, wie von der Wärme und dem Schein eines abendlichen Lagerfeuers. Doch sie sind mehr als physische Erfahrungen. Sie verfügen über einen intellektuellen Reichtum und eine Fülle, die eine Lebensreise voller Entdeckungen auf der Suche nach dem Selbst widerspiegeln.

Die Spiritualität in uns zu wecken, unsere zu wenig genutzten Fähigkeiten zu aktivieren, uns selbst zu entdecken und ästhetische Freude zu empfinden und über die rätselhafte, kryptische und tiefgründige Symbolik nachzusinnen, die wir in der Kunst finden: Dies alles sind Anliegen, die sich aus Steve Joys bisheriger kreativer Reise ergeben haben. Mit dieser Ausstellung lässt er uns daran teilhaben.

J. Brooks Joyner
Direktor, Joslyn Art Museum

einleitung

An britischen Künstlern, die das bequeme Leben daheim aufgaben, um die Welt zu bereisen, herrscht kein Mangel. Und wenngleich man von einem Briten zunächst erwarten würde, dass er sich um den Rom-Preis bemüht oder die Schönheit der Provence erkundet, begeben sich doch auch nicht wenige von ihnen lieber auf die Suche nach dem Exotischen und Unvertrauten. Im Zeitalter der Aufklärung, im späten 18. und frühen 19. Jahrhundert, zog es Künstler wie David Roberts und Edward Lear zunächst in exotische Landschaften und damals nicht vertraute Kulturen. Die Bruderschaft der Präraffaeliten etwa war bestrebt, Szenerien des Heiligen Landes zu schaffen, die eine durch die Erzählungen der Bibel vermittelte moralische Botschaft enthielten. Im Jahr 1772 fungierte William Hodges auf Captain James Cooks zweiter Reise in die Südsee als Expeditionskünstler. Die Werke, die er von dieser Reise in die Heimat sandte, waren nicht bloß dokumentarischer Natur, sondern zugleich auch außerordentliche Kunstwerke. Der Künstler Hodges nutzte das Meer zum Reisen, um neue Dinge zu sehen, Steve Joy nutzte in der Royal Air Force das Meer und das Reisen, um Künstler zu werden.

Doch das Klischee des Soldaten meint hier nicht jemanden, der in unterschiedlichen Kulturen nach universellen Wahrheiten sucht. Für Steve Joy war jeder Landgang vielmehr aufs Neue eine Gelegenheit, Proben der Kulturen seiner verschiedenen Anlaufhäfen zu nehmen und die dortigen Kunstmuseen zu besuchen. Nachdem er schließlich definitiv von Bord gegangen war, führte ihn das Bedürfnis, seine Suche fortzusetzen, für das er zunächst kein folgerichtiges Betätigungsfeld hatte, auf die Kunstakademie. Trotz Joys unverhohlener ,Wanderlust' geht es im Werk des Künstlers jedoch nicht um das Reisen oder um exotische Ansichten. Vielmehr sind seine Gemälde Ausdruck seiner Geistesverwandtschaft mit anderen Erforschern der Conditio humana, mit Künstlern, Schriftstellern, Philosophen, Theologen, ja selbst Filmregisseuren, denn diese unternehmen ihre eigene Reise, ihre eigenen spirituellen Exkursionen durch die Kunst.

Joys künstlerische Technik spiegelt diese Suche wider. Die Materialien seiner Kunst weisen eine geheimnisvolle Tiefe auf. Unter den satten Farben, den reichen Schichten von Blattgold, Blattsilber und Wachs verbergen sich unkonventionelle, mitunter massive, gelegentlich dreidimensionale Bildträger. Traditionell benutzt man Wachs, um die Wahrheit zu kaschieren, etwa um Reparaturen zu verbergen. Der Begriff ‚sin cere' oder ‚ohne Wachs' sollte den wahren Zustand von etwas zum Ausdruck bringen. Doch bei Joy verbirgt das Wachs nichts, sondern es versinnbildlicht die Geheimnisse, die Teil einer spirituellen und metaphysischen Reise sind.

Auch wenn Steve Joy seinen Künstler-Landsleuten in manchem gefolgt sein mag, bewegt sich sein Werk außerhalb der Konventionen von britischer Kunst und britischen Künstlern, und erst recht unterscheidet es sich von der aktuellen Bewegung der Young British Artists. In chronologischer Hinsicht erreichte Joy seine künstlerische Reife in der Zeit zwischen der Neoromantik britischer Künstler, die im Allgemeinen das hiesige Kunstestablishment zu Beginn seiner Laufbahn beherrschten – jene traditionellen Maler, die in den späten 1970er und frühen 1980er Jahren Mitglieder der Royal Academy wurden –, und der *Sensation*-Zeit, die ein Jahrzehnt später, in den frühen 1990er Jahren, andere Künstler in den Vordergrund der Aufmerksamkeit rückte. Joys Werk unterscheidet sich von all jenen, doch in geistiger Hinsicht dürfte ihm das Œuvre eines anderen Exilanten, nämlich das des Amerikaners R. B. Kitaj, nahe stehen, der in Großbritannien tätig war und seine Lebensreise ebenfalls mittels der Malerei zum Ausdruck brachte.

Die Aufmerksamkeit, die Joy der Kunstgeschichte widmet, verbindet ihn mit einer altehrwürdigen Gemeinschaft britischer Künstler, die von Rubens und van Dyck – den beiden Ausländern, die Großbritannien für sich beansprucht – bis zu Joshua Reynolds und Thomas Lawrence reicht. Diese Künstler kannten die Geschichte ihrer Zunft und waren bemüht, ihre eigene Kunst zu verbessern, indem sie die alten Meister studierten. Doch der bedeutendste Geistesverwandte Joys dürfte J. M. W. Turner sein. Turners kreative und originelle Technik, seine romantische und proto-impressionistische Sicht der Landschaft und Natur, seine Geschichtskenntnis und sein ständiges Streben, seine bewunderten Helden – Claude Lorrain, Nicolas Poussin, Rubens, Canaletto, Tizian –, aber auch Zeitgenossen wie David Wilkie zu übertreffen, finden einen Widerhall im Werk Joys, dessen Gemälde wie diejenigen Turners die Herausforderung gelegentlich schon in ihren Titeln kundtun. Darüber hinaus ist Joys Kunst wie diejenige Turners häufig eine Hommage an diese Künstler – oder an Filmregisseure, Schriftsteller oder an spirituelle Führer –, insofern seine Bilder an den Einfluss seiner fortgesetzten Reise erinnern.

Steve Joy arbeitet im stillen, aber fruchtbaren Umfeld von Omaha, einer kleinen Stadt, die eine ernsthafte Gemeinde kreativer Künstler unterstützt (einschließlich eines kraftvollen transitorischen Elements, das sich in den Aufenthaltsstipendien des Bemis Center for Contemporary Arts manifestiert). Sie bietet den vollkommenen Ausgangspunkt und die Folie für die intellektuellen und physischen Reisen des Künstlers. Es ist klar, dass Steve Joys Reisen wie Konstantinos Kavafis' Reise nach Ithaka mit einem Gebet beginnen, auf dass die Fahrt lang sei.

John Wilson
Senior Curator of Collections, Joslyn Art Museum

biografie

1952

Steve Joy wird am 7. Oktober in Plymouth, England, als Sohn von Dorothy Joan und Leonard Joy geboren.

1954

Die Familie zieht in das kleine, in Meeresnähe gelegene Dorf St. Anthony in Cornwall und kurze Zeit später in das nahe St. John.

1968

Schließt sich der Royal Air Force an und beginnt eine rege Reisetätigkeit durch den Fernen und Mittleren Osten und den Mittelmeerraum, einschließlich zweier Jahre auf einer kleinen tropischen Koralleninsel im südlichsten Atoll der Malediven im Indischen Ozean. Entdeckt für sich *Das Werk*, einen Roman Émile Zolas über Paul Cézanne, der ihn auf den Gedanken bringt, Maler zu werden.

1971

Schließt sich dem Rennradteam der Royal Air Force an und repräsentiert die Streitkräfte in ganz Europa ebenso wie bei den Commonwealth-Spielen in Neuseeland; trägt sich mit dem Gedanken, Radprofi zu werden. (Zufällig gab es in Frankreich und Belgien bereits die Tradition radfahrender Maler bzw. malender Radfahrer).

1973

Bei einem zufälligen Besuch im Stedelijk Museum in Amsterdam lernt Joy die Gemälde und die Philosophie Barnett Newmans kennen, was ihn in seinem Entschluss bestärkt, abstrakter Maler zu werden.
Außerdem nimmt er ein Studium der Vergleichenden Religionswissenschaften am Chaplains College (College für Militärgeistliche) der Royal Air Force in Andover, England, auf. Erwägt, Geistlicher zu werden.

1975–79

Beginnt seine künstlerische Ausbildung am Cardiff College of Art in Wales, wechselt nach Exeter und schließt dort sein Bachelor-Studium in den Schönen Künsten mit Auszeichnung ab. Studiert dort zunächst Skulptur.

1978

Erste bedeutende Soloausstellung in den Riverside Studios in London. Radelt im Sommer mit zwei anderen Malern aus dem Exeter College von Holland nach Norwegen.

1980

Beginnt ein Master's Program an der Chelsea School of Art in London; schließt das Studium 1981 mit einem M.F.A. (Master of Fine Arts) in Malerei ab. Lernt die Maler Ian Stephenson und Bob Law kennen, die ihn stark beeinflussen. Vor allem Bob Laws Auffassung von der Malerei motiviert Joy, den von ihm eingeschlagenen künstlerischen Weg weiterzuverfolgen.

1981

Nach dem Abschluss des Studiums nimmt er sich eine Auszeit, fährt allein mit dem Fahrrad durch Spanien und entdeckt die Lyrik Pablo Nerudas, Antonio Machados und vor allem das Werk des peruanischen Dichters César Vallejo, das Joy von da an stets begleiten wird.
Herbst: Erhält am Chelterham College, England, ein Stipendium für Malerei. Damit verfügt er erstmals über ein richtiges Atelier, das sich in einem ehemaligen Museum in Stroud, Cotswolds, befindet. Arbeitet an einer Serie monolithischer, monochromer Gemälde, die auf den *Duineser Elegien* Rainer Maria Rilkes beruhen. Diese werden in Joys erster Museumsausstellung in der Serpentine Gallery, London, präsentiert.

1982

Zieht nach Kioto, Japan, um dort an der Kunsthochschule Kalligrafie und japanische Kultur zu studieren. Liest Werke Yukio Mishimas, die ihn tief beeindrucken.

1983

Zieht nach Norwegen, zunächst in eine kleine Hütte in Tysnes, eine Begräbnisstätte aus Wikingerzeiten. Später zieht er nach Oslo, heiratet Elenor Martinsen und mietet ein Atelier im Zentrum von Oslo. Außerdem wird er Professor an der Kunstakademie in Trondheim.

1986

Packt seine Habseligkeiten in ein altes Auto und fährt nach Italien, wo er in Umbrien ein wunderbares Atelier findet. Zunächst bezieht er das Atelier in einem mittelalterlichen Schloss in der Nähe von Assisi (Castello di Polgeto), später Umzug in ein nahe gelegenes Atelier bei einer Kirche aus dem 11. Jahrhundert.
Beginnt sich intensiv mit der Malerei der Prärenaissance und der Renaissance zu beschäftigen.
Repräsentiert Norwegen auf der Internationalen Kunstmesse Stockholm.

werkbetrachtung

WILLIAM ZIMMER

„Steve Joy gelingt ein Gleichgewicht zwischen dem Erhabenen und dem Alltäglichen und zwischen Farbe und Form. Entscheidend für Joys Begriff der Malerei ist, dass kein Zeichen ohne Bedeutung ist."

G. FAYANCE

„Seine gesamte Malerei ist ein Fest. Joy spricht eine zarte und feinfühlige Sprache, die für alle Kulturen offen ist und über den Ethnozentrismus hinausgeht. Aufgrund seiner vielen Reisen erkennt er den Unterschied, und seine Sicht wird universell."

WILLIAM ZIMMER

„Das herausragende Merkmal von Steve Joys Malerei ist, dass sie die Waage hält zwischen dem Kryptischen, sprich Privaten und damit dem extrem persönlichen Bereich, und dem völlig Klaren, Offenen und Freundlichen. Das ist ein schwieriges Gleichgewicht, für das es erheblicher Klugheit bedarf, aber es zeigt, was wir momentan am dringendsten benötigen."

1987

Verbringt den Winter in der mittelalterlichen belgischen Stadt Brügge. Schließt sich der Galerie t'leerhuys an und arbeitet in einem Atelier in einem aus dem 16. Jahrhundert stammenden Kutscherhaus in der Nähe des Groeningemuseum. Dies – und die Nähe zu Antwerpen und Gent – ermöglicht ihm den Zugang zu den großen Meistern der flämischen Malerei. Lebt in den folgenden Jahren abwechselnd in Brügge – im Winter – und während des Sommers in Umbrien.

STEVE JOY BRÜGGE, DEZEMBER, 1988

„Es gibt in meinem Werk eine ununterbrochene Linie von der Vergangenheit in die Gegenwart. Eine schlichte Anerkennung der bahnbrechenden Werke und Phasen in der Geschichte unserer Kultur. Aber ich reise: Es gibt andere Kulturen! Und außerdem ist Kunst ein Teil des Lebens, nicht etwas Separates.
Es gilt, so vieles aufzunehmen – und den Glauben zu bewahren. Und dann gibt es die Berge und das Meer. Die Schönheit und Geschichte in der Erde in der Umgebung meines Ateliers in Umbrien. Ich mache diese Gemälde in einem Zustand der Hingabe. Sie sind kontrolliert entstanden. Verwirrt und wissend. In diesen Tafeln gibt es keine Illusion: Sie existieren physisch, um die Poesie zu vermitteln."

1989

Begibt sich nach Menorca (Balearen) und bezieht dort zunächst ein Atelier in der Hauptstadt (Mahón), später dann eines in einem ehemaligen Kloster in der Mitte der Insel.

1990

Zieht nach New York City und beginnt, in einem Atelier in der Bond Street zu arbeiten. Schließt sich der Ruth Siegel Gallery auf der West 57th Street an. Verbringt die Sommer in einem neuen Atelier in Barcelona, in der Nähe des Hafens im gotischen Viertel.

MIQUEL JANE HUGUET

„Allegorien: geometrische Formen, Fiberglas … Hotelarchitekturen: goldene und silberne Formen … verloren gegangener Glanz; ein wächsernes Grün … Kupferdächer der Türme. Das ornamentgeschmückte Fenster geht auf einen imaginären Harem. Die Sterne sind der Schlüssel zu *1001 Nacht*, der Schlüssel zur Kunst als Träger abstrakter Gedankenkomplexe."

„In seinen letzten Gemälden über orientalische Hotels erinnert sich Steve Joy der verlorenen Pracht emblematischer Paläste. Seine vielgestaltige Malweise nimmt uns mit auf eine Reise durch die Kunstgeschichte. Seine Reise durch die vielfältigen Aspekte der Kultur führt zu einer universellen Sichtweise, seine abstrakte Malweise vermittelt sein universelles Denken."

1992

Wird Professor für Malerei an der École des Beaux-Arts von Caen in Frankreich und bezieht ein Atelier in dem Dorf Thury-Harcourt (Suisse-Normande). Erste französische Museumsausstellung im Musée des Beaux-Arts de Caen.

1994

Bezieht in der Nähe der Universität ein neues Atelier in Barcelona und schließt sich der Galerie Ferran Cano in Palma de Mallorca und Barcelona an. Die Freundschaft mit Sean Scully vertieft sich; Scully lebt in Barcelona auf der anderen Seite des Flurs.

1995

Akzeptiert eine Professur an der Westlichen Kunstakademie, Bergen (Norwegen). Pendelt zwischen Norwegen und Spanien. Erste Museumsausstellungen in Norwegen, zunächst in Haugesund und später in Bergen.

1998

Wird Kurator am Bemis Center for Contemporary Arts in Omaha und zieht später im selben Jahr dauerhaft in die Vereinigten Staaten.

1999

Nach dem Abschied vom Bemis Center beginnt er wieder in New York zu arbeiten. Verbringt die Sommer in Umbrien.

STEVE JOY, 2001

„Die ursprüngliche Anregung zur Malerei erhielt ich durch die Konfrontation mit den Werken Barnett Newmans und Mark Rothkos. Bis heute fühle ich mich der Idee der spirituellen Abstraktion und der Entwicklung der Malerei und ihrer Geschichte vom 15. Jahrhundert bis heute verpflichtet. Zu den Einflüssen der Vergangenheit zählen Duccio, Giotto, Velázquez und Matisse.

Die Werke in dieser Ausstellung wurden von den antiken Städten entlang der Seidenroute beeinflusst, die in China begann und in Konstantinopel, dem heutigen Istanbul, endete, von den antiken Tempeln und heiligen Stätten auf den griechischen Kykladen und einem obskuren und entlegenen Piratenfriedhof auf der Insel Sainte Marie vor Madagaskar."

2002

Ausgiebige Reisetätigkeit in Mexiko (Yucatán), Indien und Marokko. In Marokko reist er über das Atlasgebirge nach Erfoud am Rande der Sahara. Schließt sich der Joins Galleri Elenor in Oslo an.

STEVE JOY, 2004

„Ich habe überall auf der Welt gelebt, darunter auch viele Jahre im Fernen Osten, und meine aktuellen Werke enthalten die etwas romantische Idee, dass exotische und geheimnisvolle Orte von Gemälden erfasst werden können und uns so den Geschmack des Unbekannten vermitteln, ohne dass wir die Reise selbst antreten müssen.

In den letzten Jahren habe ich Gemälde gemacht, von denen ich hoffe, dass sich in ihnen der Geist so unterschiedlicher Orte wie ein Piratenfriedhof auf Madagaskar, die großartigen, aus dem 19. Jahrhundert stammenden Hotels und Paläste Indiens und des Fernen Ostens, ein Majatempel in Süd-Yucatán oder die entlegenen Wüsten Nordafrikas befindet, um nur einige zu nennen. Die jüngsten Gemälde in dieser Ausstellung sind ein Versuch, mich mit bestimmten ethischen, ästhetischen und spirituellen Codes zu beschäftigen, die die Geschichte der Menschheit durchziehen. Dazu zählen der Kriegercode der Samurai, die Hingabe und Loyalität von Menschen wie dem

heiligen Franziskus von Assisi, die große Tradition der russisch-orthodoxen Ikonenmalerei und schließlich eine Hommage an die erhabenen, ätherischen Porträts von Leonardo da Vinci."

Besucht abermals die Malediven im Indischen Ozean sowie frühere Inspirations- und Aufenthaltsorte. Reisen ins südliche Addu Atoll, wo sich 1971 eine Basis der Royal Air Force befand.
Joy ist weiter in New York tätig. Außerdem arbeitet er in einem großen Atelier im Old Market-Viertel in Omaha. Stellt bei Anderson O'Brien Fine Arts in Omaha aus.

2002-08
Wohnt (ab 2003) weiter in Omaha, verbringt aber die meisten Sommer in seiner Heimatstadt in England, im Haus der Familie am Rand von Dartmoor, Devon.

inseln und ikonen: die ANEGADA NIGHT-BILDER

STEVE JOY, OMAHA/NEW YORK, MARCH, 2003

„Mein ganzes Leben lang habe ich mich von Inseln angezogen gefühlt und bin in Devon und Cornwall in Südwestengland inmitten früher Erinnerungen an die See und Geschichten von Schmugglern und Piraten aufgewachsen, und später in den mehr oder weniger dichten Nebeln des Moorlands und der Kelten und der Mythologie der Antike. Ich habe auf Inseln gelebt: Den Malediven, im Indischen Ozean, auf griechischen und spanischen Inseln, und ich kehre immer wieder dorthin zurück, wenn ich ruhelos bin. In einer meiner letzten Ausstellungen, die ich Architecture of Silence nannte, habe ich an heilige Orte, Abteien und Kathedralen vielleicht, gedacht, an Räume im Kerzenschein und an den Duft von Weihrauch und Spezereien aus dem Osten. Doch vor allem dachte ich an die Stille, jene Art von Stille, die ich mit Ikonen verbinde, vor allem mit den großen Ikonen aus byzantinischer Zeit. Auf diesen Gemälden sieht man Engel in einer ekstatischen, quasi Stein gewordenen Stille. Ich habe mich oft gefragt: ‚Ist es möglich, diese Art gefrorener Stille in einem Gemälde zu produzieren, jene Art, die als Stein gewordene Sehnsucht erscheint?' Ich versuche, diese Gedanken der byzantinischen Kultur miteinander zu verbinden; meine Sehnsucht nach den Inseln und den antiken Mysterien des prähistorischen Britanniens ist vermutlich nur durch die Spuren und Fäden meines Lebens möglich, die die idealisierte Geometrie dieser Gemälde zurücklassen."

2005
Sommer und Herbst: Mietet sich ein Atelier in Norwegen – eine kleine Hütte am Fjord zwischen Oslo und Bergen, neben dem Hole Art Centre in Naess.

2006
Mietet eine Hütte am Rand von Dartmoor. Beginnt die Serie The Temple of Athene.

2008
Joy bezieht ein neues Atelier in Omaha in der 1101 Jackson Street. Design und Konzept des Ateliers stammen von dem ortsansässigen Architekten Paul Nelson.

Mächtig ist die Geometrie –
und in Verbindung mit Kunst unwiderstehlich.
EURIPIDES

zugänge zum göttlichen: die kunst, die ikonografie und ‚transzendentes licht' bei steve joy

KIM CARPENTER

Kim Carpenter ist Senior Staff Writer am Bemis Center for Contemporary Arts in Omaha, Nebraska, und war außerdem am Akron Art Museum in Akron, Ohio, tätig. Sie hat für zahlreiche Publikationen über Kunst und kunstgeschichtliche Themen geschrieben, darunter *Sculpture Review*, *NY Arts Magazine*, *Ceramics Monthly*, *Review Magazine* sowie *Modernism and German Life*. Sie wurde an der Georgetown University in Geschichte promoviert, hatte ein Fulbright Stipendium in Frankfurt am Main und war DAAD-Stipendiatin in München, wo sie die Recherchen für ihre Dissertation abschloss.

Rechtecke und Quadrate, Winkel und Linien: Das sind die Formen, die Steve Joys großartig leuchtende und präzise konstruierte Gemälde beherrschen. Sie sind deshalb so markant, weil sie aufeinander aufbauen und sich miteinander verbinden, indem die Vertikalen und die Horizontalen eine Einheit bilden, die zu einem unaufdringlichen Gleichklang zwischen dem Betrachter und dem Bild insgesamt führt.

Gewiss ist der Einsatz von Quadraten und Rechtecken in der Kunst nicht neu. Einige der berühmtesten Maler der Moderne haben sich dieser geometrischen Formen bedient. Kasimir Malewitsch, Theo van Doesburg, Piet Mondrian, Mark Rothko und Barnett Newman – sie alle integrierten bekanntlich Rechtecke und Quadrate in ihre Werke auf eine Weise, dass diese Grundformen zu selbstständigen, autoreflexiven Sujets wurden. Dennoch brachte natürlich jeder dieser Künstler höchst individuelle Bilderfindungen hervor, indem er Werke schuf, deren Erscheinungsform, deren Philosophie und deren Inhalt jeweils völlig unterschiedlich war. Auch heute noch setzen zeitgenössische Künstler in ihren Werken geometrische Formen auf markante Weise ein. Insbesondere Brice Marden hat rechteckige Werke geschaffen, die, wenngleich karg und monochrom, nichtsdestotrotz höchst ausdrucksvoll sind. Und Sean Scully, einer von Joys engen Freunden, verwendet in seinen Gemälden rechteckige Bänder und Streifen, mit denen er fließend sinnliche Kompositionen schafft. Die Werke Mardens und Scullys ebenso wie diejenigen Joys deuten alle darauf hin, dass Quadrate und Rechtecke – in ihrer Schlichtheit trügerisch komplex – in künstlerischer Hinsicht auch im 21. Jahrhundert weiterhin eine Rolle spielen.

Selbstverständlich reicht diese Begeisterung, wenn nicht Besessenheit von der Geometrie Jahrtausende zurück, und vielleicht ist es auch einfach unvermeidlich, dass Künstler sich von diesen Formen inspirieren lassen. Schließlich diente die Geometrie Philosophen, Naturwissenschaftlern, Theologen und Mathematikern als Muse, und zu allen Zeiten wurde sie von Denkern als ‚heilig' erachtet, also für eine Disziplin gehalten, die die Wahrheit des Kosmos enthüllt und wie kein anderes akademisches Fach einen flüchtigen Blick auf das Göttliche erlaubt. Im antiken Griechenland lehrte Pythagoras, die Geometrie sei die Erkenntnis dessen, was ewig existiert, und Platon vertrat die Auffassung, die Geometrie habe es bereits vor der Schöpfung gegeben. Der Mathematiker und Astronom Johannes Kepler ging sogar noch weiter und verkündete, die Geometrie sei der strahlende Geist Gottes selbst. Es verwundert daher nicht, dass die Künstler die Beherrschung der Geometrie als Voraussetzung für die Schaffung

von Kunst gemäß ihrem wahrsten, reinsten Wesen betrachteten. Der Renaissancemaler und -druckgrafiker Albrecht Dürer erklärte, die Geometrie diene als die richtige Grundlage jedweder Malerei, und in einer seiner Abhandlungen zur Konstruktions- und Proportionslehre bekräftigte er, kein Gemälde, wie sorgfältig es auch gestaltet sei, könne ohne die richtigen Proportionen ein gelungenes Kunstwerk sein.[1]

Ein halbes Jahrtausend später stützten sich die Künstler der klassischen Moderne auf diese Prämisse, indem sie mittels geometrischer Formen den inneren und äußeren Sinn des Lebens erkundeten. Dabei folgten sie alle ihrer je eigenen Überzeugung, wie sich dies in ihrer Kunst erreichen ließe. Damit schufen sie einen künstlerischen Rahmen, mit dem sich die abstrakte Malerei als ein Mittel zur Untersuchung intellektueller, philosophischer und theologischer Fragen einsetzen ließ. Der Kunsthistoriker Sheldon Nodelman bemerkt diesbezüglich: „[…] die großen Pioniere der abstrakten Malerei am Anfang des 20. Jahrhunderts, Kandinsky, Malewitsch und Mondrian, betrachteten die Abstraktion einhellig nicht nur als ein formales Verfahren, sondern als einen revolutionären Durchbruch zu einer wesentlicheren Sprache, in der sich die Prinzipien und Kräfte, die das Universum sowohl in seinen inneren als auch in seinen äußeren Aspekten beherrschten, erstmals direkt zum Ausdruck bringen ließen. Dieser Ausdruck war der ‚Gehalt‘ ihrer Kunst.“[2]

Kandinskys Abhandlung *Über das Geistige in der Kunst* war besonders einflussreich und ließ viele Künstler darüber nachdenken, wie sie die Malerei als Mittel für eine Untersuchung des Spirituellen einsetzen könnten, wobei ihnen die Geometrie häufig als Ausgangspunkt für diese Erkundungen diente. Laut John Milner, Professor für Kunstgeschichte an der Universität von Newcastle-upon-Tyne, erwies sich Kasimir Malewitsch „als Geometer einer neuen Sichtweise, bei der Proportion und Perspektive offenkundig ohne Bezug zu Motiven manipuliert wurden".[3] In seiner sogenannten *Letzten futuristischen Ausstellung ‚0/10‘* im Jahr 1915 stellte Malewitsch 39 Gemälde aus, dessen wichtigstes das eher unter der Bezeichnung *Das schwarze Quadrat* bekannte Bild *Viereck* ist.

Doch Malewitschs Gemälde war nicht ‚einfach nur‘ ein Quadrat. Für ihn besaß es eine tiefgründige spirituelle Bedeutung, und er behauptete sogar, in seiner strengen schwarzen Form „das Antlitz Gottes" zu sehen. Außerdem ergänzte er: „Das Quadrat ist keine unterbewusste Form. Es ist eine Schöpfung der intuitiven Vernunft. Es ist das Antlitz

einer neuen Kunst. Das Quadrat ist ein lebendes, königliches Kind. Es ist der erste Schritt zur reinen Schöpfung in der Kunst."[4]

In den Niederlanden experimentierte Theo van Doesburg auf ähnliche Weise mit der spirituellen Bedeutung des Quadrats, doch er tat dies mit üppigen, satten Farben. Van Doesburg bediente sich der Kunst als einer Methode, um die zeitgenössische Gesellschaft zu organisieren und zu transformieren und ihr letztlich eine transzendente Harmonie zu verleihen. Er erklärte: „Für uns ist das Quadrat das, was das Kreuz für die frühen Christen ist."[5] Es ist kein Zufall, dass auch sein enger Freund und Landsmann Piet Mondrian sich der Geometrie bediente, um die Welt neu zu schaffen, indem er sie auf ihre Grundgestalt oder „abstrakte Realität" reduzierte. In einem Kommentar zu seinem Ansatz erklärte er einmal kurz und bündig: „Das Vertikale und das Horizontale gibt es auch anderswo in der Natur."[6] Doch Mondrian trieben tiefgründigere Fragen um, und er nutzte die abstrakte Kunst, um Antworten darauf zu finden.[7] „Kunst", so Mondrian, „obzwar wie die Religion ein Selbstzweck, ist das Mittel, durch das wir das Universelle erkennen können."[8]

Doch Mark Rothko, Barnett Newman und Brice Marden sind diejenigen Künstler, denen Joy in intellektueller und ästhetischer Hinsicht am meisten verdankt, und alle drei haben seine Malpraxis auf die eine oder andere Weise beeinflusst. Interessanterweise zeichnet dieses Trio auch für die Schaffung einiger der bedeutendsten spirituellen Kunstwerke der Moderne verantwortlich. Roberta Smith, eine der führenden Kunstkritikerinnen der *New York Times*, hat hierzu bemerkt: „Wie man es auch drehen und wenden mag, die Liste der großen Werke moderner religiöser Kunst, die seit der Jahrhundertmitte geschaffen wurde, ist nicht sehr lang. Meine beginnt mit Matisse‘

1 Vgl. Lüdicke, Heinz, *Albrecht Dürer*, New York 1970, S. 25. (Der orginale Wortlaut von Dürers Äußerung lautet: „Wo dw mit nemen und geben der mas dem leben gemes nit verstendig pist, so würt all dein machen vergebens, und dein weck unliblich erscheinen." Zit. nach: Hammerschmied, Ilse, *Albrecht Dürers kunsttheoretische Schriften*, Egelsbach u.a. 1997, S. 120.)

2 Nodelman, Sheldon, *The Rothko Chapel Paintings: Origins, Structure, Meaning*, Austin 1997, S. 310.

3 Milner, John, *Kazimir Malevich and the Art of Geometry*, New Haven 1996, S. 121.

4 Zit. in: ebd., S. 125.

5 Zit. in: Gablik, Suzi, *Has Modernism Failed?*, London 2004, S. 31.

6 Bois, Yve-Alain, Joop Joosten, Angelica Zander Rudenstine, Hans Janssen (Hrsg.), *Piet Mondrian: 1872–1944*, New York 1994, S. 184.

7 Bois, Yve-Alain, „The Iconoclast", in: ebd., S. 329.

8 Golding, John, *Paths to the Absolute: Mondrian, Malevich, Kandinsky, Pollock, Newman, Rothko, and Stil*, Princeton 2000, S. 26.

großartiger Kapelle in Vence, Barnett Newmans asketischem Gemäldezyklus *The Stations of the Cross*, vielleicht Brice Mardens *Annunciation*-Bildern mit ihrer Palette gedämpfter Primärfarben sowie viele von Mark Rothkos sich verflüchtigenden Bildern mit ihren dunklen, leuchtenden Farbwolken, die eine diffuse jenseitige Präsenz vermitteln."[9]

Werke Rothkos und Newmans vermittelten Joy die Einsicht, dass Kunst als Mittel zur Auseinandersetzung mit existenziellen Fragen dienen kann. Er hat diese künstlerische Inspirationsquelle ausdrücklich anerkannt; in seinem Künstlerstatement für die Ausstellung *Olive Groves and Icons* 2004 in der Galleri Elenor in Oslo, Norwegen, schrieb er: „Die ursprüngliche Inspiration, selbst zu malen, verdankt sich meiner Begegnung mit den Werken Barnett Newmans und Mark Rothkos. Noch heute fühle ich mich der Idee der spirituellen Abstraktion und der Entwicklung der Malerei und ihrer Geschichte vom 15. Jahrhundert bis heute verpflichtet."

Zufälligerweise bietet eine Stellungnahme Rothkos von 1945 Einsichten in den Ursprung von Joys Denken: „Der abstrakte Künstler hat vielen nicht wahrgenommenen Welten und Tempi eine materielle Existenz verliehen", schrieb Rothko: „Denn Kunst ist für mich eine Anekdote des Geistes und das einzige Mittel, um den Zweck ihrer abwechslungsreichen Regsamkeit und Stille konkret werden zu lassen."[10] Im Rahmen seiner Auseinandersetzung mit der Frage, wie es Rothko gelang, Werke zu schaffen, die als diese ‚Anekdote' funktionieren, verweist Mark Stevens, Kunstkritiker des *New York Magazine*, auf die Verwendung geometrischer Formen durch den Künstler: „Die grundlegende, aber flexible Struktur von Rothkos klassischen Werken eignet sich ideal dafür, dass der Geist sich entspannen und solchen Reflexionen überlassen kann. Vor allem Rothkos einfache Geometrie versetzt diejenigen, die zu religiösen Träumereien neigen, normalerweise in eine solche Gemütsverfassung. Ganz unabhängig davon, wie komplex eine Religion hinsichtlich ihrer Details sein mag, bewahrt sie sich doch nahe ihrem Herzen nicht selten eine einfache geometrische Form."[11]

Sheldon Nodelman stellt darüber hinaus fest, dass Rothkos Gemälde eine „neue geometrische Exaktheit hatten", die „eine genau umrissene, geometrische Oberfläche" schufen, „welche durch einander überschneidende vertikale und horizontale Achsen definiert wurde".[12] Rechtecke erwiesen sich für den Künstler als die in existentieller Hinsicht bedeutsamsten Formen, sogar so sehr, dass er sie auch für die

Serie seiner Gemälde in der Rothko Chapel in Houston verwendete. Als man ihn drängte, offen zu legen, welche Absicht er mit diesen Gemälden verfolgt habe, lehnte es Rothko ab, näher darauf einzugehen, und erklärte lediglich, er habe versucht, „sowohl das Endliche als auch das Unendliche zu malen". Nodelman konstatiert, diese Gemälde seien „inhärent und per se religiös, insofern sie die ewigen Fragen nach dem Schicksal des Menschen und dem Sinn der Existenz thematisieren".[13]

Auch Barnett Newman versuchte mittels seiner Gemälde, von denen die Rechtecke, die durch lange, vertikale Streifen oder ‚zips' in zwei Hälften unterteilt werden, die berühmtesten sind, diesen ‚ewigen Fragen' nahe zu kommen. Newman hatte vieles mit Rothko gemein, etwa den künstlerischen Hintergrund, Bildung und soziales Umfeld, und wie Rothko schuf er eine Serie abstrakter religiöser Gemälde, die er *The Stations of the Cross* nannte. Im Rahmen seiner Erklärung von Newmans Versuch, Gemälde zu schaffen, die über „geometrische Formen um ihrer selbst willen" hinausgehen, konstatiert der Konzeptkünstler Mel Bochner, Newman habe diese Formen verwendet, weil ihr „abstrakter Charakter einen intellektuellen Inhalt"[14] habe. Dies stand für Newman an erster Stelle. In seinem Essay *Das plasmische Bild* von 1945 schrieb er: „Der heutige Maler befasst sich nicht mit seinen eigenen Gefühlen oder mit dem Geheimnis der eigenen Persönlichkeit, sondern mit der Durchdringung des Welt-Mysteriums. Seine Vorstellungskraft versucht deshalb, zu den metaphysischen Geheimnissen vorzudringen. Insofern befasst sich seine Kunst also mit dem Sublimen. Es ist eine religiöse Kunst, die die grundlegende Wahrheit des Lebens durch Symbole einfangen möchte, was ihr eine tragische Note verleiht."[15] Im Weiteren setzte er das Schaffen von Kunst sogar mit dem Göttlichen gleich: „[...] im Verlangen des Künstlers, in seinem Willen, die geordnete Wahrheit festzulegen, also seine Haltung zum Mysterium von Leben und Tod zum Ausdruck zu bringen, vertieft er sich wie ein echter Schöpfer in das Chaos. Genau das macht ihn zum Künstler, denn bei der Erschaffung der Welt begann der Schöpfer mit dem gleichen Material – so wie der Künstler versuchte, der Leere eine Wahrheit abzuringen."[16]

Im Gegensatz zu Rothko und Newman findet sich in Joys Künstlerstatements kein expliziter Bezug auf Brice Marden. Doch in einem Interview mit dem Kunsthistoriker und -kritiker David Carrier deutete Joy an, Mardens Untersuchung des anhaltenden Einflusses der jüdisch-christlichen Tradition auf die zeitgenössische Kunst habe sein eigenes Streben beeinflusst, in der modernen, materiellen Welt Spiritua-

**die kunst, die ikonografie und ‚transzendentes licht' bei steve joy
KIM CARPENTER**

lität zum Ausdruck zu bringen. Mardens ebenso asketische wie fesselnde *Annunciation*-Serie lässt den Betrachter automatisch an Rothkos und Newmans religiöse Serien denken. Und wie sie hat Marden Geometrie als ein Schlüsselelement seines Werks bezeichnet: „Das Rechteck, die Fläche, die Struktur, das Bild sind lediglich Ausdrucksformen für einen Geist."[17] Aber vielleicht noch wichtiger für Joy ist Mardens Auffassung, welche Rolle die Malerei für die zeitgenössische Gesellschaft spielt: „Ich weiß, es ist ein heikles Gebiet, aber ich definiere Malerei gerne unter spirituellen Gesichtspunkten. Welches Sujet oder welche Struktur auch immer ich an die Malerei herantrage – und verwende und durcharbeite und als Faktoren zugrunde lege –, für mich geht es bei der Malerei stets darum, zu etwas zu gelangen, über das ich nichts weiß oder das ich nicht verstehe. Und der Weg, auf dem ich dorthin gelange, ist bildlicher Natur."[18]

Durch ihre innovative Darstellung von Quadraten und Rechtecken brachten Rothko, Newman, Marden und ihre Vorläufer das Spirituelle durch abstrakte Kunst zum Ausdruck. Womöglich waren ihre Werke genau deshalb spirituell, weil sie nicht auf der physischen Realität beruhten, da sie de facto metaphysisch waren. So oder so gibt es für Joys Verwendung geometrischer Formen zur Vermittlung einer tieferen Spiritualität bekannte künstlerische Vorläufer. Aber obwohl es zwischen ihm und diesen modernen Malern Einflüsse und Ähnlichkeiten gibt, ist Joy keineswegs ein bloßer Nachahmer. Vielmehr hat er ein neues Genre geschaffen, das über die künstlerischen Traditionen hinausgeht, die von diesen früheren Künstlern etabliert worden sind. Er hat dies getan, indem er zur älteren und ähnlich strengen Tradition der Ikonenmalerei zurückkehrte. Während andere spirituelle Abstraktionisten in vielerlei Hinsicht mit der Tradition als Möglichkeit, Heiliges auszudrücken, gebrochen haben, kombiniert Joy eine figurative religiöse Kunstform mit einer modernen abstrakten und verschmilzt beide miteinander. Zu diesem Zweck verwendet er nicht nur die ‚heilige Geometrie' als eine Grundlage für diese künstlerische Erweiterung, sondern auch das, was im Glauben der orthodoxen Kirche als ‚transzendentes Licht' bezeichnet wird.

Die Tradition der Ikonenmalerei reicht mindestens ein Jahrtausend zurück, wenn nicht sogar noch weiter, und wird meist mit der Russisch-Orthodoxen Kirche oder der orthodoxen Ostkirche in Verbindung gebracht, wo sie eine wesentliche Rolle im Kontext des religiösen Kults spielt. Da die materielle Welt und das Reich des Göttlichen eng miteinander verknüpft sind, dienen Ikonen als Bindeglied zwischen beiden. Dies bedeutet allerdings nicht, dass Anhänger des öst-

lich-orthodoxen Glaubens Ikonen verehren. Vielmehr handelt es sich bei Ikonen um Bilder, die Zugang zu göttlichem Wissen ermöglichen und als ein Mittel dienen, „durch das sowohl der Ikonograf als auch der betende Gläubige am Reich der Ewigkeit teilhaben kann".[19] Die Ikonenexpertin Linette Martin beschreibt diese heiligen Bilder als Portale, „die als Türen zwischen dieser Welt und einer anderen Welt fungieren sollen, zwischen den Menschen und dem fleischgewordenen Gott, seiner Mutter oder seinen Freunden, den Heiligen [...]. Der Hauptzweck einer Ikone besteht darin, eine unmittelbare Begegnung mit einem Heiligen zu ermöglichen oder ein heiliges Ereignis zu vergegenwärtigen, doch zugleich sind Ikonen auch eine ‚Theologie in Farbe'."[20] Insofern sind Ikonen ‚zeitlos' und existieren metaphorisch zwischen der Zeit und dem Raum.[21] Doch zugleich sind sie auch in starkem Maße Teil unserer Zeit und erleichtern das, was Martin eine „direkte Kommunikation" mit dem Göttlichen nennt, die „direkt vom Auge zum Herzen" erfolgt.[22]

Die Beschreibung einer Ikone als ‚Theologie der Farbe', die als ‚Tür' zwischen dem Irdischen und dem Göttlichen fungiert, bringt Joys reife Werke genau auf den Punkt. Anlässlich einer Ausstellung in Brügge, Belgien, in der 'tleerhuys Galerij 1989 schrieb Joy in seinem

9 Smith, Roberta, „Religion That's in the Details; A Madonna and Drain Pipe Radiate an Earthy Spirituality", in: *The New York Times*, 18. November 1997.

10 Rothko, Mark, „Personal Statement, 1945", in: López-Ramiro, Miguel (Hrsg.), *Mark Rothko: Writings*, New Haven 2006, S. 45.

11 Stevens, Mark, „The Multiforms 1947–1948", in: Glimcher, Mark (Hrsg.), *The Art of Mark Rothko: Into an Unknown World*, New York 1991, S. 43.

12 Nodelman, a.a.O., S. 101.

13 Ebd., S. 306.

14 Bochner, Mel, „Barnett Newman: Writing Painting/Painting Writing", in: Ho, Melissa (Hrsg.), *Reconsidering Barnett Newman: A Symposium at the Philadelphia Museum of Art*, New Haven 2005, S. 23.

15 Newman, Barnett, „The Plasmic Image", in: O'Neill, John P. (Hrsg.), *Barnett Newman: Selected Writings and Interviews*, New York 1990, S. 140 [Dt., „Das plasmische Bild", in: Newman, Barnett, *Schriften und Interviews 1925–1970*, übers. v. Tarcisius Schelbert, Bern, Berlin 1996, S. 113].

16 Ebd., [Dt., S. 114].

17 Zit. nach Fischer, Peter, „Brice Marden", in: *In the Power of Painting: Andy Warhol, Sigmar Polke, Gerhard Richter, Cy Twombly, Brice Marden, Ross Bleckner – A Selection from the Daros Collection*, Zürich 2000, S. 108.

18 Ebd., S. 118.

19 Zelensky, Elizabeth und Lela Gilbert, *Windows to Heaven: Introducing Icons to Protestants and Catholics*, Grand Rapids 2005, S. 22f.

20 Martin, Linette, *Sacred Doorways: A Beginner's Guide to Icons*, Brewster, Mass., 2002, S. xv.

21 Zelensky und Gilbert, a.a.O., S. 30.

22 Martin, a.a.O., S. 204f.

Künstlerstatement, er wolle, dass seine Werke „eine offene [wenn nicht ‚lebendige'] Tür" seien: „Ich versuche, meinen Glauben an die Abstraktion zu zeigen. Diese Tafeln, vielfältigen Konfigurationen, Formen und Farben (Grundlagenarbeiten für die Komplexitäten abstrakten Denkens) sind eine offene Tür, mein Versuch, mit meinen Quellen in Berührung zu bleiben."

Interessanterweise waren diese Quellen nicht osteuropäischer Herkunft, sondern entstammten der Stadt, in der diese Ausstellung stattfand. Brügge, das im westlichen Teil Belgiens liegt, hat sich seit dem Spätmittelalter relativ wenig verändert, und als Joy dort in den späten 1980er Jahren lebte, begann er Werke zu entwickeln, in denen sich seine entscheidende Hinwendung zur spirituellen Abstraktion bereits ankündigte. Bei seiner Ausstellung in der 'tleerhuys Galerij präsentierte er mehrere Gemälde, darunter *Outsinging* (1987, siehe Seite 171) und *Signal* (1989), die schon in diese Richtung deuteten. *Signal* (siehe Seite 151) etwa ähnelt dem griechischen Kreuz, das daran zu erkennen ist, dass es vier Arme gleicher Länge besitzt. Trotz des zusätzlichen dunklen Farbblocks oben rechts ist das der christlichen Tradition entstammende Motiv klar. Selbst Werke, die von diesem stilistischen Ansatz abwichen, verweisen auf Joys zunehmendes Interesse an der spirituellen Anwendbarkeit der Malerei. *Amish House Nr. 2* (1989, siehe Seite 150) ist aufgrund seines Sujets ein inhärent religiöses Bild, während *Chalice* (1988–89) bereits durch seinen Titel [Kelch] Joys spirituelle Absicht nahe legt. Selbst wenn Joy flämische und italienische Werke aus dem 14. und 15. Jahrhundert als seine Quellen nannte, verwies er zugleich auf die spirituelle Seite seines Werks: „Ich mache diese Gemälde in einem Zustand der völligen Hingabe."

Innerhalb von drei Jahren nahm Joys Malpraxis eine entscheidende Wendung. Im Herbst 2002 hatte er eine Einzelausstellung in der Galleri Elenor in Norwegen, anlässlich derer er schrieb: „Die neuesten Werke sind von der Zeit beeinflusst, die ich vor vielen Jahren in Frankreich verbracht habe und durch die erhabene Erfahrung und räumliche und spirituelle Komplexität der vielen Zisterzienserklöster und Kirchen in diesem Land. Ich habe sie die *Architecture of Silence*-Bilder genannt. Sie wurden mit ähnlichen Materialien und Techniken geschaffen, wie sie auch in der mittelalterlichen Ikonenmalerei verwendet wurden."

In dieser Zeit begann Joy, auch traditionelle in der Ikonenmalerei verwendete Materialien wie etwa Blattgold und Bienenwachs häufiger

zu benutzen. Doch erst im folgenden Jahr sollte die physische Methode mit dem intellektuellen Prozess verschmelzen. Für die Ausstellung *Island and Ikons: The Anegada Night Paintings* in der Fluxion Gallery in Omaha hatte er die seiner Kunst zugrunde liegenden Theorien vollständig ausformuliert und bediente sich nicht mehr einfach der künstlerischen Praktiken der Ikonenmaler; er fing sogar an, die Malerei an sich als einen heiligen Akt zu begreifen: Dabei „habe ich an heilige Orte, Abteien und Kathedralen vielleicht, gedacht, an Räume im Kerzenschein und an den Duft von Weihrauch und Spezereien aus dem Osten. Doch vor allem dachte ich an die Stille, jene Art von Stille, die ich mit Ikonen verbinde, vor allem mit den großen Ikonen aus byzantinischer Zeit. Auf diesen Gemälden sieht man Engel in einer ekstatischen, quasi Stein gewordenen Stille. Ich habe mich oft gefragt: ‚Ist es möglich, diese Art gefrorener Stille in einem Gemälde zu produzieren, jene Art, die als Stein gewordene Sehnsucht erscheint?'"

Im Jahr 2004 beantwortete Joy diese Frage. Anlässlich einer anderen Ausstellung in Omaha, diesmal in der Anderson O'Brien Art Gallery, erläuterte er sehr aufschlussreich, seine Gemälde seien „ein Versuch, mich mit bestimmten ethischen, ästhetischen und spirituellen Codes zu beschäftigen, die die Geschichte der Menschheit durchziehen. Dazu zählen der Kriegercode der Samurai, die Hingabe und Loyalität von Menschen wie dem heiligen Franziskus von Assisi, die große Tradition der russisch-orthodoxen Ikonenmalerei und schließlich eine Hommage an die erhabenen, ätherischen Porträts von Leonardo da Vinci."

Die Ansicht, Joy schaffe zeitgenössische Ikonen, dürfte im Widerspruch zu der Vorstellung stehen, die sich die meisten Menschen von diesen religiösen Werken machen: figurative, aber statische Porträts von Heiligen, Märtyrern oder Jesus, von einem goldenen Heiligenschein umgeben. Das heißt, es sind Bilder dessen, was Menschen gesehen haben. Im Gegensatz hierzu ‚sind' Joys Gemälde die Ikonen an und für sich. Sie funktionieren als Ikonen des nicht Wahrgenommenen und des Göttlichen und sie verwenden die Geometrie und das Licht, die das Universum umfassen.

Doch so radikal diese Abweichung von der Norm auch wirken mag, haben Joys zeitgenössische Bilder doch mehr mit der Tradition der Ikonenmalerei gemein, als es zunächst den Anschein hat. Der Gebrauch eines geometrischen Ansatzes ist für Ikonen ideal, da es ihnen ganz bewusst an Tiefe mangelt und sie auf Perspektive verzichten. Darüber hinaus spielen geometrische Formen innerhalb der

Ikonentradition eine wichtige Rolle. So repräsentiert etwa ein Kreis, der in seiner geschlossenen Struktur vollkommen ist, den Himmel, ein – unvollkommenes – Quadrat hingegen versinnbildlicht die Erde oder, genauer gesagt, den Bereich des Irdischen. Laut Alva William Steffler, Bildhauer, Kunstprofessor und Advokat der Gruppe Christians in the Visual Arts (CIVA) ist das Quadrat „die statischste, undynamischste aller Formen und wird daher verwendet, um Gleichgewicht und Entschlossenheit zu suggerieren." Steffler weist darüber hinaus darauf hin, dass das Quadrat in der Bibel die vier Himmelsrichtungen sowie die vier Winkel der Erde repräsentiert.[23] Auch das Rechteck besitzt eine eigene Symbolik. Wiederum bietet Steffler Aufschluss und seine Beobachtungen sind für Joys Werk von besonderer Relevanz: „Als Teil des Systems ‚heiliger Geometrie und Proportion' in der Tradition der Ikonenproduktion gilt das Rechteck, das auf dem Verhältnis 4:3 basiert, als das geometrische Symbol der Harmonie. Frühe Ikonenmaler verstanden diese Ordnung und Proportion als wesentliche Voraussetzung, um die spirituelle Bedeutung der Ikone zu vermitteln. Die Griechen nannten dieses in der Natur auftretende proportionale Verhältnis den Goldenen Schnitt. Dieser demonstriert mit seiner essentiellen Geometrie den Mittelwert zwischen Extremen. In Zahlen ausgedrückt lautet die Goldene Proportion 1 zu 1,618. Christliche Künstler haben das proportionale Verhältnis des Goldenen Schnitts mit dem Geheimnis Gottes in Verbindung gebracht; daher wird der Goldene Schnitt auch als die Göttliche Proportion bezeichnet."[24]

Aber das Rechteck kann auch etwas anderes bedeuten. Im Mittelalter herrschte die Meinung vor, die Erde sei flach oder rechteckig, und Ikonen stellen die Erde häufig auf diese Weise dar. Daher ist der Tisch beim letzten Abendmahl, auf den Jesus seinen Kelch stellt, ein Rechteck, das heißt: Jesus stellt seinen Kelch auf die Welt und das Schicksal der Menschheit.

In Anbetracht der Wichtigkeit, die mit bestimmten geometrischen Formen verbunden wird, hat die Geometrie, die als Grundlage für die meisten von Joys Gemälden dient, eine entscheidende Bedeutung. *Icon Anastasia the Healer* und *Icon With Sava and Symeon* (siehe Seite 43) etwa zeigen Rechtecke und Quadrate, die einander entgegengesetzte Farbblöcke bilden, die Räume skizzieren und den Blick des Betrachters umschließen und fokussieren. Die Quadrate, Streifen und Rechtecke stehen im Gegensatz zueinander und bilden wie die Farben ein kontrapunktisches Verhältnis. Diese Polarität veranlasst die Betrachter, innezuhalten und mit diesen Werken auf einer

sehr persönlichen, intimen Ebene zu interagieren, ja, an dem metaphysischen Geben und Nehmen teilzunehmen.

Diese Idee des ‚Gebens und Nehmens' steht in einem direkten Zusammenhang mit Joys Gemälde *Saint Anastasia the Healer*. In der byzantinischen Kirche wird die heilige Anastasia als Heilerin körperlicher und spiritueller Gebrechen verehrt, aber auch deshalb, weil sie böse Geister austreibt. Diese Heilige verfügt also über die Fähigkeit, Heilung zu ‚geben' und physische wie geistige Krankheiten zu ‚nehmen'. In Joys Neudeutung dieser traditionellen Ikone verwendet er bernsteinfarbene horizontale Streifen, um damit schwarze vertikale Rechtecke auszubalancieren, wobei das strahlende Licht der Ersteren die Dunkelheit der Letzteren empor- und aus dem Rahmen zu drücken scheint.

Der heilige Sava und der heilige Symeon nehmen innerhalb des orthodoxen Glaubens eine ähnlich sakrale Stellung ein und beide werden als Kirchenväter verehrt. Sava gründete im 13. Jahrhundert die Serbisch-Orthdoxe Kirche und galt als einer der wenigen, der Gott ‚erkannt' oder göttliches Wissen erlangt hatte. Der heilige Symeon, ein asketischer Mystiker, der auch als der ‚Neue Theologe' bezeichnet wurde, setzte sich für eine Rückkehr zum Wesen des Christentums durch die Erfahrung des lebenden Christus ein: „Sagt nicht, es sei unmöglich, den Geist Gottes zum empfangen. Sagt nicht, man könne ohne IHN zu einem ganzen Wesen werden. Sagt nicht, man könne IHN besitzen, ohne es zu wissen. Sagt nicht, Gott zeige sich dem Menschen nicht. Sagt nicht, die Menschen könnten das göttliche Licht nicht erkennen, oder dass es in diesem Zeitalter unmöglich sei! Es ist nie unmöglich, meine Freunde. Im Gegenteil, es ist absolut möglich, wenn man es sich heftig wünscht."[25]

Durch eine rechteckige Säule in zwei eigenständige Komponenten unterteilt, ist Joys *Icon With Sava and Symeon* eine feierliche geometrische Komposition, die als eine Metapher für jenes ‚göttliche Licht' dient. Im Verlauf der Jahrhunderte haben die Ikonenmaler den heiligen Sava typischerweise mit weißen Gewändern in warmen goldenen

23 Steffler, Alva William, *Symbols of the Christian Faith*, Grand Rapids 2002, S. 80. Steffler zitiert hier die Bibelstellen Jesaja 11, 12 und Hesekiel 7, 2.

24 Ebd., S. 80f. Steffler weist außerdem darauf hin, dass die Arche Noah (Genesis 6, 14-17) ebenso wie die Bundeslade (Exodus 25, 10-17) rechteckige Maße gehabt haben soll.

25 Der Heilige Symeon über Spiritualität, Hymnus 27, 125-132.

Tönen porträtiert, wie sie auf der linken Seite dieses Werks zu sehen sind. Savas Rolle als Gründungsvater unterstreicht den pfeilerartigen Aspekt dieses Teils des Gemäldes, der sich aus der Leinwand herauszuheben scheint. Im Gegensatz hierzu bilden die Rechtecke in Symeons ‚Teil', also auf der rechten Seite, eine Leiter, eine visuelle Form, die Leinwand stufenweise zu erklimmen, eine figurative Art, zum ‚Geist Gottes' emporzusteigen und ihn zu erleben.

In farblicher Hinsicht enthält dieses Gemälde ebenso wie *Hodegetria*, *Madonna and Child* sowie *Trinity* (siehe Seite 70 und 72f.) eine gleichermaßen eindrucksvolle Symbolik. Wie bei den geometrischen Konfigurationen haben Joys Farbkombinationen eine spezifische Bedeutung innerhalb der Ikonentradition. In vielen Fällen ist die Bedeutung der Farben offenkundig: Rot symbolisiert Blut und Leben, ebenso wie das Opfer der Märtyrer. Grün lässt an Gras, Blätter und Frühling denken, die ihrerseits für Leben und Wachstum stehen. Blau bedeutet das göttliche Reich des Himmels. Und der tiefe rotbraune Purpur repräsentiert häufig die Farbe der Gewänder der Jungfrau Maria und der Heiligen und Märtyrer, aber auch die der Königswürde, der irdischen wie der göttlichen.

Gold jedoch erweist sich als die bedeutsamste Farbe innerhalb der Farbtradition. Es repräsentiert die Sonne, also die Farbe des Lebens. Gold versinnbildlicht aber auch die Ewigkeit und das göttliche Licht. In Ikonenbildern kann der Hintergrund oder Glorienschein eines Heiligen golden sein, um zu zeigen, dass er oder sie in der Ewigkeit lebt, und selbst Gesichter sind manchmal golden, als würden sie im göttlichen Licht erstrahlen. Diese Aureolen ‚göttlichen Lichts' stehen im Mittelpunkt des byzantinischen Glaubens. Die orthodoxe Autorin und Kommentatorin Frederica Matthewes-Green erklärt: „Überall in der Schrift und der Geschichte des Christentums findet sich durchgängig die Botschaft, dass Gott das Licht ist, und von denjenigen, die zu ihm gehören, heißt es, sie seien durch SEINE Gegenwart erleuchtet." Anschließend weist sie außerdem darauf hin, die Jünger hätten Jesus, als dieser von den Toten auferstand, „in einem Licht leuchten gesehen, das nicht irdischen Ursprungs war".[26] Gold bringt dieses ‚ewige Licht Gottes' am besten zum Ausdruck, und in traditionellen Ikonengemälden stellt Gold Aureolen und das Strahlen der Gewänder Christi ebenso dar wie „das Strahlen des transzendenten Lichts".[27]

In dieser Beziehung erzeugt Joy eine weitere, noch bedeutsamere Schicht innerhalb von *Icon With Sava and Symeon*. In seinen Schriften erklärt der heilige Symeon mehrfach, man könne zur Offenbarung

Gottes und der Dreieinigkeit gelangen, indem man das „transzendente Licht" oder Gottes göttliche Energien wahrnehme. „Lasst euch nicht täuschen!" mahnt er in seiner Abhandlung *Das Licht Gottes*, „Gott ist das Licht (Johannes, 1,9) und diejenigen, die einsgeworden sind mit IHM, lässt er in dem Maße an seinem eigenen Glanz teilhaben, in dem sie geläutert sind."[28] Diese Läuterung, so Symeon, lässt sich allein durch spirituelles Wachstum und Frömmigkeit erreichen, das heißt, durch Glauben, Liebe und Wahrheit. Das Potential liegt in jedem Einzelnen von uns, aber es verlangt persönliche Disziplin und den Willen, Egozentrik und weltliche Bande zugunsten des Ewigen aufzugeben. Sobald dies geschieht, sind wir durch Gottes göttliche Gnade ‚geheilt' oder ‚erleuchtet'. Der heilige Sava war ein solcher wahrer Gläubiger, und es hieß, er strahle in seinem eigenen göttlichen Licht. Mit seinen leuchtenden Tafeln glänzenden Goldes versinnbildlicht Joys Gemälde dieser beiden Heiligen Savas strahlenden Glanz und Symeons ‚transzendentes Licht' und repräsentiert dadurch diesen Gipfel des orthodoxen Mystizismus sowohl auf einer künstlerischen als auch auf einer existenziellen Ebene.

In *Icon After Hodegetria* bedient Joy sich einer ähnlichen Symbolik, aber mit einer anderen Wirkung. Das Wort Hodegetria stammt aus dem Griechischen und bedeutet ‚Jemand, der den Weg weist'; in Hodegetria-Ikonen hält die Jungfrau Maria das Jesuskind charakteristischerweise auf dem Schoß und weist mit deutlich ausgestreckten Fingern auf den Knaben, um ihn gegenüber den Betrachtern als ‚den Weg' kenntlich zu machen. In Joys zeitgenössischer Ikone werden zwei Bilder miteinander kombiniert: das größere links, das Maria darstellt, und das kleinere, das Christus repräsentiert. Direkt nebeneinander erscheinen sie in derselben Kontur wie auf den Hodegetria-Ikonen. Auf der Tafel Marias spiegelt das Karmesinrot den intensiven rötlichen Purpur der Gewänder der Gottesmutter, während das Gold in der Mitte oben ihre Krone/Aureole symbolisiert. Im kürzeren Abschnitt des Werks ähneln die Bernsteintöne den Farben, die für die Darstellung der Kleidung des Jesuskindes verwendet werden. Von zentraler Bedeutung für die gesamte Komposition sind jedoch die drei schwarzen horizontalen Rechtecke auf der linken Seite. Wie die verlängerten Finger der Jungfrau Maria deuten sie auf den ‚Weg', eine buchstäbliche ‚heilige Geometrie'. In *Hodegetria Virgin* verwendet Joy vier vertikale Rechtecke, die in diesem Fall alle gleich groß sind. Wenn das Auge des Betrachters das Werk von links nach rechts ‚liest', so bewegt es sich von der Finsternis ins Licht. Die Säule links besteht aus einem massiven Schwarz, das die Finsternis und die Abtrennung von der Glorie Gottes symbolisiert. Doch während sich

die kunst, die ikonografie und ‚transzendentes licht' bei steve joy
KIM CARPENTER

das Auge nach rechts bewegt, beginnen sich die Farben aufzuhellen. Die zweite Tafel von links besteht aus horizontalen Streifen, die einmal mehr auf den ‚Weg' verweisen. Die bernsteinfarbenen Streifen beinhalten zwar noch schwarze Elemente, doch im Aufsteigen werden sie allmählich heller. Die weißen Streifen lenken den Blick des Betrachters auf die nächste Tafel, die völlig weiß ist und damit die Farbe des Lichts und der Reinheit besitzt.[29] Die rechte Säule manifestiert sich kraftvoll in stufenweisen Abschattungen aus Gold und führt den Betrachter schließlich in das göttliche, transzendente Licht.

Joys *Virgin of Vladimir* basiert auf einem Ikonengemälde gleichen Namens, das ein Jahrtausend zurückreicht und häufig als Russlands berühmteste Ikone bezeichnet wird. Dieses Gemälde bietet eine andere Perspektive auf die Jungfrau Maria und das Christuskind. Joy verwendet hier ein langes Paneel aus fünf verschiedenen horizontalen Farbbändern. Das Weiße repräsentiert sowohl Marias Gesicht als auch ihre Reinheit, die einmal mehr von einem goldenen, leuchtenden Glorienschein bekrönt wird, und das Dunkelbraun steht für ihre Gewänder oder irdische Kleidung. Das längste Goldband repräsentiert das Jesuskind, welches dem Gemälde im buchstäblichen und im übertragenen Sinn einen Anker verleiht. Im Gegensatz hierzu ist das Gemälde *Madonna and Child* (siehe Seite 70) ganz und gar von strahlendem und gedämpftem Licht erfüllt. Mittels einer Kombination von Gold und Bienenwachs schafft Joy so ein Werk, das gleichermaßen überschwänglich und rein ist.

Doch ob leuchtend oder matt, das Licht in diesen Gemälden zieht die Betrachter magisch an und nimmt sie völlig in Beschlag. Deshalb ist es auch wichtig, darüber nachzudenken, wie sehr Licht oder das Fehlen desselben die Art und Weise verändert, wie man diese Bilder erlebt. In hellem Licht neigen sie dazu zu glänzen, während sie in einer dunkleren Umgebung im Stillen leuchten wie jahrhundertealte Ikonen. Daher ist es möglich, mit einem von Joys Gemälden in einem dunklen Raum zu sitzen und dennoch zu sehen, wie das Licht, das von ihnen ausgeht, in der Dunkelheit pulsiert. Interessanterweise entspricht Joys Lichtbehandlung derjenigen eines seiner wichtigsten Vorbilder. 1954 pries der Kunstkritiker Hubert Crehan die Fähigkeit Mark Rothkos, die westliche Metapher des Lichts als Ausdruck des Spirituellen einzusetzen, doch sein Kommentar lässt sich ebenso gut auf Joys Umgang mit der Farbe anwenden, um damit Licht zu evozieren: „Rothkos Werk ist erfüllt von dem, was wir als Fragen des Geistes bezeichnen [… wie …] das biblische Bild des Himmels, der sich öffnet und ein überirdisches Licht offenbart, ein Licht, das manchmal so blendet und dessen Glanz so intensiv ist, dass das Licht selbst zum Inhalt der Vision wird, in der Ankündigungen von Dingen erfolgten, die dem menschlichen Geist am nächsten kommen. […] Rothkos Vision konzentriert sich auf das Bedürfnis der Sensibilität des modernen Menschen nach einer eigenen authentischen, spirituellen Erfahrung. Und das Bild seines Werks ist der symbolische Ausdruck dieser Idee."[30]

Trotz dieser Betonung des Lichts kommt der Dunkelheit eine gleichwertige Gewichtung zu, die über die negative Symbolik hinausgeht. Gewiss repräsentieren dunkle Farben häufig Tod oder Verzweiflung. Doch Dunkelheit kann auch ‚Tiefe' oder das Ewige versinnbildlichen. In *The Dwelling of the Light* macht Rowan Williams, Erzbischof von Canterbury und renommierter Theologe, eine interessante Beobachtung hinsichtlich der Dunkelheit, die sowohl in der Ikonenmalerei als auch im Hinduismus vorherrscht: „Der dunkle Hintergrund, in dem Jesus gezeigt wird, ist etwas, das man in anderen Ikonen als Darstellung der himmlischen Realität sehen wird. Bei der Verklärung sehen die Jünger sozusagen, wie sich Jesus' Menschlichkeit gegenüber ihren inneren Dimensionen ‚öffnet'. Das ähnelt der hinduistischen Geschichte vom Krishnakind, das von seiner Mutter aufgefordert wird, den Mund zu öffnen, damit sie sehen kann, ob es Schlamm gegessen hat: Sie schaut ihm in den Mund und erblickt dort im dunklen Inneren seiner Kehle das ganze Universum. So blicken die Jünger Jesus an und sehen, wie er aus einer unermesslichen Tiefe hervorkommt. Hinter oder in ihm öffnet sich die Unendlichkeit, ‚wo das Licht wohnt', um die unvergessliche Formulierung aus Hiob 38,19 aufzugreifen."[31]

26 Matthewes-Green, Frederica, *Entering the Sanctuary of Icons and Prayer*, Brewster, Mass., 2003, S. 18.
27 Martin, a.a.O., S. 48.
28 *Symeon The New Theologian: The Discourses*, übers. v. C. J. de Catanzaro, New York 1980, S. 195.
29 Martin, a.a.O., S. 98.
30 Zit. nach Sandler, Irving, „The Sectionals 1949–1959", in: *The Art of Mark Rothko*, S. 87.
31 Williams, Rowan, *The Dwelling of the Light: Praying with Icons of Christ*, Grand Rapids 2003, S. 4f.

In Werken wie *Trinity* (siehe Seite 72f.) bedient sich Joy dunkler Quadrate und Rechtecke, um dies auf ikonografische Weise zum Ausdruck zu bringen. Diese mit den anderen Farben kontrastierende Dunkelheit verleiht den Werken durch ihre subtile Kraft ihr Gleichgewicht. *Trinity* beginnt auf der linken Seite mit einer dunklen, warmtonigen braunen Säule, die die irdische, menschliche Natur Christi repräsentiert. Darüber liegen zwei goldene, zweigeteilte Rechtecke. Das eine ist in einem dunkleren, fast bernsteinfarbenen Goldton gehalten, was wiederum den menschlichen Charakter Christi symbolisiert, das andere Gold ist blass, fast weiß, und erinnert mehr an ‚transzendentes Licht‘. Mit dem Dunkelbraun, das diesen Abschnitt beherrscht, versinnbildlicht Joy das ungeheure Opfer, das Christus für die Menschen bringt. Auf der rechten Seite befindet sich ein in horizontaler Richtung dreigeteiltes Rechteck; die beiden längsten Komponenten werden oben und unten positioniert. Diese Abschnitte sind in einem leuchtenden, dunklen Karmesinrot gehalten und repräsentieren Blut, Leben und Opfer. Zwischen ihnen befindet sich ein Rechteck aus dunklem Gold, eine symbolische Verbindung von Himmel und Erde. Die Säule ganz außen rechts enthält alle diese Farben in unterschiedlichen Größen ebenso wie ein dunkles Königspurpur, das auf die ewige Existenz Gottes und seine Herrschaft über die gesamte Schöpfung verweist. Zwischen den beiden Letzteren befindet sich eine Säule aus horizontalen schwarzen und bernsteinfarbenen Streifen. Diese scheinen nicht mit der Idee der Dreifaltigkeit in Einklang zu stehen, doch Joys Bildsprache wurzelt an dieser Stelle in der Ikonentradition. Viele Dreifaltigkeitsikonen zeigen die drei Engel, die Abraham in der Genesis erscheinen, eine Dreifaltigkeit von Engeln im Gegensatz zur Dreifaltigkeit von Vater, Sohn und Heiligem Geist. Mittelalterliche Ikonografen stellten diese Himmelsboten häufig mit Stäben dar, einer Metapher für die Lebensreise, welche alle Menschen mit ihrer Geburt antreten. Nur wenn Gott als Führer uns begleitet, so die Botschaft der Ikonen, kann der Mensch diese Reise zu einem erfolgreichen Ende bringen und in der Ewigkeit ankommen.

Joy baut aber auch auf eine Weise auf der Ikonentradition auf, die über Form und Farbe hinausgeht. In der östlichen Orthodoxie betrachten die Gläubigen die Kirchen an und für sich als ‚Himmel auf Erden‘ und eine mit Ikonen bedeckte Wand trennt den Altar vom Rest der Kirche. In der Mitte dieser als Ikonostase bezeichneten Wand befindet sich eine große Tür, die sogenannte ‚königliche Tür‘, die zu beiden Seiten von zwei kleineren Türen flankiert wird. Die Ikonostase trennt auf symbolische Weise die göttliche Welt (den Altar) von der menschlichen (dem Gemeinderaum). Doch zugleich vereinigt sie die

beiden und macht sie zu einem Ganzen, da sie ein heiliges Tor zwischen Himmel und Erde darstellt. In Joys Interpretation verbinden sich mehrere Paneele, in der Regel Diptychen und Triptychen, zu einer Ikonostase. Beide *Hodegetria*-Bilder, jene, die ‚den Weg‘ weisen, lassen sich als Ikonostasen betrachten. Ihre Paneele sind unterschiedlich lang und lenken den Blick des Betrachters, sodass dieser ganze Abschnitte der Wand hinauf- und herunterwandert. Indem Joy abstrakte Ikonen schafft, reißt er einen traditionellen Zugang zum Göttlichen ein, um einen neuen, durch und durch zeitgenössischen zu öffnen. Doch diese Zugänge verschaffen dem Betrachter keinen unmittelbaren Einlass, er muss sich vielmehr auf einer kontemplativen Ebene auf sie einlassen.

All dies mag schön und gut sein, doch wenn eine Ikone per definitionem ein Bild – und zwar ein heiliges Bild – ist, was stellen Joys zeitgenössische Ikonengemälde dann dar? Ungeachtet zeitgenössischer Interpretationen traditioneller Ikonen: Kann es sich bei diesen, wenn sie abstrakt sind, tatsächlich um Ikonen handeln? Es ist wichtig, an dieser Stelle einen Schritt zurück zu gehen und das Ziel der Ikone als Gegenstand der religiösen Verehrung abermals ins Auge zu fassen. Entscheidend in der Ikonenmalerei ist nicht so sehr das dargestellte Sujet, sondern die vermittelte Botschaft insgesamt. Die orthodoxe Kirche hatte in dieser Hinsicht sehr genaue Vorstellungen. Vor über 1.300 Jahren wurde die Trullanische Synode in Konstantinopel einberufen, um die Natur Christi zu diskutieren. Dabei legte die Synode, an der die Bischöfe der Ostkirche teilnahmen, auch die dogmatische Bedeutung der Ikonen fest und betonte „die Wichtigkeit, Ikonen zur Ehrung und Anschauung Gottes zu verwenden, in dem Sinne, dass die Kunst durch eine neue Symbolik die Herrlichkeit Gottes widerspiegeln könnte".[32] Natürlich würden Künstler wie Joy zustimmen, indem sie auf die heilige Geometrie und die spirituelle Abstraktion als Mittel verweisen, um eben dieses Ziel zu erreichen.

In den letzten Jahrzehnten haben dem einige Ikonengelehrte zugestimmt und eingeräumt, dass es möglich sein könnte, Ikonen für und in einem zeitgenössischen Kontext neu zu schaffen. Unter Verweis darauf, dass die von der Trullanischen Synode erwähnte ‚historische Realität‘ traditionell die Form der menschlichen Gestalt annahm, hat Leonid Ouspensky, ein renommierter Ikonexperte, die These vertreten, es sei möglich, eine „sowohl in formaler als auch in inhaltlicher Art neue Kunst zu schaffen, die sich der materiellen Welt entlehnter Bilder und Formen bedient, um die Offenbarung der Welt des Göttlichen zu vermitteln und diese dem Verständnis und der Kontempla-

die kunst, die ikonografie und ‚transzendentes licht‘ bei steve joy
KIM CARPENTER

tion zugänglich zu machen".[33] Aus diesem Grund ist die Bildsprache der Ikonen, wie Linette Martin konstatiert, nicht „starr und unveränderlich, als habe jemand vor tausend Jahren entschieden, ein Bild Christi oder der Jungfrau Maria müsse nach einer genau festgelegten Formel angefertigt werden. [...] Die Bildsprache der Ikonen hat sich über Jahrhunderte entwickelt, weil sie eine Sprache ist. So wie sich eine gesprochene Sprache entwickelt und doch sie selbst bleibt, gilt dies auch für die Sprache der Ikonen."[34] Des Weiteren betont sie: „Innerhalb der Ikonografie der byzantinischen Kunst sorgt die Möglichkeit neuer Sujets dafür, dass die Kunst der Ikonen lebendig bleibt. Die byzantinische Ikonografie war flexibel genug, neue Sujets einzubeziehen. Neue Details in Ikonen erscheinen von Zeit zu Zeit, so wie neue Worte in einer gesprochenen Sprache auftauchen, weil man sie benötigt."[35]

Während Kunsthandwerker, die in der christlichen Ikonentradition arbeiteten, versucht haben, einen ‚unsichtbaren Gott‘ festzuhalten, indem sie Christus so darstellten, wie Christus den Menschen in körperlicher Gestalt erschien, geht Joy weiter zurück, über die Wurzeln des Christentums hinaus, um den ‚unsichtbaren Gott‘ vermittels der Heiligkeit und Universalität der Geometrie darzustellen, jener von Pythagoras zitierten „Erkenntnis des ewig Existierenden". Diesbezüglich geht es Joy darum, dass sich die Sprache der Ikonen weiterentwickelt und an eine neue Wirklichkeit der Welt anpasst. Obgleich seine Methode des Kommunizierens von Ikonen neu ist – das ‚Vokabular‘ ist es nicht. Tatsächlich ist es älter als die Ikonentradition selbst. Indem er die alte, in der heiligen Geometrie verschlüsselte Symbolik benutzt und sie gewissermaßen als eine ‚neue Symbolik‘ repräsentiert, versetzt Joy die mittelalterlichen Ikonenbilder für ein zeitgenössisches Publikum in ein zeitgenössisches Umfeld. Obwohl diese Ikonen eindeutig auf der Tradition der christlichen Ikonografie beruhen, sind sie zugleich universell und ahistorisch, aber auch persönlich und spezifisch für unser eigenes Zeitalter.

Sicherlich versuchte Malewitsch mit seinem berühmten *Schwarzen Quadrat* genau dies. Für die *Letzte futuristische Ausstellung* hängte er dieses Werk wesentlich höher als alle anderen, installierte es in einer Ecke, wo es zwei Wände miteinander verband, eine Stelle, die in orthodoxen Haushalten einer Ikone vorbehalten ist.[36] Doch Malewitsch kreierte keine Ikonenbilder, sondern ersetzte sie durch seine eigene heilige Geometrie. Im Gegensatz hierzu schafft Joy Ikonen und er tut dies, indem er das traditionelle und antiquierte, wenn nicht sogar überholte Modell dessen, was Ikonenbilder sein sollen, zer-

reißt und stattdessen ein neues Bild der religiösen Ikone erzeugt, das die östliche Orthodoxie transzendiert. In einer Gesellschaft, die von Wissenschaftlern immer wieder als ‚postmodern‘ bezeichnet wird, könnte das Abstrakte auf globaler Ebene das beste Mittel für eine kulturübergreifende Form spiritueller Kontemplation sein. Präziser noch bleiben sowohl das Rechteck als auch das Quadrat direkt zugängliche Formen, unabhängig vom jeweiligen religiösen Bekenntnis. Man benötigt keine byzantinische Ikone von Jesus oder der Jungfrau Maria, um sich dem Göttlichen nahe zu fühlen. Ob Muslim oder Christ, Hindu oder Jude, Buddhist oder Sikh, die geometrische Ikonografie dieser Formen teilt sich auf einer sehr grundlegenden, sehr menschlichen Ebene unmittelbar mit. Dies sind elementare Formen, die es in allen Kulturen gibt und die jedes fundamentalistische Glaubenssystem neutralisieren. Wie Platon in *Der Staat* schrieb: „Die Geometrie wird die Seele zur Wahrheit führen und den Geist der Philosophie hervorbringen. Die Erkenntnis, um die es bei der Geometrie geht, ist die Erkenntnis des Ewigen."

Aus allen diesen Gründen existieren Joys Gemälde zugleich als Kunst und als Ikone, als Beobachtung und Gebet. Als Kunst bietet die Beobachtung Gelegenheit zur Kontemplation im Abstrakten; als Ikone eröffnet das Gebet ein Fenster zum Ewig-Universellen. In diesem Zusammenhang ermöglicht Joy seinen Betrachtern eine intime Erfahrung ehrfürchtiger Meditation, eine Erfahrung, die letztlich unwiderstehlich und zweifelsohne völlig zeitlos ist.

32 Ouspensky, Leonid „The Meaning and Language of Icons", in: Ouspensky, Leonid und Vladimir Lossky (Hrsg.), *The Meaning of Icons*, New York 1983, S. 29.
33 Ouspensky, a.a.O., S. 30.
34 Martin, a.a.O., S. 4.
35 Ebd., S. 28.
36 Milner, a.a.O., S. 127.

Die Malerei hilft durch ihr beeindruckendes Beispiel innerer Freiheit und Erfindungsgabe, durch ihre Treue zu den künstlerischen Zielen, die die Beherrschung des Formlosen und Zufälligen mit einschließen, den kritischen Geist und die Ideale der Kreativität, Wahrhaftigkeit und des Selbstvertrauens zu erhalten, die unersetzlich für die Lebensfähigkeit unserer Kultur sind.[1]

MEYER SCHAPIRO, 1957

steve joy: sein leben in der kunst

DAVID CARRIER

David Carrier ist Champney Family Professor, eine Position, die zwischen der Case Western University und dem Cleveland Institute of Art aufgeteilt wird. Zu seinen Publikationen zählen *Artwriting* (Amherst 1987), *Principles of Art History Writing* (University Park und London 1991), *Poussin's Paintings: A Study in Art-Historical Methodology* (University Park und London 1993), *The Aesthete in the City: The Philosophy and Practice of American Abstract Painting in the 1980s* (University Park und London 1994), *Nicolas Poussin. Lettere sull'arte* (Como 1995), *High Art. Charles Baudelaire and the Origins of Modernism* (University Park und London 1996), *England and Its Aesthetes: Biography and Taste* (Amsterdam 1997), *Garner Tullis. The Life of Collaboration* (New York 1998), *The Aesthetics of the Comic Strip* (University Park und London 2000), *Rosalind Krauss and American Philosophical Art Criticism: From Formalism to beyond Postmodernism* (Westport 2002), *The Art of Artwriting* (New York 2002), *Sean Scully* (London 2003) sowie *Museum Skepticism* (Durham 2006). Demnächst erscheint *A World Art History and Its Objects*.

Sehr häufig gehen bildende Künstler auf Reisen. Und manchmal reisen sie, um die wichtigsten Werke älterer Kunst zu sehen. Im 17. Jahrhundert kamen Reisende aus Nordeuropa nach Rom, um die Skulptur der Antike und die Malerei der Renaissance zu studieren. Sie reisten außerdem, um sich Orte anzusehen, die kunsthistorisch von Bedeutung sind. So entdeckten etwa Claude Lorrain und Nicolas Poussin bei ihrem Umzug von Frankreich nach Rom jene Landschaftsszenen, die dann Bestandteil ihrer Bilder werden sollten. Die französische Regierung institutionalisierte diese Reisetätigkeit, indem sie in Rom eine Akademie gründete. Andere Nationen folgten diesem Beispiel. Als sich das Zentrum der Kunstwelt verschob, veränderten sich auch diese Reisegewohnheiten. Im 19. Jahrhundert reisten ehrgeizige Studenten aus Amerika und anderen Ländern in Europa nach Paris, um den Louvre zu besuchen und sich in französischen Kunstakademien einzuschreiben. Seit Mitte des 20. Jahrhunderts schließlich kamen Künstler aus allen Teilen Amerikas und Europas nach New York, dem Rom unserer heutigen Kunstwelt, um Museen und Galerien zu besuchen und amerikanische Künstler zu treffen.

Als Kunststudent fühlte sich Steve Joy sehr von der amerikanischen Malerei angezogen:

„Als ich Kunst studierte, zeigten mir die großen amerikanischen Maler den Ausgangspunkt und wiesen mir zugleich den weiteren Weg."[2]

Joy wurde von den abstrakten Expressionisten und ihren Nachfolgern inspiriert:

„Die amerikanischen Maler, das heißt Rothko, Newman, Pollock, de Kooning, später dann Marden, Agnes Martin usw., machten uns Mut, die, wie wir meinten, beiden restriktiven Seiten der britischen Malerei zu durchbrechen. Diese schien entweder völlig gegenständlich zu sein (Hockney, Freud, Bacon) oder eine übertrieben wörtliche – und geschraubte – lyrische Form der Abstraktion, wie etwa bei Howard Hodgkin."

Durch Kritiken lernte Joy am meisten über diese Kunst, aber es gab auch einige bedeutende Ausstellungen in London. Das Meyer Schapiro-Zitat am Anfang dieses Textes zeigt sehr deutlich, dass viele Menschen in New York und England, unter ihnen auch Joy, die moralische Bedeutung des Abstrakten Expressionismus erkannten. Einige Künstler aus dem Westen beschränkten sich bei ihrer Reisetätigkeit nicht auf Europa. Im 18. Jahrhundert begab sich der Italiener Giuseppe Castiglione (1688–1766) nach Peking. Dieser Jesuit, der die Chinesen zum katholischen Glauben bekehren wollte, lernte, im chinesischen Stil zu malen. Im Zeitalter des Imperialismus wiederum begaben sich die Europäer auf der Suche nach exotischen Sujets in unlängst kolonisierte Gegenden wie Indien und Nord- und Südamerika. Im späten 19. Jahrhundert zog Paul Gauguin in den

Südpazifik, während Orientalisten die islamische Welt erkundeten. Gauguin malte die Völker und Landschaften Tahitis, die Orientalisten präsentierten islamische Ornamente und Wüstenszenen. Zu Beginn des 20. Jahrhunderts ließ sich dann Henri Matisse in seiner Kunst wesentlich von Marokko und Russland inspirieren. Häufig waren solche Reisen für Künstler aber auch eine Form der Selbstfindung. Visueller Multikulturalismus ist wichtig, so Arthur Danto, denn um sich seiner eigenen Kultur zu vergewissern, muss man andere Kulturen kennen:

„Man […] würde kein ‚Bewusstsein' der Qualität eines Lebens erlangen, wenn man nur das eigene kennen würde. […] Bewusstsein entsteht durch Kontraste zu anderen Formen des Lebens oder durch Veränderungen im eigenen (es ist kein Zufall, dass der Vater der Geschichtsschreibung [Herodot] bekanntlich ein großer Reisender war)."[3]

Und Herodot selbst schrieb:

„Jedermann ohne Ausnahme hält seine eigenen einheimischen Gebräuche und die Religion, in der er großgezogen wurde, für die besten."[4]

Doch natürlich wird eine solch schlichte Denkungsart durch das Reisen häufig eines Besseren belehrt. Man lernt viel über sich selbst und die eigene visuelle Kultur, wenn man sich aus ihr herausbegibt. Steve Joy ist ein ungewöhnlich weit gereister Künstler. Nach dem Studium in Japan malte er lange Zeit in Belgien, Italien, Norwegen und Spanien sowie, in jüngerer Zeit, in Omaha, Nebraska. Allerdings unterscheiden sich seine Reisen in vielerlei Hinsicht deutlich von denjenigen, die früher für westliche Künstler typisch waren. Obwohl Joy sich von der amerikanischen Malerei außerordentlich angezogen fühlte, begann er erst mit 37 Jahren in New York zu leben und zu arbeiten, also erst zu einem relativ späten Zeitpunkt innerhalb seines künstlerischen Reifeprozesses. Bei seinen Reisen wiederum ging es ihm nicht um exotische Sujets. Da figurative Bilder nicht in den Zuständigkeitsbereich eines abstrakten Malers fallen, stellte er auch nie die Orte dar, an denen er sich gerade aufhielt. Auf seinen Reisen erfuhr Joy jedoch, wie wir sehen werden, mit Sicherheit sehr viel über sich selbst.

Joy interessiert sich für viele Bildtraditionen, für griechische Ikonen und die Malerei der Frührenaissance aus Umbrien, aber auch für japanische Kalligrafie. Sein eigentliches Ziel war es, Möglichkeiten zu finden, wie ein abstrakter Maler all diese verschiedenen visuellen Kulturen für sich nutzen kann. Von Anfang an wollte Joy Kunst machen, die einen Widerhall auf die Geschichte bildet:

„Wenn man an die gesamte Kunstgeschichte denkt, von den Anfängen wahrscheinlich direkt bis zum Abstrakten Expressionismus, dann ging es dabei immer um den Ort, um ein bestimmtes Ortsgefühl; man kann sich keinen Giotto in Italien, keinen van Eyck in Flandern und keinen Vermeer in Holland ansehen, ohne an die Geschichte und Kultur dieser Länder zu denken."

Joy war es ein Anliegen, dass sich dieses Ortsgefühl, dieses Gefühl für viele Orte, in seiner Kunst mitteilt. Doch da er in so unterschiedlichen Regionen wie Japan und Norwegen, aber auch Spanien und Italien abstrakte Bilder malte, war es gar nicht so einfach, dieses Ziel zu erreichen. Denn die visuellen Kulturen jener Orte, die Joy bereist hat, waren sehr vielfältiger Natur. Viele ambitionierte englische Künstler aus Joys Generation versuchten, den Grenzen der Kunstwelt ihres Landes zu entrinnen. In Amerika gab es, wie Joy wusste,

„Pollock, Newman, Rothko, einen seltsamen Querschnitt der Gesellschaft, alle in New York City."

England interessierte sich zudem weiterhin primär für gegenständliche Kunst. Als Joy sich schließlich im Alter von 25 Jahren entschied, Künstler zu werden, wusste er, dass er auf Reisen gehen musste. Wenn er reiste, war er nicht einfach bloß ein Kunsttourist, sondern lebte und arbeitete an fremden Orten mit ihm völlig unvertrauten Kulturen. Im Vorhinein konnte er nicht wissen, inwiefern seine Malerei davon profitieren würde. Dies war eines der Risiken, das er mit diesen Reisen einging:

„Alle Orte, an denen ich gelebt habe, hatten einen großartigen künstlerischen Hintergrund und es waren dort auch intellektuelle und philosophische Schlachten ausgefochten worden. Ich musste einzelne Aspekte dieser Orte in meine Kunst integrieren."

Nach seinen ausgedehnten Reisen in Kontinentaleuropa beschloss er 1997, von nun an in Omaha zu malen und zu arbeiten. Man könnte fast meinen, er habe sich dabei ganz bewusst für einen unmodischen Ort entschieden. Im Gegensatz zu Norwegen, Spanien oder Italien hatte diese Stadt keine Verbindungen zur Kunstgeschichte. Doch wie schon früher lag seiner Entscheidung für diesen Wohnort eine raffinierte Logik zugrunde: In Amerika gab es wesentlich mehr

1 Schapiro, Meyer, *Moderne Kunst – 19. und 20. Jahrhundert. Ausgewählte Aufsätze*, Köln 1982, S. 251.

2 Alle Zitate von Joy stammen aus Gesprächen mit ihm in seinem Studio am 13. und 14. Juni 2006 sowie aus unserem Briefwechsel. Inspiriert von Joseph Mashecks hellsichtigen Artikeln über Ikonizität (Wiederabdruck in seiner Publikation *Historical Present: Essays of the 1970s*, Ann Arbor, Michigan, 1984) wurde ich um 1980 Kunstkritiker. Meine Analyse von Joys Umgang mit der Ikonentradition verdankt Mashecks Schriften zahlreiche Anregungen.

3 Danto, Arthur C., *Narration and Knowledge*, New York 1985, S. 296.

4 Herodot, *Historien*, hrsg. v. Kai Brodersen, Stuttgart 2002.

Menschen, die Joys Begeisterung für spirituelle Fragen teilten. Manchmal ist ein Ort ohne große künstlerische Tradition das bessere Umfeld für einen Künstler:

„Seit ich hierher gekommen bin, ist vieles beengter geworden; das war aber keine Entscheidung, sondern es spiegelt die Tatsache wider, länger an einem Ort zu sein. Ich hatte nie die Absicht, einen bestimmten Stil zu entwickeln und dann daran festzuhalten; ich habe andere Leute gesehen, die das wesentlich erfolgreicher gemacht haben. Ich habe hier nicht jene Form von Freiheit, die ich in Italien hatte. In Amerika gibt es immer das ganze Gewicht der modernen Meister des 20. Jahrhunderts, mit denen man konkurrieren muss."

Als er noch jünger war und auf Reisen ging, machte seine Kunst zahlreiche Veränderungen durch. Doch auch wenn er sich in Omaha niederließ, wollte Joy nicht, dass seine Kunst sesshaft würde. Diese sehr ausgedehnten Reisen zeigen, dass es sehr lange dauerte, bis er sich selbst als Künstler fand:

„Ich hatte es nie eilig, ich wollte, dass mein Werk einen Punkt erreicht, an dem es weniger stark von anderen Künstlern beeinflusst war."

Wie wir sehen werden, hat sich seine sehr lange Reise gelohnt, da sie es ihm ermöglichte, eine Kunst zu schaffen, die wunderbar frei von Klischees ist.

Doch diese breit gefächerten Interessen bedeuten auch, dass Joy ungewöhnlich lange benötigte, um sich selbst zu finden. Wie aber lernte Joy dies auf seinen ausgedehnten Reisen? In diesem Buch geht es vor allem um die Beantwortung dieser Frage. George Kubler, der große Historiker der spanisch-amerikanischen Kunst, hat eine sehr nützliche Definition dessen gegeben, was er als den Einstiegspunkt des Künstlers bezeichnet:

„Die Lebenszeit jedes Menschen ist auch ein Werk in einer Serie, die über ihn hinausgeht. [...] Neben den üblichen Koordinaten, die die Position des Einzelnen bestimmen, sein Temperament und seine Ausbildung, gibt es auch den Moment seines ,Einstiegs'. [...] Natürlich kann eine Person Traditionen wechseln, und sie tut dies auch, vor allem in der modernen Welt, um einen besseren Einstieg zu finden."[5]

Hätte Joy die Kunsthochschule nur einige Jahre früher besucht, hätte er dort nichts über den Abstrakten Expressionismus erfahren, da dieser dort höchstwahrscheinlich gar nicht unterrichtet worden wäre. Vielleicht wäre er dann ein figurativer Künstler geworden. Als er in der englischen Kunstwelt debütierte, herrschte ein großes Interesse an amerikanischer Malerei, aber da Joy eine Generation vor den Young British Artists in Erscheinung trat, die berühmt und in einigen wenigen Fällen auch sehr wohlhabend wurden, musste er hart arbeiten, um Unterstützung für seine Kunst zu erlangen. Joy wurde 1952 in Plymouth, England, geboren und war Teil einer eng miteinander verbundenen englischen Arbeitergemeinde. In seiner Welt gab es keine bildende Kunst,

„aber es gab die Natur, das Meer, viele mechanische Dinge; ich erinnere mich noch daran, dass mein Vater auf dem Boden alte Motorräder auseinander nahm, was zu meinem technischen Hintergrund in der Luftwaffe beitrug."

Als er sich der Luftwaffe anschloss, begann seine Reisetätigkeit:
„Ich lebte in Deutschland, Zypern, Hongkong, Malaysia, ich kam nach Sri Lanka, ich kam auf die Malediven."

Außerdem wurde Joy vom Beruf seines Vaters beeinflusst:
„Mein Vater war ein Schuhmacher, der sein eigenes Geschäft unglücklicherweise gerade in einer Zeit eröffnete, in der es billige modische Schuhe gab, sodass niemand mehr Geld für eine Schuhreparatur ausgeben wollte. Es kann durchaus sein, dass mir durch den Stolz meines Vaters auf das Handwerk des Schuhmachers die Idee des Stolzes auf das Handwerk und die Kleinindustrie eingeflößt wurde."

Joy war ein wohlwollender Beobachter verschiedener nichtwestlicher Kulturen, darunter des arabischen Nahen Ostens. Das, was später seine Kunst beeinflussen sollte, war weniger irgendetwas Bestimmtes, das er damals sah, sondern diese Erfahrung vieler verschiedener exotischer Kulturen. Außerdem war er während seiner Zeit in der Luftwaffe ein eifriger Leser:

„Ich habe immer Dinge untersucht. Als Kind befand ich mich ein bisschen außerhalb von allem. Ich glaube, das habe ich auch in der Luftwaffe fortgesetzt; Ich erinnere mich, dass ich ein ganzes Regal mit Büchern über Solschenizyn hatte, das war damals in der Zeit des Kalten Kriegs ziemlich seltsam."

Joy wurde sehr stark von Émile Zolas *Das Werk* beeinflusst, das er 1973 las. Der Roman erzählt von Claude, einem Künstler, Zolas Schulfreund Paul Cézanne nachempfunden, der verzweifelt versucht, die Themen des modernen Lebens zu malen, daran aber scheitert. Einem jungen aufstrebenden Künstler kann das Scheitern eines ehrgeizigen Vorhabens sehr romantisch vorkommen. Obwohl sich die Werke des amerikanischen Abstrakten Expressionismus in England eines hohen Bekanntheitsgrades erfreuten und vielerorts ausgestellt wurden, entwickelte sich dort keine entsprechende einheimische Tradition.

steve joy: sein leben in der kunst
DAVID CARRIER

Joy selbst wollte Kunst schaffen, die leichter zugänglich war. Er brauchte lang, um zu begreifen, wie das ging. Doch als er soweit war, meinte er, seine frühe Kunst sei ein guter Ausgangspunkt gewesen:

„Meine frühen Gemälde als Student waren bereits ziemlich reif und zielgerichtet und kamen dem, was ich später als meine Affinität zur Ikonenmalerei begreifen sollte, schon sehr nahe. Ich wusste, dass ich die Malerei als Grundlage für meine eigene spirituelle Entwicklung nutzen konnte."

Die Kunst der Malerei hatte er etwas früher entdeckt, als er mit einigen Freunden aus der Luftwaffe in Holland war und dienstfrei hatte:
„Es war ein regnerischer Tag, wir hatten uns verlaufen und standen offenbar vor dem Stedelijk; ich sagte, lasst uns aus dem Regen gehen, und so kam es, dass ich auf den Barnett Newman stieß. Ich war völlig von den Socken, kaufte die Monografie von Thomas Hess und war erstaunt festzustellen, dass diese Gemälde von einem weltmännischen, hochkultivierten New Yorker Herrn stammten."

Joy war 24 und noch nicht an der Kunsthochschule. Aber in diesem Moment änderte sich sein Leben. Einer der Gründe dafür, dass er Kunst mit religiöser Erfahrung verbindet, ist meines Erachtens der, dass er zu diesem Zeitpunkt selbst bekehrt wurde. Inspiriert durch die Spiritualität von Newmans Kunst wollte er ein abstrakter Maler sein. In seiner eigenen Malerei erweist er Newman und anderen bewunderten Künstlern seine Reverenz. Der Titel von *Mirror (For Tarkovsky)* (1989, siehe Seite 156), mit den an Barnett-Newman erinnernden Streifen, verweist auf den großen Filmregisseur Andrej Tarkowski:
„Seine Filme haben mich seit meinen Studententagen außerordentlich beeinflusst. Nicht nur *Andrej Rubljow*, sondern auch *Stalker* und *Der Spiegel*."

Die Gemälde *Mirror* und *The Bell* (siehe Seite 159) entstanden in Erinnerung und als Hommage an Tarkowski:
„*The Bell* ist von einer Szene aus *Andrej Rubljow* inspiriert, aber auch von meiner Faszination für die Glockenherstellung jener Zeit, die größtenteils auf Intuition und einem Gespür für den richtigen Klang beruhte, was nur die großen Glockenmacher haben konnten. Manchmal scheinen die Zutaten, die in der Malerei, vor allem in der mittelalterlichen Ikonenmalerei und Werken der Frührenaissance, zum Einsatz kommen, mit derselben Form von Alchemie einherzugehen."

Die meisten aufstrebenden Maler besuchen die Kunstakademie, um herauszufinden, was für eine Art Maler sie sein wollen. Joy, der älter war als derartige Studenten, hatte ganz andere Ansichten über die Ausbildung zum Künstler:
„Ich besuchte die Kunsthochschule mit sehr genauen Vorstellungen davon, was für eine Art Maler ich sein wollte, allerdings ohne bereits über das Wissen zu verfügen, wie ich das anstellen sollte. Es war ein reines Begehren, fast wie eine religiöse Bekehrung."

Diese Überzeugung, die er sich schon früh aneignete, bildete von jeher ein Rückgrat seiner Kunst. Hier gelangen wir zum Ursprung der Bilder, die Joy 1980-1981 schuf, die *Sunstones* (siehe Seite 188-191):
„Ich unternahm mit dem Fahrrad eine Tour durch Nordspanien von Santander nach Barcelona, was damals eine ziemlich wilde Gegend war. Damals las ich gerade vor allem Antonio Machado und Lorca. Außerdem (den Peruaner) César Vallejo sowie – das war am wichtigsten für diese Gemäldeserie – das Gedicht *Die Höhen von Macchu Picchu [Las Alturas de Macchu Picchu]* von Pablo Neruda, wo in einem Vers der Ausdruck ‚Sonnensteine' vorkommt."

Diese Sonnensteine stellen einen wichtigen Schritt in Joys Laufbahn dar:
„Die Sachen, die ich davor an der Graduate School in Chelsea (London) gemacht hatte, waren beinahe farblos, sehr minimalistisch und sehr hart. Aber in den Gemälden gab es Formen oder eine Art Geometrie oder räumliche Konfigurationen. Bei den *Sunstones* wollte ich, dass die Gemälde keinerlei Motiv enthielten. Dass sie einfach nur als Gegenstände gelesen wurden, die vielleicht Gefühle bargen, aber nicht unbedingt meine eigenen. Ich wollte, dass sie nach etwas aussahen, das im Schmutz gelegen hatte und dann plötzlich entdeckt worden war."

Dies also war der Einfluss, der Joys *Sunstones* zugrunde lag:
„Ich wollte, dass sie dunkel und geheimnisvoll wären, aber auf die spanische Art, wie in den Gedichten, die ich las, oder wie *Don Quijote*. In emotionaler Hinsicht sollten sie jedoch bodenständig sein. Diese Gemälde enthielten bereits viele Intuitionen von etwas, was sowohl intellektuell als auch emotional, aber vor allem ästhetisch erst später im Leben kommen sollte. Ihre Vorbereitung war mit vielen rituellen Aspekten verbunden; dabei spielten Geduld und Disziplin und das Abwarten jenes Augenblicks der Bereitschaft eine große Rolle."

5 Kubler, George, *The Shape of Time: Remarks on the History of Things*, New Haven und London 1962, S. 6.

1980 wechselte Joy schließlich ans Chelsea College of Art, um dort einen Magisterstudiengang zu belegen. Das war eine sehr gute Kunsthochschule. Am Chelsea College schuf Joy sehr strenge Kunst: „Ich schuf Gemälde mit etwa zweihundert Schichten schwarzen Acryls mit einer bestimmten Menge Überpigmentierung, sodass meine Bilder wie Steinblöcke aussahen. Sie basierten auf Gedichten Rilkes. Dieses Werk war sehr schwierig."

Doch dann sollte sich eine Ausstellung für Joy als außerordentlich folgenreich erweisen. *Brice Marden: Paintings, Drawings and Prints 1975–80* in der Whitechapel Art Gallery (1981) war sehr eindrucksvoll, sowohl was die Qualität der Kunst betraf als auch im Hinblick auf Stephen Banns äußerst originellen Essay *Brice Marden: from the Material to the Immaterial* [*Brice Marden: Vom Materiellen zum Immateriellen*], der dem englischen Publikum den Kontext von Mardens frühen Enkaustik-Bildern erläuterte. Bann vertritt die These, Mardens *Annunciation*-Serie, die im Vorjahr in der New Yorker Pace Gallery zu sehen gewesen war, präsentiere den Fleisch gewordenen Geist – eine radikale Gegenposition zu Clement Greenbergs Verständnis der Abstraktion. Gegenüber diesem Artikel findet sich eine große Abbildung von Piero della Francescas *Verkündigung* (1455) aus Arezzo: eine klare Vorgabe für die Interpretation dieser abstrakten Gemälde. Die Verkündigung, so Bann, ist „die Inkarnation des Geistes in der materiellen Welt",[6] und genau dies ist es, was Mardens Gemälde offerieren. Joy erinnert sich noch sehr lebhaft daran, wie sehr ihn diese Ausstellung und Banns Katalog beeinflusst haben:

„Nachdem ich meine studentischen Bilder vollendet hatte und in Japan gewesen war, begann ich einen Zusammenhang zwischen der Geschichte meiner Werke und jenem Phänomen zu sehen, das später als fundamentale Malerei bekannt wurde und dem Marden und einige seiner Zeitgenossen zugerechnet wurden – in Mardens Fall zu Unrecht."

Joys Generation steckte, so Banns These, in einem Dilemma: „zwischen den letzten Zuckungen eines reduktiven Spätmodernismus und der trügerischen Morgendämmerung."

Bann, fügt Joy hinzu, könnte mit seiner Beschreibung der Möglichkeiten Mardens

„auch über meine eigenen Ideale jener Zeit gesprochen haben, als er sagte, ‚man würde sich eine gründliche Untersuchung der westlichen jüdisch-christlichen Tradition wünschen, insofern sie nicht nur unsere Reaktion auf die Alten Meister bestimmt, sondern auch unser Bewusstsein für die Kunst unserer eigenen Zeit.' Das damit Gesagte wurde vor allem von Marden in seiner Gemäldeserie, den *Annunciations*, aufgegriffen."

Um nochmals Bann zu zitieren, dessen Sätze Joy so sehr ansprachen:

„Vielleicht müssen diese Gemälde nicht einfach nur einen bestimmten Ikonografietyp oder ein bestimmtes formales Thema bezeichnen, sondern die Inkarnation des Geistes in einer materiellen Welt."[7]

Joy empfand diese Analyse als ungeheuer wichtig, weil sie ihm einen Weg für sein weiteres Vorgehen wies:

„Mir erschien dies als eine Arbeitsweise, die absolut in jenem Kontext stand, in dem sich die westliche Malerei entwickelt hatte."

Diese Denkweise war ein wichtiger, bleibender Einfluss für Joy: „Mich hat Mardens inzwischen berühmter Satz, ‚Das Rechteck, die Ebene, die Struktur, das Bild sind nur Sprachrohre des Geistes', ungeheuer beeinflusst."

Zu diesem Zeitpunkt, da die Grenzen von Greenbergs Denkweise deutlich zu Tage getreten waren und Marden Berühmtheit erlangt hatte, offerierten Kritiker ganz andere Wege zum Verständnis seiner Kunst. Jeremy Gilbert-Rolfe etwa behauptete, Marden sei ein radikaler Materialist, und brachte ihn mit Karl Marx und Bertolt Brecht in Verbindung. Banns Essay markierte damals einen Einschnitt in der Kunstkritik, eine Möglichkeit, die Abstraktion mit den Traditionen sakraler Kunst zu verbinden. Diese Ansicht vertrat auch Joseph Masheck in seinen *Iconicity*-Essays, die er in *Artforum* veröffentlichte. Masheck, das sollte man erwähnen, setzte ein Gemälde Scullys auf die Titelseite von *Artforum*, als er in den späten 1970er Jahren der Herausgeber dieser einflussreichen Zeitschrift war. Diese Parallele zwischen byzantinischer Kunst, spiritueller Kunst der Frührenaissance und der modernen buchstäblichen Abstraktion war nicht ganz neu, Greenberg hatte sie in *Art and Culture* ebenfalls gezogen, aber nicht näher ausgeführt. Letztlich vermochten weder Banns noch Mashecks Verständnis der Abstraktion restlos zu überzeugen, und die Kritiker wendeten sich anderen Dingen zu. Obgleich Marden weiterhin eine großartige Karriere macht, haben spätere Kommentatoren wie Klaus Kertess den Ansatz Banns nicht weiterverfolgt. Mardens eigene Kunst veränderte sich in den frühen 1980er Jahren radikal, in einer Richtung, die diese Verbindung mit der byzantinischen Malerei kappte. Und auch Joy ist inzwischen hinsichtlich dieses Verständnisses des Spätmodernismus kritischer geworden, selbst wenn er Marden weiterhin bewundert. Doch bei diesen strittigen Punkten handelt es sich lediglich um Details. Joy verdankt dieser Ausstellung eine bestimmte Art des Denkens über Abstraktion und spirituelle Werte, die von bleibendem Wert ist. 1981 hatte Joy eine Ausstellung in der Londoner Serpentine Gallery. Ein Kritiker „hielt mein Werk für kafkaesk, aber Kafka hatte gar nichts damit zu tun.

Die Bilder sahen finster und grausig aus. Sie befanden sich auf tiefen Keilrahmen, schwarz, blau-schwarz, niemals farbig, ziemlich extrem."

Doch vor allem aufgrund dieser Ausstellung erhielt Joy ein renommiertes Stipendium für ein Studium in Japan.

Kalligrafie spielt in Joys Gemälden keine Rolle und abgesehen von den goldenen Hintergründen, die er zuweilen verwendet, muten seine Bilder auch nicht sonderlich japanisch an. Dennoch war sein Aufenthalt in Japan eminent wichtig für den Künstler, da er dort die Bedeutung des Rituals kennen lernte. Was er dort im Hinblick auf den Wert des Unpersönlichen erfuhr, sollte später, als er sich für die Ikonenmalerei zu begeistern begann, bedeutsam für ihn werden. Nicht zuletzt stellte diese Betonung des Werts des Unpersönlichen eine besonders folgenreiche Erkenntnis für einen Maler dar, der so angetan war vom Abstrakten Expressionismus, denn vielen Künstlern, die in dieser Tradition standen, ging es vor allem um den persönlichen Ausdruck. Man sollte daher daran erinnern, dass sich Joy zunächst für Barnett Newmans unpersönliche Form des Abstrakten Expressionismus begeistere und nicht so sehr für die eher malerischen Bilder eines Willem de Kooning oder einer Joan Mitchell, so sehr er diese von fern auch bewunderte. Sein Atelier ist von einer nachgerade obsessiven Sauberkeit, kein mit Farbklecksen übersäter Arbeitsplatz. Das Ritual ist in Japan sehr wichtig, aber auch im Westen spielt es eine Rolle. Katholiken etwa legen großen Wert darauf, dass die Liturgie der Messe angemessen vollzogen wird. Um die persönlichen Anliegen des Priesters geht es den Gläubigen dabei weniger. Joy begreift die Kunstproduktion in einem ähnlichen Sinne. Dies ist entscheidend, denn im Gegensatz zum traditionellen Japan oder der rituellen Welt der Ostkirche wird in unserer Kultur die Idee der Kunst als individueller Ausdruck häufig für selbstverständlich gehalten.

Ein Jahr lang in Japan zu leben, war sehr aufregend, doch auf Dauer konnte dieses Land nicht zu seiner neuen Heimat werden. Daher zog Joy, kurz nachdem er nach London zurückgekehrt war, nach Norwegen, wo er eine Norwegerin kennen lernte und heiratete. In Norwegen lebte Joy an der Westküste in Viking Tysnes, einer einstigen Begräbnisstätte, in einer kleinen Holzhütte an einem Fjord:

„Ich wohnte dort etwa ein Jahr lang und zog daraufhin nach Oslo, wo man mir einen Job an der Kunstakademie in Trondheim anbot."

Folglich war er in der Lage, für sich selbst zu sorgen.

Wie schon früher in seinem Leben zog Joy sich stärker auf sich selbst zurück:

„In Norwegen war ich vom Mainstream der zeitgenössischen Kunstwelt abgeschnitten und ich vertiefte mich in die Kunstgeschichte, vor allem die Kunstgeschichte der Prärenaissance- und der Renaissancemalerei. Dies sollte eine Zeit der Vorbereitung auf das werden, was später meine eigene Version der europäischen Grand Tour wurde; ich konnte zwar in Japan nicht malen, aber aufgrund des Studiums dort wurde mir klar, dass ich ein waschechtes Produkt westlicher Kunsterziehung war."

Nun war er bereit, das, was er auf seinen Reisen gelernt hatte, in seine Kunst einzubeziehen:

„Ich hatte selten, wenn überhaupt, gegenständlich gezeichnet oder versucht gegenständlich zu malen, und ich wusste nicht, ob ich überhaupt zeichnen konnte. Mit Sicherheit beschränkte sich meine Verwendung von Malmaterialien auf die Frage, ob sie zu meinem Konzept passten oder nicht. Ich war unzufrieden mit dem konzeptuellen Ansatz meines Werks; das war Anfang der 1980er Jahre, als die Leute wieder anfingen zu malen, namentlich Julian Schnabel, den ich mochte und angesichts der Tatsache bewunderte, dass niemand sonst dies tat. Damals traten auch Baselitz und andere deutsche Künstler wie Kiefer auf den Plan. Daher mietete ich mir ein großes Atelier in Oslo und verbrachte dort ein Jahr lang mit Experimenten."

Genauso wichtig wie diese Entwicklungen in der zeitgenössischen Malerei war Joys aufkeimendes Interesse an den Malern der Prärenaissance:

„Meine Malerei jener Zeit enthält Abschnitte von Bildern Duccios, Giottos, Piero della Francescas und anderer. Ich wollte herausfinden, ob ich irgendwelche traditionellen Fertigkeiten hätte."

Diese Lehrtätigkeit in Norwegen hätte nahezu ideal erscheinen können:

„Ich gestaltete riesige Gemälde. Ich versuchte, den Geist Giottos neu zu deuten. Ich malte eine verschleierte Frau, die aus einem Fischerboot steigt, direkt nach Giotto. Diese Bilder brachten mich letztlich auf die Idee einer Grand Tour und entfernten mich von den Anliegen der Kunstwelt jener Zeit."

6 Bann, Stephen, „Brice Marden: from the Material to the Immaterial", in: *Brice Marden: Paintings, Drawings and Prints 1975–80*, Ausst.Kat. Whitechapel Art Gallery, London 1981. In meiner Publikation *Artwriting* (Amherst 1987) befasse ich mich mit den frühen Interpretationen Mardens.

7 Ebenda.

Es war eindeutig Zeit für eine radikale Veränderung, die einen weiteren Ortswechsel erforderlich machte. Joy sagte dazu:

„Das Wichtigste war für mich stets, ein möglichst einfaches Leben zu führen, um immer malen zu können."

Daher zog er als Nächstes nach Italien, in eine abgelegene Stadt in der Nähe von Perugia:

„Ich zog an den Wohnort Pieros."

Anders als in Japan oder Norwegen lebte Joy hier in der Nähe der Quellen seiner eigenen Kunst. Von Lehrverpflichtungen befreit, konnte er sich auf die Kunstproduktion konzentrieren:

„Ich packte ein Auto und fuhr dorthin. Ich hatte von einer zu mietenden Unterbringung in den Bergen gehört. Es handelte sich um ein Schloss, Castello di Polgeto."

Obwohl dieser Ort für einen abstrakten Maler fernab vom Geschehen lag, hatte er große historische Bedeutung:

„Ich habe mich ganz bewusst für diese Gegend, nur wenige Meilen von der Città di Castello, entschieden. Mich interessierten Piero und Fra Angelico. Mir gefiel der zurückhaltende Umgang mit der Farbe. Ich zog in eine Region, in der er und viele andere Maler sich richtig weiterentwickelt hatten. Man konnte diese Werke in Kirchen sehen."

Außerdem war es ein großartiger Ort, um Kunst zu betrachten:

„Ich hatte das große Glück, zu einer Zeit nach Italien zu ziehen, als sich Pieros *Madonna del Parto* noch in einer Kapelle befand. Heute hängt dieses Werk in einem Museum."

In dieser Zeit malte Joy *Living in the Abstract* (1988, siehe Seite 167). Die Tatsache, dass er seine Lehrverpflichtungen aufgegeben hatte, war sowohl für sein Alltagsleben als auch für seine Kunst eine Befreiung:

„Ich lebte in einem Schloss aus dem 17. Jahrhundert und malte in einer schlichten Scheune, in den Bergen von Umbrien. Es war wunderbar, die Gelegenheit zu haben, in dieser völligen Freiheit zu arbeiten. Das Leben war unmittelbar und einfach, mit einem großartigen spirituellen Fundament in der Landschaft der Umgebung, den alten Klöstern und Kirchen und der Tatsache, dass ich mir so mühelos Gemälde der großen italienischen Maler der Renaissance anschauen konnte."

Nach seinen Experimenten in Norwegen wollte Joy in Gemälden wie *Living in the Abstract* und *Broken Vase* (siehe Seite 177).

„zu einer Art des Malens zurückkehren, die mehr mit meinen studentischen Werken gemein hatte, also zu sehr reduzierten Formen, einer einfachen Geometrie und mit einer Betonung auf den Farbschichten und der Einzigartigkeit der Oberflächenbeschaffenheit."

Er konnte nun direkt auf die unglaubliche sichtbare Historie seiner unmittelbaren Umgebung reagieren. Während der Arbeit mit den Olivenhainen in der Umgebung des Ateliers veränderten sich Joys Interessen allmählich:

„Hier begann ich mich vom Einfluss Mardens, Rymans und Martins zu entfernen, weil ich mich fragte, ob es wohl möglich sei, ein reduktives, kontemplatives Gemälde zu schaffen, diesem dann Motive oder Bezugspunkte hinzuzufügen, dabei das Gemälde fast zu zerstören und es dennoch exakt bis zu jener feinen Grenzlinie zurückzuführen, wo es gerade noch funktionieren konnte. Gleichzeitig wusste ich nicht, ob irgendjemand wirklich versuchte, dies zu tun; es bestimmte aber tatsächlich mehrere Jahre lang den Stil meines Werks, ohne Zweifel zumindest bis zu dem wesentlich späteren Zeitpunkt, als ich feststellte, dass ich zu einer reineren Form der Abstraktion zurückkehren und ihr dennoch die Energie eines Inhalts und Sujets verleihen konnte."

Darüber hinaus wurde damals ein italienischer modernistischer Künstler ebenfalls bedeutsam für Joy:

„Die Stillleben Giorgio Morandis beeinflussten mich stark, vor allem seine schlichte, reine und hingebungsvolle Lebensweise sowie seine selbstgewählte Isolation vom Einfluss der Kunstwelt jener Zeit."

Broken Vase (1987) zeigt, welch großen Einfluss dieses italienische Umfeld auf Joy ausübte. In Italien schuf Joy einige wunderbare Bilder wohl auch angeregt durch die großartigen Gemälde, die er bei seinen täglichen Fahrradtouren sehen konnte:

„Das Bild *Burmese Days* (1997, siehe Seite 116) ist das erste jener Gemälde, die zu dem führten, was ich als den Korpus meiner Hauptwerke betrachte: jene Werke, welche die Geschichte und Tradition der Ikonenmalerei verkörpern. Sowohl in struktureller als auch in materieller Hinsicht ist *Burmese Days* ein sehr einfaches Bild: Die außerordentlich schöne Oberfläche aus Bienenwachs verschleiert die Blattstrukturen darunter. Dieser Schleier trägt zu der Empfindung bei, die davon ausgeht, dieses Ausgreifen, dieses Berühren des Geistes, ohne zugleich alles preiszugeben."

Hier finden Joys kunsthistorische Interessen und seine Auseinandersetzung mit der Abstraktion zueinander:

„Der Schwerpunkt des Werks wird beispielsweise in *Icon Trinity* (2005) und *Starry Night Rhone* (2005) deutlich."

Der Künstler benötigte stärkere Anregungen. Daher zog er, nachdem er zwei Jahre in Italien gearbeitet hatte und in dieser Zeit auch regelmäßig nach Belgien gefahren war, 1989 nach Spanien.

steve joy: sein leben in der kunst
DAVID CARRIER

Damals begann Joy mit einer bis heute fortgesetzten Serie von Bildern, die er als Wortgemälde bezeichnet, darunter *Communication* (siehe Seite 128), *Matador* und *Salvem Es Prat de Son Bon* (siehe Seite 129); jene Bilder wurden von Robert Motherwell beeinflusst (siehe Seite 106):

„Allgemein befand sich mein Werk damals in einer Übergangsphase des allmählichen Abschieds von der italienischen Zeit. Geistig löste ich mich bereits von der Einbeziehung von Bildern oder visuellen Verweisen."

In diesen Kunstwerken fanden seine zunehmende Begeisterung für Ikonen und sein Interesse an der modernistischen Abstraktion zueinander. Außerdem steigerten sie Joys Bedürfnis zu experimentieren:

„Ich vergleiche sie etwa mit einem klassischen Gitarristen, der einmal im Monat mit einem Jazzmusiker zusammenspielt, seine technischen Fertigkeiten übt, daran vielleicht ein bisschen Spaß hat, sich selbst überrascht und die erworbenen technischen Kenntnisse dann zu einem späteren Zeitpunkt auch in seinem eigenen Werk anwendet. Oder mit einem Schriftsteller, der sich eine Auszeit nimmt, um eine Kurzgeschichte zu schreiben und sich dabei von den Strapazen eines Romans zu erholen. Diese ungewöhnlichen Bilder von mir sind – womöglich wie eine Kurzgeschichte für einen Romancier – Wegweiser zu meinem Herzen; ich gebe darin auf intimere Weise meine Quellen preis. Das war die Methode, mittels derer ich gehofft hatte, mit meiner Kunst ein breiteres Publikum zu erreichen. Dies führte zu den Gemälden, die meiner Meinung nach dem, was ich zu machen versuchte, am nächsten kamen. Zum Beispiel *Timanfayo* und *Samarkand*." (siehe Seite 120 und Seite 121)

In Spanien veränderte sich Joys Lebensstil:

„Bis dahin hatte ich meine Zeit abwechselnd in Ateliers in Italien, New York und auf Menorca verbracht. Ich benötigte die relative Stabilität des Ateliers in Barcelona und besonders die Anregung anderer Künstler, vor allem Sean Scullys, der auf der anderen Seite des Flurs lebte; zudem brauchte ich die Inspiration einer großen Kulturmetropole wie Barcelona. Vielleicht hatte ich zu viel Zeit isoliert vom Tagesgeschehen verbracht. Ich musste disziplinierter und zielgerichteter werden."

Das Gemälde *Communication* bündelt diese Einflüsse. Die Worte stammen von einem kleinen Stück Papier, das Joy in Oslo auf der Straße gefunden hatte:

„Ein kleines Kind hatte das geschrieben; es ergab keinen Sinn, aber offenbar hat das Kind versucht, die Worte so zu formulieren, wie sie in seinem Kopf auftauchten. In mancher Hinsicht unterschied sich das gar nicht so sehr von dem, was sich im Kopf eines Malers von der Entstehung der Idee bis zum fertigen Werk abspielt. Ich habe den Text buchstäblich kopiert und ihn so vergrößert, dass er auf die Leinwand passte, die selbst

viele Elemente meiner Arbeiten aus Italien enthielt, etwa die Tafel in der Tafel oder ein kleineres gerahmtes, auf eine Leinwand montiertes Bild, viele komplexe Farbschichten und schließlich einen Überzug aus klarem Bienenwachs, der später sehr wichtig werden sollte."

Byzantium: Faith and Power 1261–1557, ein Ausstellungskatalog des Metropolitan Museum in New York, enthält den Essay *Images – Expressions of Faith and Power* von Annemarie Weyl Carr, der Joys Denkweise jener Zeit treffend veranschaulicht. Man betrachte zum Beispiel ihre Darstellung dessen, was sie als den „vermutlich beeindruckendsten Einzelaspekt der spätbyzantinischen Ikone" bezeichnet:

„Wir haben über die sowohl hinsichtlich ihrer Zahl als auch hinsichtlich ihres Formats wachsende Bedeutung der Tafelmalerei gesprochen und die Art und Weise betrachtet, wie die einzelnen Motive darauf in einer spielerischen Wechselbeziehung standen, häufig in aufeinander reagierenden Gruppierungen, die unserer Erwartung, die Ikone zeige eine einzelne Figur oder ein einzelnes Motiv, zuwiderläuft. Damit geht eine dritte wichtige Entwicklung in der Behandlung von Ikonen in den spätbyzantinischen Jahrhunderten einher. Es findet sich in den Bildern an dieser Stelle eine Selbstreferentialität, die neu und für die Zukunft von größter Bedeutung ist."

Bei Ikonen, die andere Ikonen zeigen, fährt die Autorin fort, „liegt die Bedeutung des Ereignisses nicht in den historischen Figuren, die dieses vollbrachten, sondern in der großen frontalen Ikone, die das obere Register beherrscht, eine Ikone, so frontal wie jeder Heilige, die die Anerkennung und Achtung der Betrachter verlangt. Die Ikone des Festes der Orthodoxie betrachten heißt, die Ikone in ihr und den Wert der Ikonen an sich anerkennen."

In Barcelona begann Joy „im Atelier Wachsgemälde und Gemälde mit Blattgold und -silber wie *Burmese Days* (1997, Silberrot, mit Bienenwachs überzogen, siehe Seite 116f.) zu vollenden, zur gleichen Zeit wie *Communication* (1995, siehe Seite 128)."

Nun endlich war Joy soweit und zog nach Manhattan. 1989 lebte und arbeitete er in New York, wo er in der Ruth Siegel Gallery ausstellte. Seine Arbeitsweise stand inzwischen fest, sodass er endlich eine Chance hatte, im Mittelpunkt der zeitgenössischen Kunstwelt zu stehen. Schlussendlich schaffte es Joy, nach Amerika zu ziehen, womit er dem Beispiel seines engen Freundes Sean Scully folgte.

Scully wurde 1945 geboren, sieben Jahre vor Joy.[8] Um 1984 wurden Joy und Scully enge Freunde, besuchten gemeinsam Kunstausstellungen und unternahmen viele Reisen miteinander. Beide waren von der zentralen Bedeutung des Abstrakten Expressionismus und der Kunstgeschichte überzeugt. Als etliche Künstler der nächsten Generation diese Haltung gegenüber der Geschichte ablehnten, begriff Joy, dass er diese Denkweise verteidigen musste:

Wie Joy absolvierte auch Scully eine lange Lehrzeit und erzielte erst 1981 seinen Durchbruch. Scully war für Joy

„stets sehr einflussreich; sein kolossales Talent wurde für mich zu einem Maßstab dessen, was man mit einem abstrakten Gemälde erreichen konnte."

Am aufschlussreichsten ist daher, inwiefern sich Joys Kunst von der Scullys unterscheidet, obwohl auch sie mit Streifen arbeitet. Wie Joy ist auch Scully von Ikonen und der Kunst der Frührenaissance fasziniert. Sein *Boris and Gleb* (1980) ahmt den Aufbau der Ikone *Die Heiligen Boris und Gleb* aus dem 14. Jahrhundert nach, während sein Bild *Maesta* (1983) eine abstrakte Version von Duccios *Maestà* (1308–1311) darstellt. Obgleich sich Scullys Kunst gelegentlich auf solche Vorläufer bezieht, besaß sie schon immer eine ausgesprochene Affinität für das Leben der Gegenwart. Seine Gemälde aus den 1980er Jahren bedienen sich metaphorisch der Rhythmen der urbanen Alltagserfahrung. Die Straßen und Bürogebäude sind durch repetitive Architekturformen und Formen der Popmusik gekennzeichnet. Der Künstler erläutert dies folgendermaßen:

„In meinem Werk nutze ich die Beziehungen, die ich auf der Straße in Hauseingängen, in Fenstern zwischen Häusern und den Spuren von Gebäuden sehe, die früher voller Leben waren. Ich verwende diese Farben und Formen und füge sie auf eine Weise zusammen, die den Betrachter möglicherweise an etwas erinnert, auch wenn er nicht genau weiß woran."

Hat man erst einmal erkannt, dass Streifen in Scullys Kunst für urbane Rhythmen stehen, sieht man Straßen hinterher anders und auch Musik nimmt man auf andere Weise wahr. In den 1990er Jahren trug Scully zum Verständnis seiner Kunst bei, indem er Aufnahmen marokkanischer Häuser machte, die an seine Gemälde erinnern. Während diese in materieller Hinsicht lediglich Streifen präsentieren, rufen sie bei einer metaphorischen Betrachtungsweise eben jene urbanen Rhythmen ins Gedächtnis, womit sie nahelegen, wie wir unsere Städte sehen sollen. Scullys abstrakte Kunst bezieht ihre Ausdruckskraft also ganz wesentlich aus seiner Vorliebe für das städtische Leben. Nahezu immer hat Scully in Städten oder in der Nähe von

ihnen gearbeitet. Er ist auf das Leben in der Stadt angewiesen, denn oft schildern seine Bilder urbane Konflikte. Obwohl auch Joy häufig Streifen verwendet, unterscheiden sich seine künstlerischen Anliegen jedoch deutlich von denen Scullys. So zog es Joy meist vor, an abgelegenen ländlichen Orten oder in kleineren Städten wie Omaha zu arbeiten. Außerdem nutzten beide Künstler – Joy hat darauf hingewiesen – ihre jeweiligen kunsthistorischen Quellen auf auffallend unterschiedliche Weise:

„Die meisten meiner Werke der letzten Jahre bewegen sich innerhalb der engen Grenzen, die durch die in Blattgold, als Firnis und traditionelle japanische Tinten erhältlichen Farben vorgegeben waren."

In den 1970er Jahren malte Scully strenge, minimalistische Bilder mit schmalen Streifen, die Kritiker wie Masheck prompt mit Ikonen in Verbindung brachten. Doch seit 1981 arbeitete der Künstler in der Regel in einem anderen, wesentlich sinnlicheren Stil. Die Titel neuerer Arbeiten Scullys spielen gelegentlich auf sakrale Werke an; vorwiegend wurde er aber von drei modernen Malern beeinflusst: Matisse, Mondrian und Rothko. Joy hingegen wird weiterhin von der Tradition der Ikonenmalerei inspiriert, auch wenn er selbst ganz sicher keine zur Askese neigende Persönlichkeit ist. Seit ihren Anfängen im frühen 20. Jahrhundert ging die abstrakte Malerei häufig mit spirituellen Erfahrungen einher. Kandinsky und Mondrian unterfütterten ihre Malerei mit theosophischen Schriften, und häufig haben Ausstellungen abstrakter Kunst diese mit religiösen Idealen in Verbindung gebracht. Joy hingegen wurde von dieser spezifischen Denkweise nicht geprägt. Er verbindet seine Abstraktionen allerdings mit der spirituellen Tradition der Ikonenmalerei:

„Ich habe mich seit jeher für die Geheimnisse der Firnistechniken meisterhafter Instrumentenbauer wie Stradivari interessiert und viel darüber gelesen. Wenn man an die Natur der Alchemie und den Gebrauch von ‚Materie' in der Malerei denkt, dann gibt es diesbezüglich ähnliche Regeln, oder wenn man so will, ein Fehlen von Regeln im Bezug auf die Frage, wie man in einer Violine oder einem Cello diesen zauberhaften Klang erzeugt, diese geheimnisvollen Formeln, um den richtigen Ton gegenüber dem Betrachter zu treffen, wenn sie auf angemessene Weise beherzigt werden. Obwohl ich auch eingestehen würde, dass sich ein erheblicher Teil dieses Geheimnisses dem Verstreichen der Zeit verdankt."

steve joy: sein leben in der kunst
DAVID CARRIER

Darüber hinaus beschäftigt Joy die Schilderung „des Ateliers als einer Art Psychose" in James Elkins' *What Painting Is*:

„Ich meine ebenfalls, dass es wichtig ist, nie zu vergessen, wie verrückt die Malerei ist und dass sich der Künstler, um ein Werk zu produzieren, über längere Zeitabschnitte mit Ölfarben und Lösungsmitteln einschließen muss usw. Elkins schreibt: ‚Schriftsteller und Komponisten sind dem fertigen Produkt viel näher, ihre Worte und Noten erscheinen säuberlich auf dem Papier, und es bereitet ihnen keine Mühe, die Worte A, B und C zu formen. Doch Maler müssen in einem Morast widerspenstiger Substanzen arbeiten.'"

Trotzdem weist Joy darauf hin, inwiefern sich seine Atelierpraxis davon unterscheidet:

„Was das im Entstehen begriffene Werk betrifft, so stimme ich nicht mit seiner Deutung überein. Die eigentliche Mühe besteht in der geistigen Anstrengung vor dem Malprozess selbst; der Herstellungsprozess im Atelier ist häufig, wenn auch nicht immer, ein sehr sauberer und genau kalkulierter Vorgang. Um es nochmals zu sagen: Möglicherweise hat das etwas mit dem Verstreichen der Zeit zu tun und damit, dass man an Erfahrung gewinnt, aber für mich war das Atelier stets eher ein geistiges Labor als eine Werkstatt. Daher fühle ich mich aufgrund des hohen Anteils, den das Ritual und die Vorbereitung an meinem Werk haben, auch mehr mit den Mönchen der byzantinischen Klöster verbunden als mit den Arbeitsformen der Abstrakten Expressionisten."

In der 2001 von der Fundació Caixa (Katalonien) herausgegebenen Publikation *Russian Icons from Tretyakov Gallery* kommt dieses Thema zur Sprache:

„Das Werk selbst entfaltet sich wie eine sakramentale Liturgie; die Vorbereitung der Tafel, die als Träger für das Gemälde ausersehen wurde, wird mit dem Altar verglichen, auf dem die Gottheit offenbart werden wird. Bei der Auswahl der Farben und beim Aufbringen des Blattgolds usw. bekreuzigt der Künstler sich, betet und meditiert. Die Kunst ist also eine wahrhaft spirituelle Methode, vermittels derer der Mensch sich seines Ichs entledigt und es sich selbst gestattet, in einem Akt göttlicher Aktivität von der Wesensverwandtschaft erfüllt zu werden. Tatsächlich ist die Arbeit jedweden sakralen Amts eine Fortsetzung des Schöpfungsaktes."[9]

Die Ikone, so die These dieses Buches, präsentiert universelle Denkweisen, die Menschen aus allen religiösen Traditionen verstehen können. Aus Joys Sicht funktionieren seine abstrakten Gemälde identisch:

„Die Ikone stellt einen Versuch dar, das Unsichtbare zu sehen, denn das Unsichtbare wird gezeigt."

Wir haben es hier mit einer Vorwegnahme von Joys Überzeugung

zu tun. Doch wie, so könnte man fragen, ist es möglich, im 21. Jahrhundert ein Ikonenmaler zu sein? Joys Antwort auf diese Frage enthält eine kritische Würdigung

„der relativ primitiven Techniken der frühen modernen Meister Rothko, Newman etc. Meines Erachtens haben es die aufeinander folgenden Bewegungen im 20. Jahrhundert mehr oder weniger versäumt, technische Innovationen aufzugreifen. Wegen des nie befriedigten Anspruchs, immer auf dem neuesten Stand der intellektuellen Entwicklung zu stehen, haben sie auch sehr wichtige philosophische und historische Themen nur flüchtig gestreift."

Joy möchte diese Themen aus seiner im frühen 21. Jahrhundert beheimateten Perspektive überdenken, da er der Meinung ist, frühere Künstler hätten diese Fragen zu rasch abgetan:

„Mir geht es darum, die Fragen nach dem Verhältnis des Menschen zur Spiritualität, ob in Gestalt der herkömmlichen Religion oder persönlicher Meditation, einer erneuten Betrachtung zu unterziehen. Dies ist nach wie vor eines der zentralen Themen unserer Zeit."

Ikonen stellen sakrale Sujets dar und finden sich normalerweise in Kirchen. Sie sind keine Kunstwerke, obwohl sie gelegentlich in Museen ausgestellt werden. Hans Belting verdanken wir eine exakte Darstellung der Entwicklung der Kunst in dieser Tradition des „Bildes vor dem Zeitalter der Kunst". Für den Ikonenmaler verbietet die

„Distanz Gottes […] seine Präsenz in einem gemalten Abbild für die Sinneserfahrung. […] Sie [eine neue Sinnebene zwischen dem Augenschein des Bildes und dem Verständnis des Betrachters] wird dem Künstler eingeräumt, der das Bild als den Beleg von Kunst in die eigene Regie nimmt. […] Die Auslieferung des Bildes an den Betrachter kommt handgreiflich in der neu entstehenden Kunstsammlung zum Ausdruck, in der die Bilder humanistische Themen und Kunstschönheit repräsentieren."[10]

8 Hinsichtlich einer ausführlichen Darstellung Scullys siehe meine Publikation *Sean Scully*, London 2003. Ein Absatz meiner Ausführungen über seine Kunst stammt aus meinem Aufsatz „Marcel's Studio Visit with Elstir", in: *ArtUS* 9, Juli–September 2005, S. 29–39.

9 Hani, Jean, „Symology and Transcendence", in: *Russian Icons from Tretyakov Gallery*, Ausst.Kat. Fundació Caixa, Katalonien 2001, S. 43f.

10 Belting, Hans, *Bild und Kult. Eine Geschichte des Bildes vor dem Zeitalter der Kunst*, München 1990, S. 26.

Dieselbe Unterscheidung zwischen Kunstwerken und Ikonen beschreibt der von Joy bewunderte englische Komponist John Tavener folgendermaßen:

„Ein religiöses Bild, so großartig auch immer es sein mag, ist etwas völlig anderes als eine liturgische Ikone. Das eine ist von dieser Welt; es spricht von dieser Welt und lässt den Betrachter in ihr zurück. […] Die Ikone hingegen spricht die menschliche Natur allgemein an, das Verlangen des Menschen nach etwas Jenseitigem."[11]

Doch in einigen Aspekten unterscheidet sich Joys Situation von derjenigen Taveners. Tavener, der zum orthodoxen Glauben übertrat und nach Griechenland zog, komponiert liturgische Musik. Idealerweise, so Tavener, sollten seine Kompositionen in Kirchen aufgeführt werden. Joy hingegen malt für Sammler und Museen, nicht für Kirchen; obwohl er sich also offensichtlich für die religiöse Tradition interessiert, malt er keine religiösen Sujets. Seine Gemälde zeigen keine Heiligen; diese abstrakten Bilder sind keine Ikonen, auch wenn Joy seine Kunst gerne in einem äußerst nüchternen Umfeld präsentieren möchte. Als eine Spielart von Rothkos Kapelle oder gar von Donald Judds *Marfa* wäre dies dennoch eine Galerie und keine Kirche. Warum also ist Joy der Meinung, seine Kunst ließe sich mit dieser byzantinischen religiösen Tradition verbinden? Wir können die Antwort auf abstrakte Gemälde, wenn wir wollen, mit sakralen Bildern verknüpfen:

„Bei der reinen Abstraktion muss man etwas präsentieren, das die Leute hineinzieht, etwas Geistiges, das meiner Ansicht nach mit der Oberfläche, der Textur, dem Material zusammenhängt; im Verlauf der Geschichte gibt es viele Gemälde mit solchen Formen. Ich habe immer versucht, mein Werk mit diesen großartigen Materialien zu verbinden, Materialien, die die Leute freundlich stimmen gegenüber dem, was der Künstler probiert auszudrücken."

Es ist jedoch offenkundig, dass sich die Lage eines modernen Malers, unabhängig von seinen persönlichen Glaubensüberzeugungen, von der eines Ikonenmalers unterscheidet. Ikonen sind keine Kunstwerke. Wenn Renaissancealtäre in moderne Museen gestellt werden, dann gibt es eine augenfällige Diskrepanz, denn diese sakralen Bilder wurden nicht als Kunstwerke geschaffen.

In den 1970er Jahren begannen sich einige amerikanische Maler für islamische Muster zu interessieren, die sie sich im Sinne ihrer eigenen Herangehensweisen aneigneten. Unlängst arbeitete ebenfalls Philip Taaffe auf ähnliche Weise. Diese Künstler wurden allerdings weder Muslime noch studierten sie die islamische

Geschichte oder die Geschichte der Dekoration auf ernsthafte Weise. Da sie diese Muster attraktiv fanden, verwendeten sie sie in Gemälden, die den Anliegen zeitgenössischer säkularer Kunst entsprachen, also für ihre eigenen Zwecke. Eine Generation früher verfuhr Barnett Newman bei seinen *Stations of the Cross* ähnlich, indem er ein traditionelles sakrales Motiv benutzte, um eine Serie abstrakter Bilder zu schaffen, ohne diese wirklich mit der christlichen Tradition zu verknüpfen. Man könnte vermutlich vor ihnen beten, doch käme man sich seltsam dabei vor, da diese Gemälde in der National Gallery in Washington hängen und nicht in einer Kirche. Inwiefern unterscheidet sich Joys Rückbezug auf die Ikonentradition hiervon?

Eine Ikone – ich beginne hier mit einer Verallgemeinerung, die im Folgenden differenziert werden soll – ist eine Darstellung, bei der heilige Figuren vor einem goldenen Hintergrund erscheinen. Landschaften oder Innenräume werden nur andeutungsweise präsentiert, mit gerade so vielen Details, dass die Betrachter die Geschichte begreifen können. Ausgehend von Cimabue ist die Geschichte der europäischen Malerei durch einen zunehmenden Naturalismus gekennzeichnet: Giotto ermöglicht Masaccio, der seinerseits Raffael den Weg ebnet. Diese in Giorgio Vasaris *Lebensbeschreibungen der berühmtesten Maler, Bildhauer und Architekten* (1550) erzählte Geschichte findet in der modernen Forschung ihren Widerhall. Schon bald darauf wird die gesamte Tradition schließlich mit dem Einsetzen der Moderne säkularisiert. Im Gegensatz dazu geht es den Ikonenmalern nicht um eine Weiterentwicklung der Kunst. Vielmehr lehnen sie den Naturalismus sogar ab, ist es doch ihr ausdrückliches Ziel, Bilder zu schaffen, die nicht naturgetreu sind. Damit reagierten sie selbstverständlich auf die Ikonoklasmusdebatten innerhalb der orthodoxen Kirche. In der bildlichen Darstellung sieht Christus wie ein ganz normaler Mensch aus. Daher muss uns der Ikonenmaler darin erinnern, dass ER wirklich der fleischgewordene Erlösergott ist. Je weniger eine Ikone ihren heiligen Gegenstand auf naturalistische Weise darstellt, desto weniger wird sie die Gläubigen verwirren. In der westlichen Tradition gab es einen allmählichen Wandel von der primären Auseinandersetzung mit heiligen Szenen hin zur Entwicklung säkularer Sujets wie Genreszenen, Landschaften und Porträts. Innerhalb der orthodoxen Tradition gab es indessen keinen vergleichbaren Wandel.

In der westlichen Tradition, wie sie von Vasari und seinen Nachfolgern beschrieben wird, gibt es zudem einen Bonus für Originalität: Ein großer Künstler unterscheidet sich von seinen weniger bedeutenden Zeitgenossen durch seinen radikalen Erfindungsreichtum. Ikonenmaler hingegen sind bestrebt, anonym zu bleiben, weshalb sie

ihre Bilder auch nicht signieren. Ikonen, um dies nochmals in aller gebotenen Deutlichkeit zu sagen, sind keine Kunstwerke, sondern für liturgische Zwecke genutzte Artefakte. Zu Beginn der europäischen Kunstgeschichte standen die westliche und die orthodoxe Tradition noch im Einklang miteinander, denn Cimabue und Giotto lernten unmittelbar vom Umgang mit Ikonen. Doch mit dem einsetzenden Fortschritt der westlichen Kunst verliefen beide Traditionslinien völlig unterschiedlich. Gemäß der älteren kanonischen Darstellung der modernen Malerei, wie sie von Greenberg formuliert wurde, ging die Abstraktion aus dem naturalistischen Erbe hervor, indem sie den illusionistischen Bildraum abflachte. Doch da byzantinische Kunstwerke von vornherein flach waren, ähnelten sie Gemälden des Abstrakten Expressionismus. Greenberg bemerkte diesbezüglich 1958:

„Die Byzantiner entmaterialisierten die unmittelbare Wirklichkeit, indem sie eine transzendente anriefen. Wir machen offenbar etwas Ähnliches, […] insofern wir das Material gegen sich selbst anrufen, indem wir auf seiner allumfassenden Wirklichkeit insistieren."[12]

Diese Parallele, so seine Schlussfolgerung, ist jedoch nur bedingt aussagekräftig, da heilige byzantinische Ikonen und moderne Malerei nun einmal nicht dasselbe sind. Betrachten wir nun eine Gruppe von Joys Gemälden, so finden wir darin spiegelnde goldene Tafeln, wie bei Ikonen. Das vor kurzem entstandene Werk *Icon (Trinity)* (2005, siehe Seite 48) etwa, das aus vier schmalen senkrechten Rechtecken besteht, einige mit Streifen, andere mit Gold oder gedämpften Farben, leuchtet in der Dunkelheit. Desgleichen besitzt *Portrait of a Lady* (2005) mit seinen fünf senkrechten Rechtecken eine ähnliche Struktur. Offenkundig erinnern diese Bilder ebenso wie Joys frühe Gemälde nur bedingt an Ikonen. Hier könnten wir es Ad Reinhardt nachtun, einem anderen Maler, der sich für spirituelle Kunst interessiert, und Joys Kunstwerke dadurch charakterisieren, dass wir beschreiben, was sie gerade nicht enthalten. Im Gegensatz zu den meisten Abstrakten Expressionisten bedient sich Joy keines malerischen Pinselduktus'. Er selbst sagt, obwohl er sich mit großem Vergnügen

„die spanischen Maler angesehen [habe], wurde ich nicht durch sie beeinflusst. Ich besaß nie einen besonderen Pinselduktus. In Spanien habe ich kleine Sammlungen bevorzugt, etwa die in Barcelona, die romanische Kunst im katalanischen Nationalmuseum."

Für Joy sind die Elemente abstrakter Malerei im Prinzip ziemlich einfach:

„Man musste bewusst mit der Sprache arbeiten, aber häufig blieb zu viel dem Publikum überlassen, von ihm zu verlangen, dass jedwedes Zeichen auf der Leinwand Kunst sein konnte. Ich versuchte, spezifischer zu sein."

Joy verwendet keine ‚shaped canvases', keine Leinwände mit ungewöhnlichen Formen. Seine Bilder sind rechteckig, wie etwa *Samurai Painting (Red Robe)* (2004, siehe Seite 64f.) Joy malt aber auch keine monochromen Bilder. Stets unterteilt er die Leinwand.

In einem wesentlichen Punkt arbeitet Joy allerdings wie ein Ikonenmaler:

„Meine Gemälde sind weniger gemalt als gebaut. Die malerischen Elemente werden in der Regel am Ende hinzugefügt. Das Auftragen der einzelnen Schichten ist aufwändig, wobei ich keinem bestimmten System folge. Beim Aufgießen von Wachs, von Schellack, bei all diesen technischen Aspekten kann immer etwas schief gehen."

Zudem möchte Joy, dass seinen Gemälden jene Aufmerksamkeit zuteil wird, die traditionell Ikonen vorbehalten war:

„Die Malerei ist eine ganz offene Option, die auf der Ebene der tieferen Bedeutung etwas zur Gesellschaft beitragen möchte. Ich will nicht, dass meine Gemälde rein säkular betrachtet werden. Aber diese Frage, die Idee Gott, was Gott sein mag oder vielleicht auch nicht, das ist die alles beherrschende Frage, und meine Gemälde sind ein Ausdruck dieser Art des Glaubens, so etwas wie Vermittler. Deshalb fühle ich mich der Ikonenmalerei verbunden; eine Ikone repräsentiert tatsächlich Gott hier auf der Erde und beabsichtigt nicht wie die Malerei der Renaissance, den Betrachter zu einem Begriff von Gott zu führen."

Wie Ikonen halten sich auch Joys Gemälde abseits von der alltäglichen, praxisbezogenen Welt. Doch eine solche Beschreibung könnte sie wie europäische Bilder erscheinen lassen, die einen gewissen ästhetischen Abstand von uns verlangen. Aber für jemanden, der sich für Ikonen interessiert, stellt sich die Lage anders dar. Für Joy, so könnte man sagen, steht das Sakrale für das Nicht-Utilitaristische. Man nehme beispielsweise *Icon (Trinity)* (2005). Joy, den mit den Bildermachern der orthodoxen Tradition ein reales gemeinsames Interesse verbindet, hat das Gefühl, dass unsere gegenwärtige Konzentration auf die Technologie wichtige Werte außer Acht lässt:

11 Tavener, John, *The Music of Silence: A Composer's Testament*, London und New York 1999, S. 113.

12 Greenberg, Clement, *Art and Culture: Critical Essays*, Boston 1961, S. 169.

„Gibt es, ohne dass man diese Idee des Spirituellen definiert, irgendetwas im Leben, von dem wir nicht verstehen, dass wir es nicht verstehen sollen, und das wir auch nicht verstehen sollen, das uns in einen Zustand des Mysteriums und des Staunens versetzt? Die Malerei ist dazu im Stande."

An dieser Stelle kommen wir nochmals auf das Interesse am Rituellen zurück, das Joy in Japan entwickelte:

„Disziplin, Hingabe, Demut, Ausdauer und spirituelle ‚gravitas' sind für mich, zumindest in dem Maße, in dem dies möglich ist, ohne dass man Mönch wird, Eigenschaften, die mir auch jetzt noch wichtig sind. Bei der nach einem Samurai benannten Gemäldeserie *Samurai Painting (Red Robe)* etwa geht es ganz deutlich um diese Prinzipien."

Ikonen verfügen nach Joys These über eine universelle Macht, die auch Menschen zugänglich ist, die nicht glauben und vielleicht gar nichts über diese religiöse Tradition wissen. Joys *Icon (after Hodegetria) (2005)*, um ein wichtiges Beispiel zu nennen, ist von einer Ikone inspiriert:

„Wenn ich mich eines Themas annehme, dann habe ich dabei häufig versucht, die Intention und das Gefühl nochmals zu bearbeiten. Die Künstler des 13. und 14. Jahrhunderts arbeiteten auf ähnliche Weise, mit Blattgold, Schellack und Firnis, um sie zum Schluss mit einer Schicht aus Bienenwachs zu überziehen."

In den letzten Jahrzehnten hat sich die Kunstwelt, zumindest in den USA und in England, weitgehend von der Malerei und anderen traditionellen Kunstformen ab- und technologiebasierter Kunst zugewandt. Oft fühlten sich Maler regelrecht unter Druck gesetzt. Aber Joy empfindet diesen Wandel als eine gute Entwicklung. Das bedeutet aber auch, dass sich die Malerei vergleichsweise frei entwickeln kann. Die Tatsache, dass die Malerei in der Kunstwelt heute lediglich eine marginale Rolle spielt, sollte nach Joys Dafürhalten eine befreiende Wirkung haben. Das Bewusstsein für dieses Problem, die Auseinandersetzung mit dem Handwerk des Kunstmachens, hat Joys Beschäftigung mit der Technik beeinflusst. Er interessiert sich für

„mittelalterliche Materialen, selbstgemischte Pigmente, Schellack, Firnis, reines Bienenwachs, Blattgold aus Japan, Tinten auf Ölbasis. Die Bilder vermitteln eher den Eindruck, Licht zu verströmen als es zu absorbieren. Wenn man diese byzantinischen Materialien mit Ölfarbe kombiniert, dann ergibt sich ein gewaltiger Kontrast zwischen Reflexion und Absorption."

Ikonen, so der orthodoxe Theologe Leonid Ouspensky,

„sind Mittler zwischen den dargestellten Personen und den betenden Gläubigen, die es ihnen ermöglichen, in einem Zustand der Gnade zu kommunizieren. In einer Kirche bilden die Gläubigen während einer Liturgie durch die Vermittlung von Ikonen und liturgischen Gebeten eine Gemeinschaft mit der himmlischen Kirche und werden ein einziges Ganzes."[13]

Diese sakralen Anliegen kamen in zahlreichen Kulturen zum Tragen. In vielen Zisterzienserkirchen in Frankreich, so Joy, gibt es nur noch den Raum, der so seine religiöse Bedeutung auch ohne christliche Dekoration behält. Joy ist von der Idee sakraler Räume fasziniert. Eine Kunstgalerie oder ein Kunstmuseum ist keine Kirche, aber, so Joy,

„ich würde sie gerne als kontemplative, heilige Orte betrachten, was sie ja auch bis vor kurzem gewesen sind. Ich bin der Tatsache, dass Kunst einfach nur eine weitere Aktivität innerhalb des Informationsgeflechts, eine weitere Form der Unterhaltung geworden ist, ein wenig überdrüssig. Ich dachte daran, dass man in Griechenland in eine kleine byzantinische Kirche gehen kann, in der nichts mehr von den Gemälden übrig ist als der Holzträger und das Blattgold; mich fasziniert, dass sie einen dennoch nach wie vor gefangen nehmen. Man benötigt nicht das ganze Bild."

Obwohl Ikonen für die orthodoxe Kirche hergestellt wurden, können sie in mancher, gerade für einen abstrakten Maler relevanter Hinsicht allgemein gültige visuelle Anliegen implizieren. Man denke etwa an *Portrait of a Lady (2005)* mit seinen fünf längsrechteckigen Tafeln. Wie kann ein abstraktes Gemälde eine größere Öffentlichkeit ansprechen? Die Gemälde der Alten Meister waren deshalb relevant, weil sie Geschichten erzählten. Welche vergleichbare Anziehungskraft besitzt die abstrakte Kunst? Teilweise appelliert Joy an die historische Flexibilität spiritueller Formen des Nachdenkens über Malerei:

„Was bleibt? Wir kehren immer wieder zu diesem Element der Spiritualität zurück."

Als ich Joys Gemälde zum ersten Mal sah, schienen sie mir außerordentlich zugänglich zu sein. Die Streifen erinnerten mich an die von Scully und die spiegelnden Farben der Goldhintergründe brachte ich mit einer ganzen Reihe abstrakter Künstler aus den 1980er Jahren in Verbindung. Ich brauchte eine Weile, bis ich begriff, wie glänzend originell Joys Kunst ist und welche intellektuelle Herausforderung sie darstellt. John Tavener schreibt über den Unter-

steve joy: sein leben in der kunst
DAVID CARRIER

schied zwischen der Kunst, die von den Malern der Renaissance und Ikonenmalern geschaffen wurde:

„Die eine ist das Erzeugnis des künstlerischen Talents eines Menschen, die andere der Spiegel und die Blüte des liturgischen Lebens. Die eine ist von ‚dieser‘ Welt und lässt den Betrachter dort zurück. Die andere steigt von der tiefsten Stufe empor, auf der alles im Menschen eins ist. Diese Unterscheidung liefert meines Erachtens den Schlüssel zu Joys Kunst."[14]

Anhand meines Eingangsmottos aus Meyer Schapiros Aufsatz *Moderne abstrakte Malerei* (1957) habe ich zu erläutern versucht, warum das Reisen für Joy so wichtig ist. An einer früheren Stelle in diesem Essay sagt Schapiro etwas, das eine schöne Vorwegnahme dessen darstellt, was sich als Joys Ziel erweisen sollte:

„Vielen bieten diese Künste [Malerei und Plastik] Ersatz für etwas, was man als Teil religiösen Lebens ansieht, nämlich eine aufrichtige und demütige Unterwerfung unter ein spirituelles Objekt, eine Erfahrung, die man nicht wie von selbst macht, sondern die der Vorbereitung und des reinen Sinnes bedarf."[15]

Damit ist in einem Satz zusammengefasst, worum es in Joys Kunst geht. Wir können in der zeitgenössischen säkularen Kunst nicht zur Tradition der Ikonenmalerei zurückkehren. Daher lässt sich Joys Werk meines Erachtens nur mit Hilfe einer langfristigen historischen Perspektive einordnen. Der Hauptstrang der westlichen Tradition, die Entwicklung der Malerei von Cimabue bis Jackson Pollock, zeigt, wie die Malerei zunächst säkularisiert wurde und dann zur Abstraktion führte. Im Verlauf einer langen Entwicklung, die von 1300 bis 1950 dauerte, entdeckten die Künstler, dass sie die älteren Sujets, Heilige und Sakralszenen, durch Landschaften, Stillleben und Genreszenen ersetzen konnten. In der Folge stellten sie fest, dass sie auch rein abstrakte Bilder malen und dennoch die Tradition weiterführen konnten. Bei diesem Prozess war es, wie Greenberg gezeigt hat, möglich, die Werte der Tradition aufrechtzuerhalten, auch wenn sich der soziale Kontext der Kunst radikal veränderte. Hans Belting weist darauf hin, wie dramatisch der Wandel war, der in der Frührenaissance stattfand:

„Man hatte dem alten Bild eine Realität besonderer Art zugetraut und es wörtlich genommen als Erscheinung der sakralen Person in sichtbarer Gestalt. Das neue Bild wurde [...] auf die allgemeinen Naturgesetze verpflichtet [...] und damit ohne Abstriche dem Bereich der sinnlichen Wahrnehmung zugeordnet. [...] So betrachtet, war es ein simuliertes Fenster geworden."[16]

Nachdem diese Entwicklung einmal stattgefunden hatte, ließen weitere radikale Veränderungen nicht lange auf sich warten. Cimabue malte für Kirchen und Pollock für Galerien und Museen. Als dies geschah, veränderten sich die visuellen Eigenschaften des Kunstwerks auf radikale Weise, denn man fand heraus, dass man Kunst ebenfalls rein ästhetisch und losgelöst von ihren sakralen Funktionen genießen konnte. Gleichwohl war die Kontinuität groß genug, um von einer künstlerischen Tradition zu sprechen.

Während die westliche Malerei also durch extreme Innovation modernisiert wurde, war dies bei der byzantinischen Kunst nicht der Fall. Heute wie schon zu Cimabues Zeit sind Ikonen heilige Artefakte. Zum Teil, daran besteht kein Zweifel, spiegelt diese radikale Kluft zwischen der Geschichte der östlichen und der der westlichen Kunst die politische Realität wider. Die Eroberung Konstantinopels durch die Muslime im Jahr 1453 gilt dem modernen Griechenlandexperten C. M. Woodhouse zufolge

„zugleich als Markstein für das Ende einer Ära. Denn die Stadt am Bosporus war der eine Fixpunkt im Reich, sein physisches Herz und seine spirituelle Seele. Solange sie überlebte, konnte niemand das Reich für tot erklären."[17]

Nach 1453 gerieten die mit dem ehemaligen östlichen Reich assoziierten Gebiete in kultureller Hinsicht zunehmend ins Hintertreffen. Zwar überlebte die orthodoxe Kirche, doch die Kultur und die Kunstwelt waren außer Stande, radikale Neuerungen durchzuführen. In nuce lässt sich diese Geschichte heute im Athener Nationalmuseum verfolgen. Nach dem Fall Konstantinopels, so die Kuratorin Marina Lambraki-Plaka, konnten einige Künstler in Kreta, das nicht Teil des Osmanischen Reiches wurde,

„entweder ‚alla Greca‘ oder ‚alla Latine‘ malen, also im Einklang mit dem westlichen Renaissancestil. Mitunter existierten beide Stile nebeneinander."[18]

Natürlich gab es mit Domenikos Theotokopoulos, der im Westen als El Greco (1541–1614) bezeichnet wird, einen Künstler, der von Kreta nach Italien und Spanien ging und innerhalb der europäischen Tradi-

13 Ouspensky, Leonid, *Theology of the Icon*, Crestwood, NY, 1978, S. 168.

14 Tavener, a.a.O., S. 56.

15 Schapiro, a.a.O., S. 217f.

16 Belting, a.a.O., S. 524.

17 Woodhouse, C. M., *Modern Greece: A Short History*, London 1998, S. 97.

18 Lambraki-Plaka, Marina, *National Gallery. Alexandros Soutzon Museum. Four Centuries of Greek Painting*, Athen 2000, S. 46.

tion zu einem großartig exotischen Künstler wurde. Doch El Greco ist eine Ausnahme. Als nach 1823 ein unabhängiger griechischer Staat entstand, reisten ehrgeizige Künstler nach München und Paris und schufen deutlich in der westlichen Tradition stehende Kunst, darunter auch orientalistische Bilder. Die meisten Gemälde in der Athener Nationalgalerie könnte man auf den ersten Blick für Werke westlicher Künstler halten. Im frühen 20. Jahrhundert versuchten einige wenige griechische Künstler, die östliche Überlieferung zu neuem Leben zu erwecken, wobei sie sich an den Vorgaben der Ikonenmalerei orientierten. Doch auch für diese Künstler war die Ikonenmalerei zu exotisch geworden, um weiterhin bemerkenswerte Resultate hervorzubringen. Wenn nun griechische Maler in jüngerer Zeit abstrakte Bilder schufen, so taten sie dies auf eine Frankreich oder den U.S.A. entlehnte Manier.

Im Folgenden wende ich auf Joys Malerei Denkmodelle an, die ich in meiner demnächst erscheinenden Untersuchung zur Kunstgeschichte der Welt entwickelt habe. Ich vertrete, vereinfachend gesagt, die These, dass wir die Zeitleisten betrachten müssen, in denen sich verschiedene künstlerische Traditionen entwickeln, und dann verstehen, was geschieht, wenn eine Tradition auf eine andere einwirkt. Wenn wir die Entwicklung der europäischen Kunst beispielsweise auf dieser Zeitleiste

Cimabue Masaccio Pollock

präsentieren, dann findet die Geschichte der Kunst auf einer anderen, weitgehend parallelen Zeitleiste statt, die erst ab dem 17. Jahrhundert vom Westen beeinflusst wird. Eine Zeitleiste ist deshalb praktikabel, weil sie von links nach rechts verlaufend die Entwicklung einer künstlerischen Tradition markiert. Ein Teil dieser Analyse ist für Joy von besonderer Relevanz, nämlich der Kontrast zwischen der fortlaufenden Entwicklung der westeuropäischen Malerei und der Tradition der mit der Ostkirche assoziierten Ikonenmalerei, die effektiv an den Rand gedrängt wurde, als die Osmanen 1453 Konstantinopel eroberten. Zwar wurden weiterhin Ikonen produziert, aber da die Macht der orthodoxen Kirche so drastisch eingeschränkt wurde, verlief die Entwicklung wesentlich weniger dynamisch als im Westen. Dass die Tradition der Ikonenmalerei dann relativ statisch wurde, lag nicht nur daran, dass die östlichen Künstler nicht an einer Weiterentwicklung interessiert waren, sondern auch daran, dass die schwierige politische Lage der orthodoxen Kirche ihre Schirmherrschaft relativ

unwichtig werden ließ. Unter der muslimischen Herrschaft mussten die Christen der Ostkirche häufig um ihr Überleben kämpfen. Erst 1823 sollte Griechenland ein unabhängiges Land werden.

Scullys abstrakte Bilderfindungen gehen auf eine lange westliche Tradition zurück, deren Bedeutung er für sein Werk anerkannt hat. Seine Zeitschiene sieht folgendermaßen aus:

Cimabue Piero Matisse Scully

Dass Joys Verwendung der Ikonentradition für die abstrakte Malerei im Gegensatz dazu leider relativ schwierig zu verstehen ist, erklärt sich dadurch, dass die östliche Tradition nach 1453 deutlich an Bedeutung einbüßte. Auf Joys Zeitleiste spielt daher der Bruch zwischen den alten Ikonen und seinen abstrakten Gemälden eine Rolle:

Ikonen 1453 1823 Joy

Ursprünglich waren diese beiden Zeitleisten miteinander verknüpft, da Cimabue und seine unmittelbaren Nachfolger von der Ikonenmalerei lernten. Doch nach 1453 wurden daraus faktisch unterschiedliche Traditionen. Dennoch ist es von Belang, diese komplexe Geschichte von Joys Entwicklung nicht auf eine allzu intellektuelle Weise zu beschreiben. Joy ist ein Maler, kein Kunsthistoriker. Erst post festum können wir verstehen, wie und warum er sich entwickelt hat.

Liegt es in der Natur der Ikonenmalerei, dass sich diese Kunstform weiterentwickelt? Diese Frage lässt sich nicht beantworten. Wer weiß, ob die östliche Kunst nicht ihren eigenen Masaccio, Piero oder Constable, also den großen Vertretern der westlichen Tradition ebenbürtige Gestalten hervorgebracht hätte, wäre Konstantinopel nicht erobert worden. Das Einzige, was wir sagen können, ist, dass sich infolge dieser gravierenden historischen Unterschiede zwischen Ost und West die westliche Kunst weiterentwickelte, während dies bei der östlichen Tradition nicht der Fall war. Joys eigentliche Leistung besteht daher darin, dass er die mit der Ikonenmalerei verbundene Denkweise ästhetisiert und die sakrale Tradition in eine moderne säkulare Welt überführt hat. In seiner Kunst bewegen wir uns in einem großen historischen Sprung von der religiösen Welt der Ikonen zu einer Form der abstrakten Malerei, die, soviel sie dem Abstrakten Expressionismus verdanken mag, diese östliche Tradition erweitert. Tavener beschreibt sich selbst als einen orthodoxen Komponisten, der zufällig in England geboren wurde. In Anlehnung

steve joy: sein leben in der kunst
DAVID CARRIER

daran könnte man Joy als einen Ikonenmaler bezeichnen, der zufällig in England geboren wurde. Es ist offenkundig, dass kein Künstler eine ganze Tradition erweitern oder wiederbeleben kann. Doch Joy hatte das Glück, zu einem Zeitpunkt Maler zu werden, als, wie Greenberg erklärt, die westliche Tradition der Abstraktion auf unabhängige Weise mit der byzantinischen Bildkultur verschmolzen war. Auf seinem Weg von Europa nach New York City und Omaha gelangte er zur östlichen Welt der Ikonenmalerei.

In seinem ausgesprochen schönen Buch *The Light of Early Italian Painting* schildert Paul Hills den Zusammenhang zwischen den Ursprüngen der Renaissancemalerei und dem Licht in Zentralitalien: „Zwischen 1250 und 1430 entdeckten italienische Künstler den Bildraum und das Bildlicht wieder. […] Licht ist für das Sehen so wichtig wie das Atmen für das Leben. Aber so wie wir uns die meiste Zeit nicht bewusst sind, dass wir atmen, achten wir auch nicht immer auf das Licht, mittels dessen wir sehen. […] Wir sollten stärker darauf achten, wie das Licht unser Bewusstsein beeinflusst."[19]

Auch Joy ist vom Licht und der Art und Weise fasziniert, wie es die bildende Kunst mit einem Schauplatz verbindet: „Ich möchte kein feststehendes Licht. Das geht auf die Idee zurück, dass Gemälde Objekte der Verehrung sind. Ich empfinde unterschiedlich, je nachdem, ob ich mir meine Bilder am Morgen oder am Abend ansehe. Ich liebe die byzantinischen Kirchen, wo die Bilder sich praktisch im Dunkeln befinden."

Interessanterweise spricht auch Tavener über bildende Kunst und Licht: „Die Ikone befindet sich dort vor einem und man kann sie sehen, tröstlich und klar, Tag und Nacht. Ob man die Augen geöffnet oder geschlossen hat, die Präsenz des transzendenten Lichts verliert man nicht."[20]

Joys Vorliebe für Nebraska verdankt sich partiell den dortigen Lichtverhältnissen: „Die Frage des Lichts ist eine interessante persönliche Frage. An manchen Tagen unterscheidet sich Nebraska [in dieser Hinsicht] gar nicht so sehr von Griechenland."

Für einen Maler ist das Licht, das an einem bestimmten Ort herrscht, wesentlich, denn es offenbart ihm, welche Kunst er dort machen kann: „Ich habe Orte immer danach ausgesucht, wie schön sie sind. Ich bin in alle vier Winkel Nevadas gefahren – ganz schön wild da draußen. Die Sandhügel faszinierten mich und erinnerten mich an das Mittelmeer: Lange schöne Straßen und hinter jedem Hügel erwartete man das Meer.

Das Licht vermittelte einem das Gefühl, in der Nähe des Meeres zu sein. Auf merkwürdige Weise befriedigte das mein Verlangen nach Licht, mit dem ich aufgewachsen bin."

Mitunter kann das Reisen höchst seltsame Ergebnisse zeitigen: Wir versuchen, an einen bestimmten Ort zu gelangen und kommen an einem anderen an. Doch letztlich, so Joy, „sind meine Gemälde im Grunde einfach."

Deswegen sollten wir auch seine Reisen auf einfache Weise verstehen. „Es ging mir darum, ein Gemälde zu gestalten, das jemanden in eine bestimmte Zeit, an einen bestimmten Ort, in eine bestimmte Stimmung oder ein bestimmtes Gefühl versetzen sollte, ohne diese Dinge zu illustrieren, ohne physisch an diesen Ort zu reisen."

Hier ist eine Entscheidung gefallen, jedenfalls bis auf weiteres: „Ich habe lange gebraucht, bis ich soweit war, aber jetzt befinde ich mich in einer Lage, in der ich für den Rest meines Lebens solche Bilder malen könnte."

Dieses Happy End zeigt, dass sich Joys lange Reise auf jeden Fall gelohnt hat.

19 Hills, Paul, *The Light of Early Italian Painting*, New Haven und London 1987, S. 3f.
20 Tavener, a.a.O., S. 118.

This book was published in conjunction
with the exhibition
Uncreated Light: Steve Joy Paintings, 1980–2008
held at Joslyn Art Museum
from 28 June to 5 October, 2008.

Joslyn Art Museum
2200 Dodge Street
Omaha, Nebraska 68102-1292
www.joslyn.org
http://www.joslyn.org

© **Joslyn Art Museum and Prestel Verlag,**
Munich · Berlin · London · New York 2008

© for illustrations of works by Brice Marden and
Barnett Newman:
VG Bild-Kunst, Bonn 2008; for Robert Motherwell:
Dedalus Foundation, Inc./VG Bild-Kunst, Bonn 2008;
for Sean Scully: Sean Scully

Photo Credits
pp. 7, 16–17, photo back cover: Nicole Bruneteau; pp. 7,
62–63: Hannah Samsworth; pp. 7, 88–89: Chris
Sharples; pp. 7, 114–115: Jon Groom; pp. 7, 140–141:
Steve Joy; pp. 7, 152–153: Steve Joy; pp. 7, 178–179:
Elenor Martinsen; pp. 12: Joan Joy (left), Jen Joy (right);
pp. 13: Alex Booker (upper right), Chris Sharples
(lower left), Steve Joy (lower right); pp. 14: Steve Joy
(right); pp. 15: Steve Joy (left), Nicole Bruneteau (right);
pp. 101, 103, 106: akg-images; p. 109: akg-images/
Bildarchiv Steffen; pp. 230–231: Steve Joy

Front cover *The Wait (for Robert Motherwell),*
oil and acrylic on canvas, 177 x 221 cm (69 1/2 × 87"),
Courtesy Galerie Erich Storrer, Zurich (see pages
172–173)
pp. 16–17 Boca Paila, Mexico, 2006
pp. 62–63 Portrait of Steve Joy
pp. 88–89 Times Square, New Your
pp. 114–115 Studio, Menorca, Spain
pp. 140–141 Studio, Bond Street, New York
pp. 152–153 Studio, Umbria, Italy
pp. 178–179 Portrait of Steve Joy, Plymouth, England
pp. 230–231 Studio, Omaha
Back cover Boca Paila, Mexico, 2006
 (see pages 16–17)
Frontispiece *Aquasparta,* 1998 acrylic, gold and
silver leaf, and Japanese ink on wood panels,
203 × 244 cm (80 x 96"), private collection, Council
Bluffs, Iowa, USA (see pages 96–97)

Prestel Verlag
Königinstrasse 9
80539 Munich
Tel. +49 (0)89 24 29 08-300
Fax +49 (0)89 24 29 08-335
www.prestel.de

Prestel Publishing Ltd.
4 Bloomsbury Place
London WC1A 2QA
Tel. +44 (0)20 7323-5004
Fax +44 (0)20 7636-8004

Prestel Publishing
900 Broadway, Suite 603
New York, NY 10003
Tel. +1 (212) 995-2720
Fax +1 (212) 995-2733
www.prestel.com

Library of Congress Control Number
2001012345

British Library Cataloguing-in-Publication Data:
a catalogue record for this book is available from
the British Library; Deutsche Nationalbibliothek
holds a record of this publication in the Deutsche
Nationalbibliografie; detailed bibliographical
data can be found under: http://dnb.ddb.de

Prestel books are available worldwide.
Please contact your nearest bookseller or one
of the above addresses for information concerning
your local distributor.

Project coordination
Anja Besserer
Translated from the English by
Nikolaus G. Schneider, Berlin
English texts copyedited by
Cynthia Hall, Stephanskirchen
German texts copyedited by
Dr. Alexander Müller, Munich
Production
Florian Tutte
Design and layout
a.visus, Michael Hempel, Munich
Origination
ReproLine mediateam, Munich
Printing and binding
TBB, Banská Bystrica

ISBN 978-3-7913-3961-0
(trade edition)

ISBN 978-3-7913-6157-4
(museum edition)

Special thanks to
Nicole Bruneteau for support and encourage-
ment during this project. In the preparation of
this book the artist wishes to thank
Anja Besserer and Thomas Zuhr of Prestel,
Michael Hempel for his design and enthusiasm,
Shayla Alarie of Anderson O'Brien Gallery for help
with the biography, and Thomas Jackson of Enterprise
Bank, Omaha, and his colleagues for support in
the production of this book. Thank you to Rudy
Hagerbaumer at the Joslyn Museum of Omaha, to
John Wilson for curatorial decisions and guidance,
and to the director, J. Brooks Joyner, for his vision
and commitment. The artist would like to thank
all of the collectors who have supported the work
over many years and who have loaned paintings
for the exhibition.